INSURRECTIONS
of the **MIND**

NEW REPUBLIC

INSURRECTIONS
of the MIND

100 YEARS OF
POLITICS AND CULTURE
IN AMERICA

FRANKLIN FOER

EDITOR

HARPER PERENNIAL

NEW YORK • LONDON • TORONTO • SYDNEY • NEW DELHI • AUCKLAND

HARPER ● PERENNIAL

INSURRECTIONS OF THE MIND. Copyright © 2014 by *The New Republic*. All rights reserved. Printed in the United States of America. No part of this book may be used or reproduced in any manner whatsoever without written permission except in the case of brief quotations embodied in critical articles and reviews. For information, address HarperCollins Publishers, 195 Broadway, New York, NY 10007.

HarperCollins books may be purchased for educational, business, or sales promotional use. For information, please e-mail the Special Markets Department at SPsales@harpercollins.com.

FIRST EDITION

Library of Congress Cataloging-in-Publication Data has been applied for.

ISBN 978-0-06-234039-9 (pbk.)

14 15 16 17 18 OV/RRD 10 9 8 7 6 5 4 3 2

Contents

Introduction

The Insurrectionists

FRANKLIN FOER

I.

On a summer night in 1914, Theodore Roosevelt summoned the young editors of a yet-unpublished magazine to the seat of his ex-presidency, his estate on the north shore of Long Island. The old Bull Moose had caught wind of the new project and wanted to make sure that the editors had the full benefit of his extensive wisdom. In TR's social set—Harvard and Yale men with an intellectual proclivity and a progressive bent—the impending debut of *The Republic*, as it was called in its nascent days, was much anticipated. It was grist for gossipy letters and dinnertime chatter.

The magazine's proposed title would have appealed to Roosevelt because it conjured both Plato and Rome. And the classic reference was merited, since America was in the early days of a Renaissance of sorts. A new artistic fervor occupied the narrow streets of Greenwich Village, thanks to the early arrival of European modernism and the first bootleg editions of Freud. Even more importantly, there was a proliferation of political reform movements, budding seem-

ingly everywhere and pushing a mélange of causes—temperance, suffrage, antitrust, trade unionism. The presidential campaign two years earlier, which Roosevelt lost, had amounted to a competition to capture the hearts and minds of these reformers.

All this energy needed a home and deeper thinking. That might have been the primary point that Theodore Roosevelt had hoped to impress upon his protégés over dinner. But he could never quite contain his conversational agendas, and he piled argument upon argument, so persistently and so deep into the night that the editor of the magazine, Herbert Croly, closed his eyes and drifted into an embarrassingly deep sleep.

The Republic, however, was doomed, or at least its name was. A partisan organ with the very same title already existed, owned by John F. Kennedy's gregarious grandfather "Honey Fitz" Fitzgerald. When the genteel editors politely inquired about the possibility of sharing the moniker, the old Boston pol refused. In truth, he probably hadn't intended to turn them away, only to get a little compensation for his troubles. But the editors missed the hint and renamed their magazine.

It would be *The New Republic*, which better represented the spirit of the enterprise. The magazine was born wearing an idealistic face. It soon gathered all the enthusiasm for reform and gave it coherence and intellectual heft. The editors of the magazine would help craft a new notion of American government: that the state was not just an essential tool for curbing corporations, but it could also play a more affirmative role in the life of the country, improving lives and creating a national community. The doctrine they created one hundred years ago, of course, goes by a now very familiar name: liberalism.

Over the last century, American liberalism has taken it on the chin—assaulted by the left and right. It has been smeared as a hodgepodge of contradictory ideas, cynically derived by opportu-

nistic thinkers angling for power and influence. It has been damned as a foreign implant, an ersatz version of the Germanic and Scandinavian welfare state grafted onto an unwilling American host. This volume hopefully stands as a refutation of liberalism's critics. It shows generation after generation of idealists battling their own disappointments and cynicism, not under the banner of a foreign ideology but in the name of the national interest. As much as any of its ideological competitors, modern liberalism was an American invention, and its history is a great American story.

II.

The story begins with Herbert Croly, an unlikely theorist of this movement and an even less likely maestro of an intellectual start-up. He was painfully shy. Conversations with him awkwardly stalled while he aimed his gaze at the ceiling. Paralyzing bouts of anxiety and depression had prevented him from ever graduating from Harvard. By the time he turned forty, he had slipped into a different sort of paralysis: a life of gentlemanly languor. He wrote about architecture for an obscure trade newsletter. Thanks to his wife's wealth, he could afford to spend a chunk of his year playing bridge and tennis at a country house in New Hampshire.

But his father, David, had been an eccentric newspaper editor, with wide-ranging intellectual interests and an immense mustache that cascaded toward his shoulders. David was an enthusiastic proselytizer on behalf of the French theorist Auguste Comte and his grand theory of history. Comte believed that knowledge would evolve to the point where experts could efficiently manage society with scientific precision—a doctrine that, in some respects, foreshadowed *New Republic*-style liberalism. During long walks in Central Park, David urged young Herbert to embrace Comte and continue spreading his good word. He wanted his son to assume his place among the great philosophers.

By the time he crept toward middle age, after so many years of drift, Herbert attempted to fulfill his father's dreams for him, one last mad dash for greatness. He poured all his accumulated thoughts and theories into a bulging manifesto called *The Promise of American Life*. The book, which appeared in 1909, argued that American life had grown hobbled by the lingering legacy of Thomas Jefferson—the nation celebrated an antiquated form of individualism and libertarianism that no longer matched the realities of the industrial age. Modern life had sapped the energy from America; it tolerated rampant mediocrity. To restore itself, the country would now have to turn to the theory of government espoused by Jefferson's old nemesis, Alexander Hamilton. That is, it would need a strong central state. Croly's book embodied many of the characteristics of the magazine he created: it was in turns wonky and literary; it rigorously analyzed the economic perils of unregulated trusts and calculated the toll of intellectual conformism.

It was an unusual book that attracted a small but fanatical following. One young couple read the book aloud to each other on their honeymoon. Willard Straight, a brilliant orphan from rural New York, had charmed his way into becoming J. P. Morgan's man in China. His new bride was Dorothy Whitney, an heir to a glimmering tangle of intermarried fortunes. Her parents had also died young—which left her with almost unlimited philanthropic potential and an uncommon degree of independence. As a young single woman, she had bankrolled a settlement house and spent years touring Europe. The couple shared a sense of idealism and earnestly professed the progressive faith.

When they finished reading Croly's book, they wrote him a mash note and invited him for lunch. By the time they had finished dessert, they had more or less hatched their plans for launching a political weekly that would trumpet the ideas in Croly's book and channel the enthusiasms stirred by Theodore Roosevelt's third-party bid.

By some accounts this was a golden age of journalism with the proliferation of muckraking periodicals, with all their famous by-lines (Lincoln Steffens, Ida Tarbell, and so on). Yet the success of magazines like *McClure's* and *Collier's* was fleeting. They were already in decline by the time that the Straights summoned Croly. Besides, these magazines hadn't really complemented their investigative reportage with much in the way of deep thinking; they weren't terribly intellectual.

But unlike the highbrow little magazines to come in the 1930s, *The New Republic* wasn't intended to be a clubby conversation among the hyperliterate. Croly had a very specific understanding of elites: they were meant to be a vanguard that would very self-consciously shape the political culture of the country and set its artistic standards. Croly wanted his publication to serve as a transmission belt of ideas, carrying the thoughts of intellectuals to a much broader and, therefore, much more meaningful audience. "[Our] primary purpose," Croly wrote Willard Straight, "will not be to record facts but to give certain ideals and opinions a higher value in American public opinion. If these ideas and opinions were accepted as facts it would be unnecessary to start the paper. The whole point is that we are trying to impose views on blind or reluctant people."

Croly was already in the middle of his career, but he populated *The New Republic* with bright young things, which became a magazine tradition. There were the likes of Walter Lippmann, who wrote his first groundbreaking manifesto at the age of twenty-four, and his contemporary Randolph Bourne, an idealistic hunchback mangled at birth by mishandled forceps. Their essays for the magazine were sometimes intensely personal. They exuded the idealism of youth and the era's belief in the power of the intellectual to change the world. But their faith in the intellectual took very different forms. Lippmann ingratiated himself to the establishment, attempting to

whisper in its ear. He regularly lunched at the apartment of Woodrow Wilson's top adviser, Colonel Edward House, and signed up as aide to the team that planned for the negotiations at Versailles. Meanwhile, Bourne preferred the purity of yelling from more bohemian quarters, decrying the moral costs of cozying up to power. Lippmann and Bourne came to despise each other, even as they briefly resided under the same journalistic roof.

It's hard to describe the magazine in its early years because it was such an unusual alchemy. You might encounter a short story by Willa Cather sitting next to a dense report on the aluminum tariff. (The humorist S. J. Perelman once ribbed the magazine's readers: "An old subscriber of *The New Republic*, am I, prudent, meditative, rigidly impartial. I am the man who reads those six-part exposes of the Southern utilities empires, savoring each dark peculation.") But that somewhat random quality was the point: the boundaries between policy and literature were meant to be porous. The realm of ideas prospered from having these seemingly disconnected articles jammed together—and they were part of the same social project: constructing a citizenry that has high aspirations and rigorous standards, both for its politics and its arts.

III.

The word *liberal* began appearing in the magazine not long after its launch. There was no single essay that advocated its use, no official mandate insisting upon the label. It spread organically and quietly, until Walter Lippmann noticed its proliferation and wrote about it in 1919:

> The word, liberalism, was introduced into the jargon of American politics by that group who were Progressives in 1912 and Wilson Democrats from 1916 to 1918. They wished to distinguish their own general aspirations in politics from those of the chronic partisans and the social revolutionists. They had no

other bond of unity. They were not a political movement. There was no established body of doctrine . . . If [American liberalism] has any virtue at all it is that many who call themselves liberals are aware that the temper of tolerant inquiry must be maintained.

It was easy to understand why such groups might have wanted to distance themselves from the progressives. That movement, which culminated in Teddy Roosevelt's third-party bid, had been an exhilarating rush of idealism but also an ideological mess—with pacifists sitting next to imperialists, Christian prohibitionists making common cause with proponents of birth control. Liberalism might not have been better defined than progressivism at this early moment, but it was somehow more coherent, having separated itself from the more reactionary elements that had joined up with the Progressive Party.

Liberalism's defining moment was the war. The editors weren't ecstatically grabbing guns and lining up to march, like their old friend Theodore Roosevelt (or their owner Willard Straight, for that matter). But they were hopeful that the war might transform American society, that it might jolt the country out of its deeply engrained libertarian instincts, setting it along the Hamiltonian path that Croly had prescribed. The patriotic rush of war would stir new feelings of community and connectedness. And mobilizing the nation would require an unprecedented degree of centralization.

Their greatest hopes were realized and then quickly dashed. The railroads were nationalized; food was distributed to starving Europeans with breathtaking efficiency; the federal government demonstrated logistical and organizational capabilities that stunned even its most enthusiastic boosters. But the whole experiment quickly exploded in liberalism's face. All the feelings of solidarity gave way to an outpouring of xenophobia and reaction; political dissidents

like Eugene Debs were subject to particular abuse at the hands of the government. And the fear of catching a Bolshevik contagion created a reactionary political climate, which big business and its allies deftly exploited. The moment the war ended, the wartime expansion of government was dismantled—as if this whole experiment had never happened.

The editors of *The New Republic* had conditioned their support for the war on one very specific demand: they wanted "peace without victory." That phrase had appeared in an editorial and then was repeated in Woodrow Wilson's address to Congress on the eve of war. Was it an accidental echo? Not according to Colonel House, who sent Lippmann an obsequious note congratulating him on the magazine's influence.

Just as they had hoped that the conflagration in Europe would remake America, they hoped that it would remake the international order. They believed that war provided an opportunity to halt the imperialist gamesmanship practiced by the Great Powers and end the cycle of perpetual conflict. But that outcome required a peace settlement that didn't impose draconian costs on the war's losers. And even before Wilson had finished negotiating the treaty, they understood that this cause was lost, that France and England would not be stopped in their quest for vengeful terms, and they began sinking into a fit of utter despondence. All that suffering and destruction, they quickly concluded, had been for nothing—a sense of defeat that deepened when their publication's owner Willard Straight, who had joined a unit in France, died of influenza in a Paris hospital. In their anger, Croly and Lippmann came to oppose the ratification of the League of Nations, an abrupt turnabout in editorial policy that spurred thousands of subscribers to cancel their subscriptions.

The *New Republic* editors channeled their disappointments with the war in different directions. Lippmann's loss of faith in the Amer-

ican people pulled him away from liberalism (by the time the New Deal rolled around, he denounced its "planned new social order"); Croly took an interest in Christianity and other forms of mysticism. Some in the magazine's circle drifted toward radicalism and then to the Communist Party. They were, in effect, the political wing of the Lost Generation.

But this disappointment helped give modern liberalism its shape. In response to wartime repression, the magazine published robust, innovative defenses of free speech written by John Dewey and the Harvard Law professor Zechariah Chafee. These pieces were crucial to the development of civil liberties as we know it. Justice Oliver Wendell Holmes, for one, read these pieces closely—and they changed his mind and, in turn, changed American jurisprudence, fueling Holmes's great dissents.

Before the war, Croly and his colleagues could seem more than a touch naive in their faith in the powers of the state and in their rhapsodic statements about the beneficence of the American people. The hardened liberalism that emerged was a much-improved iteration. It tempered its statist inclinations with a greater of sense of the dangers of the state run amok—a better balance of Hamilton and Jefferson. (The marriage of welfare statism and civil liberties is essentially the definition of American liberalism.) From the start, *The New Republic* had intended to create a third way between the socialists and the conservatives. If those differences had been murky, they were now a bit clearer.

IV.

After Willard Straight's death, his widow assumed control of the magazine. Her employees considered her something of a saint: unquestionably committed, tolerant of opinions that diverged from her own, and their intellectual equal. But Dorothy Straight was also an absentee owner, especially after she remarried, to an En-

glish agronomist called Leonard Elmhirst; in 1925, the newlyweds departed for Devon to launch their own utopian experiment. They bought a country estate and turned it into the English manor version of a settlement house, educating impoverished locals using the latest techniques of progressive education. Her departure from New York did no damage to the magazine. What *did* damage the magazine was her succession plan. At the end of World War II, she handed it over to her son, Michael.

There was reason to feel some empathy for young Michael. He was raised in his mother's social experiment, an emotionally disorienting way to spend childhood—and when he arrived at Trinity College, Cambridge, he felt unprepared for its academic rigors. That's one reason, he later limply explained, why he joined up with the Apostles, the Soviet spy ring orchestrated by Kim Philby. (Stalin personally tracked Straight's recruitment.) Although he claimed to have broken with the Soviets in 1941, he passed along documents to his handler well after that.

Michael Straight had grand plans for *The New Republic*. He wanted it to compete with Henry Luce's *Time* magazine, except from the left. His plan for expansion kept getting bigger—he boasted that he would grow circulation from 40,000 to 100,000, hired an expensive art director, and procured the services of Edward Bernays, the godfather of public relations. More importantly, he installed a famous figurehead at the top. Henry Wallace, FDR's old vice president and the most famous liberal in the country, became editor in 1946. But the whole experiment went wrong. Wallace degraded the prose of the magazine—filling it with claptrap that Dwight Macdonald savagely derided as "Wallese." *The New Republic* became a tiresome vehicle for Wallace's vision of world government.

Worse still, Wallace began to mount his own third-party presidential campaign with the not-so-stealth support of the Communists. After two years, Straight parted company with Wallace—

and the magazine endorsed his opponent, Harry Truman. But the damage had been significant, especially to the bottom line. Straight could no longer afford to run the magazine. He considered merging the magazine with its liberal cousin, *The Nation*. Talks had progressed to the point where they had even settled on a name for the new title, albeit a mouthful: *The Nation and New Republic*.

The Michael Straight experiment nearly cost *The New Republic* its life, but it also changed the magazine for the better, at least in one significant regard. During his tenure, he moved the magazine to Washington. It's true that the magazine had always covered the town. Its signature column, "TRB," was meant to purvey inside dish, and the magazine featured many learned pieces on policy. Still, the train ride that separated the magazine's headquarters in Chelsea from Washington manifested itself in the pages of the publication. *The New Republic* was idealistic without having a truly intimate understanding of American politics—and, as a consequence, the magazine's political writing was often absurdly disconnected from the realities of the legislative process. Perhaps the most striking sign of this dissonance was the fact that the flagship magazine of liberalism considered Franklin Roosevelt a paragon of mushy centrism and despised his New Deal. (This opposition also came despite the fact that an article in the magazine coined the term "New Deal.")

Moving to Washington sucked some of the romance from the magazine. *The New Republic* no longer sat in close proximity to the beating heart of American radicalism in Greenwich Village. Bylines of senators—Adlai Stevenson, John F. Kennedy, Paul Douglas— began appearing in the magazine. It acquired favored politicians— Eugene McCarthy, Hubert Humphrey, Al Gore. Mingling with power like this undeniably corrupts. Still, the magazine's writing about politics became more granular, better informed. *The New Republic* began to concern itself more with the legislative potential of ideas, their plausibility or, more to the point, their implausibility.

Over time, the magazine acquired an acute sense of the special interests that both constrained and enabled political possibilities; it learned to have more realistic expectations for liberalism's ability to win over public opinion.

This new hardheadedness coincided with liberalism's turn in that very same direction. In those years after the war, *The New Republic* published the likes of Niebuhr, Orwell, and Schlesinger, thinkers who dispensed with all the old utopian fantasies about radically re-making society. In their view, human nature was not infinitely malleable, and could be dispiritingly flawed; the United States faced real enemies in the world, even if its own foreign policy could be maddeningly heavy-handed and counterproductive. *The New Republic* insisted on drawing fine distinctions that were actually quite important, the sort of nuance that was dismissed as mealymouthed by progressives further to the left. One of the great examples of this was Richard Rovere's masterful dissection of the playwright Arthur Miller. Even though the magazine abhorred Joe McCarthy and his methods, it denied Miller, one of his primary targets, the status of martyr. Miller's stand against "naming names," Rovere argued, was vapid and even dangerous.

Such hardheaded realism has its flaws—at its worst, it can be soulless and technocratic. John F. Kennedy was perhaps the greatest avatar of this style, and he once delivered the most precise summation of this worldview: "The fact of the matter is that most of the problems, or at least many of them that we now face, are technical problems, are administrative problems. They are very sophisticated judgments which do not lend themselves to the great sort of 'passionate movements' which have stirred this country so often in the past." And it's true that *The New Republic* did a great deal to inject this sort of sterile thinking into the political culture. But the magazine also simultaneously buffered the country from this thinking by never fully abandoning its idealism. Just because it befriended

politicians didn't mean it ever stopped chastising them for abandoning their principles; it kept advancing the cause of reform, even if it hemmed its own ambitions for those reforms. This is the combination of styles—passionate but realistic, hardheaded but permissive of idealistic daydreams—that makes *New Republic* liberalism so confounding to both left and right. It is a style that, through all the changes in ownership, has never faded.

V.

I arrived at the magazine fourteen years ago, but it really felt more like a homecoming. My father had received a subscription as a high school graduation gift. It is often said that *The New Republic* had obtained something close to biblical status with its liberal readers. That's certainly the manner in which my father venerated the magazine. He read every single page of every single issue, sometimes even with a pen in hand to mark important passages. His consumption of the magazine was structured into his day, like his morning calisthenics and changing out of his suit after work. And like a precious religious object, the magazine was handed down from generation to generation. After he finished reading each issue, usually at night after I had fallen asleep, he quietly would slip it under my door.

As I edit the magazine, my father is always on my mind. (He's exactly the sort of person who would be loath to accord any text with canonical authority—anticlerical liberal that he is.) To an outsider, his attachment to the magazine might be befuddling. Over time, it has published a steady stream of articles that he has disliked, sometimes intensely so. With every issue (and with every editor, including his son), he has a long list of gripes. But he persists with the magazine, lovingly, despite his many disagreements—and, in fact, because of his disagreements with it. Even when the magazine hasn't always embodied his politics, it has jibed with his sensibility.

This attachment to the magazine's style is hardly a trivial thing—

liberalism is itself a sensibility as well as a set of ideas, if it is even possible to speak of them separately. For hundreds of years, long before the word was associated with Woodrow Wilson or Franklin Roosevelt, it has meant generosity and tolerance. It's pretty clear how those sentiments have evolved through the ages into a modern political program that champions a social safety net, civil rights, and civil liberties. But they are also hallmarks of an intellectual mode—which is manifested in the manner that liberals read and write as much as what they substantively argue. That approach is cosmopolitan and freethinking, willing to engage ideas that it might not share. (This magazine has a tradition of filling the masthead with socialists, communist sympathizers, English Tories, and neoconservatives.) Our doctrine proudly considers itself an antidoctrine. That is, American liberalism flaunts its pragmatism. It may have strong moral and philosophical beliefs, but it likes to claim that it derives conclusions from evidence and data, not dogma; its expectations for politics and human nature remain on the hard ground, not up in the utopian sky.

There is, admittedly, a bit of easily mocked self-congratulation in this description. And the liberal is perhaps the most mocked figure in American politics. Both the left and right seem to agree that liberals are figures of great weakness, a lot of self-righteous sentiment encrusted around a hollow core. The left's sneers grow from a sense of betrayal. Because the left assumes that liberals actually share their radical view, they can't understand why liberals won't embrace that radical view in public. Liberals, therefore, must be trimming their sails, unwilling to take righteous positions for fear of squandering their cozy place in the establishment.

The great Phil Ochs sang the most devastating version of this complaint:

I go to civil rights rallies
And I put down the old D.A.R.

I love Harry and Sidney and Sammy
I hope every colored boy becomes a star
But don't talk about revolution
That's going a little bit too far
So love me, love me, love me, I'm a liberal . . .

I read New Republic *and* Nation
I've learned to take every view
You know, I've memorized Lerner and Golden
I feel like I'm almost a Jew
But when it comes to times like Korea
There's no one more red, white and blue
So love me, love me, love me, I'm a liberal

And that style has been the source of tension within the staff. The magazine's radicals have often walked away repelled by the caution of their colleagues. Edmund Wilson, who worked at the magazine during his fellow-traveling years in the thirties, was especially disdainful of the liberals around him: "For one feels as one reads them today, that, in spite of their expression of moral and esthetic dissatisfaction, they are still sold like other middle-class Americans on the values of the middle-class world which they criticize."

Of course, this is a fairly accurate statement about liberalism. Yes, it quibbles with capitalism and our constitutional system—views them as imperfect and in need of constant improvement—but it has ultimate faith in both. But this faith doesn't grow from a desire to be invited to Georgetown cocktail parties or a fear of offending tennis partners; it is deeply felt.

On the surface, American liberals are an entirely different species than classical liberals. Locke, Montesquieu, Jefferson, and the rest of the classical liberals, after all, hated the all-powerful state and made it their mission to curb it; they celebrated the market and

trumpeted the virtues of self-interest. That American progressives chose to call themselves liberals seems a twisted and confusing misappropriation.

Old liberals and the new ones have very different methods; but at bottom, they have exactly the same convictions. They both believe in the transcendent importance of freedom and individual liberty. It's just that the threats to those values have changed. There's not a capricious monarch looming. In a constitutional democracy, the centralized state was no longer a grave danger to be contained, but an actual guardian of freedom—a protector against new menaces, like rapacious corporations and bigoted local tyrants. The state must create and enforce the rules that help ensure that the market economy remains productive and fair, despite its size and complexity.

This isn't the stuff of sloganeering; it's a complicated set of beliefs that even most liberals don't fully appreciate. And when *The New Republic* has hashed out these debates, it has sometimes created the illusion of incoherence—a step to the left here, a step to the right there, then a nice long twirl in the center. Critics of the magazine shout, "But it doesn't add up!" To which the proper response is, exactly. Aside from the works of John Rawls, American liberalism hasn't yielded volumes of great philosophical clarity. It has flourished in a magazine, which has provided the perfect venue for liberalism to explore itself—to arrive at provisional judgments and to reverse those judgments, to engage in a never-ending act of ideological seeking, to revel in the vitality that comes with the hard task of intellectual invention.

What follows is more than the greatest hits of the magazine. Nor is it simply a biography of a political idea and an intellectual style—although it aspires to tell that story. And from the outset, it's worth noting that some important pieces and beloved contributors were inevitably and painfully squeezed from the book; others didn't feel

germane or perfectly relevant to present times. And I intentionally excluded some of our more disgraceful contributions to American life. (Apologies, Henry Wallace, Betsy McCaughey, and Stephen Glass.) That's because this book hasn't been compiled in the name of definitiveness. It was put together in the spirit of the magazine that it anthologizes: it is an argument about what matters.

PART ONE
1910s

"Whatever truth you contribute to the world will be one lucky shot in a thousand misses. You cannot be right by holding your breath and taking precautions."

WALTER LIPPMANN, "BOOKS AND THINGS"

AUGUST 7, 1915

The Duty of Harsh Criticism

REBECCA WEST

November 7, 1914

From the start, the magazine bowed in the direction of the east—by which I mean London. The little magazines in New York and Boston had grown so moribund. They displayed far too little wit and failed to channel the intellectual energy of the times. For inspiration, Croly and Lippmann studied the pages of The Spectator, *the old Tory weekly, which blended politics and literature with a brashness and stylishness that they found aspirational. And a much closer ideological cousin, the* New Statesman, *had just appeared on the English scene as they were drawing up plans for* The New Republic.

Croly and Lippmann populated their new magazine with British imports. There was the economist Harold Laski, the Labour Party's in-house intellectual; the hawkish agitator Norman Angell, who may very well have been covertly planted in the magazine's office by Her Majesty's government; and, above all, the great literary journalist Rebecca West, who wrote this eternal manifesto at the age of twenty-two.

"The Duty of Harsh Criticism" appeared in Issue One. It established the tone of the best literary essays that followed. (When we launched our online book review site, we kept this piece tacked in the corner of the web page.) Her hostility to H. G. Wells, it must be noted, may have been more than a matter

of literary principle. The novelist was her lover—an affair that began when he noticed her scathing review of one of his novels. (Wells, she wrote, "is the Old Maid of novelists.") Two months before this piece appeared, she gave birth to his son.

To-day in England we think as little of art as though we had been caught up from earth and set in some windy side street of the universe among the stars. Disgust at the daily deathbed which is Europe has made us hunger and thirst for the kindly ways of righteousness, and we want to save our souls. And the immediate result of this desire will probably be a devastating reaction towards conservatism of thought and intellectual stagnation. Not unnaturally we shall scuttle for safety towards militarism and orthodoxy. Life will be lived as it might be in some white village among English elms; while the boys are drilling on the green we shall look up at the church spire and take it as proven that it is pointing to God with final accuracy.

And so we might go on very placidly, just as we were doing three months ago, until the undrained marshes of human thought stirred again and emitted some other monstrous beast, ugly with primal slime and belligerent with obscene greeds. Decidedly we shall not be safe if we forget the things of the mind. Indeed, if we want to save our souls, the mind must lead a more athletic life than it has ever done before, and must more passionately than ever practise and rejoice in art. For only through art can we cultivate annoyance with inessentials, powerful and exasperated reactions against ugliness, a ravenous appetite for beauty; and these are the true guardians of the soul.

So it is the duty of writers to deliberate in this hour of enforced silence how they can make art a more effective and obviously un-necessary thing than it has been of late years. A little grave reflec-tion shows us that our first duty is to establish a new and abusive school of criticism. There is now no criticism in England. There is

merely a chorus of weak cheers, a piping note of appreciation that is not stilled unless a book is suppressed by the police, a mild kindliness that neither heats to enthusiasm nor reverses to anger. We reviewers combine the gentleness of early Christians with a promiscuous polytheism; we reject not even the most barbarous or most fatuous gods. So great is our amiability that it might proceed from the weakness of malnutrition, were it not that it is almost impossible not to make a living as a journalist. Nor is it due to compulsion from above, for it is not worth an editor's while to veil the bright rage of an entertaining writer for the sake of publishers' advertisements. No economic force compels this vice of amiability. It springs from a faintness of the spirit, from a convention of pleasantness, which, when attacked for the monstrous things it permits to enter the mind of the world, excuses itself by protesting that it is a pity to waste fierceness on things that do not matter.

But they do matter. The mind can think of a hundred twisted traditions and ignorances that lie across the path of letters like a barbed wire entanglement and bar the mind from an important advance. For instance, there is the tradition of unreadability which the governing classes have imposed on the more learned departments of literature, such as biography and history. We must rebel against the formidable army of Englishmen who have achieved the difficult task of becoming men of letters without having written anything. They throw up platitudinous inaugural addresses like wormcasts, they edit the letters of the unprotected dead, and chew once more the more masticated portions of history; and every line they write perpetuates the pompous tradition of eighteenth century "book English" and dissociates more thoroughly the ideas of history and originality of thought. We must dispel this unlawful assembly of peers and privy councillors round the wellhead of scholarship with kindly but abusive, and, in cases of extreme academic refinement, coarse criticism.

That is one duty which lies before us. Others will be plain to any active mind; for instance, the settlement of our uncertainty as to what it is permissible to write about. One hoped, when all the literary world of London gave a dinner to M. Anatole France last year, that some writer would rise to his feet and say: "Ladies and gentlemen, we are here in honor of an author who has delighted us with a series of works which, had he been an Englishman, would have landed him in gaol for the term of his natural life." That would have shown that the fetters of the English artist are not light and may weigh down the gestures of genius. It is not liberty to describe love that he needs, for he has as much of that as any reasonable person could want, so much as the liberty to describe this and any other passion with laughter and irony.

This enfranchisement must be won partly by criticism. We must ridicule those writers who supply the wadding of the mattress of solemnity on which the British governing classes take their repose. We must overcome our natural reverence for Mrs. Humphry Ward, that grave lady who would have made so excellent a helpmate for Marcus Aurelius, and mock at her succession of rectory Cleopatras of unblemished character, womanly women who, without education and without the discipline of participation in public affairs, are yet capable of influencing politicians with wisdom. When Mr. A. C. Benson presents the world with the unprovoked exudations of his temperament, we may rejoice over the Hindu-like series of acqui-escences which take the place of religion in donnish circles. The whole of modern England is busily unveiling itself to the satirist and giving him an opportunity to dispute the reverences and reticence it has ordained.

But there is a more serious duty than these before us, the duty of listening to our geniuses in a disrespectful manner. Criticism matters as it never did in the past, because of the present pride of great writers. They take all life as their province to-day. Formerly

they sat in their studies, and thinking only of the emotional life of mankind—thinking therefore with comparative ease, of the color of life and not of its form—devised a score or so of stories before death came. Now, their pride telling them that if time would but stand still they could explain all life, they start on a breakneck journey across the world. They are tormented by the thought of time; they halt by no event, but look down upon it as they pass, cry out their impressions, and gallop on. Often it happens that because of their haste they receive a blurred impression or transmit it to their readers roughly and without precision. And just as it was the duty of the students of Kelvin the mathematician to correct his errors in arithmetic, so it is the duty of critics to rebuke these hastinesses of great writers, lest the blurred impressions weaken the surrounding mental fabric and their rough transmissions frustrate the mission of genius on earth.

There are two great writers of to-day who greatly need correction. Both are misleading in external things. When Mr. Shaw advances, rattling his long lance to wit, and Mr. Wells follows, plump and oiled with the fun of things, they seem Don Quixote and Sancho Panza. Not till one has read much does one discover that Mr. Shaw loves the world as tenderly as Sancho Panza loved his ass, and that Mr. Wells wants to drive false knights from the earth and cut the stupidity and injustice out of the spiritual stuff of mankind. And both have to struggle with their temperaments. Mr. Shaw believes too blindly in his own mental activity; he imagines that if he continues to secrete thought he must be getting on. Mr. Wells dreams into the extravagant ecstasies of the fanatic, and broods over old hated things or the future peace and wisdom of the world, while his story falls in ruins about his ears.

Yet no effective criticism has come to help them. Although in the pages of Mr. Shaw enthusiasm glows like sunsets and the heart of man is seen flowering in a hundred generous and lovely passions,

no one has ever insisted that he was a poet. We have even killed his poetry with silence. A year ago he lightened the English stage, which has been permanently fogged by Mr. Pinero's gloomy anecdotes about stockbrokers' wives and their passions, with "Androcles and the Lion," which was a miracle play and an exposition of the Christian mysteries. It taught that the simple man is the son of God, and that if men love the world it will be kind to them. Because this message was delivered with laughter, as became its optimism, English criticism accused Mr. Shaw of pertness and irreverence, and never permitted the nation to know that a spiritual teacher had addressed it. Instead, it advised Mr. Shaw to return to the discussion of social and philosophical problems, in which his talent could perhaps hope to be funny without being vulgar.

Mr. Wells' mind works more steadily than Mr. Shaw's, but it suffers from an unawareness of the reader; an unawareness, too, of his material; an unawareness of everything except the problem on which it happens to be brooding. His stories become more and more absent-minded. From "The Passionate Friends" we deduced that Mr. Wells lived on the branch line of a not too well organized railway system and wrote his books while waiting for trains at the main line junction. The novel appeared to be a year book of Indian affairs; but there were also some interesting hints on the publishing business, and once or twice one came on sections of a sympathetic study of moral imbecility in the person of a lady called Mary, who married for money and impudently deceived her owner. And what was even more amazing than its inchoateness was Mr. Wells' announcement on the last page that the book had been a discussion of jealousy. That was tragic, for it is possible that he had something to say on the subject, and what it was no one will ever know. Yet this boat of wisdom which had sprung so disastrous a leak received not one word of abuse from English criticism. No one lamented over the waste of the mind, the spilling of the idea.

That is what we must prevent. Now, when every day the souls of men go up from France like smoke, we feel that humanity is the flimsiest thing, easily divided into nothingness and rotting flesh. We must lash down humanity to the world with thongs of wisdom. We must give her an unsurprisable mind. And that will never be done while affairs of art and learning are decided without passion, and individual dulnesses allowed to dim the brightness of the collective mind. We must weepingly leave the library if we are stupid, just as in the middle ages we left the home if we were lepers. If we can offer the mind of the world nothing else we can offer it our silence.

In a Schoolroom

RANDOLPH S. BOURNE

November 7, 1914

Randolph Bourne came to hate his colleagues at The New Republic. *He would later consider them toadies, more intent on sharing a drink with power than speaking truth to it. One of his most famous essays implicitly shredded Croly and Lippmann for supporting World War I: "Their thought becomes little more than a description and justification of what is going on."*

In the emerging bohemia of Greenwich Village, Bourne seemed the perfect emblem of the nonconformist. For starters, there was his appearance. An obstetrician's forceps and a childhood case of spinal tuberculosis had turned him into a homunculus—short, bent, and ugly. Then there was his radical politics. He venerated youth culture and the young, which is why the New Left came to revere him in the sixties. Most of his essays for The New Republic *were about education, a subject that consumed many of the magazine's other thinkers, with its promise of creating a new breed of citizen. (Bourne was a devotee of John Dewey, before he angrily turned against the philosopher over his support for the war—and the philosopher turned against him, successfully insisting that Bourne be removed from the masthead of* The Dial.) *But when Bourne wrote about education, there was always an extra hint of rebellion, a paper airplane thrown across the room with a bomb buried in its belly.*

The other day I amused myself by slipping into a recitation at the suburban high school where I had once studied as a boy. The teacher let me sit, like one of the pupils, at an empty desk in the back of the room, and for an hour I had before my eyes the interesting drama of the American school as it unfolds itself day after day in how many thousands of classrooms throughout the land. I had gone primarily to study the teacher, but I soon found that the pupils, after they had forgotten my presence, demanded most of my attention.

Their attitude towards the teacher, a young man just out of college and amazingly conscientious and persevering, was that good-humored tolerance which has to take the place of enthusiastic interest in our American school. They seemed to like the teacher and recognize fully his good intentions, but their attitude was a delightful one of all making the best of a bad bargain, and co-operating loyally with him in slowly putting the hour out of its agony. This good-natured acceptance of the inevitable, this perfunctory going through by its devotees of the ritual of education, was my first striking impression, and the key to the reflections that I began to weave.

As I sank down to my seat I felt all that queer sense of depression, still familiar after ten years, that sensation, in coming into the schoolroom, of suddenly passing into a helpless, impersonal world, where expression could be achieved and curiosity asserted only in the most formal and difficult way. And the class began immediately to divide itself for me, as I looked around it, into the artificially depressed like myself, commonly called the "good" children, and the artificially stimulated, commonly known as the "bad," and the envy and despair of every "good" child. For to these "bad" children, who are, of course, simply those with more self-assertion and initiative than the rest, all the careful network of discipline and order is simply a direct and irresistible challenge. I remembered the fearful awe with which I used to watch the exhaustless ingenuity

of the "bad" boys of my class to disrupt the peacefully dragging recitation; and behold, I found myself watching intently, along with all the children in my immediate neighborhood, the patient activity of a boy who spent his entire hour in so completely sharpening a lead-pencil that there was nothing left at the end but the lead. Now what normal boy would do so silly a thing or who would look at him in real life? But here, in this artificial atmosphere, his action had a sort of symbolic quality; it was assertion against a stupid authority, a sort of blind resistance against the attempt of the schoolroom to impersonalize him. The most trivial incident assumed importance; the chiming of the town-clock, the passing automobile, a slip of the tongue, a passing footstep in the hall, would polarize the wandering attention of the entire class like an electric shock. Indeed, a large part of the teacher's business seemed to be to demagnetize, by some little ingenious touch, his little flock into their original inert and static elements.

For the whole machinery of the classroom was dependent evidently upon this segregation. Here were these thirty children, all more or less acquainted, and so congenial and sympathetic that the slightest touch threw them all together into a solid mass of attention and feeling. Yet they were forced, in accordance with some principle of order, to sit at these stiff little desks, equidistantly apart, and prevented under penalty from communicating with each other. All the lines between them were supposed to be broken. Each existed for the teacher alone. In this incorrigibly social atmosphere, with all the personal influences playing around, they were supposed to be, not a network or a group, but a collection of things, in relation only with the teacher.

These children were spending the sunniest hours of their whole lives, five days a week, in preparing themselves, I assume by the acquisition of knowledge, to take their place in a modern world of industry, ideas and business. What institution, I asked myself, in this

grown-up world bore resemblance to this so carefully segregated classroom? I smiled, indeed, when it occurred to me that the only possible thing I could think of was a State Legislature. Was not the teacher a sort of Speaker putting through the business of the session, enforcing a sublimated parliamentary order, forcing his members to address only the chair and avoid any but a formal recognition of their colleagues? How amused, I thought, would Socrates have been to come upon these thousands of little training-schools for incipient legislators? He might have recognized what admirably experienced and docile Congressmen such a discipline as this would make, if there were the least chance of any of these pupils ever reaching the House, but he might have wondered what earthly connection it had with the atmosphere and business of workshop and factory and office and store and home into which all these children would so obviously be going. He might almost have convinced himself that the business of adult American life was actually run according to the rules of parliamentary order, instead of on the plane of personal intercourse, of quick interchange of ideas, the understanding and the grasping of concrete social situations.

It is the merest platitude, of course, that those people succeed who can best manipulate personal intercourse, who can best express themselves, whose minds are most flexible and most responsive to others, and that those people would deserve to succeed in any form of society. But has there ever been devised a more ingenious enemy of personal intercourse than the modern classroom, catching, as it does, the child in his most impressionable years? The two great enemies of intercourse are bumptiousness and diffidence, and the classroom is perhaps the most successful instrument yet devised for cultivating both of them.

As I sat and watched these interesting children struggling with these enemies, I reflected that even with the best of people, thinking cannot be done without talking. For thinking is primarily a social

faculty; it requires the stimulus of other minds to excite curiosity, to arouse some emotion. Even private thinking is only a conversation with one's self. Yet in the classroom the child is evidently expected to think without being able to talk. In such a rigid and silent atmosphere, how could any thinking be done, where there is no stimulus, no personal expression?

While these reflections were running through my head, the hour dragged to its close. As the bell rang for dismissal, a sort of thrill of rejuvenation ran through the building. The "good" children straightened up, threw off their depression and took back their self-respect, the "bad" sobered up, threw off their swollen egotism, and prepared to leave behind them their mischievousness in the room that had created it. Everything suddenly became human again. The brakes were off, and life, with all its fascinations of intrigue and amusement, was flowing once more. The school streamed away in personal and intensely interested little groups. The real world of business and stimulations and rebounds was thick again here.

If I had been a teacher and watched my children going away, arms around each other, all aglow with talk, I should have been very wistful for the injection of a little of that animation into the dull and halting lessons of the classroom. Was I a horrible "intellectual," to feel sorry that all this animation and verve of life should be perpetually poured out upon the ephemeral, while thinking is made as difficult as possible, and the expressive and intellectual child made to seem a sort of monstrous pariah?

Now I know all about the logic of the classroom, the economies of time, money, and management that have to be met. I recognize that in the cities the masses that come to the schools require some sort of rigid machinery for their governance. Hand-educated children have had to go the way of hand-made buttons. Children have had to be massed together into a schoolroom, just as cotton looms have had to be massed together into a factory. The difficulty is that,

unlike cotton looms, massed children make a social group, and that the mind and personality can only be developed by the freely inter-stimulating play of minds in a group. Is it not very curious that we spend so much time on the practice and methods of teaching, and never criticise the very framework itself? Call this thing that goes on in the modern schoolroom schooling, if you like. Only don't call it education.

Life Is Cheap

WALTER LIPPMANN

December 19, 1914

This essay sounds unlike the Walter Lippmann—that granite fixture on the opinion page—who became so well known. There's not a hint of any conversations with foreign ministers or senior senators. His tone has none of his famous detachment. His prose explodes with the passion of a young man. Before Herbert Croly discovered Walter Lippmann, he had just spent a brief tour working for George Lunn, the Socialist mayor of Schenectady, New York.

The New Republic is famous for giving writers their starts and exploiting the fearlessness of youth—those early years of a career when a writer will take big journalistic risks to make a name. (Of course, this is the same exploitative strategy that produced the fabulist Stephen Glass.) When Lippmann was a young man on the make, he was at his most interesting. He helped bring Freud to an American audience and transposed the good doctor's argument into the realm of politics. He took aim at prestige targets, like The New York Times, and he frequently changed his mind in response to experiences. It's true that he shamelessly courted the Wilson administration in those early years of the magazine, but he also wrote pieces like this.

When a military expert wishes to be very technical and professional he refers to the killed, wounded and missing as the wastage of an

army. To those who do not share his preoccupation with the problems of grand strategy, the word connotes a cold and calculated horror based on a fatal disregard of human cost. It is natural, then, to fall back upon the old platitude that in war life is cheap; cheaper than guns, cheaper than dreadnoughts, cheaper even than intelligent diplomacy.

If we go behind this simple idea, however, we find curious distinctions reflected in ordinary feeling about the war. There was General Joffre's statement that the French would not waste men in furious assaults. In England this was received with approval, mixed with the feeling that the British were standing the worst of the racket. Most curious, however, was the English attitude towards the Russians. The Russians were conceived as an inexhaustible horde which could be poured endlessly against German guns. The value of individual Russians was ridiculously low as compared with individual Englishmen. In America the loss of two thousand Austrians would seem as nothing beside the loss of two thousand Englishmen. If the Canadians were to suffer heavily, we should feel it still more, no doubt.

When the *Titanic* sank, it was very noticeable that the anguish of the first-cabin passengers meant more to the newspapers than did that of the crew or steerage; and of the first-cabin passengers, it was the well-known people in whom was dramatized the full terror of the disaster. When a man is run over, the amount of space given to a report of the accident seems to depend very closely either on his social importance in the community, or on whether he is injured under circumstances which might apply to highly regarded elements of the population. The injuries of foreign-born laborers on construction work are hardly reported. It is estimated that one man is killed for every floor added to a skyscraper, but the fact does not rise to the level of popular interest. The value of a life seems to increase only as it emerges from a mass and becomes individualized.

So long as great populations remain politically inert, so long as they can be treated in lumps, so long as they can be manipulated from above, they will be lightly used or easily disregarded.

It is in time of peace that the value of life is fixed. The test of war reveals it. That is why democracies tend to be peaceful. In them the importance of each person has been enlarged, and the greater the equality, the less able are small groups to use their fellows as brute instruments. Democracies are compelled to look toward peaceful adjustments because the cost of war is too tremendous for them. The mere fact that at a certain level of comfort and self-respect the birth-rate declines makes the conservation of life imperative. It is in democracies based on fairly well distributed economic op-portunity and a modicum of education that birth ceases to be a wholesale accident and becomes a considered purpose. France is such a democracy, and France does not spend life easily. The large measure of equality which she has achieved by a prudent birth-rate, a tolerable level of well-being, and a tradition of human rights, has made dreams of lavish conquest forever impossible to her. She will defend what she has with superb courage, but she cannot dominate the world.

There, perhaps, is the most important relation between social reform and the problem of peace. The aggressors of the future are likely to be the nations in which life is cheap, and the hope of inter-national order rests with those countries in whom personality has become too valuable to be squandered. This is why the whole world waits the democratization of Germany, Russia and Japan.

But even the so-called democracies are far from a decent sense of the value of life. Here in America life is extraordinarily cheap. There is almost no task so dull, so degrading or so useless but you can find plenty of human beings to do it. You can hire a man to walk up and down the avenue carrying a sign which advertises a quack dentist. You can hire rows of men for the back line of the

chorus, just standing them there to fill up space. You can hire a man to sit next to the chauffeur; he is called a footman and his purpose is to make the owner of the car a bit more comfortable and a great deal more magnificent. There are women known as lady's maids whose business it is to dress up other women. There are flunkeys whose mission it is to powder their hair, put on white stockings and gold-trimmed knee-breeches and flank the threshold of great houses. It is possible to hire any number of caretakers for empty houses, bellhops to fetch for you, even mourners to mourn for you.

Every city is full of women whose lives are gray with emptiness, who sit for hours looking out of the windows, who rock their chairs and gossip, and long for the excitement that never comes. Unloved and unloving, and tragically unused, the world seems to have passed them by. Our cities are full of those caricatured homes, the close, curtained boarding houses to which people come from the day's drudgery to the evening's depression, the thousands of hall bedrooms in which hope dies and lives the ghost of itself in baseball scores and in movies, in the funny page and in Beatrice Fairfax, in purchased romance and in stunted reflections of the music-hall.

It is not strange that in war we spend life so easily, or that our anxiety to lower the death-rate of babies, to keep the sick alive, to help the criminal and save the feeble-minded, seems to many a trifling humanitarianism. The notion that every person is sacred, that no one is a means to some one else's end, this sentiment which is the heart of democracy, has taken only slight hold upon the modern world. It is still hardly questioned that men should die to protect concessions, to collect debts, to hold markets, to glorify their king, to avenge imaginary insults. In the industrial world men are used as "hands," kept waiting in idle crowds to fill casual jobs, put at work that exhausts and pays almost nothing, blocked in occupations from which they cannot learn, from which they become forever unfitted to escape. Women are used as drudges, as recreation, as things to

jest about or to appropriate, because all through our civilization there runs an appalling insensitiveness and disregard. We have not yet made life dignified and valuable in itself, we have not yet made it a sufficient treasury of good things, have not infused it with the riches which men will not wantonly waste.

Human life will become valuable as we invest in it. The child that is worth bearing, nursing, tending and rearing, worth educating, worth making happy, worth building good schools and laying out playgrounds for, worth all the subtle effort of modern educational science, is becoming too valuable for drudgery, too valuable for the food of cannon. It is because for some years we have been putting positive values into life that this war appalls us more than it would have appalled our ancestors. And just so far as we can induce the state to sink money and attention in human beings, by just so much do we insure ourselves against idle destruction.

This is the best internal defense against those amongst us who may be dreaming of aggression. Every dollar and every moment of care devoted to increasing the individual importance of people, all skill and training, all fine organization to humanize work, every increase of political expression, is a protection against idle use of our military power, against any attempt to convert legitimate and necessary preparation for defense into an instrument of conquest. It may be said with justice that the man is dangerous who talks loudly about military preparation and is uninterested in social reform. It is the people engaged in adding to the values of civilization who have earned the right to talk about its defense.

The Future of Pacifism

John Dewey

July 28, 1917

When the editors of The New Republic *conceived the magazine, they never intended to devote so many of their pages to the affairs of Europe. But by the time they sat down to prepare their first issue, war had erupted. The first-ever editorial announced that America could no longer afford to harbor dreams of blissful isolation from the world.*

The owner of the magazine, Willard Straight, was a full-throated hawk. He joined a training camp in Plattsburgh, New York, where proponents of "preparedness" were camping in tents and completing martial drills, with the hope that their enthusiasm for joining the fight would highlight the Wilson administration's aversion to it.

Straight's employees took a more ambivalent position. They considered war more inevitable than imperative. It wasn't something one wished, but it was also an opportunity. The cloud of conflict could be a pretext for remaking America and the world. Feelings of solidarity would weaken the natural American instinct toward individualism—and the demands of combat would necessitate the rapid expansion of the federal government. (Randolph Bourne derisively mocked this idea: "War is the health of the state.") Just as important, the ruins of Europe would need to be reconstructed so that

the continent would never again fall victim to the destructive imperialist impulse.

This argument might not have been an extension of the pragmatic school of American philosophy, which John Dewey helped create, but it was certainly expedient thinking.

There is no paradox in the fact that the American people is profoundly pacifist and yet highly impatient of the present activities of many professed or professional pacifists. The disposition to call the latter pro-German and to move for their suppression is an easy way of expressing a sense of the untimely character of their moves at the present juncture. But the war will pass, and the future of the profound American desire for peace, for amity, for unhampered and prosperous intercourse, is a topic which is intimately connected with the war itself. For upon its constant consideration depends whether the impulse to a better ordered world which reconciled America to war shall find satisfaction or meet frustration. And I know no better way to introduce the subject than a consideration of the failure of the pacifist propaganda to determine finally the course of a nation which was converted to pacifism in advance.

The explanation, I take it, is that it takes two to make peace as well as to make war; or, as the present situation abundantly testifies, a much larger number than two. He was a poor judge of politics who did not know from the very day of the Lusitania message—or at all events from that of the Sussex message—that the entrance of the United States into the war depended upon the action of Germany. Any other notion was totally inconsistent with any belief in President Wilson's sincerity; it imputed to him an almost inconceivable levity in a time when seriousness was the chief need. Those who voted for him for President on the ground that he "kept us out of war" and who felt aggrieved when we got into war have only themselves to blame. He had unmistakably plotted a line which led

inevitably to conflict with Germany in case the latter should take the course which she finally adopted.

This indictment of professional pacifism for futile gesturing may seem to rest upon acceptance of the belief in the political omnipotence of the executive; it may seem to imply the belief that his original step committed the nation irretrievably. Such an inference, however, is merely formal. It overlooks the material fact that President Wilson's action had the sanction of the country. I will not enter into the question of legal neutrality, but morally neutral the country never was, and probably the only stupid thing President Wilson did was to suppose, in his early proclamation, that it could be. And this brings us back to the basic fact that in a world organized for war there are as yet no political mechanisms which enable a nation with warm sympathies to make them effective, save through military participation. It is again an instinctive perception of this fact which encourages the idea that pacifists who do not support the war must be pro-German at heart.

The best statement which I have seen made of the pacifist position since we entered the war is that of Miss Addams. She earnestly protests against the idea that the pacifist position was negative or laissez-faire. She holds that the popular impression that pacifism meant abstinence and just keeping out of trouble is wrong; that it stood for a positive international polity in which this country should be the leader of the nations of the world "into a wider life of coordinated activity"; she insists that the growth of nations under modern conditions involves of necessity international complications which admit "of adequate treatment only through an international agency not yet created." In short, the pacifists "urge upon the United States not indifference to moral issues and to the fate of liberty and democracy, but a strenuous endeavor to lead all nations of the earth into an organized international life."

That intelligent pacifism stands for this end, and that the more

intelligent among the pacifists, like Miss Addams, saw the situation in this fashion needs not be doubted. But as Miss Addams recognized in the same address there are many types of pacifists. I question whether any one who followed the pacifist literature which appeared in the year or two before we got into the war derived it from the conception that the dominant ideal was that ascribed to pacifism by Miss Addams, namely, that the United States should play a "vitally energetic role" in a political reorganization of the world. But even if this had been the universal idea of what was theoretically desirable, the force of circumstances forbade pacifists who drew back at war as a means of bringing about this role from pressing it.

The pacifist literature of the months preceding our entrance into war was opportunistic—breathlessly, frantically so. It did not deal in the higher strategy of international politics, but in immediate day-by-day tactics for staving off the war. Because the professional pacifists were committed to the idea that anything was better than our getting into the war, their interest in general international reorganization had no chance for expression. They were in the dilemma of trying to accomplish what only definite political agencies could effect, while admitting these agencies had not been created. Thus they were pushed out of the generic position of work for the development of such agencies into the very elementary attitude that if no nation ever allowed itself to be drawn into war, no matter how great the provocation, wars would cease to be. Hence the continuous recourse to concessions and schemes, devised *ad hoc* over night, to meet each changing aspect of the diplomatic situation so as to ward off war. The logic seems sound. But the method is one of treating symptoms and ignoring the disease. At the best, such a method is likely to remain some distance behind newly appearing symptoms, and in a critical disease the time is bound to come (as events demonstrated in our case) when the disease gets so identi-

fied with the symptoms that nothing can be done. All this seems to concern the past of pacifism rather than its future. But it indicates, by elimination, what that future must be if it is to be a prosperous one. It lies in furthering whatever will bring into existence those new agencies of international control whose absence has made the efforts of pacifists idle gestures in the air. Its more immediate future lies in seeing to it that the war itself is turned to account as a means for bringing these agencies into being. To go on protesting against war in general and this war in particular, to direct effort to stopping the war rather than to determining the terms upon which it shall be stopped, is to repeat the earlier tactics after their ineffectualness has been revealed. Failure to recognize the immense impetus to re-organization afforded by this war; failure to recognize the closeness and extent of true international combinations which it necessitates, is a stupidity equaled only by the militarist's conception of war as a noble blessing in disguise.

I have little patience with those who are so anxious to save their influence for some important crisis that they never risk its use in any present emergency. But I can but feel that the pacifists wasted rather than invested their potentialities when they turned so vigorously to opposing entrance into a war which was already all but universal, instead of using their energies to form, at a plastic juncture, the con-ditions and objects of our entrance. How far this wasted power is recoverable it is hard to say. Certainly an added responsibility is put upon those who still think of themselves as fundamentally pacifists in spite of the fact that they believed our entrance into the war a needed thing. For the only way in which they can justify their posi-tion is by using their force to help make the war, so far as this coun-try can influence its final outcome, a factor in realizing the ideals which President Wilson expressed for the American people before and just upon entering the war. All such pacifists—and they com-prise in my opinion the great mass of the American people—must

see to it that these ideals are forced upon our allies, however unwilling they may be, rather than covered up by the debris of war. If the genuine pacifism of our country, a pacifism interested in permanent results rather than in momentary methods, had had leadership, it is not likely that we should have entered without obtaining in advance some stipulations. As it is, we (so far, at least, as any one knows) romantically abstained from any bargaining and thereby made our future task more difficult.

Not that the difficulty is all abroad. We have plenty of Bourbons and Bureaucrats in international diplomacy at home, and war undoubtedly strengthens their position by making them appear the genuine representatives of our war motives and policies. Their attitude is well expressed in the fact that since their imagination is confined to the flat map, their intellectual preparation for the post-bellum scene consists in redrawing the future map of Europe and the world—a form of indoor sport which even the literary men of England have now well nigh abandoned. Thus the present task of the constructive pacifist is to call attention away from the catchwords which so easily in wartime become the substitute for both facts and ideas back to realities. In view, for example, of the unjustified invasion of Serbia and Belgium, the rights of small nationalities tend to become an end in itself, a means to which is the "crushing" of Germany. The principle of nationality on its cultural side must indeed receive ample satisfaction in the terms of war settlement unless fuel for future conflagrations is to be stored up. But to get no further than setting up more small isolated nationalities on the map is almost wilfully to provoke future wars. If the day for isolated national sovereignty in the case of large nations has been rendered an anachronism by the new industry and commerce, much more is that the case for small political units. The case of Ireland, the clutter of nationalities in southeastern Europe, the fact that all the smaller neutral nations are now leading a distressed existence as appanages of the warring Powers, show how much more important questions of food supply, of coal and

iron, of lines of railway and ship-transportation are for the making and ordering of states than the principle of isolated nationality, big or small. Germany was realistically inclined in its belief that the day of the small nation—in its traditional sense—had passed. Its tragic error lay in that egotism which forbade its seeing that the day of the big isolated nation had also passed.

So one might, I think, go over, one by one, the phrases which are now urged to the front as defining the objects of war at the terms of peace and show that the interests of pacifism are bound up with securing the organs by which economic energies shall be articulated. We have an inherited political system which sits like a straitjacket on them since they came into being after the political system took on shape. These forces cannot be suppressed. They are the moving, the controlling, forces of the modern world. The question of peace or war is whether they are to continue to work furtively, blindly, and by those tricks of manipulation which have constituted the game of international diplomacy, or whether they are to be frankly recognized and the political system accommodated to them. The war does not guarantee the latter results. It gives an immense opportunity for it, an opportunity which justifies the risks. Military men continue to think within the lines laid down in the seventeenth century, in the days when modern "sovereign" nations were formed. Statesmen, guided by historians and that political science which has elevated the historic facts of temporary formations into an abstract and absolute science, work on the same model. As a result, too many influential personages are pure romanticists. They are expressing ideals which no longer have anything to do with the facts. This stereotyped political romanticism gives the pacifists their chance for revenge. Their idealism has but to undergo a course in the severe realism of those economic forces which are actually shaping the associations and organizations of men, and the future is with them.

PART TWO
1920s

"Is there anything valuable The New Republic *can do?"*
"Do not become too rabid."

<div align="right">

DOROTHY STRAIGHT IN CONVERSATION WITH

HER LATE HUSBAND, WILLARD

FROM A SÉANCE CONDUCTED IN 1925

</div>

PART TWO

Meditation in E Minor[*]

H. L. MENCKEN

September 8, 1920

The editors of The New Republic *both craved and attracted spiritual godfathers. Louis Brandeis, John Dewey, Learned Hand, and Felix Frankfurter would play this role in the early life of the magazine, passing along avuncular suggestions. Mencken never intervened in the life of* The New Republic *in this sort of way. In fact, the crusty newspaperman made an unlikely idol for the young liberals. His disappointment with his fellow humans poured forth in bilious essays that espoused deeply conservative politics.*

Still, there was something of this very same disappointment in 1920s liberalism. The Great War, and especially its ugly aftermath, had exposed the worst of the American people. The masses, it turned out, harbored xenophobia and racism; they celebrated repression of unpopular minorities; they elected uninspiring dolts to high office.

Mencken embodied a style that liberals widely emulated. They adored his ability to write about both politics and literature—and to write about politics with literary flair. His wit, with its edge of misanthropy and condescension, became something of the house style for the decade.

[*] Passed reluctantly by the censor. —The Editors.

I.

I seem to be the only sort of man who is never heard of in politics in the Republic, either as candidate or as voter. *Also,* I must write my own platform, make my own speeches, point with my own pride, view with my own alarm, pump up my own hopes and ideals, invent my own lies, posture and grimace upon my own front porch . . .

II.

Politically I am absolutely honest, which is to say, as honest as possible; which is to say, honest more or less; which is to say, far more honest than the general. My politics are based frankly and wholly upon what, in the dim light now shining in the world, I take to be my self-interest. I do not pretend to any pressing interest in the welfare of any other man, whether material or spiritual; in particular, I do not pretend to any interest in the welfare of any man who belongs to a class that differs clearly from my own. In other words, I am intensely class-conscious—almost the ideal citizen of the radical vision. Virtually all of the men that I know and like and respect belong to my own class, or to some class very closely allied to it. I can't imagine having any active good-will toward a man of a widely differing class—say the class of professional politicians and bureaucrats, or that of wealthy manufacturers, or that of schoolmasters, or that of policemen, ordained and lay. Such men simply do not interest me, save as convenient targets for the malevolence that is in all of us. I like to vex them; beyond that, as old Friedrich used to say, I hand them over to statistics and the devil. If all the members of such a class were deported by Dr. Palmer and his blacklegs tomorrow, my indignation would be transient and theoretical; if I yelled, it would be as I yell occasionally about the massacres in Ireland, Haiti, Armenia and India, hoping all the while that the show doesn't stop.

Here, of course, I wallow in platitudes; I, too, am an American, God save us all! The blather of politics is made up almost wholly of violent and disingenuous attempts to sophisticate and obfuscate

those platitudes. Often, of course, the bosh-monger succumbs to his own bosh. The late Major-General Roosevelt, I have no doubt, convinced himself eventually that he was actually the valiant and aseptic Bayard of Service that he pretended to be—that he was a Lafayette sweating unselfishly and agonizingly to protect, instruct, inspire, guide and lift up the great masses of the plain people, his inferiors. He was, perhaps, honest, but he was wrong. What moved him was simply a craving for facile and meaningless banzais, for the gaudy eminence and power of the leader of a band of lynchers, for the mean admiration of mean men. His autobiography gives him away; what he left out of it he babbled to the deacon of his mass, Leary, and to the sub-deacon, Abbott. Had Roosevelt been the aristocrat that legend made him, his career would have presented a truly astonishing spectacle: Brahms seeking the applause of organ grinders, piano tuners and union cornetists. But he was no such aristocrat, either by birth or by training. He was simply a professional politician of the democratic kidney, by Harvard out of the Rotary Club bourgeoisie, and his good was always the good of his well-fed, bombastic and extremely shallow class. Immediately his usual victims became class-conscious on their own hook, he was their enemy, and showed all the horror of them that one would look for in John D. Rockefeller, Jr., Judge Gary or Frank A. Munsey.

III.

The class that I belong to is of the order of capitalists. I am not rich, but my ease and welfare depend very largely upon the security of wealth. If stocks and bonds became valueless tomorrow, I'd be forced to supplement my present agreeable work with a good deal of intensely disagreeable work. Hence I am in favor of laws protecting property, and am an admirer of the Constitution of the United States in its original form. If such laws can be enforced peacefully, i.e., by deluding and hornswoggling the classes whose interests they

stand against, then I am in favor of so enforcing them; if not, then I am in favor of employing professional bullies, e.g., policemen, soldiers and Department of Justice thugs, to enforce them with the sword. Here I borrow the morality of the radicals, who are my enemies; their arguments in favor of an alert class-consciousness convince me, but I stick to my own class. I borrow even more from the liberals, who are also my enemies. In particular, I borrow the doctrine that peace in such matters is better than war—that it is foolish to hire gunmen when it is so much simpler and easier to bamboozle the boobs with phrases. Here, of course, a trade interest helps out my class consciousness; I am a professional maker of the phrases and delight in displays of virtuosity. The liberals feed me with that delight. This explains why I like them and encourage them, though their politics usually depress me.

But though I am thus in favor of property and would be quite content to see one mob of poor men (in uniform) set to gouging and ham-stringing another mob of poor men (in overalls) in order to protect it, it by no means follows that I am in favor of the wealthy bounders who now run the United States, or of the politics that they preach in their kept press. On the contrary, I am even more violently against them than I am against the radicals with their sticks of dynamite and the liberals with their jugs of Peruna. And for a plain reason. On the one hand, these swine oppress me excessively and unnecessarily—by putting up prices, by loading me with inordinate taxes, by setting hordes of bureaucrats to looting me, by demanding that I give my assent to all their imbecile and dishonest ideas, and by threatening me with the cost of endless wars, to them extremely profitable. On the other hand, and even more importantly, their intolerable hoggishness threatens to raise the boobery in revolt and bring about a reign of terror from which only the strongest will emerge. That revolt would ruin me. I am not large enough, as a capitalist, to make a profit out of wars and turmoils. I believe that

the rising of the proletariat, if it ever comes in this country, will end in a colossal victory for capitalism—that capitalism, as at present and in the past, will play off one mob against another, and pick the pockets of both. But it will also pick my pockets. It will also force me, who had nothing to do with the row, and protested against it bitterly, to pay a tremendous price for getting out alive. I'll have my naked hide, but everything else will be lost, including honor.

Ah, that my vision were a mere nightmare, the child of encroaching senility and bad beer! Unluckily, the late lamentable war showed its terrible reality. That war was fought against my advice and consent, and I took no part in it whatever, save as spectator. In particular, I made no profit out of it—not a cent, directly or indirectly. Well, what is my situation today? In brief, I find that my property is worth, roughly speaking, no more than half of what it was worth at the end of 1916, and that, considering its ratio to the total national wealth, and the difference between the national debt then and now, I owe, as a citizen of the United States, something between \$8,000 and \$10,000. To whom? Who got it, and how, and for what? . . . Let us not go into the question too particularly. I find my class-consciousness wobbling!

IV.

Meanwhile, however, I still manage to eat without too much labor, and so I incline to the Right, and am a Tory in politics, and trust in God. It would give me great pleasure to vote for a Tory candidate for the Presidency—not a hollow ass like General Wood, but an honest and unashamed Tory, one voicing the sincere views of the more civilized section of the propertied class, not a mere puppet for usurers. Unfortunately, no such candidate ever offers himself. The men put up by the usurers are always such transparent frauds that it is impossible, without anaesthetics, to vote for them. I admire liars, but surely not liars so clumsy that they cannot fool even themselves.

I am an old hand at political shows, and witnessed both the nomination of Harding at Chicago and that of Cox at San Francisco. It would be difficult to imagine more obscene spectacles. Who, being privy to their disgusting trimming, their mean courting of mean men, their absolute lack of any sense of dignity, honor or self-respect, could vote for either? It will take me all the time between now and November, abandoning all other concerns, to work up the necessary cynicism—and no doubt I'll fail even then. But could I vote for Christensen? He is a Knight of Pythias; allow me my prejudices! Debs? Please don't suggest it in plain words. It would be anguish unspeakable; I am probably the only man in Christendom who has never been a Socialist even for an instant. An idiot, this Debs, but honest, and he says plainly that he is against me. I'd be a worse idiot if I voted for him.

My dilemma, alas, is not unique. Thousands of other men must face it—men of my class, men of related classes, perhaps even men of classes far removed. It visualizes one of the penalties that democracy, the damnedest of frauds, inflicts upon every man who violates all its principles by trying to be honest.

The Eclipse of Progressivism

HERBERT CROLY

October 27, 1920

Herbert Croly celebrated the virtues of intellectual detachment, or what he preferred to call disinterestedness, the ability to transcend narrowly self-interested thinking. In a way, that's how he viewed the true liberal, as the greatest exemplar of disinterestedness. That trait was also the basis for the liberal's mission in life: he needed to educate the rest of the country to adopt this same manner, to convince his compatriots to stop indulging their parochial impulses and to begin putting the nation's interests first.

Not everyone who shared Croly's politics, however, shared his ideal of disinterestedness. Labor unions, for one, exist in order to promote the interests of their members. Croly was quite hard on the unions in his magnum opus, The Promise of American Life. *Over time, as the nation's politics shifted even further to the right, his own politics shifted to the left. And his skepticism about labor softened.*

Around the office, there was an expression used to describe the editor's writing style: "Crolier than thou." You could say the same about this essay, a fine encapsulation of its author, with its brooding quality, sweeping historical analysis, and intense moral purpose.

I.

The chief distinguishing aspect of the Presidential campaign of 1920 is the eclipse of liberalism or progressivism as an effective force in American politics. In every previous election, at least since 1896, one candidate or one party advanced a valid claim for support of those voters who believed that the public welfare demanded more or less drastic changes in national organization and policy; and since 1904 the preponderant preference of this progressive vote has determined the result of the election. In 1920, however, the voters with progressive opinions are confused, scattered, distracted and impotent. The Democratic candidate is bidding for their support; but his bid is low and, considering the record of his party, of more than doubtful cash value. It attracts few former progressives except those who are Democrats first and progressives second. On the other hand the Republican candidate not only dares to defy progressivism by being unmistakably reactionary, but he is counting on his partiality for private business and his renunciation of any meddling with it in the public interest to win the election for him. It is this fact which most clearly betrays and proves the contemporary political impotence of progressivism.

Harding's frank resurrection of pre-Roosevelt Republicanism is a natural result of the practically confessed political bankruptcy of every group of progressives from those of the extreme right to those of the extreme left. Progressivism or liberalism is fundamentally the attempt to mould social life in the light of the best available knowledge and in the interest of a humane ideal. It lives by the definite formulation of convictions, by the initiation of specific programs and by the creation of opportunities to try them out. It is necessarily aggressive. In order to be successfully aggressive it must know what it wants; it must know how to get what it wants; and it must be willing to make the sacrifices which are necessary for the success of its aspirations and plans. The various progressive groups are no longer

sure or clear about what they want. They do not know how to get what they want; nor are they willing to pay the price. Their political futility is born of the equivocal meaning of American liberalism, its failure to keep abreast of the best available social knowledge and its inability to interpret candidly the lessons of its own checkered career.

The Roosevelt progressive party was an extremely composite political camp-meeting. It included not only every shade of liberalism but almost every degree of conservatism. It sheltered millions of Mr. Roosevelt's personal followers who never possessed any sincere or intelligent grasp of progressive principles. Those who may recall the spectacle of such political heathen as the present directors of the New York Sun, the Chicago Tribune and the Philadelphia North American standing at Armageddon and battling for the Lord will take off their hats to Theodore Roosevelt as the evangelist of a progressive faith. But too often he beguiled rather than convinced his converts, and they soon fell away from him or he from them. The party never possessed any body of common conviction or of economic impulse sufficient to preserve its members from backsliding during the intervals between camp meetings. Mr. Roosevelt himself by his behavior before and during the convention of 1916 took away from the remnant of the party its integrity of principle. He was willing to sacrifice essential progressive interests and convictions to the satisfaction of an intense personal animosity to the President and the Democratic party. The result was to pass on to Mr. Wilson the temporary leadership of American progressivism. The mass of progressive voters rallied to the support of the Democratic candidate as the most promising way out of a bad business. But they never entirely trusted him and his party. Nor did they accept without substantial qualifications his formulation of progressive principles. He finally justified these misgiv-

ings. By his behavior since the armistice he, like Mr. Roosevelt, forced his progressive supporters to choose between their loyalty to their principles and their loyalty to him. He shattered what was left of American progressivism as a coherent body of conviction. The hodge-podge of factions and sects which remain of the progressive movement know neither their own minds nor the dangerous new world in which they live.

The behavior of these groups during the primary campaign betrayed their political negligibility. Throughout the early months of 1920 an unusually large, disinterested and intelligent mass of progressive opinion, knowing that the existing problems of American domestic and foreign policy needed more liberal and statesmanlike treatment than they would receive from the dominant leadership of either party, looked around for some effective political embodiment of their point of view. They finally concentrated on Mr. Hoover— himself an almost perfect mouthpiece of both their misgivings and their liberal convictions. Yet they failed from the start to impart any vital impulse to Mr. Hoover's candidacy. For the candidate with the undoubted approval of the majority of his supporters early announced that he was first, last and always a good party man and a liberal only in so far as liberalism did not conflict with party loyalty. This was what the politicians wanted to know. They could and did ignore and defy him and his supporters just as they always will defy such docile and well-behaved insurrections against their authority. Neither did they lose anything by their defiance. In the end the Republican machine secured the support of Mr. Hoover and most of his followers without paying for it even in an issue of irredeemable paper promises. When Mr. Hoover rallied to a candidate such as Harding, middle-of-the-road liberalism skidded far away from the middle of the road. It did not stop skidding until it almost reached the declivity on the extreme right, and it is now engaged in maintaining its balance by shutting its eyes to the dangerous actualities of its situation.

The factions and sects who were ready and anxious to break away from the older parties did not succeed in putting up a better showing for liberalism in politics than did their more amenable former associates. The Committee of 48 started out expressly to capitalize liberal and radical discontent with the existing parties and to formulate a program which would focus and clarify the new progressivism. But it did not start with the support of enough voters to constitute by itself a formidable political group. Its few thousands of urban middle-class members were politically negligible unless they could adjust their own program to that of some large body of wage-earners and farmers. In July at Chicago they tried and failed to accomplish this adjustment. Although they themselves represented only an insignificant fraction of the middle class they insisted on a middle-class program—one which ignored the fact that no mere redistribution of property will give the needed dignity and power to labor. The original group separated after the usual manner of progressives into several smaller sects, the largest of which joined the Farmer-Labor party while the others, deprived even of this frail habitation, were left completely exposed to the inclemency of the political weather.

Thus those liberals who declared war on the existing parties proved as incapable of imparting an effective political expression to their convictions as did those liberals who put their Democracy or Republicanism first. American progressives seem unable either to dispense with party organizations or to control them in the interest of a liberal purpose. Fifty years of reforming agitation, during which in the great majority of cases the reformers have had to fight the national parties, have left those organizations with their prestige unimpaired. The party politicians are for the time being completely triumphant over their progressive adversaries and they are consequently fairly wallowing in the trough of equivocal verbosity which the eclipse of aggressive liberalism permits them to substitute

for the honest definition of conflicting issues. Their success makes it look very much as if they and their combination of realistic machine methods with unlimited patriotic pretense must represent something more fundamental in the American democracy than the reformers and progressives have represented.

II.

As a progressive democrat whose faith survives the contemporary eclipse of progressivism I am not willing to impute the triumph of unreformed and unrepentant party politics and economic privilege to the superior reality of their principles. It is due rather to the unreality which liberals have allowed to pervade liberalism. They have not studied the meaning of their experience and failures during the last twenty-five years. They have not as the result of this experience divined the need of adopting a more radical and realistic view of the nature and object of a liberal agitation under the conditions of the American democracy. They accepted in the beginning and continue to accept certain assumptions about the seat of effective power in the American commonwealth and the relation between the state and social progress which condemn them to remain either the uneasy accomplices or the impotent enemies of the powers that be in American society. Progressives have assumed that the American commonwealth, as now instituted and operated, is a complete and essentially classless democracy whose citizens can cure its ailments and adjust its conflicts by virtue exclusively of political action, agitation and education. This assumption they share with their adversaries. It has falsified and will continue to falsify the American progressive movement. If progressives wish to vindicate their claim to serve as indispensable agents of American national fulfillment they will need consciously to abandon it.

During the period before the Civil War when natural resources were still so abundant that all smaller classes were merged into the

dominant class of the pioneer farmer, merchant or manufacturer, the American commonwealth came nearer to being an equalitarian democracy than any previously existing state. But it never succeeded even at its best in living up to the idea of the more democratic of its founders; and now that its rich inheritance of natural resources is so largely dissipated or appropriated, the existing American union fails as completely to be a flexible, classless and consummate democracy as do older European states. Our existing institutions are, it is plain, actually provoking class divisions and conflicts similar to those which have existed in undemocratic societies. These divisions and conflicts have steadily increased during the past fifty years and the state has not only done nothing to cure them, but it has done nothing to prevent them from becoming more numerous and more acute.

The class cleavage is spreading and intensifying in certain respects because of our existing institutions. It is spreading because the existing national economy is too largely a one-class economy and the existing state too largely a one-class state. Liberalism has always believed that popular self-government can ultimately overcome such a partial appropriation of the state by one class; and I would be the last to suggest the abandonment of this article in the liberal creed. But just at present popular self-government is sick, and as long as it is sick, it lacks the recuperative power to come to the assistance of a divided society. Class cleavage born of one-class domination itself poisons the democratic government which should be able to cure its own maladies. Political democracy must call to its assistance social and industrial democracy in order to regain its health. Those progressives who refuse a radical diagnosis of the sickness of political democracy will cease to be progressives. If they wish to renew the original formative American ideal—that of a moralized democracy righteously triumphant over class divisions— they must admit the temporary need of strengthening the wage-

earners to resist capitalist domination and so of helping to restore a wholesome balance of economic and social power in the American commonwealth.

The excessive preponderance of one class has impaired the credit of that circulating medium upon which the whole system of democratic values rests. It has impaired the vitality of opinion and discussion by depriving them of their indispensable nourishment. It has deprived the American public of a full and fair account of the news about industrial and social conflicts. It has to a large extent substituted a policy of intimidation for the former patient and good humored toleration of radical criticism of existing institutions and drastic proposals for their reform. These departures from the American tradition have so far impaired the ability of American public opinion to understand its ailments and provide appropriate cures that the remedy must derive in part from an independent source.

Whenever an industrial conflict involves the majority of its employees in an important industry and so threatens to raise a question between the organized employer and employees as to the future control of the industry, the newspapers both in their reporting of the news and their comments on it line up with the employers and accept a class interpretation of the controversy and of its salient facts. With few exceptions they followed this course in respect to the steel and coal strikes of last year and prejudged those controversies in a sense prejudicial to organized labor. Moreover this prejudice implied a condemnation of the strikers much more severe than that which is ordinarily visited on the unpopular party in an industrial conflict. Public opinion was induced by the newspapers to condemn both strikes as antisocial conspiracies against the public welfare. There was a successful attempt to intimidate opinion and to prevent any but one side from obtaining a fair hearing. The result in both cases was a solution disadvantageous to organized labor and favorable to the growth of the previously existing class cleavage. The

settlements have only prepared the way for a renewal of the conflict as soon as the defeated strikers consider conditions favorable.

These instances convinced me of the futility of expecting the American government to heal the class cleavage through the action exclusively of the existing machinery of political self-government. American law and practice place economic and social power preponderantly in the hands of one class. The class exploits the organization and shibboleths of democracy in order to disqualify any attack on its autocratic authority in industry as antisocial agitation. Its ownership of the press enables it to fasten the stigma of disloyalty upon wage earners who are threatening in the interest of their own independence the existing control of industry, or upon publicists who insist on the need of a radical redistribution of economic power. Its ownership of the party machines enables it to prevent any radical industrial issue from becoming the subject of controversy between major parties. In so far as the class cleavage is based on real class grievances, the stability of the American state is being compromised. The continuation of this sacrifice of moral order to the preservation intact of the existing distribution of economic and social power will end by emasculating democracy, by converting the existing state into a completely and irrevocably class organization and by rendering ultimately inevitable violent class warfare.

III.

If the foregoing analysis is correct, the American Commonwealth is the partial victim of the preponderance and the dominion of one class, which while preserving the forms has corrupted the substance of popular self-government. Instead of beginning by recognizing the legitimacy of this perversion of democracy, progressivism must begin by repudiating it. The one effective way of repudiating it is to call in another class to redress the balance. The one group whose interests, whose numbers and whose existing social disfranchise-

ment qualify it to redress the balance is that of the workers. It is important for them to become conscious of the need of collective class action, not for the purpose of undermining the loyalty of the wage-earners to the state, but for the purpose of creating in a re-distribution of power among classes the needed foundation for an ultimate class concert. For labor and liberalism alike, class rule, disguised by protective coloration to look like traditional democracy, is the common enemy. They need to make common cause against it. The future political power of liberalism depends upon its ability to secure the voting support of those who live by labor, including under the phrase those who work with the body and with the mind and those who work on the farm and in the office as well as in the factory. The workers on their side will remain incapable of assuming either the full political or the social responsibility of American citizens unless they play their part in bringing about such a partnership. The lack of it accounts for the political impotence both of labor and liberalism. Its consummation as an effective political force is the all-important task of progressive American democrats.

It is, however, the liberals rather than labor who should initiate such a partnership. In order to bring it about the majority of American liberals will have to alter their attitude towards the only organized and articulate group of workers. The attitude has usually been unsympathetic and unintelligent. The great majority of American progressives are educated and comparatively well-to-do business and professional men. They have never sought social contacts with the leaders of organized labor and their understanding of the wage-earners' point of view has suffered from ignorance of the impulses, necessities and the ideas which give form to labor unionism. They have regarded the contest between the employers and their organized employees as at bottom a fight between two social groups of equal power, both of which tended to pursue their class interests unscrupulously and both of which need regulative disci-

pline in the public interest. Their proposed method of dealing with the contest has never gone further than some measure of compulsory arbitration or collective bargaining under the protection of the state. They have not regarded the participation of the workers in the management of the industry as an essential part of a democratic industrial policy and of democratic education for citizenship. They have always considered the intrusion of unionized wage-earners into politics as an example of disrupting class organization in what should be a classless democracy.

As long as liberals determine their behavior towards the labor movement by foregoing ideas there is no chance of a political and social partnership. The conscious organized worker regards himself and rightly regards himself and his fellows not as a selfish group which is extorting all it can from the community, but as a group which, under the conditions of a modern industrial society, is now occupying the firing line in the battle for human liberation. The next advance in the art of human association demands the introduction into capitalist industry of the same government by the consent of the governed as that which the founders of the American republic intended to introduce into the state. If liberalism implies an interest in human liberation, the wage-earners who are fighting the battle for this advance deserve the sympathy and support of liberals. They are performing the same dangerous and disagreeable pioneer work on behalf of a humanized industry as the Wycliffites did on behalf of the Protestant Reformation or the unruly medieval communes did on behalf of political democracy.

Of course, like all engaged in a fight, they often borrow their weapons from their adversaries. But if they frequently use arrogant language or if they insist on conditions which restrict production or if they lack the ability wisely to employ the power which they are grasping, they are entitled to have their delinquency traced to its psychological and social cause. The situation of organized labor

compels it to be aggressive, pugnacious and self-interested. Since the beginning of the labor movement the unions have never won a concession from their employers or from the state unless they possessed the power to extort it. Their masters have taught them the grim lessons of macht-politik—the importance of being irresistible rather than scrupulously just. Organized labor seeks power more than anything else and it does not always use the power which it conquers with wise moderation. But inasmuch as it would not survive unless it did seek power, liberals should not allow this fact to deter them from lending support to the general aims and movement of labor. They should have the common sense to recognize the necessity in a civilization as callous as ours for a disfranchised class to force upon society its claim for greater social responsibility and consideration.

A socially enlightened government might have enabled the wage-earning worker to attain social equality, consideration and power by another route. It might have introduced a system of industrial and technical education which would have equipped the workers for positions of increased economic responsibility and social consideration. The unanswerable indictment against capitalism as an American institution is not that enterprising business men seized and exploited the opportunities and power which society placed at their disposal. It was natural and even necessary that they should organize production and distribution on a basis more profitable to themselves than to society. The offense against the American national welfare with which they are indictable is of a different kind. It is their blindness to the social penalties of their methods of hiring, firing and paying labor and their refusal to make the technical and social education of their employees a charge upon business or upon the business man's state. While boasting of their citizenship in a commonwealth which abolished class distinctions, they deprived the typical wage-earner of sufficient leisure, sufficient remuneration

and sufficient sense of security in his job to enable him to assume a position of social responsibility and dignity. His status as a wage-earner interfered with, if it did not prevent, the kind of education which he needed to qualify him for citizenship in an equalitarian democracy. The most notorious and nauseating example of this capitalist irresponsibility is the spectacle of the Steel Corporation working over fifty per cent of its employees twelve hours a day or seven days a week and of denying them an American standard of living and then accusing them, when they strike, of conspiring to destroy the American Republic. A system which is capable of such hypocrisy is corrupt at the core.

Exploited by their employers and deserted by the state, the wage-earners had to educate themselves in the only way they knew how—that is, by fighting to obtain as a group the power and the independence which society denied to them as individuals. Such is the final significance of the trade-union movement and until the American national conscience adjusts its valuation of the movement to some such conception of its significance, a dangerous class cleavage will rend American society. The whole established tradition in American politics, jurisprudence and social consciousness is impervious to this interpretation and refuses to act upon it. The conservatives, being blind to the existence of class domination and to the accompanying miseducation of both master and servant, cannot and will not recognize the temporary need of class consciousness on the part of the worker as a means of overcoming his class minority. They insist that such class consciousness, no matter how tentative it may be, constitutes a betrayal of the national ideal. Yet in truth it is they who are betraying the national ideal. For their misinterpretation of the aims and necessities of organized labor and their blindness to the tendency of the wages system to deny to the industrial worker a position of individual independence and social dignity will, if it continues, prepare the way for a revolutionary class conflict.

It remains to be seen whether the American democracy can escape such a calamity by a wise prevision. It cannot escape by carrying on its recent policy of physical and moral intimidation, for that will accelerate rather than prevent the catastrophe. It cannot escape by welfare legislation, compulsory arbitration or any other expedient which ignores the need of the wage-earning workers for the independence and dignity which must come from substantial economic power and social responsibility. It can only escape by crediting to the organized workers a salutary social purpose which transcends class interests but which under the circumstances they cannot attain without class organization and consciousness. If this class organization and consciousness is treated by good middle-class Americans as disreputable and maleficent, it may develop in a manner dangerous to social order. On the other hand with anything like fair and intelligent treatment it will serve as a stage in the educational adjustment of the wage-earner to society. It will not mean in that event the subordination of the American commonwealth to class domination but rather its triumph over such domination through a gradual moral reconciliation among classes.

American progressives will remain divided into impotent factions and sects until they come to understand what an essential part progressivism must play in bringing about this adjustment. Organized labor cannot make the adjustment alone. If progressives do not interpret the movement as the march of a socially disfranchised class towards larger opportunities, it is likely to become blindly and destructively pugnacious and will tend more and more to depend exclusively on direct action. But if American labor can obtain the candid, discriminating yet loyal support of a sufficiently numerous group of liberals who belong to other classes, the consciousness of being understood and the new inter-class association will undoubtedly ameliorate its frequently harsh, suspicious and aggressive attitude.

The progressives will testify to the possibility of creating a political democracy superior to class by themselves rising above class misunderstanding and prejudice. A large fraction of the English liberals have already assumed this attitude towards the labor movement. They have joined the Labour party and so created a fighting organization, which is the conscious political instrument of the social and industrial enfranchisement of the wage-earning and salaried worker. The American progressive is under a heavier obligation to adopt this course than the English liberal. For while the British Commonwealth has frankly recognized class discriminations, the complacent acceptance of such discriminations is peculiarly abhorrent to the American national consciousness.

That is the reason why as an American who called himself a reformer from 1890 to 1908, a Republican insurgent from 1908 to 1912, and since 1912 a progressive, and who shared most of the mistakes and illusions of the reformers, insurgents and progressives, I shall vote for the Farmer-Labor candidate for the Presidency. The Farmer-Labor party is an attempt to unite the American workers, whether industrial or agricultural, whether by hand or brain, whether salaried or wage-earning as a homogeneous group which is capable of exercising and deserves to exercise its share of economic, social and political power. It seeks to adjust the American labor movement both to the interests of the other classes and to its place in a humane commonwealth. A party which itself overcomes the class conflict is necessary to reconstruct a state which is capable of providing for the moral reconciliation of the classes.

The arguments against voting for the Farmer-Labor candidate are numerous and formidable. The chief of them is that the new party is far more of an aspiration than a reality. It has failed to secure the support of any large number of farmers and laborers. It does not represent either organized labor or the organized farmer. Instead of being supported by the American Federation of Labor,

the leaders of that organization are its bitterest enemies. Its platform includes some things that I should like to see omitted and omits much that I should like to see included. In voting for Christensen I shall vote for a group of principles of which I do not wholly approve and for a platform which the existing party does not possess the administrative ability to carry into effect.

These serious drawbacks are traceable chiefly to one underlying cause. Practically all of the educational groundwork in public opinion for a Farmer-Labor party still remains to be done. Marxian Socialism has the advantage both of a definite creed and a Bible which focuses the convictions and emotions of its adherents. The British Labour party is built upon the experience of the British trades-union movement throughout three generations and upon over thirty years of the educational work of Sidney Webb and the other Fabians. The older parties in this country possess all the advantages of custom. Their tradition of seeking remedies for social maladies by means exclusively of direct governmental action is deeply rooted in the American political consciousness, and is taken for granted by the enormous majority of good American citizens. Nothing has happened to impair its authority. Thus the Farmer-Labor party is starting out to capture votes and become a political force in spite of the fact that only a small part of the American people is prepared to welcome and to understand its proposal to vindicate the deepest American social tradition of an equalitarian commonwealth by means not of disregarding but of recognizing and overcoming class dissensions. Before its formative idea can become politically effective it will need not only a more thorough, a more lucid and a more persuasive presentation than it has yet received but a radical change of mental attitudes on the part of all the groups which the party seeks to unite—of organized labor, of the farmers and of the progressive members of other classes. This change of attitude can hardly take place except as the result of supplementing the political

coalition of the groups by an association among them for economic cooperation as consumers.

Those who cast a vote for the Farmer-Labor candidates should not cherish illusions about the ability of the party to win easy and numerous future converts. Much as the new party needs votes, it needs even more than votes a candid understanding of the gulf which separates the formative idea upon which the party is built from the actual state of mind of the farmers, laborers and liberals whose cooperation is necessary to make it practically effective. That gulf is wide and deep—as wide and deep as the class cleavage which the party recognizes and proposes to overcome. In this sense a vote for Christensen becomes pale with an unreality similar to the unreality which afflicts every attempt in this abominable election to give effective political expression to the aspirations of a progressive to make his vote count on behalf of human liberation. But there is one merit in such a vote which to my mind is decisive in its favor. Plain as is the political unreality to which the lack of antecedent preparation condemns the Farmer-Labor party as an expression of liberal aspiration, the party is born of a sound application of the traditional American ideal of a homogeneous equalitarian democracy to the existing facts of American economic and social life. It looks like the best way in 1920 of vindicating American nationality as an expression of an essentially ethical and humane ideal. I am thankful, consequently, to those people who have unfurled the new party flag and afforded me an opportunity of saluting it. Although it floats over a castle in the air, it does not call for blood as does the red flag of socialism and it means more of the good which good Americans have meant by the Stars and Stripes than do the besmeared, tawdry and drooping flags of the Democratic and Republican parties. To vote for it is only an expression of faith, but it is an expression of faith at a moment when in my opinion the old parties afford the voter no opportunity of using his vote as an expression of humane power.

Soviet Russia

JOHN MAYNARD KEYNES

October 28, 1925

During the years between the wars, there were many moments when The New Republic *willfully glanced past the horrors of the Soviet Union. Even after the show trials of the thirties, the magazine's editor Bruce Bliven was willing to largely exonerate Stalin for his horrific sins. He wrote him an "open letter" in 1938, full of the gentlest criticism and laced with flattery. ("It would be natural for you to say this is nobody's business but Soviet Russia; such an attitude has been held by many great rulers through history. But you are too wise, I am sure, to hold this view.") This failure in analysis—the utopian smudge on the lens of rigorous thinking—should not be whitewashed from history. But the same editors who apologized for the purges and executions also published some of the most prescient pieces about the USSR.*

Unlike most of the editors of The New Republic, *Keynes had visited Russia, seen the future, and found it grotesque. (He had gone with his wife, Lydia Lopokova, a dancer in Diaghilev's company.) He understood the very specific perils of the Communist mind-set. They angered him so much that they could provoke his own ugly outbursts. In another essay for the magazine, he sought to blame the rampant mud and rubbish he witnessed on "the beastliness in Russian nature—or in the Russian and Jewish natures, when, as now, they are allied together." Editors of the magazine attempted to excise the line, but the*

master economist wouldn't budge. It was, of course, an expression of a reflexive Bloomsbury prejudice, but the incident is also evidence of the bullheadedness that stopped him from caving to the fashionable politics of his times.

It is extraordinarily difficult to be fair-minded about Russia. And even with fair-mindedness, how is a true impression to be conveyed of a thing so unfamiliar, contradictory, and shifting, about which almost no one in England has a background of knowledge or of comparable experience? No English newspaper has a regular correspondent resident in Russia. We rightly attach small credence to what the Soviet authorities say about themselves. Most of our news is from prejudiced and deceived Labour deputations or from prejudiced and untruthful *émigrés*. Thus a belt of fog separates us from what goes on in the other world where the Union of Socialist Soviet Republics rules and experiments and evolves a kind of order. Russia is suffering the penalty of years of "propaganda," which by taking away credence from words, almost destroys, in the end, the means of communication at a distance.

Leninism is a combination of two things which Europeans have kept for some centuries in different compartments of the soul— religion and business. We are shocked because the religion is new, and contemptuous because the business, being subordinated to the religion instead of the other way round, is highly inefficient.

Like other new religions, Leninism derives its power not from the multitude but from a small minority of enthusiastic converts, whose faith and zeal and intolerance make each one the equal in strength of a hundred indifferentists. Like other new religions, it is led by those who can combine the new spirit, perhaps sincerely, with seeing a good deal more than their followers, politicians with at least an average dose of political cynicism, who can smile as well as frown, volatile experimentalists, released by religion from truth and mercy but not blinded to facts and expediency, and open there-

fore to the charge (superficial and useless though it is, where politicians, lay or ecclesiastical, are concerned) of hypocrisy. Like other new religions, it seems to take the color and gaiety and freedom out of everyday life and to offer but a drab substitute in the square wooden faces of its devotees. Like other new religions, it persecutes without justice or pity those who actively resist it. Like other new religions, it is unscrupulous. Like other new religions, it is filled with missionary ardor and ecumenical ambitions. To say that Leninism is the faith of a persecuting and propagating minority of fanatics led by hypocrites, is, after all, to say no more nor less than that it *is* a religion and not merely a party, and Lenin a Mahomet, not a Bismarck. If we want to frighten ourselves in our capitalist easy chairs, we can picture the Communists of Russia as though the early Christians led by Attila were using the equipment of the Holy Inquisition and the Jesuit Missions to enforce the literal economics of the New Testament; but when we want to comfort ourselves in the same chairs, can we hopefully repeat that these economics are fortunately so contrary to human nature that they cannot finance either missionaries or armies and will surely end in defeat?

There are three questions which need an answer. Is the new religion partly true, or sympathetic to the souls of modern men? Is it on the material side so inefficient as to render it incapable to survive? Will it, in the course of time, with sufficient dilution and added impurity, catch the multitude?

As for the first question, those who are completely satisfied by Christian Capitalism or by Egotistic Capitalism untempered by subterfuge, will not hesitate how to answer it; for they either have a religion or need none. But many, in this age without religion, are bound to feel a strong emotional curiosity towards any religion, which is really new and not merely a recrudescence of old ones and has proved its motive force; and all the more when the new thing comes out of Russia, the beautiful and foolish youngest son of the

European family, with hair on his head, nearer both to the earth and to heaven than his bald brothers in the West—who, having been born two centuries later, has been able to pick up the middle-aged disillusionment of the rest of the family before he has lost the genius of youth or become addicted to comfort and to habits. I sympathize with those who seek for something good in Soviet Russia.

But when we come to the actual thing, what is one to say? For me, brought up in a free air undarkened by the horrors of religion with nothing to be afraid of, Red Russia holds too much which is detestable. Comfort and habits let us be ready to forgo, but I am not ready for a creed which does not care how much it destroys the liberty and security of daily life, which uses deliberately the weapons of persecution, destruction, and international strife. How can I admire a policy which finds a characteristic expression in spending millions to suborn spies in every family and group at home, and to stir up trouble abroad? Perhaps this is no worse and has more purpose than the greedy, warlike and imperialist propensities of other governments; but it must be far better than these to shift me out of my rut. How can I accept a doctrine which sets up as its bible, above and beyond criticism, an obsolete economic textbook which I know to be not only scientifically erroneous but without interest or application for the modern world? How can I adopt a creed which, preferring the mud to the fish, exalts the boorish proletariat above the bourgeois and the intelligentsia who, with whatever faults, are the quality in life and surely carry the seeds of all human advancement? Even if we need a religion, how can we find it in the turbid rubbish of the red bookshops? It is hard for an educated, decent, intelligent son of Western Europe to find his ideals here, unless he has first suffered some strange and horrid process of conversion which has changed all his values.

Yet we shall miss the essence of the new religion if we stop at this point. The Communist may justly reply that all these things

belong not to his true religion but to the tactics of Revolution. For he believes in two things—the introduction of a New Order upon earth and the *method* of the Revolution as the *only* means thereto. The New Order must not be judged either by the horrors of the Revolution or by the privations of the transitionary period. The Revolution is to be a supreme example of the end justifying the means. The soldier of the Revolution must crucify his own human nature, becoming unscrupulous and ruthless and suffering himself a life without security or joy—but as the means to his purpose and not its end.

What, then, is the essence of the new religion as a New Order upon earth? Looking from outside, I do not clearly know. Sometimes its mouthpieces speak as though it was purely materialistic and technical in just the same sense that modern Capitalism is—as though, that is to say, Communism merely claimed to be in the long run a superior technical instrument for obtaining the same materialistic economic benefits as Capitalism offers—that in time it will cause the fields to yield more and the forces of Nature to be more straitly harnessed. In this case there is no religion after all, nothing but a bluff to facilitate a change to what may or may not be a better economic technique. But I suspect that, in fact, such talk is largely a reaction against the charges of economic inefficiency which we on our side launch, and that at the heart of Russian Communism there is something else of more concern to mankind.

In one respect Communism but follows other famous religions. It exalts the common man and makes him everything. Here there is nothing new. But there is another factor in it which also is not new but which may, nevertheless, in a changed form and a new setting contribute something to the true religion of the future, if there be any true religion. *Leninism is absolutely, defiantly non-supernatural, and its emotional and ethical essence centres about the individual's and the community's attitude towards the Love of Money.*

I do not mean that Russian Communism alters, or even seeks to alter, human nature—that it makes misers less avaricious or spendthrifts less extravagant than they were before. I do not merely mean that it sets up a new ideal. I mean that it tries to construct a framework of society in which pecuniary motives as influencing action shall have a changed relative importance, in which social approbations shall be differently distributed, and where behavior, which previously was normal and respectable, ceases to be either the one or the other.

In England today a talented and virtuous youth, about to enter the world, will balance the advantages of entering the Civil Service and of seeking a fortune in business; and public opinion will esteem him not less if he prefers the second. Moneymaking, as such, on as large a scale as possible, is not less respectable socially, perhaps more so, than a life devoted to the service of the State or of Religion, Education, Learning, and Art. But in the Russia of the future it is intended that the career of moneymaking as such will simply not occur to a respectable young man as a possible opening, any more than the career of a gentleman burglar or acquiring skill in forgery and embezzlement. Even the most admirable aspects of the love of money in our existing society, such as thrift and saving, and the attainment of financial security and independence for one's self and one's family, whilst not deemed morally wrong, will be rendered so difficult and impracticable as to be not worth while. Everyone should work for the community—the new creed runs—and, if he does his duty, the community will uphold him.

This system does not mean a complete leveling down of incomes—at least at the present stage. A clever and successful person in Soviet Russia has a bigger income and a better time than other people. The Commissar with $25 a week (*plus* sundry free services, a motor-car, a flat, a box at the ballet, etc., etc.) lives well enough, but not *in the least* like a rich man in London. The suc-

cessful Professor or Civil Servant with $30 or $35 a week (*minus* sundry impositions) has, perhaps, a real income three times that of the proletarian worker, and six times those of the poorer peasants. Some peasants are three or four times as rich as others. A man who is out of work receives half pay, not full pay. But no one can afford on these incomes, with high Russian prices and stiff progressive taxes, to save anything worth saving; it is hard enough to live day by day. The progressive taxation and the mode of assessing rents and other charges are such that it is actually disadvantageous to have an acknowledged income exceeding $40 to $50 a week. Nor is there any possibility of large gains except by taking the same sort of risks as attach to bribery and embezzlement elsewhere—not that bribery and embezzlement have disappeared in Russia or are even rare, but anyone whose extravagance or whose instincts drive him to such courses runs serious risk of detection and penalties which include death.

Nor, at the present stage, does the system involve the actual prohibition of buying and selling at a profit. The policy is not to forbid these professions, but to render them precarious and disgraceful. The private trader is a sort of permitted outlaw, without privileges or protection, like the Jew in the Middle Ages—an outlet for those who have overwhelming instincts in this direction, but not a natural or agreeable job for the normal man.

The effect of these social changes has been, I think, to make a real change in the predominant attitude towards money, and will probably make a far greater change when a new generation has grown up which has known nothing else. A small, characteristic example of the way in which the true Communist endeavors to influence public opinion towards money is given by the campaign which is going on about the waiters in communal restaurants accepting tips. There is a strong propaganda to the effect that to give or to receive tips is disgusting; and, as a result, it is becoming impolite to

offer a tip in a public way, and a not unknown thing for a tip to be refused!

Now all this may prove Utopian, or destructive of true welfare, though, perhaps, not so Utopian, pursued in an intense religious spirit, as it would be if it were pursued in a matter-of-fact way. But is it appropriate to assume, as almost the whole of the English and American press do assume, and the public also, that it is insincere or that it is abominably wicked?

In Dedham Jail

A Visit to Sacco and Vanzetti

BRUCE BLIVEN

June 22, 1927

The shoemaker Nicola Sacco and the fishmonger Bartolomeo Vanzetti were anar-chists who wanted the state smashed, violently. But their venomous convictions were hardly the same thing as concrete proof that they had entered a factory in Braintree, Massachusetts, their revolvers raised, and murdered its paymaster and his guard. In fact, the overwhelming evidence suggested that they had nothing to do with the crime. What's more, the government's efforts to rig their guilt were screamingly obvious.

The New Republic *returned to the injustice of their plight again and again. Bruce Bliven, Croly's deputy, called it "America's Dreyfus affair." And that pretty much captures its resonance with liberals. They viewed it as the ulti-mate emblem of the rough treatment immigrants received in those postwar years, when the country blockaded its borders and the WASP establishment attempted to shut the Jews out of bastions like Harvard. And the persecution of poor Sacco and Vanzetti represented another unattractive quality of the twenties: the state-sanctioned rage against holders of unpopular political opinions.*

Over the 1920s, the liberals had been a distraught lot. The reactionary politics had sunk them into a deep funk. Here was the euphoria of a genuinely noble cause to distract them from their woes. It was more than inspiring; it was

clarifying. John Dos Passos wrote to Edmund Wilson that "during the last days before the executions" it was "as if by some fairy-tale spell, all different kinds of Americans, eminent and obscure, had suddenly, in a short sudden burst of intensified life, been compelled to reveal their true character in a heightened exaggerated form."

The joyous high that comes with hurling oneself into a cause made the inevitable conclusion even worse. Bliven took the execution of Sacco and Vanzetti especially hard. He wandered aimlessly across Manhattan that night. When Croly wrote the magazine's editorial responding to their deaths, he flashed uncharacteristic anger. His unsigned editorial predicted that the country might be "torn to pieces" as a result of this travesty. It was such a clarifying moment that it's possible to say that, there and then, the magazine began its decade-long swing toward a more radical left.

The automobile slides through a pleasant green New England landscape: parks and ponds and big houses set far back from the road, among Louisa Alcott's own lilacs. A sharp turn through the elms, a hundred feet down a side road, and here we are.

It does not look like a prison, this nondescript, rambling structure, painted white and gray, and, like the houses, set back in a lawn, with a curving driveway and wooden stables at one side. It looks like a private school—or do all private schools look like prisons? . . . The stables have been converted to garages, but even so, there is such an air of 1880 about them that involuntarily you lift your eyes to the gable for the galloping horse, silhouetted in iron, which should be there as a weather-vane. Up a flight of steps, through a door, and now we know where we are. Before us is another door, made of big vertical steel bars. A guard lets us in—an elderly, silver-haired New Englander, like a lobsterman come ashore. We are in a huge rectangular space, flooded with sunshine on this lovely June day. It is hardly a room. So much wall space has been removed and so many iron bars substituted, that it is like a cage; and here come those it en-

closes. No ball-and-chain, no lockstep; but men in single file, heads
bent, arms folded on their breasts. They look young and healthy,
on the whole; there are some fine faces and well-modeled heads,
and others which are less pleasing. These men wear trousers of gray
stuff, uncouthly cylindrical—since they never have been pressed
and never will be—and gray-and-white-striped shirts, cheap and
coarse. They mount the stairs and pass along the balcony before the
cell blocks, falling out of line one by one. The air resounds with the
clash of metal, ringing harshly in our ears, as they lock themselves
in. Every few minutes during the next half-hour, another such file
passes through, silhouetted against the bars and the lush green of
grass and trees, climbs the stairs and breaks up as it enters the cells.

From the cell block they appear, these two most famous prison-
ers in all the world, walking briskly, side by side. No bars are inter-
posed between them and their visitors; we are introduced, shake
hands, sit down on a bench and some chairs, like so many delegates
to a convention, meeting for the first time in a hotel lobby. They are
in prison garb like the others; they look well, seem in good spirits.
Both are of average height; both black-haired, both somewhat bald
in front, a baldness which somehow gives them a mild domestic air.
Vanzetti wears a big, bristling Italian moustache; Sacco is clean
shaven and his hair is clipped rather close on his round Southern
skull. Vanzetti is expansive, a glowing friendly temperament, with
bright eyes, an expressive face; Sacco is intelligent, too, but less
emotional. He listens acutely, interjects a shrewd word or two at
times. He judges men's specific acts, pessimistically, in the light of
general principles, and usually for the purpose of deflating Van-
zetti's too-generous view of human nature. What he says sounds
true; and sometimes profound as well. He is not sullen. Neither of
them reveals to the casual visitor any trace of that warping of the
faculties which the experts say has been produced in them.

Today is an anniversary of a sort, for these two. One month

from today, or within the six days thereafter, they are to die. Unless the Governor of Massachusetts acts to stay the process of the law, these strong and healthy men, eager and full of life, will sit in the electric chair, their heads tonsured, their trouser legs split, for the electrodes, and say farewell to life. Thus the state will take its Old Testament revenge for a murder which someone committed seven years ago.

Well, perhaps Sacco and Vanzetti were members of the band which did that deed, though I know what I am talking about when I say the chances against it are a thousand to one. But that they did not have a fair trial, there is no doubt whatever. No intelligent man has ever read the record of what happened in the courtroom, coming to the case with an open mind, without being convinced that these two were the haphazard victims of a blind hostility to the community, which was compounded of "patriotic" fervor, anti-foreignism, and of hatred of these men in particular because, as Professor Felix Frankfurter has summed it up, they denied the three things judge and jury hold most dear: God, country and property.

We try sitting now on these hard chairs in Dedham jail, to speak of their plight, to offer the words of cheer which decency seems to dictate. They listen gravely, and we read in their eyes the disbelief which they are too courteous to put into words. When you have been under the shadow of death for seven years, you do not any longer clutch at straws of hope. "We'll be glad if you are right," says Vanzetti politely; but it is as though one said to a baby, "It will be nice, if you can reach the moon." They have long expected that their martyrdom, which has already been so incredibly cruel, will be completed, and that they will die in the chair.

They are willing to spend but a moment on their own case, however. Vanzetti's mind is full of something else, and now, impatiently, he pours it out. He is troubled about Tom Mooney, who is dying of a broken heart in a bleak gray California prison by the Golden Gate.

He looks at us appealingly, his words tumble out. God in Heaven! This man, who is to die in four weeks, is thinking only of another man 3,000 miles away, victim of an injustice like his own. Could we do something, Vanzetti asks, for poor Tom Mooney? He himself has been doing all he can—writing, writing, letters to many people, especially to some Austrian friends, urging them to keep up the fight. "I may not be able to help much longer," says Vanzetti, with a twisted little smile. "And he needs help, Tom Mooney. He's a sick man. If they don't look after him, he'll die."

Vanzetti's English, if not always idiomatically correct, is fluent and, on the whole, accurate. Sacco, perhaps, does not do quite so well; but it is fair to remember that most of the time they try to say things that are not too easy even in one's mother tongue. You must not be deceived by the accent, or by the workingman's easy way they have of sitting on a hard bench as though they were used to it. These are book men. Their political faith is philosophical anarchism, and they know its literature from Kropotkin down. In this year's graduating class at Harvard, there will not be twenty men who, on their own initiative, have read as many difficult, abstruse works as these gray-clad prisoners.

Since today's visitors are in no mood for abstract controversy, the hosts, ever courteous, follow their lead. The homes of these two men in Italy are mentioned. Have we ever been there? We never have, but we have been not far away. Florence, we all agree, is charming. The polite Americans call it Firenze, the polite Italians give it the Anglicized form. And Naples! Ah yes, lovely, is it not? And we go on to speak of a famous Italian wine; and one says, "When you are free, you will perhaps go back to Italy and drink again the *lacrimae Christi*?"

"When we are free . . ." says Vanzetti thoughtfully. Does he see against the bars a great clock which is ticking away his life and that of his companion?—"*Tick, tock!* thirty one days to live! *Tick, tock!* thirty days to live!"

One does not know. He says nothing for a few minutes, and then speaks quietly of exercise. Lately they have been given an Italian lawn-bowling set, which they use during the hour and a half they are permitted to be out-of-doors. "It is good," says Sacco, and Vanzetti corroborates: "It makes you sweat." Besides this, every morning in his cell, Vanzetti takes setting-up exercises; he flexes his biceps to show you, lest his English may not have conveyed the idea. The prison food, he goes on, is not well selected, too much starch. Before they had the set of lawn-bowls, Vanzetti had terrible indigestion much of the time. Now things are better. In their earlier years in prison, these men were treated with abominable cruelty. As their plight has become better known around the world, things have been made easier for them. Indeed, they have little to complain of, if you overlook their deadly peril of being victim of a foul judicial murder.

One of their visitors loses the thread of the conversation, thinking about that murder. One can understand a good hot-blooded killing; some day I shall commit one myself, if the organ grinder keeps on playing under my window. But to murder in blood that is seven years cold!—to assassinate men in order to bolster the prestige of an unbalanced judge . . . And now to find majority opinion in a great American community supporting that murder! . . .

He comes back from this by-path with a start, to hear Vanzetti speaking of his other trial, the one at Plymouth, which was even more brazen in its denial of common justice and common decency than the joint ordeal with Sacco. He remembers, Vanzetti does, with mild reproach, that some of the little funds which his friends—poor people, like himself—had raised to defend him, was squandered. A man took money to get an automobile and interview defense witnesses. (Judge Thayer subsequently failed to take these witnesses seriously, on the ground that they were Italians and that their testimony, therefore, could not be important.) But this man

who was given funds to get an automobile, instead of seeing witnesses, went joy riding instead. Was that fair? Vanzetti asks.

He has a hatred of injustice, one sees that in him perhaps most clearly of all. With his philosophical and political ideas this writer does not happen to agree; and yet one must recognize that no other sect in the modern world comes as close to primitive Christianity as his. He is opposed equally to Mussolinism in Italy and Sovietism in Russia, and for the same reason—he is against any rule supported by force. They do not believe in force, these two men who (according to the state's official theory) after a lifetime of sober industry, on a given day suddenly turned murderers to get money "for the cause," when the cause didn't need it; planned a crime which bore every earmark of the expert professional, didn't get any of the money when it was over, and made no effort to hide or escape afterward.

And now they are to die in four weeks.

Four weeks! Our conversation has halted for a little; we all have things to think about. We learn now—by accident—that we are keeping our hosts from their dinner; if they are delayed much longer it will be cold, or they will get none. And so we stand up and shake hands and say good-bye. "Good-bye." "Good-bye." "You see my friend Mr. A— in New York? You tell him I thank him so much. Perhaps you do something to help Tom Mooney?"

And they walk away toward the cell block, these three—Sacco and Vanzetti and the unseen gray-robed figure which is ever at their side; and we go into the glorious June evening, to the car and the chauffeur and the road home.

The Birth-Control Raid

MARGARET SANGER

May 1, 1929

The New Republic *abandoned New York for Washington in 1950, but the fact of its birthplace is crucial to its story. Greenwich Village, with its burgeoning bohemianism, was both physically and spiritually a short walk from the office. During the earliest years of the magazine, Walter Lippmann was often there, drinking at Mabel Dodge's famous salon just off Washington Square, where he met the likes of Gertrude Stein and Emma Goldman. Margaret Sanger, the contraception crusader, also inhabited this demimonde. Her big issue—birth control, a term she invented—was considered impolite for more respectable company. But the necessity of contraception resonated with all the early concerns of the magazine. It wasn't about sexual liberation, at least not explicitly. The movement emphasized the plight of immigrants, whose supersized families defied any reasonable set of household economics. Then there was the heavy hand of the state, which confiscated the pamphlets that Sanger and her comrades wrote. Birth control gained its initial traction as a civil liberties issue.*

With its early articles on the subject, The New Republic *helped imbue contraception with a touch of needed legitimacy, transporting it from the domain of Wobblies and socialists into the mainstream. And like Lippmann, Sanger eventually exited the world of radicalism, an ideological odyssey that culminated*

*in her founding of the organization that would become Planned Parenthood.
But as this essay shows, Sanger's turn toward the center hardly insulated birth
control from the opprobrium heaped on it by authorities.*

"This is *my* party!" shouted Policewoman Mary Sullivan, in the
midst of her personally conducted raid on the Birth Control Clin-
ical Research Bureau in New York City, last week. Subsequent de-
velopments have demonstrated that this boast was as premature as
it was untruthful. For Policewoman Sullivan's little raiding party,
carried out with a vigor that swept aside as unnecessary such things
as common courtesy and ordinary good manners, has proved to
be of vital interest to every thinking member of this community.
And the end is not yet in sight. As I write these indignant words,
the announcement comes that Chief Magistrate William McAdoo
now admits that the police, in seizing the case histories of our pa-
tients, had exceeded the scope of the search warrant he had issued
authorizing this raid—an act on their part which constitutes a mis-
demeanor.

After you have spent some fifteen years, slowly and with infinite
pains and patience working for the right to test the value of contra-
ceptive practice in a scientific and hygienic—and lawful—manner,
without interfering with the habits or the morals of those who dis-
agree with you, it is indeed difficult to submit with equanimity to
such brutal indignities as were gratuitously thrust upon us at the
clinic a week ago. Compensations there have been, of course—
mainly in the enlightened attitude of such dailies as the New York
Herald Tribune and others, and the generous offers of aid from dis-
tinguished physicians. But even these can scarcely counterbalance
the evidence of the sinister and secret power of our enemies.

As in the breaking up of the birth-control meeting in the Town
Hall, in 1921, the raid on the Birth Control Clinical Research Bureau
gives us a glimpse of the animus which may direct the action of the

police. In their futile efforts to annihilate a social agency which had already been given a clean bill of health by the health department of the municipality, by the state board of charities and by the Academy of Medicine, our hypocritical antagonists have not the courage to fight us squarely, in the open, but adopt the cowardly subterfuge of utilizing minor and crassly ignorant members of the police force. Our research bureau has been functioning since 1923, operating within the law, and cooperating with recognized charitable institutions.

From whatever point of view it is analyzed, Policewoman Sullivan's "party" was a deplorable failure. A failure, first of all, because it has exposed a complete lack of intelligence in those who conducted it, and a woeful lack of coordination in the police department itself. It is not enough for Grover Whalen or District Attorney Banton to disclaim all foreknowledge of the raid. Modest as may be the headquarters of the research bureau, it is highly significant and important. Therefore, to permit minor members of the police force, or hostile assistants in the office of the District Attorney, to pass judgment upon its fate, denotes either a lack of coordination of powers, or a bland carelessness in directing them. Certainly no official of the city government, cognizant of awakened public opinion concerning the social value of contraception, and aware, moreover, of the searching criticism to which the police department of New York City is now subjected, would ever have chosen the present moment as one psychologically suited to inaugurate a brutal raid upon a modest unadvertised clinic which was functioning quietly and successfully in an obscure side street, minding its own business and hoping that its powerful ecclesiastical neighbors would mind theirs. At a time when the criminal elements of the city—racketeers, gangsters, gunmen and hijackers—are so active and successful, it would seem to a bystander that all the intelligence, skill, and brawn of the force should be mobilized and focused upon "crime control."

Even the thrill of satisfaction we have had in the offers of distinguished doctors to testify in our behalf, in the letters to the press, and the courageous outspoken editorials, cannot obliterate the memory of Policewoman Sullivan standing in the clinic and shouting vigorously and victoriously "This is my party!" I would rather forget that here was a woman fighting against other women who were devoting their lives to succor and to save their fellow women. By trickery and hypocrisy she had obtained her "evidence," and now she triumphantly commanded the doctors and nurses into the waiting patrol wagons.

Whatever the outcome of this raiding party, I hereby call upon the citizens of New York to find out for themselves how and where it originated, and why it was carried out. I ask them to recall the breaking up by the police of the birth-control meeting in Town Hall, with the subsequent revelation that this illegal action was instigated by Roman Catholic ecclesiastical authorities. We are paying, and paying heavily, for the support of a great police force. It is our right and duty to insist that it shall function in an efficient, legal, and socially effective manner. Policewoman Sullivan's "party" exposes it as operating in a manner which suggests the gratification of private prejudices and unreasoning emotion, rather than the even-handed administration of justice and the law.

PART THREE
1930s

"Whenever a liberal editor wants to reassure himself of his own liberalism, he searches for a fly-speck upon the record of one of the few liberals in public office and proceeds to magnify it until it is as big as the side of a barn."

HAROLD ICKES, UNPUBLISHED LETTER TO THE EDITOR
APRIL 14, 1938

Progress and Poverty

EDMUND WILSON

May 20, 1931

When Herbert Croly died in 1930, the magazine was left without its ideological father. Even though his leadership style contained not a trace of charisma, he had meticulously maintained a liberal editorial line. He had permitted sympathy for radicals and published them, but the official editorial position never came too close to socialism. Yet with his passing, his young protégés began insisting on a harder leftism.

Edmund Wilson didn't have the temperament of a party hack. But the trauma of the Great Depression had launched him toward the Communist Party, where he dabbled on the margins. He wanted "to take Communism away from the Communists," as he wrote in the magazine in 1931, and to apply the party's best teachings to American politics. The spirit of the party—with its adoration of the common man—also inspired him to step down as the magazine's literary editor. (The Daily Worker *was keen to hire him; he hesitatingly resisted.) Wilson asked for a pay cut so that he could travel the country reporting on the ravages of economic collapse. Despite Wilson's befouled politics, these pieces stand the test of time. He managed to capture American life from almost every angle: he interviewed autoworkers, traveled across the South with a Red Cross worker, and wrote about fancy hotels. The title of this piece is also the title of Henry George's nineteenth-century tract, one of the greatest works of American radicalism.*

I.

There is no question that the Empire State Building is New York's handsomest skyscraper. The first five stories, with their gray façade, silver-framed windows and long rainlike lines in the stone, rise graceful and sheer from the street: one feels a sudden relief as one passes them—they do not crowd and overpower Fifth Avenue as most of the newer Fifth Avenue buildings do. And the successive tiers fall back, each just in time not to make too heavy and dull a wall—till the main towering plinth is reached. Seen close, the long lines of the nickel facings have the look of a silver inlay and the whole long pale and silver strip might be an inlay on the pale even blue of the sky. This towering plinth, though it is the tallest in the city, has almost always an effect of lightness. From far off the gray observation tower looks as light as if it were made of shadows, its silver cap as it catches the sun, as bright and brittle as a Christmas-tree globe. In a warm afternoon sun the building is bisque-pink, with delicate nickel lines: a rainy day makes a pleasant harmony with bright pale facings on dull pale gray; on a chilly late afternoon, the mast is like a bright piece of silverware, an old salt-cellar elegantly chased. And though in a rawer light the building looks less fine, it may still seem as insubstantial as a packet of straw-colored Nabiscos stuck together and stood on end. In the cold dazing light of a winter morning, a bluish-gray block with gleaming silvery edges against a grayish-blue sky, it seems semi-translucent like a cake of ice. Only rarely in glaring midday does it look metallic, functional and hard like a machine-part.

The Empire State Building is the tallest building in the world: it is 1,250 feet high. There is a telescope in Madison Square Park for people to look at the tower through, just as they used to look at the moon. There are 86 stories, not counting the mast; 6,400 windows; and 67 elevators. The building contains 10,000,000 bricks and weighs 600,000,000 pounds—distributed, however, so evenly

that "the weight on any given square inch is no greater than that normally borne by a French heel." The plot on which it stands is only about 200 by 425 feet, but the building contains 37,000,000 cubic feet. It is calculated that, if it were full, there would be 25,000 people working there and 40,000 more people going in and out every day. In the immediate future, however, there will not be by any means that many, because business is extremely bad and even the office buildings already erected are full of untenanted space. Of the offices in the Empire State Building only a quarter have so far been rented, and in moving into it, most of the tenants will merely be leaving further vacancies elsewhere. The Empire State Building was put up at top speed in less than a year: in one case, telephoto had to be employed to get the right materials rushed from Cleveland. And now here it is planted in the business district where nobody needs it at all and where it is sure to make a good deal worse one of the worst traffic-jams in town.

The people responsible for the Empire State Building, who contributed more than half the $52,000,000 required for it, are John J. Raskob of the Democratic National Committee, Pierre du Pont of the Du Pont Powder Company, and the presidents of the Nipissing Mines Company and the Chatham Phenix National Bank and Trust Company. Al Smith is the president of the owning company and is said to get $50,000 a year. Today, the first of May, the day of the formal opening, he looks very compact, decent and well satisfied, in his dark coat and black derby, with his official family around him. It is his two little grandchildren who perform the ceremony of opening the building by cutting a ribbon across the Fifth Avenue entrance. Then the lights are switched on by an electric button pressed by President Hoover in Washington. Then there are speeches on the eighty-sixth floor. Al Smith reads a telegram from President Hoover,

who congratulates "everyone who had any part in its conception and construction" on "one of the outstanding glories of a great city." Governor Roosevelt congratulates them on their "grasp of the needs of the future"—he asserts that the Empire State Building "is needed not only by the city, it is needed by the whole nation." There are two keynotes today, he says: one is the keynote of vision, the other is the keynote of faith. Mayor Walker, whose administration is under calamitous inquiry and whose impeachment has recently been demanded, congratulates them on having provided "a place higher, further removed than any in the world, where some public officials might like to come and hide." Then the R.K.O. "Theatre of the Air" broadcasts a radio program.

The entrance hall of the Empire State Building is four stories high and made of gray German marble with an effect of crushed strawberries rubbed into it. On the far illuminated cream of the long ceiling are gold and silver circles, stars and suns, conventionalized geometrical patterns supposed to be derived from snowflake crystals. At the end of the hallway is an enormous flat steely sun blazing on the flat steely Empire State Building with a bombardment of rays like railroad tracks. The elevator doors are black with silver lines and have a suggestion of Egyptian tombs. There are a great many uniformed guards, with guns in holsters, posted around.

The fifty-fifth floor is the show floor. Green marble and green doors: a great empty loft with bright white walls with black ends of wire sticking out of them and crumbs of plaster on the floor. Through the unwashed windows streaked with dirt the windowed square-walled wilderness of buildings has the same dreary yellow as the streaks. If one looks out of an open window, one can see the water-tanks on top of other buildings, somebody's expensive penthouse done in green and very luxurious with steamer-chairs, an ad which says "Buy Your Furs from Fox" printed in big letters on the roof of a building and aimed at the occupants of the Empire State,

and an American flag. Below that, if one leans out, one sees the streets with the pedestrians and the motor cars very small moving straight and slow among them. To the west, the steamboats and barges moving slowly along the Hudson; to the south, the narrowing wedge of the island studded and pronged at the lower end with its own planting of enormous buildings; to the east, the iron blue-gray East River, strung across with black skeleton bridges, a gray airplane above it; to the north, the dwindled Chrysler tower, a tinny scaled armadillo-tail ending in a stiff stinglike drill, the white vertically-grooved flat-headed Daily News Building, the chocolate and guilded Luna Park summits of the American Radiator Company Building, like a large "castle" out of a goldfish bowl. Here the light of the setting sun strikes that crowded mass of upright rectangles and blunt truncated towers, bringing out in the raw stone and drab bricks their yellows without delicacy or brightness, their browns without richness or warmth. Brooklyn, Long Island City, Bronx, Englewood, Hoboken, Jersey City: straight streets, square walls, crowded bulks, regular rectangular windows—more than ten million people sucked into that vast ever-expanding barracks, with scarcely a garden, scarcely a park, scarcely an open square, whose distances in all directions are blotted out in a pale slate-gray. And here is the pile of stone, brick, nickel and steel, the shell of offices, shafts, windows and steps, that outmultiplies and outstacks them all—that, more purposeless and superfluous than any, is being advertized as a triumph in the hour when the planless competitive society, the dehumanized urban community, of which it represents the culmination, is bankrupt.

This big loft is absolutely empty, there is nothing to look at in it—or rather there is only one thing: a crude but genial mural drawn in pencil by, presumably, one of the plasterers or electricians, which, all unknown to the management, confronts every visitor to the fifty-fifth floor. A large male figure is seen standing upright and

fornicating, *Venus aversa*, with a stooping female figure, who has no arms but pendulous breasts. The man is saying, "O, man!" Further along is a gigantic vagina with its name in four large letters written under it.

One is grateful to the man who drew these pictures: he is a public benefactor. He has done something to take the curse off the opening of the Empire State Building.

II.

John Dravic* came to Buchanan six years ago and got a job in the Semlin car-shop. Before that he had been in Pennsylvania. He was born in Jugoslavia and his wife was an Austrian. He was forty and she was thirty. They had two sons, five and six, and two years after they came to Buchanan they had another son.

John Dravic bought a little house in Buchanan on Broda Avenue. There is more variety and more space in Broda Avenue than in most places in mill communities. The mill itself is a big low brick building with a notched roof and it has a picket-fence around it, guarded by a man with a gun in a holster; but outside there are little gardens with—just now, the first days of May—some white flowers as well as green vegetables; a corner saloon with billiard tables and Polish newspapers; an Italian store with vases of gay yellow, white and pink paper flowers in the windows and another with a stuffed eagle spreading its wings; a little backyard apple orchard with apple trees all in white bloom and with their trunks whitewashed up to the branches; and a little slimy and greenish but running stream with the rusty foot of an iron bedstead sticking out of it and a baby-carriage tire lying on the bottom. Across the street from John Dravic's house are several tiny bright-red brick mansions with little stone terraces built up from the street and thick clumps of creeping pinks, their pink livid beside the brick, oozing over the terraces toward

* The names of the people and places are fictitious.

the street. At the foot of the street is the Payson River, fresh and gleaming below its falls, flowing nervously and swiftly past the new greenery of its locust-grown bank. But beyond the river is a waste-darkened canal between a textile mill and a paper mill. The road that goes over the Payson has on one side a splendid green-and-orange Tom Thumb golf-course, with special little heart-shaped chairs, and on the other side a grisly dump for old scrapped car-bodies. And the whole landscape, even in May, coming to life as it is with spring, seems irremediably infected with the disease that blights industrial settlements—so that what ought to be fields and country hillsides are everywhere wastes going bald of grass and the finest country weather is made gassy and tarnished with smoke.

John Dravic's house is not fancy, as some of the Buchanan houses are—it is a plain two-story affair, dark-green, with a white double porch for both stories. He always let out the bottom floor and lived above: there are four very small rooms and a kitchen and a bath on each. About a year ago an Italian woman and her family rented the bottom floor. She was a big, tall, strong woman from Bologna with gray hair and gray eyes. Her first husband had died of t.b. and she had three tubercular children by him. Her second husband drank and left her. Both the girls had to be sent to the free tuberculosis hospital. The boy had earned a living in a butcher-shop, but when he came down with t.b. too, Mrs. Berelli had to go to work in the mill. And when the slump came she found herself earning only $15 or $20, working four days every other week. Finally she found herself laid off altogether. They didn't want anybody over forty, and if she went to the factory gate, they'd chase her away like a dog. They were putting in automatic looms which made it possible to produce more with fewer people. One person was supposed to be able to attend to six of the new looms, whereas each weaver had had only two of the old ones. She had to sell her insurance, and lost money on it, but even so she didn't have enough to live on and pay the rent.

One of her girls, who had only had light symptoms, was being sent home from the hospital. Mrs. Berelli appealed to the city for relief, and the city agreed to pay her rent.

John Dravic was her landlord and he wouldn't have put her out, but he was out of work himself. After five years in the Semlin car-shop he had been laid off last January and there was no hope of their taking anybody back. For a short time after that he had had a job minding the furnace in a New York theatre, but the play went off and the theatre closed, and since then he had had nothing. He walked all over New York and Payson and everywhere within walk-ing distance (because his money was so low that he couldn't even afford carfare), but he couldn't find anything to do.

The Dravics were quiet people and kept very much to them-selves. They didn't know anybody well, because they had only been in Buchanan six years, and in a community of mixed Germans, Poles, Hungarians, Italians and Jews it takes longer than that to make friends—that's one reason they don't get together to orga-nize. But Mrs. Berelli liked them and they were nice to her. When Mrs. Berelli had just come back from the hospital after an opera-tion, Mrs. Dravic, who was a delicate woman herself, had always come down every night after she had gotten into bed to see that she was all right. Every morning she would talk to Mr. Dravic when he started out to look for work. He had gotten very gloomy about it. He would say: "You're the only one workin' in the house and now you're not workin'!" She would try to cheer him up by saying: "Well, now that we're not workin', we might just as well not worry and go out in the backyard and take a sunbath!" That was what she used to do, though the truth was she didn't know which way to turn. But she always tried to keep the Dravics' spirits up, just as whenever she went to see her son in the hospital, she always said she was doing fine, so that he wouldn't worry about her.

Mr. Dravic, when he was home, used to work hard over a little

vegetable garden and a little strip of lawn beside the house. He always kept himself busy. Another thing he used to do was teach his two older boys music. He loved music and had two violins, a 'cello and a guitar. One of the boys learned the violin and the other the 'cello, and they would play trios almost every evening. Sometimes they would get other people in and have an amateur orchestra. John Dravic was extremely fond of his boys. Mrs. Berelli would see them all out walking together: Mr. Dravic was tall and the four-year-old baby was tiny. The oldest boy went to high school and was brilliant. He made little airplanes and boats and he wrote a piece in the high-school paper about how the government in Russia looked after the poor people whereas in America it didn't care. Mrs. Berelli herself couldn't understand how the rich people could do such a thing as to let the millworkers starve. Buchanan, Payson and Semlin and all the other neighboring mill towns were full of families out of work. Mrs. Berelli didn't know why that President in the White House didn't do something about it.

At last, a few weeks ago, John Dravic decided to go into business. He bought a little corner store which sold soft drinks, cigars and candies, across the river in Payson. Somebody persuaded him it was a good investment and he borrowed $300 to buy it. But it turned out that it wasn't such a good investment, because there was a much bigger and better candy and cigar store only a few blocks away; and John Dravic had never had any experience at store-keeping: he had never done anything but work in car-shops. He began to get discouraged when he came to realize how meager his stock was, that he had no money to buy any more and that he was $300 in debt. After a week of spending every day sitting alone in the shop and waiting for customers that didn't come, he got so that he hated to get up in the morning and go there. He never did anything about the slovenly-looking signs which said "Soft Drinks" and "Cigars" scrawled up in watery white print on the insides of the windows and

when the pile of Between the Acts boxes which was the sole window display toppled over, he didn't fix it up again.

Early in the morning of the first of May, sometime between one and two, Mrs. Berelli's daughter, who was home from the hospital now, came in and waked her up. She had just been waked up herself by an awful bang from the floor above. The next minute, Mrs. Dravic came running downstairs and said that her husband had shot himself. They rushed up and found John Dravic on the floor of the boys' bedroom: he was reaching with his hands and straining with the upper part of his body as if he were trying to get hold of something to get up by. Mrs. Dravic turned on the light and Mrs. Berelli saw that the bed was all soaking in blood.

All three of the boys were there, with blood like upset paint all over their faces. He had shot them all while they were asleep. A little while before, he had taken the baby out of his crib in the room where Mrs. Dravic slept. She had thought nothing of it at the time, because he did that every night to carry him to the bathroom before he went to bed. But tonight he had taken him in and put him into bed with the two boys.

They were all dead by six o'clock in the morning. Now poor Mrs. Dravic, who yesterday had a family that played trios in the evenings has nothing but four corpses for whom the cheap undertaker has done his best to patch up heads blown out with point-blank pistol shots. The only comfort is that the baby looks pretty good.

Out of the Red with Roosevelt

JOHN DOS PASSOS

July 13, 1932

The New Republic *trumpeted its connections to the New Deal. One of its adver-tisements cited testimony from a visitor to the Oval Office who claimed to have wit-nessed copies of the magazine stacked on Roosevelt's desk. This was a bit of disingenu-ous marketing. Until the late thirties,* The New Republic *raked FDR on a regular basis, even when it should have been nodding its head in agreement with his policies.*

All this hostility to Roosevelt was fairly predictable. Intellectuals are paid to be skeptical—and liberalism cherishes skepticism more than any ideology. But fulminations against Roosevelt were especially inevitable when the maga-zine assigned radicals like John Dos Passos to cover politics. When Sherwood Anderson once asked him about the difference between Socialists and Commu-nists, he quipped, "The Communists mean it." Like many of the magazine's most cherished writers, he simply couldn't fathom that the Great Depression had elicited so little revolutionary enthusiasm.

Dos Passos's revolutionary instincts, however, faded not long after this piece. His brush with the Stalinists in Spain, where they had executed his friend José Robles, had convinced him of Communism's rottenness. But as soon as his politics began shifting rightward, the magazine disowned him. Literary editor Malcolm Cowley, once his enthusiastic patron, trashed his novels.

They came out of the Stadium with a stale taste in their mouths. Down West Madison Street, walking between lanes of cops and a scattering of bums, the crowds from the galleries found the proud suave voice of the National Broadcasting Company still filling their jaded ears from every loudspeaker, enumerating the technical agencies that had worked together to obtain the superb hook-up through which they broadcast the proceedings of the Democratic Convention of 1932. Well, they did their part: the two big white disks above the speakers' platform (the ears of the radio audience) delicately caught every intonation of the oratory, the dragged-out "gre-eats" when the "great Senator from the great state of . . ." was introduced, the deep "stalwart" always being prefixed to "Democrat" when a candidate was being nominated, the indignant rumble in the voice when the present administration was "branded" as having induced "an orgy of crime and a saturnalia of corruption"; the page with the portable microphone in his buttonhole had invariably been on hand when a delegate was recognized from the floor; the managers for the N.B.C. had been there all the time, stage-managing, moving quietly and deftly around the platform, with the expression and gestures of old-fashioned photographers; coaxing the speakers into poses from which they could be heard; telegrams had been read giving the minute-to-minute position of the nominee's plane speeding west, the radio voice of Wally Butterworth had whooped things up describing the adverse flying conditions, the plane's arrival at the airport, the cheering throngs, the jolly ride from Buffalo, the Governor's nice smile; but when Franklin D. Roosevelt (in person) walked to the front of the rostrum on his son's arm while the organ played the "Star Spangled Banner" and an irrepressible young lady from Texas waved a bouquet of red, white and blue flowers over his head, to greet with a plain sensible and unassuming speech the crowd that had yelled itself hoarse for an hour for Al Smith three days before, that had gone delirious over the Wet plank and applauded every phrase in the

party platform, and sat with eager patience through the week-long vaudeville show—nothing happened. Courteous applause, but no feeling. The crowd in the huge hall sat blank, blinking in the glare of the lights. Neither delegates nor the public seemed to be able to keep their minds on what the candidate, whom they had nominated after such long sessions and such frantic trading and bickering downtown in their hotel rooms, had to say. As he talked the faces in the galleries and boxes melted away, leaving red blocks of seats, even the delegates on the floor slunk out in twos and threes.

Starting on Monday with the "Star Spangled Banner" and an inaugural address of Thomas Jefferson's read by a stout gentleman with a white gardenia in his buttonhole; through the Senator from Kentucky's keynote speech, during which he so dextrously caught his glasses every time they fell from his nose when he jerked his head to one side and up to emphasize a point; through Wednesday's all-star variety show that offered Clarence Darrow, Will Rogers, Amos 'n' Andy, and Father Coughlin "the radio priest" (who, by the way, advised the convention to put Jesus Christ in the White House), all on one bill; through the joyful reading of the platform with its promise of beer now and a quietus by and by on prohibition snoopers and bootleggers; through the all-night cabaret on Thursday, with its smoke and sweaty shirts and fatigue and watered Coca Cola and putty sandwiches and the cockeyed idiocy of the demonstrations: Governor Byrd's band in plumes and rabbit's fur (which he kindly loaned to Ritchie and to Alfalfa Bill when their turn came) and the pigeons and the young women who kept climbing up on the platform and bathing in the klieg lights like people under a warm shower, and the sleepy little Oklahoma girls in their kilties; and the grim balloting while the sky outside the windows went blue and then pink until at last the sun rose and sent long frightening bright horizontal shafts through the cigar smoke and the spotlights and the huddled groups of worn-out politicians; through the nom-

inating speeches, and the seconding speeches and the reseconding speeches, and the old-time tunes, "The Old Gray Mare," "A Hot Time in the Old Town Tonight," "I've Been Working on the Railroad" . . . through all the convention week and flickering of flashlight bulbs and the roar of voices there had been built up a myth, as incongruous to this age as the myth of the keen-eyed pilot at the helm of the ship of state that the Republicans tried to revitalize three weeks ago; the myth of the young American working his way by honesty and brawn, from Log Cabin to President. This stalwart Democrat was to rise in his might, wrench the government out of the hands of the old bogey Republicans, Wall Street, Privilege, Graft and Corruption, return it to the people and thus in some mystic way give a job to the jobless, relieve the farmers of their mortgages, save the money the little fellow had deposited in the tottering banks, restore business to the small storekeeper and producer and thereby bring the would-be Democratic office holders massed on the floor back to the fleshpots of power. A powerful myth and an old myth. But when, largely through the backstage efforts of Mr. McAdoo, the myth took flesh in the crippled body and unassuming speech of the actual Governor of New York, the illusion crashed. Too late.

You come out of the Stadium and walk down the street. It's West Madison Street, the home address of migratory workers and hoboes and jobless men all over the Middle West. Gradually the din of speeches fades out of your ears, you forget the taste of the cigar you were smoking, the cracks and gossip of the press gallery. Nobody on the street knows about the convention that's deciding who shall run their government, or cares. The convention is the sirens of police motorcycles, a new set of scare headlines, a new sensation over the radio. There are six-day bicycle races and battles of the century and eucharistic congresses and big-league games and political conventions; and a man has got a job, or else he hasn't got a job, he's got jack in his pocket, or else he's broke, he's got a business, or else

he's a bum. Way off some place headline events happen. Even if they're right on West Madison Street, they're way off. Roosevelt or Hoover? It'll be the same cops.

You walk on down, across the great train yards and the river to the Loop, out onto Michigan Avenue where Chicago is raising every year a more imposing front of skyscrapers, into the clean wind off the lake. Shiny store-fronts, doormen, smartly dressed girls, taxis, buses taking shoppers, clerks, business men home to the South Side and North Side. In Grant Park more jobless men lying under the bushes, beyond them sails in the harbor, a white steamboat putting out into the lake. Overhead pursuit planes fly in formation advertising the military show at Soldiers' Field. To get their ominous buzz out of your ears, you go down a flight of steps, into the darkness feebly lit by ranks of dusty red electric lights of the roadway under Michigan Avenue. The fine smart marble and plate-glass front of the city peels off as you walk down the steps. Down here the air, drenched with the exhaust from the grinding motors of trucks, is full of dust and grit and the roar of the heavy traffic that hauls the city's freight. When your eyes get used to the darkness, you discover that, like the world upstairs of store-fronts and hotel lobbies and battles of the century and political conventions, this world too has its leisure class. They lie in rows along the ledges above the roadway, huddled in grimed newspapers, gray sag-faced men in worn-out clothes, discards, men who have nothing left but their stiff hungry grimy bodies, men who have lost the power to want. Try to tell one of them that the *gre-eat* Franklin D. Roosevelt, Governor of the *gre-eat* state of New York, has been nominated by the *gre-eat* Democratic party as its candidate for President, and you'll get what the galleries at the convention gave Mr. McAdoo when they discovered that he had the votes of Texas and California in his pocket and was about to shovel them into the Roosevelt band wagon, a prolonged and enthusiastic *Boooo*. Hoover or Roosevelt, it'll be the same cops.

The Future of Democracy

BENEDETTO CROCE

April 7, 1937

The symposium is an old trick of the little magazine. Invite a bunch of famous names to chew over a big subject—and in the fog of debate, the reader is distracted from the fact that the editors can't figure out their own positions on the issue. In 1937, The New Republic *evidently couldn't make up its own mind about the future of democracy. It asked some of the world's greatest philosophers to debate whether democracy even deserved to survive. Of all the eminences who submitted essays—Bertrand Russell, George Bernard Shaw—the editors were most excited by the piece that arrived from Naples, written by the aesthetician-cum-politician Benedetto Croce. That name has largely receded, which is a shame. His disappearance may have something to do with his style. He wrote with his arms gesticulating wildly—polemically, passionately, with a vigor that feels somehow less trustworthy with time. It's a style befitting a philosopher who venerated the role of intuition in the creation of art. Croce was one of the century's true liberals, a stalwart opponent of fascism (despite an initial flirtation with Mussolini) and a rousing explicator of democratic values (despite an initial flirtation with Marx). How powerful were his arguments? Fascists considered him worrisome enough that they plotted to kidnap him; Mussolini's own paper declared him a "walking corpse."*

People are always asking, "Do you think that the world is moving toward an authoritarian system of government? Do you think that philosophy is moving toward a new anti-idealistic realism? Do you think that art is moving toward futurism or dadaism or 'hermitism'?" and so on.

I call this kind of question "meteorological": it is like asking, "Do you think that it is going to rain today? Had I better take my umbrella?"

But moral, intellectual, esthetic and political problems are not things outside ourselves, like rain or fine weather; they are within ourselves and for that reason there is no sense in asking what is more or less likely to happen. We need solely to make up our own minds and to act, each one according to his understanding and his capacity.

You will permit me also to state that, among the insults today offered to liberty, none seems to me more gross than that implied in the question whether the liberal system is to be preferred to the authoritarian system.

It reminds me of the story of a man who went to a friend and said: "I was given a slap in the face today, what do you advise me to do about it?" and the friend replied, "Why, if it was given to you, keep it." It is evident that a man who asks advice about his personal dignity has already actually renounced it.

The choice between liberty and suppression of liberty is not on the same plane as a choice between things of different values, one of which may reasonably be preferred to the other—the first means human dignity and civilization, the second the debasing of men until they are either a flock to be led to pasture, or captured, trained animals in a cage.

Coming to our own times, I see the future that liberty promises always as a beacon; I do not see any light in the future promised

by authoritarianism. In the past, under the forms of theocracy, of monarchy or of oligarchy, authority had at least a background of religious mystery. Modern humanistic thought has dissipated the mystery, replacing it by simple humanitarian ideals.

But authoritarianism in our times, in those we see looming ahead, is irreligious and materialistic, despite its pretenses and rhetoric, and comes down to a brutal rule of violence over people who are prevented from seeing and knowing what is going on, and who are forced to submit to leadership and give unquestioning obedience to it.

To lend glamor to this obedience by associating it with the noble and the heroic, it is usually called military discipline, which has been extended, or should be extended, to the whole of society. But military discipline has its function only as one aspect of the social order. If instead of being contained within the society, it is itself the containing body or is coextensive with society; it can no longer be called military discipline, but is a general process of fostering universal stupidity. An artist with the face of a corporal, a scientist with that of a sergeant, a politician who waits for his orders and blindly carries them out, is no longer an artist, a scientist or a politician, but an imbecile.

We see it also as a phase of mental decadence that the political problem is now usually presented in terms of "the masses," and what is suitable "for the masses." "Masses" are not, as people seem to believe, something new in history; they have always existed, smaller than today, to be sure, since the proportions of society as a whole were smaller, but of the same nature and with the same spirit, the same threat, the same peril.

Sound political sense has never regarded the masses as the directing force of society, but has always delegated this directive function to a class which was not economic in its basis of selection, but political; one capable of governing. The problem concerns therefore

not the masses but the governing class. Here too the evil, if evil there be, is in ourselves, and in ourselves alone is the remedy. It is vain to look for it elsewhere.

Liberalism should be at one and the same time the friend and the foe of democracy. It should be its friend, because the governing class is fluid, and its efforts are applied to increasing its membership and its following and to choosing them more carefully, and thus democracy implies an administration that provides at the same time an education of the governed for governing. But liberalism must be the foe of democracy when the latter tends to substitute mere numbers or quantity for quality, because by so doing democracy is preparing the way for demagoguery, and, quite unintentionally, for dictatorship and tyranny and its own destruction.

A practical corollary for men of good will: to work unremittingly under whatever conditions prevail, with every means at hand, and continuously, to work for the preservation and strengthening of the liberal spirit, seeking the most suitable means, but always those that lead to the end in view and not to its abandonment or its replacement by other ends.

A man who works for an ideal finds in that ideal his hope and his joy. And yet his human flesh may perhaps look for comfort in some more specific aspiration. And this too he can have, if he considers that, under the present conditions of the world, the reserve of intellectual and moral force is still enormous, and that civil liberties have been preserved in great and powerful nations. These will withstand the perils to which they are exposed and will serve as signal flares for general recovery and resumption of progress. Even under authoritarian governments the achievements won by a liberty formerly enjoyed still endure in many persistent attitudes of mind, and such governments make use of these attitudes, even while they seek to change them and to blight their seeds of future growth, destroying or compromising

for the future the very productive forces which the governments need for their maintenance.

But supposing we assume that the worst will happen. The worst that can be envisaged is that the struggle which is today tearing the world asunder will culminate in the complete rout of liberty and the triumph of authoritarianism, or as it is now called, "totalitarianism," even in the countries which have up to this time remained immune.

Well, then, freedom will succumb, to be sure, but with the certainty that the processes of acquiring it will have to begin all over again, and that, in order to begin again, people will resume the efforts which for the time being have failed to win victory but which will win it in days to come.

In this sense, and not in that of obedience, in this knowing how to suffer death for a greater life, the task of humanity is in truth inspired by a military and a heroic spirit.

To the last of your questions (which falls outside the political or moral problem) "whether authoritarian systems provide better than liberal systems for the 'safety of the individual,' that is, for his material and economic interests," I can reply only with another query, "Can we suppose that our affairs will be in safer hands if we give *carte blanche* to others to manage them as they see fit, without the interested persons being able to intervene, to object, or even to ask questions?"

Here, too, an anecdote comes to mind, that of the king of Illyria in Daudet's "Les Rois en Exil" who renounces his throne to live blissfully as a private individual with a woman. When he triumphantly announces to her that he has done so, she laughs in his face, "*Jobard, va!*" (you poor simpleton) and walks out.

PART FOUR
The 1940s

"But the liberal, partial to reasonableness and understanding though he is, thrives on battle."

<div align="right">

THE EDITORS
APRIL 29, 1940

</div>

The Corruption of Liberalism

LEWIS MUMFORD

April 29, 1940

Liberals have a great tradition of thunderously denouncing each other. Of course, they often deserve it. Many of the complaints about liberals contain at least a shred of truth. They congratulate themselves for their capacity to view the world in all its complexity and nuance, which is often an excuse for inaction. They disavow metaphysics and grand theories of history, but don't have their own strong set of core beliefs—or rather, they often ended up extolling the morally hollow goals of economic growth, consumerism, and private pleasure.

This essay is a masterwork in the genre of liberal self-flagellation—and makes a very good case for the long overdue revival of Lewis Mumford. The illegitimate son of a German housekeeper, Mumford trained himself to be a cultural critic and political theorist. His autodidacticism yielded idiosyncratic, sweeping arguments. The twentieth century irked him: modern life was soul-crushingly empty; capitalism had created a depressing schism between art and labor. Initially, Mumford hoped that technocracy would heal these wounds. Urban planning would create cities that would allow humans to better achieve their potential.

This essay represented a turn in his thinking. With liberals reluctant to intervene in World War II, Mumford came to see the flaws in his comrades. In

the battle against communism and fascism, what did liberalism have to offer?
And could it really provide a bulwark against the power-mad totalitarians?
After Mumford handed in this essay, he asked the editors to remove his name
from its roll of contributing editors.

Mumford's essay prefigured arguments that both George Orwell and Rein-
hold Niebuhr would make. Of course, in the end, liberalism proved itself more
than up to the task of battling evil, as Hitler and Mussolini could well attest.
But even with such a thorough debunking of his central thesis, his critique is
hard to shake.

As an economic creed, liberalism was undermined by imperialism
and monopoly before the nineteenth century closed. But as a per-
sonal and social philosophy, liberalism has been dissolving before
our eyes only during the past decade. The liberal lacks confidence
in himself and in his vision of life. He has shown in every country
where the attacks on liberalism have been forceful that he either
does not possess stable convictions, or that he lacks the insight and
the courage that would enable him to defend them. Continually
hoping for the best, the liberal remains unprepared to face the
worst; and on the brink of what may turn out another Dark Ages,
he continues to scan the horizon for signs of dawn.

The record of liberalism during the last decade has been one of
shameful evasion and inept retreat.

Liberalism has compromised with despotism because despotism
promised economic benefits to the masses—an old device of des-
potism. In the case of Soviet Russia liberals continued to preserve
an embarrassed silence about the notorious plight of freedom and
justice in that country because they had esthetic scruples about ap-
pearing to align themselves with those forces in America that op-
posed Russia for purely reactionary reasons. So they preferred to
be tacitly on the side of the greater despots, like Stalin and Hitler,
in order to be free of any taint of association with the minor despots

of American capitalism. In international affairs liberalism has likewise graciously lent support to the forces of barbarism, in an effort to give the devil his due. And on the theory that war is the worst of evils, the liberals have tearfully acquiesced in the rule of those who, as Blake said, would "forever depress mental and prolong corporeal war."

Liberalism has been on the side of passivism, in the face of danger; it has been on the side of appeasement, when confronted with aggressive acts of injustice; and finally, in America today, as in England yesterday, liberalism has been on the side of "isolation," when confronted with the imminent threat of a worldwide upsurgence of barbarism. Today liberals, by their unwillingness to admit the consequences of a victory by Hitler and Stalin, are emotionally on the side of "peace"—when peace, so-called, at this moment means capitulation to the forces that will not merely wipe out liberalism, but will overthrow certain precious principles with which one element of liberalism has been indelibly associated: freedom of thought, belief in an objective reason, belief in human dignity.

The weakness and confusion and self-betrayal of liberalism during the crisis that has now come to a head, provide one of the most pitiable spectacles that these pitiful times have shown.

Unable to take the measure of our present catastrophe and unable, because of their inner doubts and contradictions and subtleties to make effective decisions, liberals have lost most of their essential convictions, for ideals remain real only when one continues to realize them. Liberals no longer act as if justice mattered, as if the truth mattered, as if right mattered, as if humanity as a whole were any concern of theirs: the truth is they no longer dare to act. During the period of the United Front, liberals accepted the leadership of a small Communist minority, fanatical, unscrupulous, deeply contemptuous of essential human values, incredibly stupid in tactics and incredibly arrogant in matters of intellectual belief; they

accepted this leadership simply because the Communists, alone among the political groups, had firm convictions and the courage to act on them.

Now that the moral treachery of the Communists has placed them alongside their natural tactical allies, the fascists, many of these liberals have, on practical points at issue, even drifted into a covert defense of Hitlerism. They show far more distrust of the English and French and Finnish peoples, who are resisting the barbarians, than they do of the German and Russian masses who follow, blindly, stupidly, irrationally, without access to any sources of objective fact, the leadership of Hitler and Stalin. These liberals were against Chamberlain when he sought to appease the fascist powers; and they are still against Chamberlain, now that he has reversed his old position. To comfort themselves and keep to their illusions, they concoct imaginary situations in which Stalin suddenly reverses his obvious plans and undermines Hitler—as if anything would be gained for humanity by substituting one impudent dictator for two . . . In their imaginary world, these liberals are always right; in the real world, they have been consistently wrong. So victimized are some of these liberals by their protective illusions and self-deceptions that it is easy to predict that they will presently swallow without a grimace Hitler's hoax that Nazi Germany is defending the masses against the "capitalist plutocracies."

The Romans used to say that the worst results come about through the corruption of what is good; and one may say this about the present state of liberalism. But the defects of liberalism are not due to isolated mistakes of judgment that individual liberals have made; they are due to fatal deficiencies that go to the very roots of liberal philosophy. Unfortunately, liberalism's weaknesses are so debilitating that they not merely undermine its will-to-survive, but they may also give up elements in a longer human tradition, on whose maintenance our very civilization depends.

Liberalism is a very mixed body of doctrine. So it is important that, in discussing its errors, we should detach its essential and enduring values from those which have characterized a particular age, class or group.

Like democracy, with which it has close historic affiliations, liberalism during the last generation has been subject to a violent assault. This came originally from the Marxian revolutionaries of the Left; but the blows were doubled through the triumphant action of the fascist revolutionaries of the Right. By now these extremes have met in their attack on liberalism.

According to the Marxian critics, liberalism arose at the same time as capitalism; and therefore, liberalism is doomed to disappear when capitalism is overthrown. From the Marxian point of view, ideas are but the shadows of existing economic institutions: human liberty depends on freedom of investment, freedom of trade. One might think, to hear a Marxian critic, that the concept of freedom had never been framed before the Manchester school came into existence.

So the anti-liberals, pretending mainly to attack capitalism, have also attacked the belief in the worth and dignity of the individual personality: they have undermined the notion of *Humanity*, extending beyond race, creed, class or other boundaries. So, too, they have sought to wipe out the concept of an impersonal law, built up by slow accretions that reach back into an ancient past, forming a coherent pattern tending toward justice. The anti-liberals have upheld, rather, the one-sided personal rule of a party or a man. In Germany and Spain the basic concept of law has been so completely overthrown that a man may be tried and convicted for a crime that did not exist in law at the time he committed it.

Now the universal elements in liberalism, the moralizing elements, are the real objects of the fascist attacks. These universal elements arose long before modern capitalism: they were part of

the larger human tradition, embodied in the folkways of the Jews, in the experimental philosophy of the Greeks, in the secular practices of the Roman Empire, in the sacred doctrines of the Christian Church, in the philosophies of the great post-medieval humanists. The Marxian notion that ideas are always the shadows of the existing economic institutions runs bluntly against facts precisely at this point. For although a culture forms a related organic whole, a residue is left in each period and place which tends to become part of the general heritage of mankind. This residue is relatively small in amount but infinitely precious; and no single class or people can create it or be its sole keeper.

The effort to equate Manchester liberalism with the humanist traditions of personal responsibility, personal freedom and personal expression is sometimes shared by the defenders of capitalistic privilege; that is the gross fallacy of those who try to tie together private capitalism and "the American way." But these notions are false, whether held by the absolutists of private property or by the absolutists who would challenge the regime of private property. The most important principles in liberalism do not cling exclusively to liberalism: what gives them their strength is their universality and their historic continuity. Confucius, Socrates, Plato, Aristotle, testify to them no less than Jefferson and Mill. Liberalism took over this humanist tradition, revamped it, and finally united it to a new body of hopes and beliefs that grew up in the eighteenth century.

This second element in liberalism, which seems to many people as important as the first, rests upon a quite different set of premises. Liberalism in this sense was symbolically a child of Voltaire and Rousseau: the Voltaire who thought that the craft of priests was responsible for the misery of the world, and the Rousseau who thought that man was born naturally good and had been corrupted only by evil institutions. It was likewise a by-product of the inventors and industrialists of the period, who, concentrating upon the

improvements of the means of life, thought sincerely that the ends of living would more or less take care of themselves.

This pragmatic liberalism, which I shall here distinguish from the ideal liberalism, was vastly preoccupied with the machinery of life. It was characteristic of this creed to overemphasize the part played by political and mechanical invention, by abstract thought and practical contrivance. And accordingly it minimized the role of instinct, tradition, history; it was unaware of the dark forces of the unconscious; it was suspicious of either the capricious or the incalculable, for the only universe it could rule was a measured one, and the only type of human character it could understand was the utilitarian one. That there are modes of insight into man and into the cosmos which science does not possess, the liberal did not suspect; he took for granted that the emotional and spiritual life of man needs no other foundation than the rational, utilitarian activities associated with the getting of a living. Hence, finally, liberalism's progressive neglect of the fields of esthetics, ethics and religion: these matters were left to traditional thinkers, with the confident belief that they would eventually drop out of existence, mere vestiges of the race's childhood. On the whole most liberals today have produced no effective thought in any of these fields; and they live, as it were, on the debris of past dogmas and buried formulations. Unconscious, for example, of the sources of their ethical ideas, they pick up more or less what happens to be lying around them, without any effort at consistency or clarity, still less at creativeness: here a scrap left over from childhood, there a fragment of Kant or Bentham, or again a dash of Machiavelli, pacifist Quakers one moment and quaking Nietzscheans the next.

In short, it is not unfair to say that the pragmatic liberal has taken the world of personality, the world of values, feelings, emotions, wishes, purposes, for granted. He assumed either that this world did not exist, or that it was relatively unimportant; at all events,

if it did exist, it could be safely left to itself, without cultivation. For him men were essentially good, and only faulty economic and political institutions—defects purely in the mechanism of society— kept them from becoming better. That there might be internal obstacles to external improvement seemed to him absurd. That there was as large a field for imaginative design and rational discipline in the building of a personality as in the building of a skyscraper did not occur to him. Unfortunately, immature personalities, irrational personalities, demoralized personalities are as inevitable as weeds in an uncultivated garden when no deliberate attempt is made to provide a constructive basis for personal development.

Behind this failure to establish, on a fresh basis, a normative discipline for the personality was a singular optimism—the belief that it was not needed. Did not liberalism imply an emancipation from the empty institutional religion, from the saws, precepts, moralizings of the past? Did this not mean that "science," which confessedly despised norms, would eventually supply all the guidance necessary for human conduct? Such was the innocence of the liberal that those who were indifferent to ethical values thought of themselves as realists. They could hardly understand William James when he called emotionality the *sine qua non* of moral perception. But the fact was that the most old-fashioned theologian, with a sense of human guilt and human error, was by far the better realist. Though the theologian's view of the external world might be scientifically weak, his view of the internal world, the world of value and personality, included an understanding of constant human phenomena, sin, corruption, evil—on which the liberal closed his eyes.

Pragmatic liberalism did not believe in a world where the questions of good and evil were not incidental but of radical importance. Its adherents thought that they would presently abolish the

evils inherent in life by popularizing anesthetics and by extending the blessings of the machine. They did not believe in the personal life. That was outmoded. Esthetic interests, moral discipline, the habits of contemplation and evaluation, all this seemed mere spiritual gymnastics: they preferred more physical exercises. By activity (busy work) pragmatic liberals kept their eyes manfully on the mere surface of living. They did not believe that any sensible man would, except when he made his will, face the more ultimate facts of existence. For them, the appraisal of death was a neurotic symptom; happily, science's steady advances in hygiene and medicine might postpone further and further that unpleasant occasion itself.

This failure to deal with first and last things, to confront, except in a hurried, shamefaced way, the essential facts of life and death, has been responsible for some of the slippery thinking on the subject of war that has characterized liberals recently. One of them, in private conversation, told me that he could not face a political decision which might lead to war and thereby bring about the death of other human beings. When I objected that the failure to make such a decision in the present international crisis would possibly lead to the less fruitful death of the same human beings six months or six years hence, he confessed that any extra time spared for the private enjoyment of life today seemed that much gained. I do not doubt the honesty of this liberal; but it is obvious that he has ceased to live in a meaningful world. For a meaningful world is one that holds a future that extends beyond the incomplete personal life of the individual; so that a life sacrificed at the right moment is a life well spent, while a life too carefully hoarded, too ignominiously preserved, may be a life utterly wasted.

Is it any wonder, then, that pragmatic liberalism has been incapable of making firm ethical judgments or of implementing them with action? Its color-blindness to moral values is its most serious weakness today; hence it cannot distinguish between barbarism

and civilization. Indeed, it is even inclined to pass a more favorable verdict on barbarism when it shows superiority in material organization. Refusing to recognize the crucial problem of evil, those who follow this creed are incapable of coping with the intentions of evil men: they look in vain for merely intellectual mistakes to account for the conduct of those who have chosen to flout man's long efforts to become civilized. Evil for the pragmatic liberal has no positive dimensions: he conceives it as a mere lack of something whose presence would be good. Poverty is an evil, because it indicates the lack of a good, namely riches. For this kind of liberal, the most heinous fact about a war is not the evil intentions and purposes that one or both sides may disclose: it is mainly the needless waste of material, the unbearable amount of human suffering, the premature deaths.

Lacking any true insight into these stubborn facts of human experience—corruption, evil, irrational desire—liberals also fail to understand that evil often lies beyond purely rational treatment, that a mere inquiry into causes, mere reasonableness and sweetness in one's attitude, may not only fail to cure an evil disposition but may aggravate it. Now, unfortunately, there are times when an attitude of intellectual humility and sympathy is entirely inappropriate to the press of a particular situation. There are times when active resistance or coercion is the only safeguard against the conduct of men who mean ill against human society. The alternative to coercion is what the religious call conversion, salvation, grace, on the part of the offender. That, too, is essentially a pre-rational process, not hostile to reason, but proceeding by a short cut into an area that reason cannot directly touch. Liberals tend to minimize the effectiveness of both coercion and conversion, both force and grace; but it is hard to point to any large and significant social change in which both elements did not play a part.

Coercion is, of course, no substitute for intelligent inquiry and no cure in itself for anti-social conduct. But just as there are maladies

in the human body which call for surgery rather than diet—though diet, if applied at an early stage, might have been sufficient—so there are moments of crisis in society when anti-social groups or nations that resist the ordinary methods of persuasion and compromise must be dealt with by coercion. In such moments, to hesitate, to temporize, only gives the disease a deeper hold on the organism; and to center one's efforts upon changing the mind of one's opponent, by opposing reason to his irrationality, and to overlook the elementary precaution of depriving him of his weapons for attacking one, is to commit a fatal offense against the very method one seeks to uphold.

The liberal's notion that reasoning in the spirit of affable compromise is the only truly human way of meeting one's opponent overlooks the important part played by force and grace. And his unctuous notion that evil must not seriously be combated because the person who attempts to oppose it may ultimately have to use physical force, and will become soiled by the act of fighting, is a gospel of despair. This belief is the core of his defeatist response to Nazism; it means in practice turning the world over to the rule of the violent, the brutal and the inhuman, who have no such fine scruples, because the humane are too dainty in their virtue to submit to any possible assault on it. Now the dangers are real: force *does* brutalize the users of it; when blood is spilt, anger rises and reason temporarily disappears. Hence force is not to be used daily in the body politic, like food or exercise; it is only to be used in an emergency, like medicine or the surgeon's knife. Fascism is barbarous, not because it uses force, but because it *prefers* force to rational accommodation: it deliberately turns mental and physical coercion into human nature's daily food.

But to surrender in advance, to take no step because one may make a false step, is to pursue an illusory perfection and to achieve an actual paralysis. Force cannot be left behind, no matter how

humane and rational our standards of conduct. He who under no circumstances and for no humane purpose will resort to force, abandons the possibility of justice and freedom. The German socialists took their legalistic pacifism seriously; they got their reward in the concentration camp. The English Laborites, following the nerveless Tory leadership, took the same position in international affairs; and that led not alone to the betrayal of Czecho-Slovakia but to the present endangerment of Western civilization itself.

Despite these sinister examples, the same guileless reasoning has been driving our American liberals into a position of queasy nonresistance, on the ground that the only motive that could sanction our immediate opposition to Hitlerism would be our belief that those opposing him now were angels. People who think in these terms are secretly complimenting themselves upon virtues and purities that neither they nor their countrymen possess; they are guilty of that most typical liberal sin, the sin of Pharisaism. It is because we, too, are not without guilt that we may, in the interest of preserving humanity from more abject humiliations, oppose Hitler and Stalin with a clean heart. To be too virtuous to live is one of the characteristic moral perversions of liberalism in our generation.

The essential moral weakness of liberalism, which I have only glanced at here, is coupled with a larger weakness in the liberal philosophy. Along with liberalism's admirable respect for rational science and experimental practice, goes an overvaluation of intellectual activities as such, and an undervaluation of the emotional and affective sides of life. In the liberal theology, emotions and feelings have taken the place of a personal devil. Now as every good psychologist knows, and as Count Korzybski has ably demonstrated, emotions and feelings, associated with the most devious and remote body processes, are involved in all thought. Reason and emotion

are inseparable: their detachment is a practical device of limited use. Thought that is empty of emotion and feeling, that bears no organic relation to life, is just as foreign to effective reason as emotion that is disproportionate to the stimulus or is without intellectual foundations and references. The body, the unconscious, the pre-rational are all important to sound thought. But because the liberal has sought no positive discipline for emotion and feeling, there is an open breach between his affective life and his intellectual interests. His first impulse in any situation is to get rid of emotion because it may cause him to go wrong. Unfortunately for his effort to achieve poise, a purely intellectual judgment, eviscerated of emotional reference, often causes wry miscalculations. The calmness and sang-froid of Benes was perhaps his most serious weakness during the long period before the Munich crisis; ominously, it repeated the self-defeating mood of Bruening, in the days preceding his removal. Instead of priding himself on not being "carried away by his emotions," the liberal should rather be a little alarmed because he often has no emotions that could, under any conceivable circumstances, carry him away.

This is not a new criticism. Graham Wallas lectured on the subject twenty years ago. He showed that in all valid thinking that referred to human situations it was important to be able to use the emotions, not to put them into cold storage. Liberalism, by and large, has prided itself upon its colorlessness and its emotional neutrality; and this liberal suspicion of passion is partly responsible for the liberal's ineptitude for action. In a friendly world, pragmatic liberalism leads to nothing worse than a tepid and boring life; but in a hostile world, it may easily lead to death. If one meets a poisonous snake in one's path it is important, for a *rational* reaction, to have a prompt emotion of fear; for fear releases the flow of adrenin into the bloodstream, and that will not merely put the organism on the alert but will give it the extra strength either to run away or to attack.

Merely to look at the snake abstractedly, without sensing danger and experiencing fear, may lead to the highly irrational step of permitting the snake to draw near without being on guard against the reptile's bite. The liberal's lack of a sense of danger when confronted by the avowed programs and the devastating achievements of the totalitarian regimes is one cause of society's rapid disintegration.

Liberalism under its assumption that men ideally should think without emotion or feeling deprives itself of the capacity to be human. This is one of the gravest features of the present crisis; the cold withdrawal of human feeling by the liberals today is almost as terrible a crime against civilization as the active inhumanity of the fascists. And that withdrawal is responsible for liberalism's deep-seated impotence.

Closely allied with the liberal's emotional anesthesia is his incurable optimism—a wrinkled smile left over from the eighteenth century, when, in the first flush of confidence, the possibilities of human advance seemed boundless. This optimism belonged to a constructive and expanding age: in its inception, it was a healthy reaction against the moldering institutions and precedents of the past. But it has become an unfortunate handicap in a period when destructive forces are gaining the upper hand, and when, in the approaching stabilization of population and industry, the malevolence of the human will, on the part of the propertied classes, may at critical moments—as already in Germany and Italy—give unlimited power to those who represent barbarism. Destruction, malice, violence, hold no temptation for the liberal; and in the kindness of his heart, he cannot bring himself to believe that they may viciously influence the conduct of any large part of mankind. The liberals could not understand that the gift of Czecho-Slovakia to Nazi Germany could not appease Hitler: that one might as well offer the carcass of a dead deer in a butcher store to a hunter who seeks the animal as prey—the meat being valued chiefly as a symbol of his

prowess. And that is why the talk of mere economic adjustments that would enable the fascist states to live at peace with the rest of the world is muddled nonsense; it assumes, contrary to fact, that fascism springs out of rational motives and pursues concrete utilitarian ends. The bad arrangements of the peace of Versailles did not by themselves create fascism, nor will the best results of a magnanimous peace conference be able at once to wipe out its destructive impulses and undermine its irrational philosophy. Unfortunately it is not in Ricardo or Marx or Lenin, but in Dante and Shakespeare and Dostoevsky, that an understanding of the true sources of fascism are to be found. Economic explanations reflected a reality in the nineteenth century; they disguise a reality—the claim to barbaric conquest—today.

During the last ten years, the optimism of the liberals has remained unshaken. The incurable tendency of the liberal is to believe the best about everybody: to hope when there is no reason to hope, and to exhibit the nicest moral qualms, the most delicate intellectual scruples, in situations that demand that he wade in and coarsely exert his utmost effort. We now face a world that is on the brink, perhaps of another Dark Age; and because a Dark Age is not included in the liberal chronology, liberalism glibly refuses to accept the evidence of its senses. Like the sun-dial, it cannot tell time on a stormy day. So, habitually, the pragmatic liberals brand those whose eyes are open to the human devastation around them as "hysterical," "mystical," "having concealed fascist tendencies," or—taking a leaf from the Hitlerites—as "warmongers."

Now one must remember that liberalism has two sides. There is an ideal liberalism, deeply rooted in the example and experience of humanity: a doctrine that commands the allegiance of all well disposed men. And there is a transient doctrine of liberalism, the

pragmatic side, which grew up in the eighteenth century out of a rather adolescent pride in the scientific conquest of nature and the invention of power machinery: this is the side that emphasizes the utilitarian aspects of life, that concentrates on purely intellectual issues, and that, in its exclusive concern for tolerance and "open-mindedness" is ready to extend its benevolent protection to those who openly oppose the very purpose of civilization. What is important in ideal liberalism are elements like the great Roman notion of *Humanity*, united in the pursuit of freedom and justice, embracing all races and conditions. This ideal is radically opposed at every point to the autarchy advocated by the fascists; and it is no less opposed to the isolationism, moral and physical and political, advocated by most American liberals—a passive milk-and-water version of the fascist's contemptuous attitude toward the rest of the human race.

Plainly the liberal who proposes to do nothing on behalf of humanity until the lives of individual Americans are actually threatened by a fascist military invasion will have very little left to save. For life is not worth fighting for: bare life is worthless. Justice is worth fighting for, order is worth fighting for, culture—and cooperation and the communion of the peoples of the world—is worth fighting for: these universal principles and values give purpose and direction to human life. At present, the liberals are so completely deflated and debunked, they have unconsciously swallowed so many of the systematic lies and beliefs of barbarism, that they lack the will to struggle for the essential principles of ideal liberalism: justice, freedom, truth. By clinging to the myth of isolationism, they are helping to create that insane national pride and that moral callousness out of which fascism so easily flowers.

What is the result? Pragmatic liberalism has flatly betrayed ideal liberalism. The values that belong to the latter have been compromised away, vitiated, ruthlessly cast overboard. The permanent

heritage of liberalism has been bartered for the essentially ignoble notion of national security, in itself a gross illusion. These liberals are loath to conceive of the present war as one waged by barbarism against civilization. Though many of them were moved by the plight of the Spanish Republicans, they have managed to insulate themselves from any human feeling over the fate of the humiliated and bullied Czechs, the tortured Jews, the murdered Poles, the basely threatened Finns—or the French and English who may next face extermination—just as many of them have managed to keep supremely cool about the horrors that have befallen the Chinese. They have eyes and they see not; they have ears and they hear not; and in their deliberate withholding of themselves from the plight of humanity they have even betrayed their own narrow values, for they are witnessing the dissolution of those worldwide cooperations upon which the growth of science, technics and industrial wealth depends. This corruption has bitten deep into pragmatic liberalism. The isolationism of a Charles Beard or a Stuart Chase or a Quincy Howe is indeed almost as much a sign of barbarism as the doctrines of a Rosenberg or a Gottfried Feder. No doubt the American liberals mean well; their good intentions are traditional. But they cling to the monstrous illusion that they can save themselves and their country by cutting themselves off—to use Hawthorne's words in "Ethan Brand"—from the magnetic chain of humanity. Their success would spell the end of every human hope they still share.

In a disintegrating world, pragmatic liberalism has lost its integrity but retained its limitations. The moral ardor of the eighteenth-century liberals, who faced difficult odds, strove mightily, risked much, has gone. The isolationism that is preached by our liberals today means fascism tomorrow. Their passivism today means militarism tomorrow. Their emphasis upon mere security today—and this applies especially to the current American youth movement—

means the acceptance of despotism tomorrow. While their complacency, their emotional tepidity, their virtuous circumspectness, *their unwillingness to defend civilization with all its faults and all its capacity for rectifying those faults*, means barbarism tomorrow. Meanwhile, the ideal values of liberalism lack support and the human horizon contracts before our eyes. While the barbarians brazenly attack our civilization, those who should now be exerting every fiber to defend it are covertly attacking it, too. On the latter falls the heavier guilt.

What are the prospects, then, for the Western World's surviving the present crisis, with even a handful of the scientific discoveries, the inventions, the literary and esthetic and scholarly achievements, the humanizing patterns of life, that the last three centuries so magnificently created or expanded? On any candid view, the prospects are poor. Barbarism has seized the initiative and is on the march. But as the crisis sharpens, as the evils that threaten us become more formidable, one possibility remains, born of the crisis itself: the psychological possibility of a large-scale conversion. Are the pragmatic liberals shattered enough yet to be ready for a reintegration? Are they capable of rededicating themselves to the tasks of ideal liberalism? If so, there is at least a ray of hope: the optimism of pathology, a commonplace of both religion and psychoanalysis.

To achieve a new basis for personal development and communal action, the liberal need not abandon his earlier concern for science, mechanism, the rational organization of society. But he can no longer regard the world that is embraced by those things as complete or all-sufficient. The world of political action must transcend that of the Economic Man: it must be as large as the fully developed human personality itself. No mere revision of Marxism, no mere ingenious political program with a few socialistic planks added or taken away, no attempt to make five disparate economic systems produce profit in a community where new social motives must take the place of dwindling or absent profits—none of these

shallow dodges will suffice. What is demanded is a recrystalliza-tion of the positive values of life, and an understanding of the basic issues of good and evil, of power and form, of force and grace, in the actual world. In short: the crisis presses toward a social conver-sion, deep-seated, organic, religious in its essence, so that no part of personal or political existence will be untouched by it: a conver-sion that will transcend the arid pragmatism that has served as a substitute religion. For only the living—those for whom the world has meaning—can continue to live, and willingly make the fierce sacrifices and heroic efforts the present moment demands.

To the disoriented liberals of today one must repeat the advice that Krishna offered Arjuna on the eve of battle, as reported in the Bhagavad-Gita. Like the liberals, Arjuna hesitated, debated, had specious moral scruples, remembered his relatives and friends on the other side, clung to the hope of safety in a situation that did not permit him to enjoy it. Victory, Krishna pointed out, is never guaranteed beforehand; and what is more, it is irrelevant to the issue one must face. What is important is that one should attend to the overwhelming duty of the moment, in a spirit of clear-sighted understanding. "Counting gain or loss as one, prepare for battle!" In that spirit—*only* in that spirit—can civilization still be saved.

Thoughts on Peace in an Air Raid

VIRGINIA WOOLF

October 21, 1940

Virginia Woolf's war years swung wildly between bouts of defiance and depression. She made a pact with her husband, Leonard, that if the Nazis prevailed, they would close the door to their garage, turn the car's ignition, and inhale the fumes to evade the indignity of surrendering to fascism. A month after she wrote this piece, bombs flattened her home and office. Five months later, she did, in fact, kill herself.

The Germans were over this house last night and the night before that. Here they are again. It is a queer experience, lying in the dark and listening to the zoom of a hornet which may at any moment sting you to death. It is a sound that interrupts cool and consecutive thinking about peace. Yet it is a sound—far more than prayers and anthems—that should compel one to think about peace. Unless we can think peace into existence we—not this one body in this one bed but millions of bodies yet to be born—will lie in the same darkness and hear the same death rattle overhead. Let us think what we can do to create the only efficient air-raid shelter while the guns on the hill go pop pop pop and the searchlights finger the clouds

and now and then, sometimes close at hand, sometimes far away a bomb drops.

Up there in the sky young Englishmen and young German men are fighting each other. The defenders are men, the attackers are men. Arms are not given to Englishwomen either to fight the enemy or to defend herself. She must lie weaponless tonight. Yet if she believes that the fight going on up in the sky is a fight by the English to protect freedom, by the Germans to destroy freedom, she must fight, so far as she can, on the side of the English. How far can she fight for freedom without firearms? By making arms, or clothes or food. But there is another way of fighting for freedom without arms; we can fight with the mind. We can make ideas that will help the young Englishman who is fighting up in the sky to defeat the enemy.

But to make ideas effective, we must be able to fire them off. We must put them into action. And the hornet in the sky rouses another hornet in the mind. There was one zooming in The Times this morning—a woman's voice saying, "Women have not a word to say in politics." There is no woman in the Cabinet; nor in any responsible post. All the idea makers who are in a position to make ideas effective are men. That is a thought that damps thinking, and encourages irresponsibility. Why not bury the head in the pillow, plug the ears, and cease this futile activity of idea making? Because there are other tables besides officer tables and conference tables. Are we not leaving the young Englishman without a weapon that might be of value to him if we give up private thinking, tea-table thinking, because it seems useless? Are we not stressing our disability because our ability exposes us perhaps to abuse, perhaps to contempt? "I will not cease from mental fight," Blake wrote. Mental fight means thinking against the current, not with it.

The current flows fast and furious. It issues in a spate of words from the loudspeakers and the politicians. Every day they tell us that we are a free people, fighting to defend freedom. That is the

current that has whirled the young airman up into the sky and keeps him circling there among the clouds. Down here, with a roof to cover us and a gas mask handy, it is our business to puncture gas bags and discover seeds of truth. It is not true that we are free. We are both prisoners tonight—he boxed up in his machine with a gun handy; we lying in the dark with a gas mask handy. If we were free we should be out in the open, dancing, at the play, or sitting at the window talking together. What is it that prevents us? "Hitler!" the loudspeakers cry with one voice. Who is Hitler? What is he? Aggressiveness, tyranny, the insane love of power made manifest, they reply. Destroy that, and you will be free.

The drone of the planes is now like the sawing of a branch overhead. Round and round it goes, sawing and sawing at a branch directly above the house. Another sound begins sawing its way into the brain. "Women of ability"—it was Lady Astor speaking in The Times this morning—"are held down because of a subconscious Hitlerism in the hearts of men." Certainly we are held down. We are equally prisoners tonight—the Englishmen in their planes, the Englishwomen in their beds. But if he stops to think he may be killed; and we too. So let us think for him. Let us try to drag up into consciousness the subconscious Hitlerism that holds us down. It is the desire for aggression; the desire to dominate and enslave. Even in the darkness we can see that made visible. We can see shop windows blazing; and women gazing; painted women; dressed-up women; women with crimson lips and crimson fingernails. They are slaves who are trying to enslave. If we could free ourselves from slavery we should free men from tyranny. Hitlers are bred by slaves.

A bomb drops. All the windows rattle. The anti-aircraft guns are getting active. Up there on the hill under a net tagged with strips of green and brown stuff to imitate the hues of autumn leaves guns are concealed. Now they all fire at once. On the nine o'clock radio we shall be told "Forty-four enemy planes were shot down

during the night, ten of them by anti-aircraft fire." And one of the terms of peace, the loudspeakers say, is to be disarmament. There are to be no more guns, no army, no navy, no air force in the future. No more young men will be trained to fight with arms. That rouses another mind-hornet in the chambers of the brain—another quotation. "To fight against a real enemy, to earn undying honor and glory by shooting total strangers, and to come home with my breast covered with medals and decorations, that was the summit of my hope . . . It was for this that my whole life so far had been dedicated, my education, training, everything . . ."

Those were the words of a young Englishman who fought in the last war. In the face of them, do the current thinkers honestly believe that by writing "Disarmament" on a sheet of paper at a conference table they will have done all that is needful? Othello's occupation will be gone; but he will remain Othello. The young airman up in the sky is driven not only by the voices of loudspeakers; he is driven by voices in himself—ancient instincts, instincts fostered and cherished by education and tradition. Is he to be blamed for those instincts? Could we switch off the maternal instinct at the command of a table full of politicians? Suppose that imperative among the peace terms was: "Childbearing is to be restricted to a very small class of specially selected women," would we submit? Should we not say, "The maternal instinct is a woman's glory. It was for this that my whole life has been dedicated, my education, training, everything." . . . But if it were necessary for the sake of humanity, for the peace of the world, that childbearing should be restricted, the maternal instinct subdued, women would attempt it. Men would help them. They would honor them for their refusal to bear children. They would give them other openings for their creative power. That too must make part of our fight for freedom. We must help the young Englishmen to root out from themselves the love of medals and decorations. We must create more honorable

activities for those who try to conquer in themselves their fighting instinct, their subconscious Hitlerism. We must compensate the man for the loss of his gun.

The sound of sawing overhead has increased. All the search-lights are erect. They point at a spot exactly above this roof. At any moment a bomb may fall on this very room. One, two, three, four, five, six . . . the seconds pass. The bomb did not fall. But during those seconds of suspense all thinking stopped. All feeling, save one dull dread, ceased. A nail fixed the whole being to one hard board. The emotion of fear and of hate is therefore sterile, unfer-tile. Directly that fear passes, the mind reaches out and instinc-tively revives itself by trying to create. Since the room is dark it can create only from memory. It reaches out to the memory of other Augusts—in Bayreuth, listening to Wagner; in Rome, walking over the Campagna; in London. Friends' voices come back. Scraps of poetry return. Each of those thoughts, even in memory, was far more positive, reviving, healing and creative than the dull dread made of fear and hate. Therefore if we are to compensate the young man for the loss of his glory and of his gun, we must give him access to the creative feelings. We must make happiness. We must free him from the machine. We must bring him out of his prison into the open air. But what is the use of freeing the young Englishman if the young German and the young Italian remain slaves?

The searchlights, wavering across the flat, have picked up the plane now. From this window one can see a little silver insect turning and twisting in the light. The guns go pop pop pop. Then they cease. Probably the raider was brought down behind the hill. One of the pilots landed safe in a field near here the other day. He said to his captors, speaking fairly good English, "How glad I am that the fight is over!" Then an Englishman gave him a cigarette, and an English woman made him a cup of tea. That would seem to show that if you can free the man

from the machine, the seed does not fall upon altogether stony ground. The seed may be fertile.

At last all the guns have stopped firing. All the searchlights have been extinguished. The natural darkness of a summer's night returns. The innocent sounds of the country are heard again. An apple thuds to the ground. An owl hoots, winging its way from tree to tree. And some half-forgotten words of an old English writer come to mind: "The huntsmen are up in America . . ." Let us send these fragmentary notes to the huntsmen who are up in America, to the men and women whose sleep has not yet been broken by machine-gun fire, in the belief that they will rethink them generously and charitably, perhaps shape them into something serviceable. And now, in the shadowed half of the world, to sleep.

Young Man with a Horn Again

OTIS FERGUSON

November 18, 1940

The magazine found Otis Ferguson at Clark University; he had placed first in a New Republic–sponsored essay contest for college kids. And for six glorious years, Ferguson used the pages of the magazine to invent. His great subject was jazz—an art in search of recognition of its ambitions. Ferguson's prose channeled the music he revered, but without sinking into the straining staccato of latter-day hipsters. As his editor Malcolm Cowley recalled, "The boys in the big-name bands, who were reading TNR *for the first time in their lives, said that he was the only writer who came anywhere near expressing what they were trying to do."*

Many years before Pauline Kael, Ferguson proved that intellectual rigor and popular culture were hardly mortal enemies. His film reviews, especially his hatchet jobs, remain canonical. About The Wizard of Oz, *he wrote: "It has dwarfs, Technicolor, freak characters, and Judy Garland. It can't be expected to have a sense of humor as well." He never did get the chance turn to transcend the short reviews he produced each week, to write the hefty cultural criticism that seemed the next turn in his career. After Pearl Harbor, he enlisted in the merchant marine and perished in the Bay of Salerno in 1943.*

It is almost ten years since Bix Beiderbecke died, shortly after his twenty-eighth birthday; it is at least twelve years since he played the bulk of his music. But he is as new and wonderful now as he was in those fast days on the big time, the highest expression of jazz when jazz was still young, the golden boy with the cornet he would sometimes carry around under his arm in a paper bag. Columbia has just reissued some of the famous recordings (Album C-29; 8 ten-inch sides, $2.50). They aren't the half of it, not the tenth of what was recorded, of course; and most of them aren't even among the best. But Columbia has acquired some of the masters of the old Okeh company, and now resurrects "Royal Garden Blues," "Goose Pimples," "Thou Swell," etc., for those with ears.

I suppose the kids growing up in the belief that Glenn Miller is what it really takes to blow the roof off would wonder, in the midst of this rather dated small-band clamor, what they were listening to and why. Well, it's just jazz, kids, and as far as the groups in general go, not the best of its period. But Bix, the fellow riding above and ahead and all around with that clear-bell horn, Bix had swing before the phonies knew the word. He had it at its best and purest, for he had not only the compelling lift of syncopation, the ease within an intense and relentless rhythm; he had music in a way of invention that is only found when you find a good song, inevitable, sweet and perfect. He could take off out of any chord sequence, any good or silly tune, and wheel and lift with his gay new melodic figures as free of strain in the air as pigeons. He had a sense of harmonic structure that none can learn and few are born with; he had absolute pitch and absolute control of his instrument—in fact, no trumpet player I've ever heard could be so reckless and yet so right, so assured in all the range from tender to brash, from sorrow to a shout; his tone was as perfect without artifice as water in the brooks, and his lip and tongue and valve-work so exact in all registers that he could jump into a line of notes and make it sound like

he'd slapped every one of them square in the face. With this techni-
cal assurance, he never had to cramp and plan and fuss himself: he
could start at any point, and land on a dime.

This makes it sound too tossed off. He worked on his music,
and worried always. Any jealous little stinkfinger (and there were
plenty around to envy and fear his talent) could always bring him
down by low-rating the thing he'd just played; any musician who
had something was the object of his admiration. He never got over
feeling uneasy about his lack of facility in sight reading—but it was
too natural and easy to play it by ear. He had a memory in music
like nobody's business, and could and at certain hilarious times did
imitate a corny solo just preceding his, so closely note for note that
the only one who wasn't holding his sides was the soloist himself,
who figgered that young feller was rarin' to go.

I don't know anybody who did more in the way of opening up
the set rhythm of jazz. Everything is written in four-four time, and
the pace can be said to vary through twelve or fifteen standard
tempos, from slow-drag to fast-jump. But Bix as he went along ac-
tually wrote his own time signature over the implied beat for danc-
ing, by subtleties of phrasing, by delayed attack or a quick rush on
ahead, and by the varying duration of a note.

It was no mere gut-bucket, emotion without control, virtuosity
without pattern, louder and faster and higher. He sweat, and for all
the ease of his solo in flight, the men around him would see the lines
tighten in his face every time he stood up. One of the easy remarks
in jazz is: He played it fifteen times, every one different. Bix played
it different, all right. But when he got just the note of the chord,
just the intervals, just the main line the way he wanted—that was
his structure and there couldn't be a better, so why go off into new
scales and razz-mah-tazz? At times—and you could hear it proved
on half a dozen records—he would get a way of playing for the
brass section and have the arranger leave that chorus blank; then

he would get the boys together outside and play a phrase and then another, and then go back and play it in chords, patiently, carefully, just as he used to do with the glee club back in grade school in Davenport, note for note and chord for chord, until that part of the arrangement was a section in solo, established in the book and no need for writing. It couldn't be written anyway.

And all of this makes him sound too perfect, as well, like a church-going cousin always being thrown up in your face. He was perfect only in music, and in the simple goodness and loyalty that was always there under the rusty tux with the soup stains, the underwear and sox you never could get off him for sending to the laundry until they fell off, and he'd borrowed them from you in the first place, like as not. As a kid he had wanted to be Douglas Fairbanks; he kept himself in trim and was great at skating, swimming, jumping over walls and the like, an all-around first in his neighborhood, and so generally hardy that an old sweater was all he found necessary for an Iowa winter. But music as it became a profession and almost a religion shut out his concern for just about everything else. Things were always happening to him, partly because he couldn't spare the time to study about them—missing the train, losing his tie, falling off the stand in a whirlwind of music racks, getting thrown out of the hotel.

Of his considerable achievements as a rumpot, people still speak with wonder and endlessly, and there were indeed some funny times, before the dark days. But one of his troubles was a capacity rare in brass men: he could tie quite a handsome one on without going technically fuzzy and lip-numb, so that he could stand up and get off those clear round notes as innocent as pie, and then solemnly take his seat in the middle of the whole boilerworks of a drummer's outfit. He lacked a natural brake in that; and his constitution was so good to start with that he wasn't retarded physically until he'd blown the fuse on the whole works. Also, he could make as big money as you want without having

a dime, a very rough man on a dollar bill. Also, while no one ever suffered musical fools more gladly, stood by for and worked over them, he had no use for any stuffed shirt in music or anything else, except as a target for a slingshot. He'd run into any such rich spreading trees as quick and head-on as the horse in the fable: he wasn't blind, he just didn't give a damn.

The story of his musical career is outlined in the book "Jazz Men" about as well as it can be. The dates, the cities, the things done, the people met are established enough by now for a pattern, if only in fragments. But he had started in music early, and there is not so much known about that. His family was well off; his father was a good solid lumber merchant; his mother an amateur musician. There was always a piano in the house and there was a phonograph when few people had them. Bix (his real name was Leon Bismarck, for it was a family of German-American extraction) was a perfectly normal boy, except that he was always fussing around with music. He had a sister and an older brother, who was enough a hero to him so that he swiped the nickname Bix from him, and would not part with it. He lived in a big house across a sloping playground from the school, and the school was more a center of life than schools usually get to be.

There was a playground, the sliding and skating and wrassling, but there was also a lot of singing: the kind of spontaneous thing where a whole grade of kids will enjoy their cantatas and what-not so much that they not only start a ball rolling through the classes in general but work at it and get pretty good. They used to have the run of the school at night for rehearsal; they used to have a barber-shop quartet out on the fire-escape. In one grade they wanted a piano for their own room, so they arranged a local concert, which was so successful they gave another, and before the year was out they had the piano, bought and paid for. One of those happy things that cannot be incubated, taught or fostered.

Anyhow, Bix went through all the grades without being kept back, and in this social-musical atmosphere he was the number-one boy. Anything he heard he could play on the piano; anything he could play he could figure out the parts for, and teach the others to sing in chords. He liked music and music liked him and gave him a place, and the world was very young. Then on top of that, first off the crank-winding phonograph and later up the river from New Orleans in boats, came jazz, with horns. He got a cornet and taught himself to play it, for that was the kind of instrument it took to blast out this new thing in music. He got quite a little drunk on the excitement of it and did not want to be Douglas Fairbanks any more. His family began to worry about him, for it was one of those happy families that enjoy their group with pride and a fierce concern that it shall have the best. They sent Bix from high school to Lake Forest Military Academy, thinking to get him away from the bad balance of nothing but music. But Lake Forest was near Chicago, and Chicago was jazz then. It was as though jazz were a house that had been built just for him. And he moved in.

I was no intimate, but I think I could say in general why he blew up. It was partly the pace, of course, and taking it too fast. He began to see little fellows with green beards walking up and down on his chest, and Whiteman sent him back to Davenport, to get squared up. He was too far gone for any working band at that time, which was 1928. At home, he came out of it. He was shaky but still good, and he jobbed around with his old friend from grade-school, Larry Andrews, and watched his hand when he held it out every morning to see if it still looked as though he were waving at somebody. He had been at the top but somewhere along the line, some time or other, he'd taken a fall. And he wasn't sure in his own heart he would fit back there again, even if he stayed off brass rails. He was honestly anxious. Was it just liquor that had pulled the knife on him? Maybe it was something else too?

It was, all right. He lifted his horn over the sixty-odd dancers or the beer tables of this cover-your-expenses circuit, and the other musicians (if no one else) would shake their heads and marvel; and it was the same as in the first days when he showed up in an Indiana town where the boys had thought they were really going, and played a few sets, and as one of them reports today, a day in which he is pretty famous, "I tell you the tears stood in my eyes, I couldn't get out the next number in the book."

He stayed on the wagon and the music was as good as ever— which he proved later on the last recording date he had before he died, with Hoagy Carmichael's pick-up band. But what he couldn't see, the nameless thing that was his trouble, had got him down. First he'd wanted to be "as good" as the men out front whose music had excited him. Then he wanted to stay good, and be if possible better. This was a preoccupation to bridge the years from the rusty clangor of the Wolverines to the bright lights of the Goldkette and Whiteman shows; this and the handy gin pitcher kept him assuming that if he felt low and the road ahead was flat and lonesome, it was just a hangover, just feeling low, let's sick a hare on the hound that bit me. Actually something else had been creeping up, something he never saw clearly. He had come to the top like a cork, and he had no more place to go.

And still he had to be going, he had to travel, so completely a musician that music was his ticket and there was no other line. He didn't go much for women. He was loyal, true and happy in his friendships with men, even self-effacing, but his friends were, after all, musicians. It had to be music for him, and as far as he could see when he could see, he wanted neither the money, nor the place, nor the show. But what else? He dreamed of being a composer. He had written some piano pieces and he wanted to do something even more ambitious. But what? He had no equipment, not the kind of equipment that a so-called legitimate musician acquires from study of the great body of Western

music, which has had its best time in other times and is now gone fairly sterile. He didn't know what to do, and listened with awe to Debussy records (Debussy is for some strange reason a great favorite of good jazz men), and would sequester himself and sit morosely at the piano, fingering the chords of a new music without being able to reconcile the old, which he didn't comprehend, with the new, which was in him as natural as a voice in your throat and which he had spent his brief lifetime tuning for song.

From the top of folk music as folk music, there is no place to go, actually. Jazz is a folk music, but Bix had never taken time out to think of things like that: jazz was the country where he grew up, the fine high thing, the sun coming up to fill the world through the morning.

He never heard about what was troubling him and only knew it was trouble. He came back to the big time eventually, but he could no longer stay on it, he played here and there, hole and corner, but he was too unreliable now for the standard type of show—and the big time was letting jazz go underground quietly by these days, for whatever life there had been in bands like Pollack, Goldkette, Whiteman in 1927-28 was no longer in demand by 1930, and even the great jumping Negro outfits were either breaking up or high-tailing off to Europe. Bix played for dances and recordings, and went back to the bottle and was not seen in the better places; and even moped around fearing he had lost his sense of perfect pitch; but when he lifted that stumpy dented cornet at the fraction of the second after the release, for dancing or just for the record in a dead studio, it came tumbling and leaping out as complete and lovely as ever. What he could always do he could still do, from the jazz-band tone to sadness. But what he had was more than enough, and he didn't know where to put it.

Perhaps you will have to hear him a lot; perhaps you won't have any ear for the jazz music that grew up around you and in your

time, and so will never hear the voice, almost as if speaking, but there is something in these recordings that goes beyond a mere instrument or the improviser on it, some unconquerable bright spirit that leaves no slops even in confusion and defeat and darkness gathering; some gallant human thing which is as near to us as it is completely marvelous, and which makes only just and apposite that end of a career so next to the heart of all who would like this country to be a country of happy people, singing. In the summer of 1931 Bix Beiderbecke got out of a sick bed, and against the best advice, to ride a rickety bus to a place some fellows were playing a dance. He had promised the fellows he would go for the date, which would fall through if there were not some stubby cornet lifting over the boys and girls on the floor, and through the close air to the roof, some special glad thing to dance by. So he went, walking up to the bus and from the bus to the band room with that peculiar purposeful air of walking a straight line to some immediate destination, eyes going neither left nor right. He had promised to play; he played, and music was around him like rain falling once more. That was all.

He got pneumonia out of it, of course, and died of that a few days later. That is, they buried the body. For those who had been around and those to come after there was something, grown in this country out of the Iowa dirt, that didn't die and could not be buried so long as there should be a record left in the world, and a turntable to spin it on.

The Art of Translation

Vladimir Nabokov

August 4, 1941

It greatly helped Vladimir Nabokov's career that his arrival in the United States coincided with Edmund Wilson's infatuation with Russian literature. Wilson was an enthusiast who spent his life acquiring and jettisoning all-consuming obsessions. Though Wilson treated many of his fellow human beings contemptibly, he was Nabokov's generous champion. He arranged meetings for Nabokov across the New York publishing world. Even after Wilson left The New Republic *in 1940, he prodded his old colleagues to publish his new friend's work. There were moments when Wilson lent an editor's surreptitious hand to Nabokov's work, improving, say, a translation of a Pushkin poem for the magazine's Back of the Book. Every word in this essay, however, is unmistakably Nabokov's.*

Three grades of evil can be discerned in the queer world of verbal transmigration. The first, and lesser one, comprises obvious errors due to ignorance or misguided knowledge. This is mere human frailty and thus excusable. The next step to Hell is taken by the translator who intentionally skips words or passages that he does not bother to understand or that might seem obscure or obscene to vaguely imagined readers; he accepts the blank look that his dictionary gives him without

any qualms; or subjects scholarship to primness: he is as ready to know less than the author as he is to think he knows better. The third, and worst, degree of turpitude is reached when a masterpiece is planished and patted into such a shape, vilely beautified in such a fashion as to conform to the notions and prejudices of a given public. This is a crime, to be punished by the stocks as plagiarists were in the shoebuckle days.

The howlers included in the first category may be in their turn divided into two classes. Insufficient acquaintance with the foreign language involved may transform a commonplace expression into some remarkable statement that the real author never intended to make. "*Bien être general*" becomes the manly assertion that "it is good to be a general"; to which gallant general a French translator of "Hamlet" has been known to pass the caviar. Likewise, in a German edition of Chekhov, a certain teacher, as soon as he enters the classroom, is made to become engrossed in "his newspaper," which prompted a pompous reviewer to comment on the sad condition of public instruction in pre-Soviet Russia. But the real Chekhov was simply referring to the classroom "journal" which a teacher would open to check lessons, marks and absentees. And inversely, innocent words in an English novel such as "first night" and "public house" have become in a Russian translation "nuptial night" and "a brothel." These simple examples suffice. They are ridiculous and jarring, but they contain no pernicious purpose; and more often than not the garbled sentence still makes some sense in the original context.

The other class of blunders in the first category includes a more sophisticated kind of mistake, one which is caused by an attack of linguistic Daltonism suddenly blinding the translator. Whether attracted by the far-fetched when the obvious was at hand (What does an Eskimo prefer to eat—ice cream or tallow? Ice cream), or whether unconsciously basing his rendering on some false meaning which repeated readings have imprinted on his mind, he manages

to distort in an unexpected and sometimes quite brilliant way the most honest word or the tamest metaphor. I knew a very conscientious poet who in wrestling with the translation of a much tortured text rendered "is sicklied o'er with the pale cast of thought" in such a manner as to convey an impression of pale moonlight. He did this by taking for granted that "sickle" referred to the form of the new moon. And a national sense of humor, set into motion by the likeness between the Russian words meaning "arc" and "onion," led a German professor to translate "a bend of the shore" (in a Pushkin fairy tale) by "the Onion Sea."

The second, and much more serious, sin of leaving out tricky passages is still excusable when the translator is baffled by them himself; but how contemptible is the smug person who, although quite understanding the sense, fears it might stump a dunce or debauch a dauphin! Instead of blissfully nestling in the arms of the great writer, he keeps worrying about the little reader playing in a corner with something dangerous or unclean. Perhaps the most charming example of Victorian modesty that has ever come my way was in an early English translation of "Anna Karenina." Vronsky had asked Anna what was the matter with her. "I am *beremenna*" (the translator's italics), replied Anna, making the foreign reader wonder what strange and awful Oriental disease that was; all because the translator thought that "I am pregnant" might shock some pure soul, and that a good idea would be to leave the Russian just as it stood.

But masking and toning down seem petty sins in comparison with those of the third category; for here he comes strutting and shooting out his bejeweled cuffs, the slick translator who arranges Scheherazade's boudoir according to his own taste and with professional elegance tries to improve the looks of his victims. Thus it was the rule with Russian versions of Shakespeare to give Ophelia richer flowers than the poor weeds she found. The Russian rendering of

There with fantastic garlands did she come
Of crowflowers, nettles, daisies and long purples

if translated back into English would run like this:

There with most lovely garlands did she come
Of violets, carnations, roses, lilies.

The splendor of this floral display speaks for itself; incidentally it bowdlerized the Queen's digressions, granting her the gentility she so sadly lacked and dismissing the liberal shepherds; how anyone could make such a botanical collection beside the Helje or the Avon is another question.

But no such questions were asked by the solemn Russian reader, first, because he did not know the original text, second, because he did not care a fig for botany, and third, because the only thing that interested him in Shakespeare was what German commentators and native radicals had discovered in the way of "eternal problems." So nobody minded what happened to Goneril's lapdogs when the line

Tray, Blanche and Sweetheart, see, they bark at me

was grimly metamorphosed into

A pack of hounds is barking at my heels.

All local color, all tangible and irreplaceable details were swallowed by those hounds.

But, revenge is sweet—even unconscious revenge. The greatest Russian short story ever written is Gogol's "The Overcoat" (or "Mantle," or "Cloak," or "She-nel"). Its essential feature, that ir-

rational part which forms the tragic undercurrent of an otherwise meaningless anecdote, is organically connected with the special style in which this story is written: there are weird repetitions of the same absurd adverb, and these repetitions become a kind of canny incantation; there are descriptions which look innocent enough until you discover that chaos lies right round the corner, and that Gogol has inserted into this or that harmless sentence a word or a simile that makes a passage burst into a wild display of nightmare fireworks. There is also that groping clumsiness which, on the author's part, is a conscious rendering of the uncouth gestures of our dreams.

Nothing of these remains in the prim, and perky, and very matter-of-fact English version (see—and never see again—"The Mantle," translated by Claude Field). The following example leaves me with the impression that I am witnessing a murder and can do nothing to prevent it:

Gogol:

> ... his [a petty official's] third or fourth-story flat ... displaying a few fashionable trifles, *such as a lamp for instance*—trifles purchased by many sacrifices. ...

Field:

> ... fitted with some pretentious articles of furniture purchased, etc. ...

Tampering with foreign major or minor masterpieces may involve an innocent third party in the farce. Quite recently a famous Russian composer asked me to translate into English a Russian poem which forty years ago he had set to music. The English trans-

lation, he pointed out, had to follow closely the very sounds of the text—which text was unfortunately K. Balmont's version of Edgar Allan Poe's "Bells." What Balmont's numerous translations look like may be readily understood when I say that his own work invariably disclosed an almost pathological inability to write one single melodious line. Having at his disposal a sufficient number of hackneyed rhymes and taking up as he rode any hitch-hiking metaphor that he happened to meet, he turned something that Poe had taken considerable pains to compose into something that any Russian rhymester could dash off at a moment's notice. In reversing it into English I was solely concerned with finding English words that would sound like the Russian ones. Now, if somebody one day comes across my English version of that Russian version, he may foolishly retranslate it into Russian so that the Poe-less poem will go on being balmontized until, perhaps, the "Bells" become "Silence." Something still more grotesque happened to Baudelaire's exquisitely dreamy "Invitation au Voyage" ("*Mon amie, ma soeur, connais-tu la douceur . . .*") The Russian version was due to the pen of Merejkovsky, who had even less poetical talent than Balmont. It began like this:

My sweet little bride.
Let's go for a ride;

Promptly it begot a rollicking tune and was adopted by all organ-grinders of Russia. I like to imagine a future French translator of Russian folksongs re-Frenchifying it into:

Viens, mon p'tit,
A Nijni

and so on, *ad malinfinitum.*
Barring downright deceivers, mild imbeciles and impotent poets,

there exist, roughly speaking, three types of translators—and this has nothing to do with my three categories of evil; or, rather, any of the three types may err in a similar way. These three are: the scholar who is eager to make the world appreciate the works of an obscure genius as much as he does himself; the well meaning hack; and the professional writer relaxing in the company of a foreign confrere. The scholar will be, I hope, exact and pedantic: footnotes—on the *same* page as the text and not tucked away at the end of the volume—can never be too copious and detailed. The laborious lady translating at the eleventh hour the eleventh volume of somebody's collected works will be, I am afraid, less exact and less pedantic; but the point is not that the scholar commits fewer blunders than a drudge; the point is that as a rule both he and she are hopelessly devoid of any semblance of creative genius. Neither learning nor diligence can replace imagination and style.

Now comes the authentic poet who has the two last assets and who finds relaxation in translating a bit of Lermontov or Verlaine between writing poems of his own. Either he does not know the original language and calmly relies upon the so-called "literal" translation made for him by a far less brilliant but a little more learned person, or else, knowing the language, he lacks the scholar's precision and the professional translator's experience. The main drawback, however, in this case is the fact that the greater his individual talent, the more apt he will be to drown the foreign masterpiece under the sparkling ripples of his own personal style. Instead of dressing up like the real author, he dresses up the author as himself.

We can deduce now the requirements that a translator must possess in order to be able to give an ideal version of a foreign masterpiece. First of all he must have as much talent, or at least the same kind of talent, as the author he chooses. In this, though only in this, respect Baudelaire and Poe or Joukovsky and Schiller made

ideal playmates. Second, he must know thoroughly the two nations and the two languages involved and be perfectly acquainted with all details relating to his author's manner and methods; also, with the social background of words, their fashions, history and period associations. This leads to the third point: while having genius and knowledge he must possess the gift of mimicry and be able to act, as it were, the real author's part by impersonating his tricks of demeanor and speech, his ways and his mind, with the utmost degree of verisimilitude.

I have lately tried to translate several Russian poets who had either been badly disfigured by former attempts or who had never been translated at all. The English at my disposal is certainly thinner than my Russian; the difference being, in fact, that which exists between a semi-detached villa and a hereditary estate, between self-conscious comfort and habitual luxury. I am not satisfied therefore with the results attained, but my studies disclosed several rules that other writers might follow with profit.

I was confronted for instance with the following opening line of one of Pushkin's most prodigious poems:

Yah pom-new chewed-no-yay mg-no-vain-yay

I have rendered the syllables by the nearest English sounds I could find; their mimetic disguise makes them look rather ugly; but never mind; the "chew" and the "vain" are associated phonetically with other Russian words meaning beautiful and important things, and the melody of the line with the plump, golden-ripe "chewed-no-yay" right in the middle and the "m's" and "n's" balancing each other on both sides, is to the Russian ear most exciting and soothing—a paradoxical combination that any artist will understand.

Now, if you take a dictionary and look up those four words you will obtain the following foolish, flat and familiar statement: "I re-

member a wonderful moment." What is to be done with this bird you have shot down only to find that it is not a bird of paradise, but an escaped parrot, still screeching its idiotic message as it flaps on the ground? For no stretch of the imagination can persuade an English reader that "I remember a wonderful moment" is the perfect beginning of a perfect poem. The first thing I discovered was that the expression "a literal translation" is more or less nonsense. "Yah pom-new" is a deeper and smoother plunge into the past than "I remember," which falls flat on its belly like an inexperienced diver; "chewed-no-yay" has a lovely Russian "monster" in it, and a whispered "listen," and the dative ending of a "sunbeam," and many other fair relations among Russian words. It belongs phonetically and mentally to a certain series of words, and this Russian series does not correspond to the English series in which "I remember" is found. And inversely, "remember," though it clashes with the corresponding "pom-new" series, is connected with an English series of its own whenever real poets do use it. And the central word in Housman's "What are those blue *remembered* hills?" becomes in Russian "vspom-neev-she-yesyah," a horrible straggly thing, all humps and horns, which cannot fuse into any inner connection with "blue," as it does so smoothly in English, because the Russian sense of blueness belongs to a different series than the Russian "remember" does.

This interrelation of words and non-correspondence of verbal series in different tongues suggest yet another rule, namely, that the three main words of the line draw one another out, and add something which none of them would have had separately or in any other combination. What makes this exchange of secret values possible is not only the mere contact between the words, but their exact position in regard both to the rhythm of the line and to one another. This must be taken into account by the translator.

Finally, there is the problem of the rhyme. "Mg-no-vainyay" has over two thousand Jack-in-the-box rhymes popping out at the

slightest pressure, whereas I cannot think of one to "moment." The position of "mg-no-vain-yay" at the end of the line is not negligible either, due as it is to Pushkin's more or less consciously knowing that he would not have to hunt for its mate. But the position of "moment" in the English line implies no such security; on the contrary he would be a singularly reckless fellow who placed it there.

Thus I was confronted by that opening line, so full of Pushkin, so individual and harmonious; and after examining it gingerly from the various angles here suggested, I tackled it. The tackling process lasted the worst part of the night. I did translate it at last; but to give my version at this point might lead the reader to doubt that perfection be attainable by merely following a few perfect rules.

"In Every Voice, in Every Ban"

Alfred Kazin

January 10, 1944

*How did New York Jewish intellectuals write about the Holocaust as it happened?
Well, they didn't. This essay by the magazine's literary editor Alfred Kazin was
a lonely exception. On the whole,* The New Republic *did a far better job of
reporting Hitler's fiendishness than it did with Stalin's. It devoted more pages to the
impending doom of European Jewry than almost every other American publication.
During the thirties, it published a series of grim dispatches from Germany; in 1942,
it ran the courageous journalist Varian Fry's urgent report on the catastrophe, "The
Massacre of the Jews." Kazin, who succeeded Edmund Wilson as literary editor,
was always far more comfortable with his Jewish identity than were his other col-
leagues in the intelligentsia. Perhaps this better attuned him to the slaughter, and
made him acutely sensitive to the world's "silent complicity."*

On May 12 of this year, a man named Shmuel Ziegelboim, who
was a Socialist, a Jew and a Pole, was found dead by his own
hand in a London flat. His wife and child had been killed by
the Nazis in Poland; and no doubt he had had his fill of Polish
politics—even (or especially) in London. I had never heard of
Shmuel Ziegelboim before I read of his death; and so many So-

cialists, Jews and Poles have died in these last few years that it is possible—conscience and memory being what they are even for one's own—that I would never again have thought of him had he not left a letter that was published in a negligible corner of *The New York Times*.

His letter was addressed in Polish to the President of Poland and to Sikorski, who was then Premier. What he wrote was this:

I take the liberty of addressing to you my last words, and through you to the Polish government and the Polish people, to the governments and peoples of the Allied states—to the conscience of the world.

From the latest information received from Poland, it is evident that the Germans, with the most ruthless cruelty, are now murdering the few remaining Jews in Poland. Behind the ghetto's walls the last act of a tragedy unprecedented in history is being performed. The responsibility for this crime of murdering the entire Jewish population of Poland falls in the first instance on the perpetrators, but indirectly it is also a burden on the whole of humanity, the people and the governments of the Allied states which thus far have made no effort toward concrete action for the purpose of curtailing this crime.

By the passive observation of the murder of defenseless millions, and of the maltreatment of children, women and old men, these countries have become the criminals' accomplices. I must also state that although the Polish government has in a high degree contributed to the enlistment of world opinion, it has yet done so insufficiently. It has not done anything that could correspond to the magnitude of the drama being enacted now in Poland. From some 3,500,000 Polish Jews and about 700,000 other Jews deported to Poland from other countries— according to official statistics provided by the underground

Bund organization—there remained in April of this year only about 300,000, and this remaining murder still goes on.

I cannot be silent—I cannot live—while remnants of the Jewish people of Poland, of whom I am a representative, are perishing. My comrades in the Warsaw ghetto took weapons in their hands on that last heroic impulse. It was not my destiny to die there together with them, but I belong to them, and in their mass graves. By my death I wish to express my strongest protest against the inactivity with which the world is looking on and permitting the extermination of my people.

I know how little human life is worth today; but, as I was unable to do anything during my life, perhaps by my death I shall contribute to breaking down that indifference of those who may now—at the last moment—rescue the few Polish Jews still alive from certain annihilation. My life belongs to the Jewish people of Poland and I therefore give it to them. I wish that this remaining handful of the original several millions of Polish Jews could live to see the liberation of a new world of freedom, and the justice of true socialism. I believe that such a Poland will arise and that such a world will come.

I trust that the President and the Prime Minister will direct my words to all those for whom they are destined, and that the Polish government will immediately take appropriate action in the fields of diplomacy. I bid my farewell herewith to everybody and everything dear to me and loved by me.

—S. Ziegelboim

After the text, the newspaper report added: "That was the letter. It suggests that possibly Shmuel Ziegelboim will have accomplished as much in dying as he did in living."

I bring the matter up now because I have been thinking about the meaning of that letter ever since I clipped it out of *The Times*,

and because I hope I can now write thoughtfully about it, since I no longer feel any hatred for the newspaper writer who added with such mechanical emotion that possibly "Shmuel Ziegelboim will have accomplished as much . . ." Of course the newspaper writer did not believe that he had accomplished anything; nor did the Polish National Council, which released it to the world; nor do I. Shmuel Ziegelboim died because some men can find their ultimate grace only in the fulfilment of their will—even if their will, in 1943, is toward a death that has so desperate a symbolism. He died because the burden of carrying our contemporary self-disgust became too much even for a man who believed that a new world of freedom would come, "and the justice of true socialism." And he died because his wife and child were dead, and the millions in the great Jewish worlds of Poland, and the thousands of thousands of his comrades in the Jewish Labor Bund—the disenchanted and dispossessed Jews who lived on air and were called *Luftmenschen*, but helped to defend Warsaw when the colonels fled.

I think I know how great and indirect a wish for immortality can go into suicide. I shall believe that men want to die only when I hear of men living (or writing) in complete anonymity. I know something of the ultimate and forgivable egotism of any human spirit, and that the one thing we can never afford to lose is the promise of our identity. Shmuel Ziegelboim wrote at the end with the instinctive rhetorical optimism of those who feel that they are dying without too much division in themselves, and for something greater than their own ambitions. But I have wanted to believe, and now do believe, that Shmuel Ziegelboim died because he was finally unable to withstand the real despair of our time—which arises not out of the burning and the killing and the endless political betrayals, but out of a humiliation which some of us can still feel before so terrible a break in human solidarity. I think he died, as so many greater men have already died morally, because he was unable to believe in a

future built on so unrecognized and unreported a human isolation and barbarism as we know today. Shmuel Ziegelboim came from a ghetto-driven, self-driven, but spiritually generous culture; and I honestly believe that he was thinking not only of his own people at the end, but of the hollowness of a world in which such a massacre could have so little meaning. In any event I should like to think that I am more "fortunate"—that is, relatively untouched and able to think about what freedom is. And that is why I bring the matter up now, as a token of what Shmuel Ziegelboim died for, and in an effort to say some very elementary things which liberals especially have not always cared to face.

I do not speak here of the massacre of the Jews, for there is nothing to say about it that has not already been said. I can add nothing, nor would I wish to add anything, to the private imprecations and the public appeals. I do not say that they are useless, for I do not dare to believe that anything here will be useless. It is merely that something has already been done—and not by the Nazis—which can never be undone, except as we seek to understand it and to grow human again (or expectant, or merely wise) through it. For the tragedy is in our minds, in the basic quality of our personal culture; and that is why it will be the tragedy of the peace. The tragedy lies in the quality of our belief—not in the lack of it, but in the unconsciousness or dishonesty of it; and above all in the merely political thinking, the desperate and unreal optimism, with which we try to cover up the void in ourselves. Yet I speak pragmatically: I am thinking of concrete situations. For Hitler will leave anti-Semitism as his last political trick, as it was his first; and the people who have been most indifferent to the historic *meaning* of the massacre of the Jews will be just those who will wonder why all the pacts and all the armies and all the formal justice will have

done so little to give them their pre-Fascist "security" again. If liberal optimism is false now, it will seem cruel later, when in even a post-Hitler Europe men will see again (many of them know it now, but for other, for purely political, reasons) that fascism remains, even though fascists, too, can die.

The treatment of the Jews, historically, has always been a touchstone of the degree of imagination, of Christian confidence, really, which formally Christian countries have been able to feel in themselves. Historically, no massacre was ever unexpected, no act of cruelty ever so great that it violated the professions of a civilization—every civilization being what it was even when the cathedrals rose highest. But surely there was never so much self-deception about our essential goodness or our dream of "social security," so little philosophic (or moral) searching of the lies our hopes build on our lack of community, as there is today. The real materialism of our time has nothing to do with our intellectual naturalism, which is indispensable to those who do not believe in magic; or to our complete technological reliance upon ourselves, which is that it is. The real materialism, the real heresy, is the blindness of those who, declining to believe that there is a prime cause in the heavens, believe bitterly that society is always the prime cause of what we are. It is the materialism that comes with passing the buck so persistently to everyone but yourself that you never know whom to blame, even when you are Koestler's Rubashov in Lubyanka. It is the materialism of those who believe, as radicals, that you can begin by lying and making your victim lie (especially in public; a public life has a public apotheosis)—and that *then* you can build a brave new world based on the ultimate good sense of cooperativeness and the higher self-interest. It is the materialism of those who believe, as reactionaries, that you can build a tolerable society by appealing to an inner contempt among men for their "romantic"—and quite indestructible—hopes. It is the materialism of those who believe, as

liberals, that you so fascinate men in a legality of good intentions, or even philanthropy, that you will

> *By faith, and faith alone, embrace,*
> *Believing where we cannot prove . . .*

But it is above all the materialism of all those—not liberals, not radicals, certainly not reactionaries—who want only to live and let live, to have the good life back—and who think that you can dump three million helpless Jews into your furnace, and sigh in the genuine impotence of your undeniable regret, and then build Europe back again.

That is the central point—not a "moral" point which any true unbeliever need be afraid of for its own sake, but the coarsely shrewd point based on the knowledge that life is also a process of memory, and that where so great a murder has been allowed, no one is safe. I do not believe in ghosts; if I did, I could be falsely heroic and satisfyingly sentimental, and say that the blood of the Jews over Europe is like that Christ's blood which Marlowe's Faustus saw streaming in the firmament. For I know that the indifference—the historic contemporary indifference, with everything it suggests about our governments as well as ourselves: I do not forget the rulers in describing the ruled—is far more terrible than physical terror and far more "tangible" than conscience. And what I am saying is not that the peoples will be remorseful (did we do it?), but that they will be betrayed by the human practices encouraged by the massacre of the Jews. Something has been set forth in Europe that is subtle, and suspended, and destructive; and it will break the power-pacts, and the high declarations, and even the armies, since armies are only men. That something is all our silent complicity in the massacre of the Jews (and surely not of them alone; it is merely that their deaths were so peculiarly hopeless). For it means that men are not ashamed

of what they have been in this time, and are therefore not prepared for the further outbreaks of fascism which are so deep in all of us. It means that we still do not realize why

> *In every Infant's cry of fear,*
> *In every cry of every Man,*
> *In every voice, in every ban,*
> *The mind-forg'd manacles I hear.*

Blake knew it, as we can still know it: the manacles are always forged by the mind. Can the mind still break them free? Can it?

Politics and the English Language

GEORGE ORWELL

June 17, 1946

Despite the rank hypocrisy of Orwell's use of the passive voice, this is one of the most sublimely constructed essays ever published in the English language. I wish The New Republic *could claim full credit for this one. But Orwell initially ran the piece in London with Cyril Connolly's* Horizon *before publishing it here. The piece perfectly expresses the hardheaded turn that liberalism would take in the postwar years—when it lost all patience with the obfuscations that had enabled utopian fantasies to persist.*

Most people who bother with the matter at all would admit that the English language is in a bad way, but it is generally assumed that we cannot by conscious action do anything about it. Our civilization is decadent, and our language—so the argument runs—must inevitably share in the general collapse. It follows that any struggle against the abuse of language is a sentimental archaism, like preferring candles to electric light or hansom cabs to airplanes. Underneath this lies the half-conscious belief that language is a natural growth and not an instrument which we shape for our own purposes.

Now, it is clear that the decline of a language must ultimately have political and economic causes: it is not due simply to the bad influence of this or that individual writer. But an effect can become a cause, reinforcing the original cause and producing the same effect in an intensified form, and so on indefinitely. The point is that the process is reversible. Modern English, especially written English, is full of bad habits which spread by imitation and which can be avoided if one is willing to take the necessary trouble. If one gets rid of these habits one can think more clearly, and to think clearly is a necessary first step toward political regeneration: so that the fight against bad English is not frivolous and is not the exclusive concern of professional writers. I will come back to this presently, and I hope that by that time the meaning of what I have said here will have become clearer. Meanwhile, here are four specimens of the English language as it is now habitually written.

These passages have not been picked out because they are especially bad—I could have quoted far worse if I had chosen—but because they illustrate various of the mental vices from which we now suffer. They are a little below the average, but are fairly representative samples. I number them so that I can refer back to them when necessary:

(1) I am not, indeed, sure whether it is not true to say that the Milton who once seemed not unlike a seventeenth-century Shelley had not become, out of an experience ever more bitter in each year, more alien (*sic*) to the founder of that Jesuit sect which nothing could induce him to tolerate.

—PROFESSOR HAROLD LASKI (ESSAY IN *FREEDOM OF EXPRESSION*).

(2) Above all, we cannot play ducks and drakes with a native battery of idioms which prescribes such egregious collocations

of vocables as the Basic *put up with* for *tolerate* or *put at a loss* for
bewilder.

—PROFESSOR LANCELOT HOGBEN (*INTERGLOSSA*).

(3) On the one side we have the free personality: by definition it is
not neurotic, for it has neither conflict nor dream. Its desires, such
as they are, are transparent, for they are just what institutional
approval keeps in the forefront of consciousness; another insti-
tutional pattern would alter their number and intensity; there is
little in them that is natural, irreducible, or culturally dangerous.
But *on the other side*, the social bond itself is nothing but the mutual
reflection of these self-secure integrities. Recall the definition of
love. Is not this the very picture of a small academic? Where is
there a place in this hall of mirrors for either personality or fra-
ternity?

—ESSAY ON PSYCHOLOGY IN *POLITICS* (NEW YORK).

(4) All the "best people" from the gentlemen's clubs, and all the
frantic fascist captains, united in common hatred of socialism
and bestial horror of the rising tide of the mass revolutionary
movement, have turned to acts of provocation, to foul incendi-
arism, to medieval legends of poisoned wells, to legalize their
own destruction of proletarian organizations, and rouse the ag-
itated petty-bourgeoisie to chauvinistic fervor on behalf of the
fight against the revolutionary way out of the crisis.

—COMMUNIST PAMPHLET.

Each of these passages has faults of its own, but quite apart from
avoidable ugliness, two qualities are common to all of them. The
first is staleness of imagery; the other is lack of precision. The writer
either has a meaning and cannot express it, or he inadvertently says

something else, or he is almost indifferent as to whether his words mean anything or not. This mixture of vagueness and sheer incompetence is the most marked characteristic of modern English prose, and especially of any kind of political writing. As soon as certain topics are raised, the concrete melts into the abstract and no one seems able to think of turns of speech that are not hackneyed: prose consists less and less of *words* chosen for the sake of their meaning, and more and more of *phrases* tacked together like the sections of a prefabricated hen-house. I list below various of the tricks by means of which the work of prose-construction is habitually dodged:

Dying metaphors.—A newly invented metaphor assists thought by evoking a visual image, while on the other hand a metaphor which is technically "dead" (e.g., *iron resolution*) has in effect reverted to being an ordinary word and can generally be used without loss of vividness. But in between these two classes there is a huge dump of worn-out metaphors which have lost all evocative power and are merely used because they save people the trouble of inventing phrases for themselves. Examples are: *Ring the changes on, take up the cudgels for, toe the line, ride roughshod over, stand shoulder to shoulder with, play into the hands of, no axe to grind, grist to the mill, fishing in troubled waters, Achilles' heel, swan song, hotbed*. Many of these are used without knowledge of their meaning (what is a "rift," for instance?), and incompatible metaphors are frequently mixed, a sure sign that the writer is not interested in what he is saying.

Operators, or verbal false limbs.—These save the trouble of picking out appropriate verbs and nouns, and at the same time pad each sentence with extra syllables which give it an appearance of symmetry. Characteristic phrases are: *render inoperative, militate against, prove unacceptable, make contact with, be subjected to, give rise to, give grounds for, have the effect of, play a leading part (role) in, make itself felt, serve*

the purpose of, etc., etc. The keynote is the elimination of simple verbs. Instead of being a single word, such as *break, stop, spoil, mend, kill*, a verb becomes a phrase, made up of a noun or adjective tacked on to some general-purposes verb such as *prove, serve, form, play, render*. In addition, the passive voice is wherever possible used in preference to the active, and noun constructions are used instead of gerunds (*by examination of* instead of *by examining*). The range of verbs is further cut down by means of the *-ize* and *de-* formations, and banal statements are given an appearance of profundity by means of the *not un-* formation. Simple conjunctions and prepositions are replaced by such phrases as *with respect to, the fact that, in view of, in the interests of, on the hypothesis that*; and the ends of sentences are saved from anti-climax by such resounding commonplaces as *greatly to be desired, cannot be left out of account, a development to be expected in the near future, deserving of serious consideration, brought to a satisfactory conclusion*, etc.

Pretentious diction.—Words like *phenomenon, element, individual* (as noun), *objective, categorical, effective, virtual, basic, primary, constitute, exhibit, exploit, utilize, eliminate, liquidate*, are used to dress up simple statements and give an air of scientific impartiality to biased judgments. Adjectives like *epoch-making, epic, historic, unforgettable, triumphant, inevitable, inexorable, veritable*, are used to dignify the sordid processes of international politics, while writing that aims at glorifying war usually takes on an archaic color, its characteristic words being: *realm, throne, chariot, trident, sword, shield, banner, jackboot, clarion*. Foreign words and expressions such as *cul de sac, ancien régime, deus ex machina, status quo, gleichschaltung, weltanschauung*, are used to give an air of culture and elegance. Except for the useful abbreviations *i.e., e.g.* and *etc.*, there is no real need for any of the hundreds of foreign phrases now current in English. Bad writers, and especially scientific, political and sociological writers, are nearly always haunted by the notion that Latin or Greek words are grander than Saxon ones,

and unnecessary words like *expedite, ameliorate, predict, extraneous, clandestine, subaqueous* and hundreds of others constantly gain ground from their Anglo-Saxon opposite numbers. The jargon peculiar to Marxist writing (*hyena, hangman, cannibal, petit bourgeois, lackeys, flunkey, mad dog, White Guard,* etc.) consists largely of words and phrases translated from Russian, German or French; but the normal way of coining a new word is to use a Latin or Greek root with the appropriate affix and, where necessary, the *-ize* formation. It is often easier to make up words of this kind (*deregionalize, impermissible, extramarital, non-fragmentatory*) than to think up the English words that will cover one's meaning. The result, in general, is an increase in slovenliness and vagueness.

Meaningless words.—In certain kinds of writing, particularly in art criticism and literary criticism, it is normal to come across long passages which are almost completely lacking in meaning. Words like *romantic, plastic, values, human, dead, sentimental, natural, vitality,* as used in art criticism, are strictly meaningless, in the sense that they not only do not point to any discoverable object, but are hardly even expected to do so by the reader. When one critic writes, "The outstanding feature of Mr. X's work is its living quality," while another writes, "The immediately striking thing about Mr. X's work is its peculiar deadness," the reader accepts this as a simple difference of opinion. If words like *black* and *white* were involved, instead of the jargon words *dead* and *living,* he would see at once that language was being used in an improper way. Many political words are similarly abused. The word *fascism* has now no meaning except in so far as it signifies "something not desirable." The words *democracy, socialism, freedom, patriotic, realistic, justice,* have each of them several different meanings which cannot be reconciled with one another. In the case of a word like *democracy,* not only is there no agreed definition, but the attempt to make one

is resisted from all sides. It is almost universally felt that when we call a country democratic we are praising it: consequently the defenders of every kind of regime claim that it is a democracy, and fear that they might have to stop using the word if it were tied down to any one meaning. Words of this kind are often used in a consciously dishonest way. That is, the person who uses them has his own private definition, but allows his hearer to think he means something quite different. Statements like *Marshal Pétain was a true patriot, The Soviet Press is the freest in the world, The Catholic Church is opposed to persecution*, are almost always made with the intent to deceive. Others words used in variable meanings, in most cases more or less dishonestly, are: *class, totalitarian, science, progressive, reactionary, bourgeois, equality.*

Now that I have made this catalogue of swindles and perversions, let me give another example of the kind of writing that they lead to. This time it must of its nature be an imaginary one. I am going to translate a passage of good English into modern English of the worst sort. Here is a well known verse from "Ecclesiastes":

I returned, and saw under the sun, that the race is not to the swift, nor the battle to the strong, neither yet bread to the wise, nor yet riches to men of understanding, nor yet favor to men of skill; but time and chance happeneth to them all.

Here it is in modern English:

Objective consideration of contemporary phenomena compels the conclusion that success or failure in competitive activities exhibits no tendency to be commensurate with innate capacity, but that a considerable element of the unpredictable must invariably be taken into account.

This is a parody, but not a very gross one. Exhibit (3), for instance, contains several patches of the same kind of English. It will be seen that I have not made a full translation. The beginning and ending of the sentence follow the original meaning fairly closely, but in the middle the concrete illustrations—race, battle, bread—dissolve into the vague phrase "success or failure in competitive activities." This had to be so, because no modern writer of the kind I am discussing—no one capable of using phrases like "objective consideration of contemporary phenomena"—would ever tabulate his thoughts in that precise and detailed way. The whole tendency of modern prose is away from concreteness.

As I have tried to show, modern writing at its worst does not consist in picking out words for the sake of their meaning and inventing images in order to make the meaning clearer. It consists in gumming together long strips of words which have already been set in order by someone else, and making the results presentable by sheer humbug. The attraction of this way of writing is that it is easy. It is easier—even quicker, once you have the habit—to say *In my opinion it is a not unjustifiable assumption that* than to say *I think*. When you are composing in a hurry—when you are dictating to a stenographer, for instance, or making a public speech—it is natural to fall into a pretentious, Latinized style. Tags like *a consideration which we should do well to bear in mind* or *a conclusion to which all of us would readily assent* will save many a sentence from coming down with a bump. By using stale metaphors, similes and idioms, you save much mental effort, at the cost of leaving your meaning vague, not only for your reader but for yourself. This is the significance of mixed metaphors. The sole aim of a metaphor is to call up a visual image. When these images clash—as in *The Fascist octopus has sung its swan song, the jackboot is thrown into the melting pot*—it can be taken as certain that the writer is not seeing a mental image of the objects he is naming; in other words he is not really thinking. Look again at the examples I

gave at the beginning of this essay. Professor Laski (1) uses five negatives in 53 words. One of these is superfluous, making nonsense of the whole passage, and in addition there is the [printer's] slip *alien* for *akin*, making further nonsense, and several avoidable pieces of clumsiness which increase the general vagueness. Professor Hogben (2) plays ducks and drakes with a battery which is able to write prescriptions, and while disapproving of the everyday phrase *put up with*, is unwilling to look *egregious* up in the dictionary and see what it means. (3), if one takes an uncharitable attitude toward it, is simply meaningless: probably one could work out its intended meaning by reading the whole of the article in which it occurs. In (4), the writer knows more or less what he wants to say, but an accumulation of stale phrases chokes him like tea leaves blocking a sink. People who write in this manner usually have a general emotional meaning—they dislike one thing and want to express solidarity with another—but they are not interested in the detail of what they are saying. A scrupulous writer, in every sentence that he writes, will ask himself at least four questions, thus: What am I trying to say? What words will express it? What image or idiom will make it clearer? Is this image fresh enough to have an effect? And he will probably ask himself two more: Could I put it more shortly? Have I said anything that is avoidably ugly? But you are not obliged to go to all this trouble. You can shirk it by simply throwing your mind open and letting the ready-made phrases come crowding in. They will construct your sentences for you—even think your thoughts for you, to a certain extent—and at need they will perform the important service of partially concealing your meaning even from yourself. It is at this point that the special connection between politics and the debasement of language becomes clear.

PART FIVE
1950s

"To demean our intellectuals is to deny the very basis of our national greatness."

ADLAI E. STEVENSON, "IDEAS AND POLITICS"
NOVEMBER 22, 1954

Sigmund Freud

W. H. AUDEN

October 6, 1952

During the postwar years, the quality of the magazine's political writing was uneven, at best. Michael Straight, who succeeded his mother as owner, simply didn't have great editorial taste. The New Republic *merely attempted to keep up with the news, without much philosophical or literary ambition. (For a time, Straight wanted the magazine to become the left-wing version of* Time.*) But one of the eternal facts of* The New Republic *is that it houses two magazines in one. Once readers cross the halfway point of an issue, they find themselves in the realm of culture, our Back of the Book. This division has saved the magazine over the years. When its political writing has suffered, it has usually managed to publish the finest criticism. Even in these darker years,* The New Republic *could boast of running the likes of Auden.*

Today, thanks to Freud, the man-in-the-street knows (to quote by an inaccurate memory from *Punch*) that, when he thinks a thing, the thing he thinks is not the thing he thinks he thinks, but only the thing he thinks he thinks he thinks. Fifty years ago, a girl who sprained her ankle on the eve of a long-looked-forward-to ball, or a man who suffered from a shrewish wife, could be certain of the neighbors' sympathy; today the latter will probably decide that mis-

fortune is their real pleasure. The letter of apology to the hostess whose dinner invitation you have forgotten is much more difficult to write than it used to be. If an Isolde worries all day lest her absent Tristan should be run over by a bus, the dumbest Brangaene could warn her that her love includes a hope that he will never return. As for parents, not only the few who have read up on the Oedipus Complex and Erogenous Zones, but also the newspaper-reading mass, the poor things are today scared out of their wits that they will make some terrible mistake; the Victorian, even the Edwardian, paterfamilias who knew what was right is almost extinct, which is, perhaps, a pity. (However, if the bearded thunder god has turned into a clean-shaven pal, there is still the iron-toothed witch).

It always comes as a shock to me to remember that, when Freud was born, *The Origin of Species* had not yet appeared, and that he was in his fortieth year before he published his first "freudian" papers. Freud's formative years, that is, were a time when the great intellectual battle was between Science and the sort of bourgeois idealist manicheeism of which, in 1875, Mrs. Eddy became Popess. The feeling that matter and the body are low or unreal and that the good and the real are spiritual or mental is always likely to become popular in a society where wealth and social prestige go to those who work with their heads; as long as the aristocracy thinks of itself as the warrior class, it is protected from this heresy because, while it may despise manual labor, athletic fitness is a badge of class: further, as long as their work is really manual, the market value of physical strength and manual skill prevents the working-classes from underestimating the body, but with the coming of the machine which can be minded perfectly well by an unskilled child, white-collar manicheeism infects them as well. The great dramatic interest of the second half of the nineteenth century lies in the fact that, at the very time when the scientific advances which were being made

in the natural sciences like chemistry and biology seemed to suggest that all reality might ultimately be explicable in terms of quantity and necessity, the development of society was making the notion of any relation of the good and the beautiful to matter peculiarly repugnant. One cannot read either the scientists or the naturalistic novelists of the period without feeling, in the very passion with which they assert that man is *only* an animal, their selection for portrayal of the ugliest "nature" they can find, the same horror as was exhibited by their episcopal opponents; they see themselves as preaching the truth, but none of them thinks that the truth is good news. Freud is no exception; the very man who has done most to free us from a manicheean horror of sex quotes more than once, with an unmistakable shudder of distaste, the Church Father who pointed out that we are born *inter urinas et faeces*. Some wag once summed up the message of psychoanalysis as saying: "We are born mad; we grow sane and unhappy; then we die." There are photographs of Freud in which he almost looks as if he would agree.

In this battle between those who asserted that the egg is only a dream of the hen and those who asserted that the hen is only a dream of the egg, Freud certainly thought of himself as a dyed-in-the-wool egg-fancier. He observes all the egg-fancier tabus; Beatrice, for instance, becomes the Love Object and the four-letter words always appear veiled in the decent obscurity of the Latin language. (The child-like faith of even the most anticlerical members of the medical profession in the magical properties of the tongue is extremely comic and warrants psychoanalytic investigation).

But Freud is a clear and beautiful example of a revolutionary thinker—it probably holds good for them all—who is much more revolutionary and in quite another way than he himself realizes.

Had one asked a doctor in the 80's and 90's to forecast the future of psychology, he would almost certainly have replied somewhat as follows:

"It seems probable that we shall soon be able to describe all mental events in terms of physical events in the brain, but even if we cannot, we may safely assume:

1. Like the human body, the human mind has a constant nature, typical for the species; individual variations are either pathological or insignificant.

2. The behavior of this mind can be explained in terms of stimulus and response. Similar stimuli will necessarily produce similar responses. Both are quantitatively measurable in terms of intensity and duration.

3. Mental development is like physical growth, i.e., the mind passes from a younger or earlier phase into an older or later one. This process can be arrested or become morbid, but two phases cannot exist simultaneously any more than an oak can be an acorn at the same time.

4. The neuroses and psychoses must be typical diagnostic entities, identical in every patient. To discover a cure for one means to discover the procedure which is effective independently of the individual doctor or the individual patient.

One has only to read a few lines of Freud to realize that one is moving in a very different world, one in which there are decisive

battles, defeats, victories, decisions, doubts, where things happen that need not have happened and even things which ought not to have happened, a world where novelties exist side by side with ancient monuments, a world of guilt and responsibility, a world, heaven help us, that has to be described with analogical *metaphors*. The Master may sometimes write as if he thought that saying a three-year-old child wishes to commit incest with his mother were the same kind of statement as saying he wishes to go to the bathroom, but we are not deceived. Whatever we may think of that famous trio Ego, Super-Ego and Id, we can see that they are like Prince Tamino, Zorastro and The Queen of The Night and not like mathematical equations. We may find the account of the Fall in *Totem and Taboo* more or less plausible than the account in *Genesis* (the Bible version which makes the psychological sin, and therefore the sense of guilt, prior to the moral crime seems to me the more "freudian"), but we shall not dream of applying the standards of "scientific" evidence employed in Chemistry or Biology to either.

In fact, if every one of his theories should turn out to be false, Freud would still tower up as the genius who perceived that psychological events are not natural events but historical and that, therefore, psychology as distinct from neurology, must be based on the pre-suppositions and methodology, not of the biologist but of the historian. As a child of his age who was consciously in a polemic with the "idealists" he may officially subscribe to the "realist" dogma that human nature and animal nature are the same, but the moment he gets down to work, every thing he says denies it. In his theories of infantile sexuality, repression, etc., he pushes back the beginnings of free-will and responsibility earlier than even most theologians had previously dared; his therapeutic technique of making the patient re-live his past and discover the truth for himself with a minimum of prompting and interference from the analyst (meanwhile, one might add, doing penance by paying till it

hurts), the importance of Transference to the outcome of the therapy, imply that every patient is a unique historical person and not a typical case.

Freud is not always aware of what he is doing and some of the difficulties he gets into arise from his trying to retain biological notions of development when he is actually thinking historically. For example, he sometimes talks as if civilization were a morbid growth caused by sexual inhibition; at other times he attacks conventional morality on the grounds that the conformists exhaust in repression the energies which should be available for cultural tasks: similarly, he sometimes speaks of dream symbolism as if it were pure allegory, whereas the actual descriptions he gives of the dreaming mind at work demonstrate that, in addition to its need to disguise truth, it has an even greater need to create truth, to make historical sense of its experience by discovering analogies, an activity in which it shows the most extraordinary skill and humor. In a biological organism, everything was once something else which it now no longer is, and change is cyclical, soma-germsoma; a normal condition is one that regularly re-occurs in the cycle, a morbid one is an exception. But history is the realm of unique and novel events and of monuments—the historical past is present in the present and the norm of health or pathology cannot be based on regularity.

Freud certainly expected opposition and obloquy from the conventional moralists and the man-in-the-street for his theories about human sexuality; in actual fact, the general public took him to their bosoms rather less critically, perhaps, than they should have done, while the real opposition came and still comes from the behaviorists, the neurologists and all the schools of psychiatry that regard their subject as a natural science and are therefore outraged by the whole approach of the psychoanalysts, irrespective of any particular theory they may hold.

The opposition can certainly find plenty of ammunition in psychoanalytic literature; for, while it is possible to do important work (though not, I believe, the greatest) in the natural sciences without being a wise and great man, the most routine exercises in a field that involves the personal and historical demand wisdom, and a psychoanalyst who lacks it cannot write a five-minute paper without giving himself away as a vulgar nincompoop.

The same holds for the reader; a man may fail to understand a text-book of physics but he knows he has not understood it and that is the end of the matter; but he may read a psychoanalytical treatise and come out more of a damned fool at the end than he was before he began it. Or more of a crook—every defense lawyer in a seemingly hopeless criminal case knows how to instruct his client in his unloved childhood to embarrass Bench and Jury.

In the long run, however, the welcome given to psychoanalysis by the public is based on a sound intuition that it stands for treating every one as a unique and morally responsible person, not as a keyboard—it speaks of the narcissism of the Ego, but it believes in the existence of that Ego and its capacity to recognize its own limitations—and that in these days is a great deal. The behaviorists are certainly right in one thing; the human mind does have a nature which can be tampered with: with a few drugs and a little regular torture every human mind can be reduced to a condition in which it is no longer a subject for psychology.

Psychoanalysts and their patients may sometimes seem funny little people, but the fact that they exist is evidence that society is still partly human.

Indo-China

GRAHAM GREENE

April 5, 1954

This dispatch was sent from the nomadic novelist's second trip to Vietnam. It can be read as a study for his anti-imperialist novel The Quiet American, *which appeared two years later. But it played an arguably more significant role. Greene's dispatches from Vietnam awakened liberals like Eugene McCarthy to the dangers of further American involvement in Indo-China. Even though* The New Republic *never had much patience for the antiwar movement and published influential critiques of the New Left, the magazine was always a strident critic of Kennedy and Johnson's plans for escalation.*

For the third time, and after two years, one was back. There seemed at first so little that had changed: in Saigon there were new traffic lights in the Rue Catinat and rather more beer bottle tops trodden into the asphalt outside the Continental Hotel and the Imperial Bar. *Le Journal d'Extreme Orient* reported the same operations in the north within the delta defenses erected by De Lattre, around Nam Dinh and Thai-Binh, the same account of enemy losses, the same reticence about French Union losses.

In Hong Kong one had read the alarmist reports—the fall of

Thakhek, the cutting in two of Annam and Laos above the 16th parallel, "thousands of columns pouring south on the route to Saigon." One knew then these reports were unreal—this grim shadow-bowing war will never end spectacularly for either side, and in Saigon I knew there would be little sign of war except the soldiers in the cafés, the landing craft tied up outside the Majestic for repairs as noisy as road drills in a London summer—less now than ever, for two years ago there still remained the evening hand grenades, flung in their home-made hit-or-miss way into cinemas and cafés spreading a little local destruction and listed in a back-page column of the *Journal*. (They had ceased with the shooting of some prisoners, and who could blame the executioners? Is it worse to shoot a prisoner than to maim a child?) The only people in Saigon who were thoroughly aware of war were the doctors, and they were aware of something the French were most of them inclined to forget. "Until I became a doctor in a military hospital," one said to me, "I had not realized that nine out of every 10 wounded men were Vietnamiens."

And yes, there was another change. There is a despondency of return as well as a sadness of departure, and I noted that first evening in my journal, "Is there any solution here the West can offer? But the bar tonight was loud with innocent American voices and that was the worst disquiet. There weren't so many Americans in 1951 and 1952." They were there, one couldn't help being aware, to protect an investment, but couldn't the investment have been avoided? In 1945, after the fall of Japan, they had done their best to eliminate French influence in Tonkin. M. Sainteny, the first postwar Commissioner in Hanoi, has told the sad ignoble story in his recent book, *Histoire d'une Paix Manquée*—air-planes forbidden to take off with their French passengers from China, couriers who never arrived, help withheld at moments of crisis. Now they had been forced to invest in a French victory. I suggested to a member of the American Economic Mission that French participation in the

war might be drawing to an end. "Oh no," he said, "they can't do that. They'd have to pay us back——" I cannot remember how many thousand million dollars.

It is possible of course to argue that America had reason in 1945, but if their policy was right then, it should have been followed to the end—and the end could not have been more bitter than today's. The policy of our own representative in Hanoi, to whom M. Sainteny pays tribute, was to combine a wise sympathy for the new national-ism of Viet-Nam with a recognition that France was our ally who had special responsibilities and, more important perhaps, a special emotion after the years of defeat and occupation. Who knows, if that policy had been properly followed, whether the goodwill of Ho Chi Minh and of Sainteny might not have led Viet-Nam toward a grad-ual and peaceful independence? American hostility, humiliation at the hands of the defeated Japanese and the Chinese occupying forces exposed French weakness and saw to it that Viet-Namese in-transigence should grow until in 1946 it is doubtful whether France could have bought peace with less than total surrender.

I suppose in a war the safe areas are always the most depress-ing because there is time to brood not only on dead hopes, dead policies, but even on dead jokes. What on my first two visits had seemed gay and bizarre were now like a game that has gone on too long—I am thinking particularly of the religious sects of the South, the local armies and their barons to whom much of the defense of the Saigon delta is entrusted: the Buddhist Hoa Haos for instance. Their general's wife has formed an Amazon army which is popularly believed to have eliminated some of the general's concubines. The French had originally appointed the Hoa Hao leader a "one star" general (it is said that he was once a trishaw driver in Saigon), but when he came to the city to order his uniform, he learned from the tailor that there was no such rank in the French army. Only a quick promotion to two

stars prevented the general from leading his troops over to the Viet-Minh.

The Caodaists too began by amusing—this new religious sect founded by a Cochin civil servant in the 1920's, with its amalgam of Confucianism, Buddhism and Christianity, its Pope, its Holy See, its female cardinals, its canonization of Victor Hugo, its prophecies by a kind of planchette. But that joke—and that adept salesmanship—had palled too; the technicolor cathedral in the Walt Disney manner, full of snakes and dragons and staring eyes of God seemed no longer naïve and charming but cunning and unreliable like a smart advertisement. You cannot fight a war satisfactorily with allies like this. The Caodaists by the military absorption of the surrounding country number two million and have an army of 20,000. They have had to be courted and the moment the courtship loses warmth the threat appears. They have been given no ministerial appointment in the new government of Prince Buu-Loc, and no minister went down to their great feast day last February that was supposed to commemorate the seventh anniversary of the Caodaist fight against Communism. The ambiguous figure of the former president, Mr. Van Tam, beside the Pope in his Chu Chin Chow robes seemed to emphasize their absence, and though messages were read from General Navarre and the Emperor Bao Dai, there were none from the government. When the turn came for the Caodaist Commander-in-Chief to speak, his venom seemed directed as much at his government as at the Communists—"who could foresee the treatment reserved for us, the suspicions of which we were to become the object?"

The Pope under his gleaming mushroom hat smiled and smiled. In the Cathedral the effigies of Confucius, Buddha and the Sacred Heart stared down the glittering pastel nave at the pythons coiled

round the papal throne. It was all very tricky and it might well cost blood. I remembered how the Chief of Staff, Colonel Thé, had taken to the sacred mountain in 1952 with eight thousand men to make war on French and Communists alike and how a Caodaist officer had told me that they had made no attempt to capture him because he had done no harm to the Caodaists. There was a time when certain Americans dreaming of a third force showed an interest in Thé which one hoped waned that morning in the square of Saigon when his 200-pound bombs exploded among the shopping crowds. Now he had kidnapped a cardinal, but the cardinal was rumored to have offended the Pope, and the leader of yet another private army told me he could always arrange a meeting for me with the self-promoted General Thé in the Holy See itself. The eye of God watched the Caodaists from every window, but sharp human eyes were also very much required.

And then of course there was the leader who treated his faulty liver homeopathically with the help of human livers supplied by his troops, and the Binh-Kuyen, the private army under General Le Van Vien who controlled the gambling joints and opium houses of Cholon, the Chinese city which is a suburb of Saigon itself. (He had cleaned the city of beggars by putting them all, one-legged, armless, broken-backed, into a grim concentration camp on the swamps outside.) These, and such as these, were the men at arms in the South, fighting haphazardly the guerrilla war in the Saigon delta, while the real troops drained north into Annam and Laos and Tonkin, the Foreign Legion, the Moroccans, the Senegalese, and the Viet-Nam army itself under officers who had neither the money nor the influence to ensure their stay in the relative peace of the South.

One flies from the bizarre and complicated Cochin to the sadder and simpler North. In the plane to Hanoi, I thought of what the doctor had told me, for in the plane were many crippled Tonkinese

returning home after being patched in the South. One had seen just such faces, patient, gentle, expecting nothing, behind the water buffaloes plowing the drowned paddy fields: it seemed wrong that war should have picked on them and lopped off a leg or an arm—war should belong to the brazen battalions, the ribboned commanders, the goose step and the Guards' march. Outside the air terminus at Hanoi the trishaw drivers waited for fares, and not one driver would lend a hand to help his crippled countrymen alight. A French officer shouted at them furiously to help, but they watched without interest or pity the shambling descent of the wounded. There, by the dusty rim of the street, lay the great problem—those men were not cruel, they were indifferent.

One cannot escape the problem anywhere, in the office of a general, the hut of a priest, at an Annamite tea party. Viet-Nam cannot be held without the Viet-Namese, and the Viet-Namese army, not yet two years old, cannot, except here and there stiffened by French officers, stand up against their fellow countrymen trained by Giap since 1945. Last year General Cogny made the brave experiment outside the delta of entrusting the region of Buichu purely to Viet-Namese troops. It seemed a favorable place for the experiment since the region is almost entirely Catholic, and the Catholics, however nationalist, are absolute opponents of Viet-Minh. But Giap's intelligence was good: he loosed on these troops one of his crack regiments and two battalions deserted with their arms. A third of Buichu with its villages and ricefields passed under Viet-Minh control. One could match this of course in European armies with incidents from Narvik or North Africa—inexperience can look like cowardice, but perhaps the cause in this case was neither.

The repeated argument of the Viet-Namese is: "How can we fight until we have real independence—we have nothing to fight for." They recognize that their present army without the French could not stand up against the revolutionary regiments of Giap for

a fortnight. They cannot expect full independence until their army is capable of resistance, and their army cannot fight without proper heart until they have achieved it. It is the old question of which came first, the chicken or the egg. The result is frustration and bewilderment.

The frustration and repetitiveness of this war leads inevitably to day dreams. In time of despair people await a miracle, hopes become irrational. With rapidity and energy the French in a matter of weeks leveled a forest, erased a village, erected the great fortified camp of Dien-Bien-Phu in Laos, guarding the main route to Luang Prabang, the capital. Bulldozers dropped by parachute leveled the ground for transport planes. Trenches, dug-outs, elaborate preparations for enfilading fire; tanks parachuted in by pieces and assembled in the camp: the achievement was magnificent, if Giap, who had proved himself a first-class tactician, were foolish enough to risk a direct attack. On the mountains which completely surrounded the plain a division of his troops kept watch and ward: all was under their eye. Artillery was on the way, fog which settled down every night over the camp prevented air support before 11 in the morning. "When they attack," French officers would say. "Suppose they don't attack," the ugly supposition cropped up more frequently. "They've got to attack," a French officer said with sad cynicism. In the dug-out mess the colonel lost temper with one of his officers. "I will not have the name of Na-Sam mentioned in the mess." (Na-Sam was the fortified post abandoned in 1952.) "This is not Na-Sam." His second-in-command rapidly changed the subject. Had I seen Claudel's new play when I was last in Paris? Meanwhile as one of Giap's divisions encircled the camp, his troops moved by a more circuitous route toward Luang Prabang. "At least we have made him shift troops from within the delta." True, but so had the French, and sometimes one wondered wither General Navarre's reserves were as adequate as Giap's.

One propaganda offensive is matched by another. Both sides perform before a European audience and gain inexpensive tactical successes. Giap seizes for awhile Thakhek and the world's press takes notice (its recapture like the denial of a newspaper report figured very small). The French stage Operation Atlante on the coast of Annam, reclaiming an area of impressive size that had been administered by the Viet-Minh since 1946—an easy offensive, for there were hardly more soldiers in the area than administrators. But troops were needed to guard the new territory so that Giap was enabled to attack on the high plateau and the fall of Kontum took the news value from Atlante. You could find Kontum on a map.

So the war goes drearily on its way with local successes ignored in the Paris press and local defeats magnified into disasters. Dien-Bien-Phu takes the place of Na-Sam in the news: the 1953 attack on Luang Prabang is repeated in 1954 and stops again within a few miles of the Laotian capital. Lunching at Nam Dinh and eating an excellent soufflée I was asked by the general commanding whether I had ever had so good a soufflée before to the sound of gunfire. I could have replied that I had—two years before, at the same table, to the sound of the same guns.

Everybody knows now on both sides that the fate of Viet-Nam does not rest with the armies. It would be hard for either army to lose the war, and certainly neither can win it. However much material the Americans and Chinese pour in, they can only keep the pot hot, they will never make it boil. Two years ago men believed in the possibility of military defeat or victory; now they know the war will be decided elsewhere by men who have never waded waist-deep in the fields of paddy, struggled up mountain sides, been involved in the middle of attack or the long boredom of waiting.

Our Stake in the State of Israel

REINHOLD NIEBUHR

February 4, 1957

When I started at The New Republic *in 2000, the magazine was assailed by a common misperception. Its owner at the time, Marty Peretz, was an especially vociferous Zionist. Every time an article sympathetic to Israel appeared in the magazine, it was widely assumed the author was simply doing the bidding of the paymaster. But Zionism was a core cause of the magazine nearly from its start, a stance inspired by Louis Brandeis and Felix Frankfurter. (Frankfurter, who had filial feeling for Croly, had represented the Zionists at the Paris Peace Conference in 1919.)*

To be sure, The New Republic *was hardly the most Zionist of the liberal weeklies. That honor went to* The Nation. *But Zionism was very much part of the fabric of the liberalism of the day—and the most famous of the midcentury liberals, Reinhold Niebuhr, was also the most ardent of the Zionists. It might be assumed that a Christian prelate like Niebuhr arrived at his love of Israel on religious grounds. But there wasn't a trace of theology in his arguments. He derived his Zionism from the same moral realism that informed every other view he strongly held.*

The tragic epic of the people of Hungary has so enthralled the imagination of the world that we are in danger of being indifferent

to another drama of current history, which is invested with a peculiar pathos and which may end in tragedy because of our blindness.

To appreciate the full flavor of the drama of the state of Israel one must recount its history from the beginning, and even from the beginnings before its birth. The calendar beginning of Israel was the United Nations resolution, which sanctioned the new state and the heroic battle which the nascent nation waged against the Arab nations, sworn to throttle Israel in its cradle. Thus the state's birth was both a gift from the world community and an achievement of the redoubtable army which the little nation was able to organize. It will be remembered that the Arab nations defeated in that conflict were then, as now, without unity or effective discipline, and that a young lieutenant of the Egyptian army, by the name of Nasser, was so moved by the shame of the defeat that he resolved on the overthrow of the corrupt Farouk monarchical regime, which symbolized the impotence of Egypt so perfectly.

But there were other beginnings before this calendar birth, without which the obvious beginning would not be explicable. Among those there was the dream of the young Jewish intellectual, turned Zionist, Theodor Herzl, who conceived of a homeland for a homeless nation; and the dream of a British Jewish scientist, Chaim Weizmann, who persuaded a reluctant British Government, holding a mandate in Palestine, to commit itself after World War I to the Balfour Declaration which promised to provide a "homeland" for the Jews in Palestine. Nationhood was not promised, but the declaration permitted a more generous Jewish immigration to Palestine though the rate of immigration was a constant source of friction between the Jews and Britain. The British naturally hoped to contain the Jewish homeland within the bounds of their imperial system and to guard the rights of the indigenous Arabs in a bi-national state. Indeed there were religious, rather than political, Zionists who thought that such a state would furnish the best solution for

the problem of justice between Jews and Arabs. The famed Jewish philosopher, Martin Buber, and the late rector of the Hebrew University, Judah Magnes, were proponents of this plan, though it was probably unrealistic to expect an Arab majority gradually to accept a minority status, particularly when its loyalty would be divided between the pull of kinship and the pull of traditional homeland in Palestine.

Actually this modus vivendi was overwhelmed by the events which followed in the wake of the catastrophic fate of the Jews in the Nazi period. One hopes that the nascent anti-Semitism of the present period will be somewhat assuaged by a remembrance of these events, by a reminder of the fact that millions of Jews perished in the gas ovens and concentration camps of Hitler's Germany, and that the remnant found the continued insecurity of a corrupt Europe intolerable. Jewish immigration flooded Palestine and the uneasy conscience of the world as a result of the Nazi atrocities, and the humanitarian interest in finding security for the Jews of Europe, together with the sheer necessity of the Jews created political forces which finally resulted in invalidating the British mandate, in prompting the United Nations to grant statehood to the nascent nation, and in assuring the new country of the passive sympathy of the non-Jewish world and the active sympathy of the Jews of the world, particularly the most numerous and prosperous Jewry of the United States.

Since then the new state has opened its doors to Jews from all over the world, has integrated them into a new community, whether they be from the backward culture of Yemen or the most advanced European cultures. It brought the most advanced techniques into the service of the new community, irrigated deserts in order to create orange groves and built a healthy industrial life through the skills of its people. Of course these miracles of integration and creativity would not have been possible without the continued financial sup-

port of world Jewry and particularly of the Jews of America, though critics who emphasize this fact usually do not consider that the oil royalties which flow into the Arab states exceed in value even these generous subsidies. But only a trickle of this oil wealth is used for raising the miserable standards of these moribund Islamic nations.

The history of the new state of Israel is thrilling in many respects. It represents a remarkable co-operation of "capitalistic" European and American Jews with the essentially socialist Jews of Israel. For the prevailing political ideology of Israel was determined by the Polish Jewish socialists, turned Zionists, so completely typified by the robust Prime Minister of today, Ben-Gurion. The collective farms or "kibbutzim" are, in fact, based upon rather doctrinaire socialist principles of the 19th Century, and are probably too consistently collectivist in their attitude toward family life to satisfy our robust individualism. A witty Jewish Oxford don, a friend of Chaim Weizmann, has given it as his opinion that Israel is served by the German Jews, who became honest and skillful "bureaucrats" and scientists, and by the Polish Jews who furnish the ideology and the political skill of the new state. Certainly the effective leadership of the state is divided between the German and the Polish Jews.

The co-operation between the religious Jews and the essentially secular idealists in the new state is equally worthy of note. Zionism is a political dream of religious origin, and before the Nazi period it was nourished only among those who were poor and orthodox, rather than among the "liberal" and assimilated and prosperous Jews. Hitler's persecutions changed all this and made Zionism popular in the congregations of liberal Judaism. From a religious standpoint one might say that it became too popular because the liberal rabbis were as preoccupied with Hitler for two decades as they are now with Nasser, so that even a Christian, with sympathies for Zi-

onism, such as the present writer, can appreciate the protests of the anti-Zionist "Council for Judaism," which believes that political and nationalistic preoccupations of the rabbis imperil the religious substance of Judaism as a monotheistic faith.

It is a fact, however, that liberal versions of Judaism have found no lodging place in the new state of Israel. The religious Jews are orthodox and to such a degree that, if they would have their way, they would fasten upon this essentially secular community political standards directly derived from the book of Deuteronomy, which would, among other embarrassments, make the life of a modern woman intolerable. During the meeting of the World Council of Churches, held in Amsterdam in 1948, one of the members of the council was approached by an orthodox rabbi from Jerusalem with the suggestion that the religious Jews of Israel would like the support of Christians for their effort to create a religious state. He was very much surprised to be told that this Protestant assembly had just condemned religious political parties, that it avowed secular politics for the sake of religious principles and that it abhorred a sacerdotal state.

It is a matter of fact one of the marvels of the new state that a religious party (informed by an archaic piety) and a secular party (informed by a rather self-conscious secular enlightenment) could co-operate in building the new nation. This miracle can only be explained by the force of the overarching national loyalty, the different interpretations which Ben-Gurion and the orthodox rabbis place upon the traditional liturgies and festivals of the Jewish faith which are undoubtedly religious but are susceptible to political and cultural interpretations. A shrewd Israeli journalist informed the present writer that the chasm between the two groups prompted abandonment of the plan of writing a constitution for the new state. It was a wise move because the chasm could not have been bridged by any legal arrangement but only by the pressures and creativities

of actual history. It must be counted as one of the achievements of American liberal religious Jews that they have not allowed either the doctrinaire secularism or the archaic religion to dampen the ardor of their support of Israel.

In any event it is apparent that no nation has ever come into being through a confluence of so many political and cultural and religious factors as this new state. The economic and spiritual investments in it by the West are very great. So also is our strategic stake. For Israel is the only sure strategic anchor of the democratic world, particularly since Khrushchev and Nasser have proved that Islam is not as immune to Communism as had been supposed, but is, rather, an almost ideal ground for the growth of nationalism posing as Communism and Communism posing as nationalism.

The question for us is how we can save the state from annihilation, for it is still the sworn intent not only of Nasser but of the whole Arab world to destroy it. There is in fact a real pathos in the fact that the Jews should have exchanged the insecurity of Europe for the collective insecurity of the Middle East. The West did not reckon with the depth of the Arab spirit of vengeance, nor did it appreciate that this technically efficient democracy would exacerbate the ancient feud between the Jews and the Arabs. For Israel is an offense to the Arab world for three reasons:

1. It has claimed by conquest what the Arabs regard as their soil; and Denis Brogan may be right (*NR*, Dec. 17, 1956) in declaring that this is one modern state which has been brought into being by force of arms. The West and the Jews may claim the previous Jewish right to the soil of Palestine, but we tend to forget that this right evaporated some thousands of years ago and that the Arabs are not

impressed by the prophecies of the Old Testament, at least not by the political relevance of these prophecies. So strong is this Arab feeling that no Arab leader has yet promised to confer with Israel directly about any mutual problem.

2. This enmity has been increased by the problem of the refugees whom the Arab states will not resettle and whom the Jews cannot absorb except in small numbers without imperiling the security of their nation, because the refugees are sworn enemies of the new state. I do not pretend to judge between the Arab claims that they were driven out and the Jewish claims that they fled or were called out during the war. Both claims may be partially true or true in some sense. The point is that the refugees are a constant source of anti-Israel animus in the region.

3. The third cause of trouble is even more potent. The state of Israel is, by its very technical efficiency and democratic justice, a source of danger to the moribund feudal or pastoral economics and monarchical political forms of the Islamic world and a threat to the rich overlords of desperately poor peasants of the Middle East. It is also a threat to those Islamic religious people who delight in the "organic" quality of this ancient life and who know that modern techniques would certainly destroy the old way of life in the process of lifting the burden of the poor.

The sources of enmity are in fact so many that it is idle to expect to pacify the region by even the most ambitious plan for the development of the economic resources of the whole region. All such proposals do not gauge the depth and the breadth of the Arab spirit of vengeance correctly. It is of such proportions that even an erstwhile

pro-Zionist may be permitted to doubt whether it was right for the Western world to push its unsolved problem upon the Middle East where there was so much tinder for conflagration. Zionism was, of course, unthinkable without the original religious impetus, even though the statesmanlike achievements of the modern state are purely secular. But perhaps these qualms are irrelevant, for it is not possible to roll history back, and it has been proved that we cannot wean the Arabs from their passions by equivocation in regard to Israel.

The simple fact is that all schemes for political appeasement and economic co-operation must fail unless there is an unequivocal voice from us that we will not allow the state to be annihilated and that we will not judge its desperate efforts to gain some strategic security (by holding on to the Gaza Strip and demanding access to the Gulf of Aqaba, for instance) as an illegitimate use of force. The fact is that our new pacifism, which seems to avoid the danger of becoming involved in the ultimate global war by disavowing all local wars, actually exposes us to the danger which Chamberlain overlooked at Munich. That is the danger of abandoning strategic fortresses in the interest of "peace in our time" only to be forced to fight in the end without those fortresses. It is risky for our nation to declare that we regard the security and integrity of Israel as important to our national interest. But it is not more risky than the statement we made about the Baghdad Pact nations. Meanwhile it will be well to remember that the Russians are as anxious as we are to avoid the ultimate conflict. They are more likely to yield to an unequivocal word than to respect vacillation. Their own troubles might drive them to desperate ventures. But the disintegration of their empire has proceeded rapidly enough to make it quite certain that a general war would not unify but would destroy whatever unity they still have. That is why strategic shrewdness is more important now than the lofty platitudes on which Nehru and Eisen-

hower seemed so fervently to agree. We always have the problem of the uncommitted nations of Asia and Africa. But we dare not forget that in the Middle East we have the problem of a direct strategic intervention by Russia in the so-called uncommitted world.

The location of the state of Israel may have been a mistake; though the confluence of historical forces made it unavoidable. The birth and growth of the nation is a glorious spiritual and political achievement. Its continued existence may require detailed economic strategies for the whole region and policies for the resettlement of the Arab refugees. But the primary condition of its existence is our word that we will not allow "any nation so conceived and so dedicated to perish from the earth." Nehru, representing India, is a bridge between East and West. Ambiguous words from him may be proper. But we are not a bridge, but the great hegemonous power of the free world. Equivocal words by us are highly improper. Life and death depend upon a clear policy.

The ultimate in strategic confusion was reached in the United Nations Assembly resolution of January 19. The usual, fashionable majority of Russia, America and the Arab-Asian bloc decreed that the Israelis must leave the Gaza Strip and the Gulf of Aqaba, and censured them for not obeying the "forthwith" resolution of some weeks ago with the speed which Mr. Krishna Menon and his able lieutenant, Mr. Cabot Lodge, desired. The Israelis were tardy in heeding the wishes of the United Nations resolution because they wanted guarantees about the passage of Israeli ships through the Suez Canal and they also argued that the emergency force of the United Nations would have to take over the Gaza Strip and the approaches to the Gulf of Aqaba if they were to have any security against further Egyptian raids and if the port of Elath was to be freed for commerce. The freeing of that port would, incidentally, permit an alternative oil pipeline to the Mediterranean and so make the West less dependent upon Nasser. But our strategy is more intent on wooing the monarchs

than on establishing alternative routes for the vital oil, the possession and transportation of which gives Nasser and the monarchs such a power over the economy of Europe and the UN's strategy.

The Assembly discussed the possibility of the deployment of the emergency force for such a purpose, but Menon warned that this would have to be negotiated with Nasser. The prospect of success was so remote that the Assembly gave up and simply ordered the Israelis out. Subsequently the Arab-Asian bloc has proposed economic sanctions if they do not obey. The Western European nations regard this spectacle of strategic confusion with increasing contempt. The same powerful nation whose President seeks stand-by authority to resist Communist aggression in the Middle East is meanwhile confused in co-operating with the pawns of Russia to destroy our only secure bastion in this troubled area. One wonders whether this strategic confusion can be quite as stupid as it seems to be. Could the British be right when they suggest that American oil interests, particularly in Saudi Arabia, whose monarch is presently paying us a visit, are determining this policy? That might make some kind of sense out of what seems otherwise a policy of complete strategic nonsense.

Perhaps the footnote should be added that a Washington official expressed disappointment about Nasser's continued intransigence. Evidently it was felt that gratitude should have moderated his excessive demands. If this be the calculation, the State Department does not know Nasser as well as he knows himself. Just as Hitler before him, he achieved all his ends by inordinate demands. Why should the sentiment of gratitude deter him from his triumphant course, particularly since we seem so intent on removing any road blocks to his progress?

Positive Thinking on Pennsylvania Avenue

PHILIP ROTH

June 3, 1957

Humor is not the primary métier of The New Republic—*nor, for that matter, of liberalism. But there's a small tradition that includes this cute, fairly mild satire by a very young Philip Roth, mocking both Eisenhower and the Power of Positive Thinking. During the seventies, Woody Allen wrote regular send-ups for the magazine. The magazine most regularly deployed humor, and to great effect, during the eighties and nineties, a period when it gleefully attempted to overthrow the oppressive orthodoxies of liberalism. It was a style that fit the cause.*

. . . He [Congressman Walter Judd of Minnesota] told me this fascinating story about President Eisenhower. Mrs. Judd had been having a visit with Mrs. Eisenhower who told her, "Ike goes into bed, lies back on the pillow, and prays out loud, something like this: 'Lord, I want to thank You for helping me today. You really stuck by me. I know, Lord, that I muffed a few and I'm sorry about that. But both the ones we did all right and the ones we muffed I am turning them all over to You. You take over from here. Good night, Lord, I'm going to sleep.' And,"

added the President's wife to Mrs. Judd, "that is just what he does; he just turns over and goes to sleep . . ."

NORMAN VINCENT PEALE, DECEMBER, 1956

The man of deep religious conscience and conviction tradition- ally speaks to his God with words of awe, love, fear, and wonder: he lifts his voice to the mysterious bigger-than-space, longer- than-time God, and his own finiteness, ignorance, and sinfulness grip his spirit and carve for his tongue a language of humility. Only recently Mrs. Eisenhower revealed to a White House guest the words the President himself speaks each night to the Lord from the quiet of his bed. As the President himself is half-way through his fifth year in office, it would perhaps be fitting to ex- amine the short prayer which has helped to carry him through to the present, the prayer with which he attempts to crash through the barriers of flesh and finitude in his quest for communion with God.

To imagine the tone of voice with which the President delivers his prayers one need only read the closing sentences as Mrs. Eisen- hower reports them. "You take over from here," the President says aloud. "Good night, Lord, I'm going to sleep." The President's tone is clear: if one were to substitute the word "James" for "Lord" one might hear the voice of a man calling not to his God, but to his valet. "I have polished my left shoe, James. As for the right, well—you take over from here. Good night, James, I'm going to sleep." The tone is a chummy one, as opposed, say, to the tone taken toward Cinderella by her despised stepsisters; "Sweep the floor, wash the clothes, polish the shoes, and then get the hell out of here . . ." The President addresses his valet as he does his God, as an equal. Where the theologian, Martin Buber, has suggested that man is related to his God as an "I" to a "Thou," Mr. Eisenhower's tone would seem

to suggest that the I and Thou of Buber's thinking be converted into the more democratic You and Me.

"Lord," the President's prayer begins, "I want to thank You for helping me today. You really stuck by me . . ." The Lord is not so much his shepherd, Mr. Eisenhower indicates, as his helper, his *aide-de-camp*. He is a kind of celestial Secretary of State, and one who apparently knows his place in the chain of command; it is quite clearly stated, "You stuck by me" and not "I stuck by you." The prayer continues, "I know, Lord, that I muffed a few and I'm sorry about that. But both the ones we did all right and the ones we muffed I am turning them all over to You." A slight ambiguity exists around the words "a few." A few what? Does Mr. Eisenhower mean decisions? And how many are a few? If, as we are led to suspect, the Lord works hand in hand with the President, then such questions are academic, for God would doubtless know precisely the decisions to which Mr. Eisenhower is alluding. Of course one cannot dismiss the possibility that all this mystery is intentional, as a sort of security measure. You will remember that Mrs. Eisenhower is no more than a few feet away, listening to every word.

Uncertain as he may *appear* as to the nature and number of the decisions, the President leaves no doubt as to how the decisions are formulated: it is a bipartisan set-up, the President and God working together right down the line. What seems unusual about the procedure is that while both share the responsibility for the successful ventures ("the ones we did all right"), the burden of failure falls rather singly upon the Shoulders of the Lord. Though admittedly "sorry" about muffing a few, Mr. Eisenhower informs the Lord point-blank, "I am turning them all over to You." Now nobility in defeat is a glorious spectacle—it is what immortalizes Oedipus and Othello, Socrates and Lincoln. The vision of a soul alone in the

night confessing to his God that he has failed Him is in a way the tragic vision, the supreme gesture of humility and courage. However, to admit failure is one thing, and to sneak out on a partnership is another. If the once flourishing business of X and Y suddenly tumbles into bankruptcy, Y does not expect that X will put on his hat and gloves and walk out muttering, "I'll see you—you pay the creditors whatever it is we owe them. Bye, bye . . ." One should think that X and Y must pay the debts just as they had shared the profits: together.

Perhaps it is unjust to draw any implications from an analogy which is, I fear, not entirely appropriate. For instance, in the X and Y example it is assumed that the initial capital for the enterprise had been supplied equally by both X *and* Y; now whether or not this is analogous to the Eisenhower-God relationship is uncertain—as yet evidence released by the White House staff is not sufficient for any but the most zealous to conclude that the Chief Executive shared in either the planning or execution of the Original Creation. Moreover, I am confident that a religious consciousness like the President's, which manifests itself in prayer and good works, would be outraged at the notion of God as a partner; though the Lord is addressed as *an equal*, and functions as *a helper*, His ultimate powers, Mr. Eisenhower well knows, are those of *a superior*. Surely the President would be the first to remind us that he himself is in the service of the Lord, as are we all. The vital question then is not the responsibility of partner to partner but of subordinate to superior, worker to boss. Perhaps Mr. Eisenhower's own history, as a halfback on the West Point football team and as a professional soldier, can provide analogies more appropriate to this problem.

Imagine, for example, that the Army football team has been beaten by Navy, 56 to 0; the quarterback returns to the bench and explains to the Coach, "Coach, I muffed a few and I'm sorry about that. But both the ones we did all right and the ones we muffed I am

turning them all over to You." Or picture a Colonel whose regiment has suffered disastrous and unpardonable losses; he is summoned to divisional headquarters; he enters the office of the Commanding General; he salutes; he speaks: "Sir, I muffed a few and I'm sorry about that," he admits. "But," he adds quickly, "both the ones we did all right and the ones we muffed I am turning them all over to You."

Anyone who has ever played left guard for a grade school team or toiled at KP in a company mess hall could conjecture the answer of both coach and general; as for the reaction of the Lord to so novel a concept of responsibility, my limited acquaintance with historical theology does not permit of conjecture. Off the cuff, I imagine it might strain even *His* infinite mercy.

Mrs. Eisenhower reports that when the President ends his prayer, "he just turns over and goes to sleep." I suspect at this point the First Lady is not telling the whole truth, her own humility in operation now. The way I figure it, when the President has finished his man-to-man talk with the Lord, he removes his gaze from the ceiling of the White House bedroom, pauses for a moment, and then looking upward again, says, "And now, Lord, Mrs. Eisenhower would like a few words with You." And then with that grin of his he turns to the First Lady and whispers, "He's ready . . ."

Arthur Miller's Conscience

RICHARD ROVERE

June 17, 1957

In its first decade, The New Republic *assisted the birth of the modern ideal of free speech. But it doesn't follow that a civil libertarian magazine must endorse every dissident who invokes the Founding Fathers. When Richard Rovere wrote this essay, he was at work on his devastating biography of Joseph McCarthy. His animus toward the accuser didn't lead him toward total sympathy for the accused. Arthur Miller had achieved the status of martyr on the basis of his refusal to "name names." Rovere shows the hollowness of this principle and the great flaw at the center of Miller's work. His essay is a case study in the construction of fine distinctions and their necessity.*

"I will protect my sense of myself," Arthur Miller told the House Committee on Un-American Activities when he refused to identify some writers who had once been Communists. "I could not use the name of another person and bring trouble on him." The refusal brought Miller a conviction for contempt of Congress from a judge who found his motives "commendable" but his action legally indefensible.

A writer's sense of himself is to be projected as well as protected. It becomes, through publication and production, a rather public

affair. For this and other reasons, it is fitting that what Miller saw as the testing of his integrity—the challenge to his sense of himself—was a question involving not himself but others. Of himself, he had talked freely, not to say garrulously. He chatted, almost gaily, about his views in the Thirties, his views in the Forties, his views in the Fifties, about Ezra Pound and Elia Kazan and other notables, about the Smith Act and Congressional investigations and all manner of things. When he was asked why he wrote "so morbidly, so sadly," he responded patiently and courteously, rather as if it were the "question period" following a paid lecture to a ladies club. His self-esteem was offended only when he was asked to identify others.

Thus, one might say, it was really a social or political ethic that he was defending, while of his sense of himself he gave freely. In legal terms, this might be a quibble, for there is no reason why a man should not have a right to his own definition of self-respect. In a literary sense, it is not a quibble, for Miller is a writer of a particular sort, and it was in character for him to see things this way. He is, basically, a political, or "socially conscious" writer. He is a distinguished survivor of the Thirties, and his values derive mostly from that decade. He is not much of a hand at exploring or exploiting his own consciousness. He is not inward. He writes at times with what may be a matchless power in the American theatre today, but not with a style of his own, and those who see his plays can leave them with little or no sense of the author as a character. He is not, in fact, much concerned with individuality of any sort. This is not an adverse judgment; it is a distinction, or an attempt at one. What interests Miller and what he can often convey with force is the crushing impact of society upon its members. His human beings are always on the anvil, awaiting the hammer, and the act that landed him in his present trouble was an attempt to shield two or three of them from the blow. (It was, of course, a symbolic act, a gesture, for Miller knew very well that the committee knew all about the

men he was asked to identify. He could not really shield; he could only assert the shielding principle.) What he was protecting was, in any case, a self-esteem that rested upon a social rule or principle or ethic.

One could almost say that Miller's sense of himself *is* the principle that holds "informing" to be the ultimate in human wickedness. It is certainly a recurrent theme in his writing. In *The Crucible*, his play about the Salem witchcraft trials, his own case is so strikingly paralleled as to lend color—though doubtless not truth—to the view that his performance in Washington was a case of life paying art the sincere flattery of imitation. To save his life, John Proctor, the hero, makes a compromise with the truth. He confesses, falsely, to having trafficked with Satan. "Did you see the Devil?" the prosecutor asks him. "I did," Proctor says. He recognizes the character of his act, but this affects him little. "Good, then—it is evil, and I do it," he says to his wife, who is shocked. He has reasoned that a few more years on earth are worth this betrayal of his sense of himself. (It is not to be concluded that Proctor's concession to the mad conformity of the time parallels Miller's testimony, for Proctor had never in fact seen the devil, whereas Miller had in fact seen Communists.) The prosecutor will not let him off with mere self-incrimination. He wants names; the names of those Proctor has seen with the Devil. Proctor refuses; does not balk at a self-serving lie, but a self-serving lie that involves others will not cross his lips. "I speak my own sins," he says, either metaphorically or hypocritically, since the sins in question are a fiction. "I cannot judge another. I have no tongue for it." He is hanged, a martyr.

In his latest play, *A View from the Bridge*, Miller returns to the theme, this time with immense wrath. He holds that the conscience—indeed humanity itself—is put to the final test when a man is asked to "inform." Eddie, a longshoreman in the grip of a terrible passion for his teen-age niece, receives generous amounts of love and sym-

pathy from those around him until his monstrous desire goads him into tipping off the Immigration officers to the illegal presence in his home of a pair of aliens. His lust for the child has had dreadful consequences for the girl herself, for the youth she wishes to marry, and for Eddie's wife. It has destroyed Eddie's sense of himself and made a brute of him. Yet up to the moment he "informs" he gets the therapy of affection and understanding from those he has hurt the most. But once he turns in the aliens, he is lost; he crosses the last threshold of iniquity. "In the garbage can he belongs," his wife says. "Nobody is gonna talk to him again if he lives to a hundred."

A View from the Bridge is not a very lucid play, and it may be that Miller, for all of his wrath, takes a somewhat less simple view of the problem of the informer than he does in *The Crucible*. There is a closing scene in which he appears to be saying that even this terrible transgression may be understood and dealt with in terms other than those employed by Murder, Incorporated. I think, though, that the basic principle for which Miller speaks is far commoner in Eddie's and our world than it could have been in John Proctor's. The morality that supports it is post-Darwinian. It is more available to those not bound by the Christian view of the soul's infinite preciousness or of the body as a temple than it could have been to pre-Darwinian society. Today, in most Western countries, ethics derive mainly from society and almost all values are social. What we do to and with ourselves is thought to be our own affair and thus not, in most circumstances, a matter that involves morality at all. People will be found to say that suicide, for a man or woman with few obligations to others, should not be judged harshly, while the old sanctions on murder remain. Masochism is in one moral category, sadism in another. Masturbation receives a tolerance that fornication does not quite receive. A man's person and his "sense of himself" are disposable assets, provided he chooses to see them that way; sin is only possible when we involve others. Thus, Arthur

Miller's John Proctor was a modern man when, after lying about his relations with the Devil, he said, "God in heaven, what is John Proctor, what is John Proctor? I think it is honest, I think so. I am no saint." It is doubtful if anyone in the 17th Century could have spoken that way. The real John Proctor surely thought he had an immortal soul, and if he had used the word "honest" at all, it would not have been in the sophisticated way in which Miller had him use it. He might have weakened sufficiently to lie about himself and the Devil, but he would surely not have said it was "honest" to do so or reasoned that it didn't really matter because he was only a speck of dust. He was speaking for the social ethic which is Arthur Miller's—and he resisted just where Miller did, at "informing."

It is, I think, useful to look rather closely at Miller's social ethic and at what he has been saying about the problems of conscience, for circumstances have conspired to make him the leading symbol of the militant, risk-taking conscience in this period. I do not wish to quarrel with the whole of his morality, for much of it I share—as do, I suppose, most people who have not found it possible to accept any of the revealed religions. Moreover, I believe, as Judge McLaughlin did, that the action Miller took before the committee was a courageous one. Nevertheless, I think that behind the action and behind Miller's defense of it there is a certain amount of moral and political confusion. If I am right, then we ought to set about examining it, lest conscience and political morality come to be seen entirely in terms of "naming names"—a simplification which the House Un-American Activities Committee seems eager to foist upon us and which Miller, too, evidently accepts.

A healthy conscience, Miller seems to be saying, can stand anything but "informing." On the other hand, it makes little political sense and not a great deal of moral sense. Not all "informing"

is bad, and not all of it is despised by the people who invariably speak of it as despicable. The question of guilt is relevant. My wife and I, for example, instruct our children not to tattle on one another. I am fairly certain, though, that if either of us saw a hit-and-run driver knock over a child or even a dog, we would, if we could, take down the man's license number and turn him in to the police. Even in the case of children, we have found it necessary to modify the rule so that we may be quickly advised if anyone is in serious danger of hurting himself or another. (The *social* principle again.) Proctor, I think, was not stating a fact when he said, "I cannot judge another"—nor was Miller when he said substantially the same thing. For the decision *not* to inform involves judging others. "They think to go like saints," Proctor said of those he claimed he could not judge, and Miller must have had something of the sort in mind about the writers he refused to discuss. He reasoned, no doubt, that their impulses were noble and that they had sought to do good in the world. We refuse to inform, I believe, either when we decide that those whose names we are asked to reveal are guilty of no wrong or when we perceive that what they have done is no worse than what we ourselves have often done. Wherever their offenses are clearly worse—as in the case of a hit-and-run driver or a spy or a thief—we drop the ban.

If the position taken by Miller were in all cases right, then it would seem wise to supplement the Fifth Amendment with one holding that no man could be required to incriminate another. If this were done, the whole machinery of law enforcement would collapse; it would be simply impossible to determine the facts about a crime. Of course, Congressional committees are not courts, and it might be held that such a rule would be useful in their proceedings. It would be useful only if we wished to destroy the investigative power. For we live, after all, in a community, in the midst of other people, and all of our problems—certainly all of those with which

Congress has a legitimate concern—involve others. It is rarely possible to conduct a serious inquiry of any sort without talking about other people and without running the risk of saying something that would hurt them. We can honor the conscience that says, "I speak my own sins. I cannot judge another," but those of us who accept any principle of social organization and certainly those of us who believe that our present social order, whatever changes it may stand in need of, is worth preserving cannot make a universal principle of refusing to inform. If any agency of the community is authorized to undertake a serious investigation of any of our common problems, then the identities of others—*names*—are of great importance. What would be the point of investigating, say, industrial espionage if the labor spies subpoenaed refused to identify their employers? What would be the point of investigating the Dixon-Yates contract if it were impossible to learn the identity of the businessmen and government officials involved?

The joker, the source of much present confusion, lies in the matter of *seriousness*. Miller and his attorneys have argued that the names of the writers Miller had known were not relevant to the legislation on passports the Committee was supposed to be studying. This would certainly seem to be the case, and one may regret that Judge McLaughlin did not accept this argument and acquit Miller on the strength of it. Nevertheless, the argument really fudges the central issue, which is that the Committee wasn't really investigating passport abuses at all when it called Miller before it. It was only pretending to do so. The rambling talk of its members with Miller was basically frivolous, and the Un-American Activities Committee has almost always lacked seriousness. In this case, as Mary McCarthy has pointed out, the most that it wanted from Miller was to have him agree to its procedure of testing the good faith of witnesses by

their willingness to produce names. It was on this that Miller was morally justified in his refusal.

Still, Miller's principle, the social ethic he was defending, cannot be made a universal rule or a political right. For it is one thing to say in *The New Republic* that a committee is frivolous or mischievous and another to assert before the law that such a judgment gives a witness the right to stand mute without being held in contempt. As matters stand today, Miller was plainly in contempt. At one point in *The Crucible*, John Proctor is called upon to justify his failure to attend the church of the Reverend Mr. Parris and to have his children baptized by that divine. He replies that he disapproves of the clergyman. "I see no light of God in that man," he says. "That is not for you to decide," he is told. "The man is ordained, therefore the light of God is in him." And this, of course, is the way the world is. In a free society, any one of us may arrive at and freely express a judgment about the competence of duly constituted authority. But in an orderly society, no one of us can expect the protection of the law whenever we decide that a particular authority is unworthy of our cooperation. We may stand by the decision, and we may seek the law's protection, but we cannot expect it as a matter of right. There are many courses of action that may have a sanction in morality and none whatever in law.

Yet the law is intended to be, among other things, a codification of morality, and we cannot be pleased with the thought that a man should be penalized for an act of conscience—even when his conscience may seem not as fully informed by reason as it ought to be. In a much more serious matter, war, we excuse from participation those who say their consciences will permit them no part in it. One of the reasons the order of American society seems worth preserving is that it allows, on the whole, a free play to the individual's moral judgments. In recent years, Congressional committees have posed the largest single threat to this freedom. The issues have often

been confused by the bad faith of witnesses on the one hand and committee members on the other. Still and all, the problem is a real one, as the Miller case shows. If there is not sufficient latitude for conscience in the law, then there ought to be. It would be unrealistic, I think, simply to permit anyone who chooses to withhold whatever information he chooses. The Fifth Amendment seems to go as far as is generally justified in this direction. Changes in committee procedures have often been urged, but it is doubtful if much clarification of a problem such as this can be written into rules and by-laws. The problem is essentially one of discretion and measurement; it is, in other words, the most difficult sort of problem and one of the kind that has, customarily, been dealt with by the establishment of broad and morally informed judicial doctrines. It is surely to be hoped that in the several cases, including Arthur Miller's, now in one stage or another of review, the courts will find a way of setting forth a realistic and workable charter for the modern conscience.

PART SIX
1960s

"There is a 'new frontier' as Senator Kennedy said in his acceptance speech, unlimited by national frontiers, unenclosed by the space above us, unapproachable by narrow paths of the past—but there for discovery and mastery by those who have the requisite intelligence, courage and imagination."

THE EDITORS
JULY 25, 1960

Candidate on the Eve

Liberalism Without Tears

JAMES MACGREGOR BURNS

October 31, 1960

John F. Kennedy made a small career of winning over New Republic *readers. He understood that he needed to overcome the doubts liberals harbored about his ideological bona fides. The young senator wrote the occasional piece for the magazine. He made an ostentatious show of bounding down the steps of Air Force One with a copy of it stashed under his arm.*

It is striking that this hagiographic essay would predict Kennedy's martyrdom with such precision. Burns was a committed court historian of Camelot, so the fact that he ardently vouches for Kennedy isn't terribly surprising. What makes the essay significant is the way in which it channels and distills the liberalism of the times: hardheaded, self-confident, and technocratic.

Two years ago, when I began a full-scale study of John Kennedy as a Presidential aspirant, I knew him to be a superb campaigner, a wholly engaging person, and a solid supporter of the Roosevelt-Truman economic policies, but I was uncertain about the scope, intensity and durability of his liberalism. Clearly he wanted bread-

and-butter liberalism, but on our great moral heritage of civil liberties and civil rights his position was not so clear to me.

A year ago, on finishing that study, I concluded that he had moved into a position of solid intellectual and political commitment to liberalism in its broadest terms, including civil liberties and civil rights. The haunting question remained: could he summon zeal and warmth and emotional commitment in defense of the positions he seemed to have arrived at through wholly cerebral processes? To the struggle for American survival Kennedy would bring bravery and wisdom, I felt, but whether he would bring passion and power would depend on his making a commitment not only of mind but of heart.

Today, on the eve of America's great choice, I believe that Kennedy in his campaign has deliberately prepared the way for the most consistently and comprehensively liberal Administration in the history of the country. Whether in the end he will, if elected, produce such an Administration is another question turning on the nature of the next Congress, events abroad, and other factors. But of Kennedy's absolute determination to stand behind liberal policies, I have no question.

For he has shown that determination is the sternest test a politician can face—the crucible of a presidential campaign. As in all campaigns, there have been many advisers within the party as well as outside urging Kennedy to soften his line, to make concessions. He has not heeded this advice. Quite deliberately he has followed the Roosevelt-Truman-Stevenson tradition in the party, and where he has departed from his predecessors it has been to take a stronger line rather than a weaker one, as in the case of medical care, aid to education, and civil rights.

A politician's beliefs can be tested by two measures—by what he says, and by the kind of people he gathers around him. On both these scores Kennedy has come through with very high marks.

Consider the Democratic platform. Kennedy's strength in the

convention last July was such that he directly and indirectly dominated the writing of the platform. It is his program. Moreover, the Kennedy forces were so sure several weeks before the convention of winning the nomination that they were in a position to shape the platform to the needs less of a convention victory than of a final election victory. The fact that Kennedy demanded and received an emphatically liberal platform as the basis for his Presidential campaign is proof that he considers liberalism both politically wise and morally essential. It is instructive to compare, in this regard, the enormous concessions that Franklin Roosevelt made to conservatism when campaigning during the depression in 1932. And if Kennedy considers liberalism to be good politics for winning the Presidency, he would also consider it to be good politics in administering the Presidency, especially with Nelson Rockefeller looming as the most likely Republican candidate in 1964.

Perhaps an even better test of the durability of Kennedy's liberalism is the type of men he has gathered around him. As in the case of FDR, they are of two basic types—men of thought who advise him on policy and men of action who conduct the practical work of vote-getting. Also as in the case of Roosevelt, the men of thought have the decisive impact on policies and the men of action have the larger role in electioneering. Although one of the unique and impressive aspects of Kennedy's group is that the men of thought are also men of action, the crucial point is that the campaign technicians are not modifying policy to meet the needs of some special section such as the South or some special interest such as those who wish to boost tariffs. The liberal advisers, with their stable of intellectuals, are securely in control of policy-making, under Senator Kennedy's close direction.

But far more important than a candidate's immediate entourage—since he can, after all, change its make-up overnight should he wish—is the nature of his political allies, especially those

who have their independent bases of power. I refer to the Senators and Representatives and pressure group leaders with whom the candidate has been conducting his campaign and with whom he would share power and influence in the job of governing the nation. These are the liberal Representatives such as Chester Bowles of Connecticut, Stewart Udall of Arizona, John Brademas of Indiana, Frank Thompson of New Jersey, Richard Bolling of Missouri, Edith Green of Oregon and scores of others. Kennedy's close political associates in the Senate have been Paul Douglas, Joseph Clark, Henry Jackson and (except during their struggle in the primaries) Hubert Humphrey. The leaders he conspicuously summoned to his councils at Hyannisport after the convention were Adlai Stevenson, Humphrey, Averell Harriman, and Mennen Williams. The group leaders he has been doing political business with are officials of the AFL-CIO, the NAACP, the Farmers Union and other such liberal organizations.

Intellectuals watching a politician in action like to ask: what does the man really believe, in the innermost recesses of his mind? The question is unrealistic. His political personality and outlook are defined in large part by the men to whom he turns for counsel, for then he establishes personal obligations to them and they can expect continuing access to him. If Kennedy leans so publicly on liberal advisers such as Archibald Cox, and on liberal aides such as Theodore Sorensen, during the campaign, when the Republicans try to make political capital out of it, should he lean any less on these advisers and aides once he has attained the relative security of office?

Is It the Ghostwriters?

Some would dismiss all this with the cynical observation that Kennedy has purchased his liberal image by hiring scores of liberal advisers and speech writers. Many have wondered whether Kennedy

had simply tested the political winds and trimmed his craft in a way that seemed most likely to catch the popular breezes and carry him to the White House. His conduct of the campaign has, I think, stilled this suspicion. He has repeatedly departed from his prepared texts not to soften his liberal stand but to emphasize it. The TV debates, above all, have shown how false is the claim that Kennedy was dependent on his ghostwriters. That this man, terribly alone before 60 million viewers and listeners, could so decisively have spilled out a cataract of names, statements, legislation, dates, quotations and doctrine was illustrative of the enormous reservoir of information and ideas within that bright and capacious mind. He has shown himself deserving of Walter Lippmann's recent description: "It has been truly impressive to see the precision of Mr. Kennedy's mind, his immense command of the facts, his instinct for the crucial point, his singular lack of demagoguery and sloganeering, his intense concern and interest in the subject itself, the stability and steadfastness of his nerves and his coolness and his courage."

I do not pretend that the proof I am offering is anything new. Quite the contrary, all the items that I have mentioned—the nature of the Democratic platform, the kind of political associates Kennedy has gathered around himself, his articulation of liberal ideas under fire—are well known to anyone who has watched his performance. And here lies the supreme irony of the role of liberals in this campaign. For although they know all this, although Kennedy has taken a liberal posture few would have dreamed likely three years ago, many liberals are in effect still sitting out the 1960 election.

Most of these will vote for Kennedy. Some will even give money to the national campaign or put Kennedy bumper strips on their car. But they will vote for Kennedy largely in order to vote against Nixon, if they show up at the polls at all. And any contribution they make to the campaign will be a kind of reflex action set off by the political sights and smells and sounds of October during the qua-

drennial election year, rather than an act produced by their own commitment to a candidate. The question remains: why?

The answer lies in part, I think, in the kind of men who are running Kennedy's campaign. They are no more—and no less—ideological than Jim Farley or Hugh Johnson were, but whereas Johnson or Farley could deliver themselves of a good New Deal speech when need be, Kennedy's election technicians hardly bother. And certainly they are a tough, cool bunch lacking in the kind of humility that Nixon has affected so successfully. Sometimes the toughness and coolness make one wince a bit; in August, when the failure of the special session of Congress and other campaign woes had lowered morale in the Kennedy camp, his aides were saying that morale would be at a low ebb during the next month but would then start rising—probably the first case in politics of built-in, predicted and automatically compensated pessimism.

Another reason for the apathy of some liberals is that Kennedy still makes no symbolic concession to them in the image he creates. He deals in specifics rather than in generalities. Occasionally he gets off a somewhat moving sentence as he did last month when he told the Liberal Party meeting that "liberalism is not so much a party creed or a set of fixed platform promises as it is an attitude of mind and heart, a faith in man's ability through the experience of his reason and judgment to increase for himself and his fellow men the amount of justice and freedom and progress which all human life deserves." Yet one feels that such a sentence *was* probably ghost-written and that the real Kennedy shows most clearly in his handling of concrete problems. One misses in Kennedy, too, traits that Nixon has mastered—oversimplification, timing for emphasis, repetition, the use of cloudy symbols to obscure positions. One almost wishes that Kennedy would "ham it up"—that he would give the crowd a really big wave of his hand, that he would give a baby—or even a woman voter—a really lusty kiss, that he would end a telling

point in such a way that the crowd would get a chance to give a big cheer, that when suggesting that we leave Mr. Truman's profanity up to Mrs. Truman he would do so with a broad smile so that we could be sure he was in on the joke too. But this is not Kennedy's way—nor is it Kennedy's way to manufacture an artificial and meretricious political style. Hence we simply have to face the fact that he may never offer liberals anything like Wilson's magnificent rhetoric or Roosevelt's warming eloquence or even the "give-'em-hell" bombast of Truman.

No Tragic Hero

But the reasons for some liberals' noncommitment to the Democratic candidate go deeper than all this. Their main difficulty with Kennedy, I think, is that he has been too successful—heir both to wealth and great political opportunity, a hero in the war, a winner in all his political battles, the possessor of glamor and good looks and of great political qualities that seem not earned but almost magically endowed. The trouble with Kennedy is that he lacks liberalism's tragic quality.

By liberalism's tragic quality I mean that so many of its finest and most passionate causes, like Spain, have been lost causes; that so many liberal heroes have had their tragic denouements, as in Lincoln's assassination, Wilson's defeat on the League, and Roosevelt's death in office; that the pursuit of great causes has often been far more rewarding emotionally than their realization; that the great achievements of liberalism have often ended, desirable though they might be, in labyrinthine legislation and huge social-welfare bureaucracies, as in the case of social security or the TVA.

Kennedy simply is—or at least has been—too successful. If he should die tomorrow in a plane crash, he would become at once a liberal martyr, for the liberal publicists of the land would rush to construct a hero out of a young man of wealth who ran the most

liberal campaign in history, or out of the young Catholic who defied the forces of bigotry, or out of the wounded P-T boat commander who would not risk the life of a single American for the defense of the strategically worthless islands of Quemoy and Matsu. But Kennedy today, in sharp contrast to Stevenson, who from the beginning in 1952 and all through 1956 seemed to be fighting impossible odds, gives the impression of being too much in control of his fortunes and too much destined for success. His seems to be a liberalism without tears.

It would be easy to say that Kennedy in office will develop the passionate, evocative qualities that this brand of liberalism demands, just as Franklin Roosevelt did in the White House. For the Presidential office does work its magic on a man. But in Kennedy's case such a prediction might not come true. For he is a different type of liberal from any we have known. He is in love not with lost causes, not with passionate evocations, not with insuperable difficulties; he is in love with political effectiveness.

In Kennedy, American liberals are encountering a different kind of leader—one who missed out on much of the rhetoric of the liberalism of the 1930's but who instead constructed his liberalism slowly and belatedly and painstakingly out of his own 14 years in politics, in years of parliamentary struggle and legislative draftsmanship. His liberalism may be all the more sound and durable precisely because it was so constructed. But it is not Stevenson's liberalism, nor Truman's. It is his.

In office he would establish, I think, a kind of policy machine—with all the efficiency, productivity and dispassion that such a term denotes. Because government would have to act quickly along many lines across broad fronts, a Kennedy Administration would be obsessed with the formulation and execution of one specific program after another. He knows, I think, that the liberal agenda of the 1960's will be executed not simply in a dramatic "100 days"

but in a thousand days of persistent action, that the campaign to get the country moving forward will be fought in hundreds of little, drawn-out battles in Congressional committees and cloakrooms, in government bureaus and United States embassies abroad. Such a far-flung campaign will indeed call for a policy machine powered by a steady flow of Presidential authority. But of the liberal direction of that machine there can now be no doubt.

Some liberals might find such an Administration a bit dull, especially if it were successful; few of us will be thrilled by the policy machine. Yet I think there are many of us too who feel that action is so vitally needed, so long overdue, on so many wide fronts of national purpose that we might be willing to sacrifice some of the intoxication of liberal evocations—as long as we knew that federal aid to education, an FEPC, a start on disarmament, more generous immigration policies, and all the rest, were actually going into effect.

Kennedy in his own way has shown his intense commitment to liberalism. When will the hold-out liberals show their political commitment to him?

A Jolly Good Fellini

STANLEY KAUFFMANN

July 13, 1963

Stanley Kauffmann had the greatest run of any American film critic. He joined the magazine in 1958 and, with only a few exceptional bouts of illness and a short detour at The New York Times, *never failed to hand in his weekly review for the next fifty-five years. His sensibility and tastes hardly changed over time, which made him an incredibly reliable and beloved guide to the movies. He made the case for films that most readers would not have encountered without his steady hand pointing them to the theater. Because he largely wrote about the films that he cared to see—for the most part skipping over the popcorn blockbuster—he never suffered the disillusionment that inevitably damages the critical facilities of most reviewers.*

Like most autobiographical works Federico Fellini's scintillating new film *8½* reveals something more than its author intended. Begin with the title. It derives from the fact that, up to now, Fellini has made six full-length films and has contributed three "half" segments to anthology films. Before we step into the theater, the title tells us that he is clever, and that he sees the film as part of his personal history. It also tells us that he found himself stuck for a title.

The story is about a director stuck for a story, an artist in a cre-

ative slump, in the familiar *nel mezzo del cammin* crisis. The director is at a luxurious spa hotel trying to straighten out the script for his next job. With him is his writer, a fair sample of the intellectual *manqué* who clings to much European film-making as both a suppliant and a hair-shirt. The director is joined by his married mistress who stays at a neighboring hotel. His producer arrives with entourage. His wife arrives and is not deceived about the mistress. One of the best moments is his lying about the mistress to his wife with the face of truth and the wife's knowledge of this and her disgust—principally that he can sound so truthful when he lies; and—one step beyond this—*his* acknowledge of *her* knowledge. His mind accommodates this with a perception of the gulf between moral myth and moral fact, then it flies off into a harem-scene fantasy. The film is thickly laced with fantasy—with recollection, projection, wish fulfillment, and a dream girl who reappears throughout. The director, harassed by his producer to come to a decision after months of vacillation about script and casting, is paralyzed by apathy and ennui. At last he decides to abandon the film. Then, in further fantasy, he faces all the facts of his past and present, accepts them, and decides to make a film out of the very elements we have been witnessing.

In terms of execution I cannot remember a more brilliant film. In image, visual ingenuity, subtlety of pace, sardonic humor, it is stunning. We see a wizard at the height of his wizardry, and it has something of the effect, given in contemporary reports, of Liszt playing Liszt. The film opens in a silent dream as the director suffocates in a traffic-jam car while impassive faces in other cars watch or don't watch. He floats up through the sun roof into the sky, and in a perspective like that of Dali's *Crucifixion*, we look down past his leg along a kite-rope attached to it, held by a man on a beach. He crashes—and wakes in his hotel bed.

The telling imaginative touches keep tumbling out one after an-

other. In a dream his dead mother suddenly kisses him passionately on the mouth; when she pulls her head away, it is his wife. When his writer quotes one too many pearls of wisdom, the director wearily lifts a finger in command, two bravoes suddenly appear, slip a black hood over the writer's head and hang him on the spot. When certain nonsense syllables remind him of his childhood, we go back to his family's house—as spacious and safe as it seemed to him then— when he and his cousins were treading grapes in a tun, then were washed and carried off to bed in clean sheets in their nurses' arms. There is no point in a catalogue; the effects are many and marvelous. The dreams do not fade out and in, they are part of the fabric. If it takes a moment to decide whether what is happening is dream or not, the confusion is probably part of the design.

But when we ask what the theme of the film really is, what the director learns from his crisis about his crisis, what the resolution really means, the answers are less satisfactory. He says at the end, as he watches the dramatis personae of his life dancing around a circus ring, that he has learned to live with his past. There is little indication up to now that he was not living with it; the resolution seems a somewhat hollow convenience to end the film pleasantly. (It could easily be argued that his fantasy suicide near the end ought to be the true end and is the logical conclusion: that the resolved, happy ending in reality is itself a fantasy.) The genuine *raison d'être* of the picture is in the opportunities it provides for Fellini. The reason that certain operas exist is that certain singers existed who could sing them. The prime reason for this film is that Fellini is a prodigious film virtuoso.

What *8½* reveals that is perhaps more than Fellini intended is this: it is not about a creative crisis, encountered and survived; it reveals a continuing movement in his work that was first clear in *La Dolce Vita*. Up to then, there had been a generally consistent welding of method and meaning, as in *I Vitelloni* (which I still like best). In

Dolce Vita there is a strong sense of theme used as opportunity rather than as concern. This sense was strengthened in his section of *Boccaccio '70*. It flowers in *8½*. I offer this observation in appraisal, not derogation. Virtuosity has an esthetic and value of its own, whether it is coloratura singing or fantastic pirouettes or *trompe-l'oeil* painting, and when it is as overwhelming as Fellini's virtuosity, one can be moved by it very nearly as much as by art that "says" something. In fact I don't think that *8½* "says" very much, but it is breathtaking to watch. One doesn't come away from it as from, say, the best Bergman or Renoir—with a continuing, immanent experience; one has to think *back* to it and remember the effect. But that is easy, for the experience is unforgettable.

Star billing ought to go to the director of photography, Gianni di Venanzo, and the editor, Leo Catozzo, who have wrought assorted miracles. Playing the director, Marcello Mastroianni invests the role with presence and portent. *Divorce—Italian Style* clarified to many what was apparent years ago to some: that he is a skillful comedian. Here he interweaves that skill with his ability to touch the commonplaces of life with grave poetry. Sandra Milo makes a serious-silly pneumatic mistress, Anouk Aimee convinces as the wife, and the rest of the large company confirm another of Fellini's gifts: his ability to cast even the smallest parts perfectly.

The March on Washington

MURRAY KEMPTON

September 14, 1963

Murray Kempton despised Washington, so he aborted his tour at The New Re-
public *after one year—a shame, since he was the master of opinionated reporting, a
style particularly suited to the magazine. But it is fitting that his year at* The New
Republic *coincided with King's march. During the fifties, Kempton had knocked
on doors across the deepest South and passionately chronicled the earliest years of
the civil rights struggle. As much as any Northern journalist, he had hurled himself
into the story and supplied it with urgency. (There was also a touch of the Northern
liberal's condescension in his work, too, as you will see here.) In* The New Re-
public's *obituary for Kempton, who passed in 1997, Ronald Steel called him "the
Anglican priest of New York City, periodically rising to awe-inspiring levels of moral
indignation over the transgressions of the mighty and the sufferings of the powerless."*

The most consistent quality of white America's experience with the
Negro is that almost nothing happens that we—or perhaps even
he—expects to have happen. Faithful to that tradition, Washington
waited most of the summer for the avenging Negro army to march
on Washington for Jobs and Freedom; what came was the largest
religious pilgrimage of Americans that any of us is ever likely to see.

When it was over, Malcolm X, the Muslim, was observed in the lobby of the Statler. It had, he conceded, been something of a show. "Kennedy," said Malcolm X, "should win the Academy Award— for direction." Yet while the President may have triumphed as director-manipulator, he was also deftly manipulated by those whom he strove to direct.

"When the Negro leaders announced the march, the President asked them to call it off," Bayard Rustin, its manager, remembered the next day. "When they thumbed—when they told him they wouldn't—he almost smothered us. We had to keep raising our demands . . . to keep him from getting ahead of us."

Rustin and A. Philip Randolph are men who had to learn long ago that in order to handle they must first permit themselves to be handled. The moment in that afternoon which most strained belief was near its end, when Rustin led the assemblage in a mass pledge never to cease until they had won their demands. A radical pacifist, every sentence punctuated by his upraised hand, was calling for a $2 an hour minimum wage. Every television camera at the disposal of the networks was upon him. No expression one-tenth so radical has ever been seen or heard by so many Americans.

To produce this scene had taken some delicate maneuvering. Randolph called the march last spring at a moment when the civil rights groups had fallen into a particularly painful season of personal rancor. Randolph is unique because he accepts everyone in a movement whose members do not always accept one another. His first support came from the non-violent actionists; they hoped for passionate protests. That prospect was Randolph's weapon; the moderates had to come in or be defenseless against embarrassing disorder. Randolph welcomed them not just with benevolence but with genuine gratitude. When President Kennedy expressed his doubts, Randolph answered that some demonstration was unavoidable and that what had to be done was to make it orderly.

It was the best appeal that feeling could make to calculation. The White House knew that the ordinary Negro cherishes the Kennedy brothers and that the larger the assemblage the better disposed it would be not to embarrass them. When the President finally mentioned the march in public, he issued something as close as possible to a social invitation.

No labor leader since John L. Lewis in 1933 has succeeded in employing the President of the United States as an organizer. Even Lewis only sent his organizers about the pits telling the miners that the President wanted them to join the union, and was careful never to tell Mr. Roosevelt about it. Randolph got his President live, whole and direct.

If the march was important, it was because it represented an acceptance of the Negro revolt as part of the American myth, and so an acceptance of the revolutionaries into the American establishment. That acceptance, of course, carries the hope that the Negro revolt will stop where it is. Yet that acceptance is also the most powerful incentive and assurance that the revolt will continue. The children from Wilmington, North Carolina, climbed back on their buses with the shining memory of a moment when they marched with all America—a memory to sustain them when they return to march alone. So it was, too, for all the others who came from Birmingham, Montgomery, Danville, Gadsden and Jackson—places whose very names evoke not only the cause but the way it is being won.

Gray from Jail, Haggard from Tension

The result of such support—the limits it placed on the spectacle—was illustrated by the experience of John Lewis, chairman of the Student Non-Violent Coordinating Committee. Lewis is only 25; his only credential for being there was combat experience; he has been arrested 22 times and beaten half as often. The Student Non-

Violent Coordinating Committee is a tiny battalion, its members gray from jail and exhausted from tension. They have the gallant cynicism of troops of the line; they revere Martin Luther King (some of them) as a captain who has faced the dogs with them and they call him with affectionate irreverence, "De Lawd." We could hardly have had this afternoon without them.

Lewis, in their spirit, had prepared a speech full of temerities about how useless the civil rights bill is and what frauds the Democrats and Republicans are. Three of the white speakers told Randolph that they could not appear at a platform where such sedition was pronounced, and John Lewis had to soften his words in deference to elders. Equal rights for the young to say their say may, perhaps, come later.

Yet Lewis' speech, even as laundered, remained discomfiting enough to produce a significant tableau at its end. "My friends," he said, "let us not forget that we are engaged in a significant social revolution. By and large American politics is dominated by politicians who build their careers on immoral compromising and ally themselves with open forums of political, economic and social exploitation." When he had finished, every Negro on the speakers' row pumped his hand and patted his back; and every white one looked out into the distance.

So even in the middle of this ceremony of reconciliation, the void between the Negro American and a white one remained. Or rather, it did and it didn't. At one point, Martin King mentioned with gratitude the great number of white people (about 40,000 to 50,000 out of an estimated 200,000) who had joined the march. There was little response from the platform—where it must have seemed formal courtesy—but as the sound of those words moved across the great spaces between King and the visitors from the Southern towns, there was the sudden sight and sound of Negroes cheering far away. Nothing all afternoon was

quite so moving as the sight of these people, whose trust has been violated so often in the particular, proclaiming it so touchingly intact in the general.

We do not move the Negro often, it would seem, and we do it only when we are silent and just standing there. On the speakers' stand there was the inevitable Protestant, Catholic and Jew without which no national ceremony can be certified. Is it hopeless to long for a day when the white brother will just once accept the duty to march, and forego the privilege to preach? Dr. Eugene Carson Blake of the National Council of Churches told the audience that the Protestants were coming and "late we come." It was the rarest blessing—an apology. We have begun to stoop a little; and yet it is so hard for us to leave off condescending.

We cannot move the Negro by speaking, because the public white America seems to know no words except the ones worn out from having been so long unmeant. Even if they are meant now, they have been empty too long not to *sound* empty still; whatever our desires, our language calls up only the memory of the long years when just the same language served only to convey indifference.

Yet the Negro moves us most when he touches our memory, even as we chill him most when we touch his. August 28 was to many whites only a demonstration of power and importance until Mahalia Jackson arose to sing the old song about having been rebuked and scorned and going home. Then King near the end began working as country preachers do, the words for the first time not as to listeners but as to participants, the intimate private conversation of invocation and response. For just those few minutes, we were back where this movement began and has endured, older than the language of the society which was taking these pilgrims in, but still fresh where the newer language was threadbare.

The Negro comes from a time the rest of us have forgotten; he seems new and complicated only because he represents something so old and simple. He reminds us that the new, after which we have run so long, was back there all the time. Something new will some day be said, and it will be something permanent, if it starts from such a memory.

The War on Poverty

GUNNAR MYRDAL

February 8, 1964

When the Swedish economist published An American Dilemma *(1944), his seminal 1,500-page work on race in America,* The New Republic *was the only publication to assign the book to an African American reviewer. That book deserves its place in the canon of liberalism for the role it played in shifting elite opinion. Yet the book is somewhat overrated, more widely cited as impactful than actually read. Myrdal caricatured both white Southern culture and its black counterpart. He didn't much care for the numbing effect of religion on black culture—with all the "shouting and noisy religious hysteria in old-time Negro churches." It would take a liberal vanguard, he argued, to challenge Jim Crow, to educate the masses and prepare them for change. His book, in other words, failed to anticipate the civil rights movement.*

As an outsider—a Scandinavian Tocqueville—Myrdal wasn't hindered by any inherited assumptions about American politics. And even if he got some big things wrong, he could be a genuine prophet. As Lyndon Johnson unleashed his antipoverty programs, he already understood the dangers of racializing social policy in America. Myrdal foresaw the backlash against affirmative action and welfare; he understood that the white working class, with its racial prejudices, might turn against social policy even if it stood to gain itself.

Having to live with large pockets of poverty-stricken people in their midst is not a new experience in the American nation. Right from slavery the masses of Negroes formed such pockets, both in the rural South and in the cities South and North. Such pockets were also formed by other colored people who immigrated to work as laborers from Asia, Mexico and Puerto Rico. Most American Indians in their reservations were also poor and isolated as they are today. There were also, as there are still, pockets of "poor whites," ordinarily of old American stock, who lived by themselves in abject poverty and cultural isolation.

I believe it is important to have in our minds this broad picture of the historical reality of American poverty as a background to the discussion of the problems facing us today. The regular, prosperous Americans have become accustomed to living with unassimilated groups of people in their midst, about whom they know in a distant and general way that they are very poor. The fact that in earlier times they themselves lived under the risk of being thrown out of work and losing their livelihood, if only temporarily, made it easier for them to feel unconcerned about the people who more permanently were enclosed in the pockets of poverty. Otherwise, the existence of all this poverty in the midst of progressive America stood out in blunt contradiction to the inherited and cherished American ideals of liberty and equal opportunity, as these ideals increasingly had been interpreted, particularly since Franklin D. Roosevelt and the New Deal.

Automation and other changes are all the time decreasing the demand for unskilled and uneducated labor. Standards are rising fast even in household and other menial work. Something like a caste line is drawn between the people in the urban and rural slums, and the majority of Americans who live in a virtual full-employment economy, even while the unemployment rate is rising and the growth rate of the economy is low. Except for a lower

fringe, they experience a hitherto unknown security, for it is a tacit understanding in America, as in the rest of the Western world, that a recession will never again be permitted to develop into anything like the Great Depression. But there is an underclass of people in the poverty pockets who live an ever more precarious life and are increasingly excluded from any jobs worth having, or who do not find any jobs at all.

I want to stress one important political fact. This underclass has been, and is largely still, what I have been accustomed to call the world's least revolutionary proletariat. They do not organize themselves to press for their interests. The trade union movement comprises only about one-fourth of the workers, mostly its upper strata who in the main belong to the prosperous majority. To a relatively higher extent than normally they do not register and vote at elections—even apart from the large masses of Negroes in the South who are prevented from doing so.

In very recent times we have seen one important break of this empirical rule of the political apathy of the poor in America. I am, of course, referring to the rebellion of the Negroes in Southern and Northern cities. Without any doubt, this is a true mass movement—so much so that the Negro leaders in the upper and middle class have had to run very fast to remain in the lead, as have, on the other side of the fence, the Administration and other whites responsible for American policy.

I am not at this time going into the question of how this movement, so exceptional to what has been the pattern of passivity on the part of the poor in America, has come about. But I should mention two things about which I am pretty sure. One is my belief that the outbreak of this rebellion just now is not unconnected with the high and, as a trend, rising rate of unemployment, which as always runs much higher—about double—for Negro workers than for whites. Another thing of which I am convinced is that this movement will

not abate unless very substantial reforms are rapidly undertaken to improve the status in American society of its Negro citizens. I am optimistic enough to forecast that in the next 10 years the Negroes will get legal rights equal to the white majority, and that these will be enforced. What will still be needed are, in particular, social sanctions to defend the Negroes' equal opportunities to employment, against the resistance of trade unions more than employers and the business world, particularly big business. And even when all this is accomplished, the Negro masses will nevertheless continue to suffer all the lasting effects of the disabilities and disadvantages of their poverty, their slum existence and their previous exclusion from easy access to education and training for good jobs.

Indeed, it is easy to understand why some of the Negro leaders, and some white liberals, are now raising the demand for a new Marshall Plan to make good the effects of the maltreatment in America of the Negroes from slavery and up till this day. Nevertheless, I am convinced that this demand for a discrimination in reverse, *i.e.*, to the advantage of the Negroes, is misdirected. Nothing would with more certainty create hatred for Negroes among other poor groups in America, who have mostly been their bitterest enemies as they have been the only ones who have felt them as competitors. Moreover, special welfare policies for Negroes are not very practical. Negro housing cannot very well be improved except as part of a plan to improve the housing situation for poor people in general. The same is true of education. Special welfare policies in favor of the Negroes would strengthen their exclusion from the main stream of American life, while what the Negroes want is to have equal opportunities.

What America needs is a Marshall Plan to eradicate poverty in the nation. This is a moral imperative. The unemployed, the underemployed and the now unemployables are also America's biggest wastage of economic resources. The poor represent a suppressed

demand which needs to be released to support a steady rapid growth of American production. The goals of social justice and economic progress thus are compatible. A rapid steady economic growth is impossible without mobilizing the productive power of the poor and clothing their unfilled needs with effective demand. The existence of mass poverty in the midst of plenty is a heavy drag on the entire economy.

The statistics on unemployment in America do not tell the whole story. Besides the four million unemployed there are the workers who are only part-time employed, those who have given up seeking work, and all the underemployed. It is an ominous fact that even the prolonged upturn in production from 1961 and onward has not implied a substantial decrease in the rate of unemployment. Nobody seems to expect that the continuation of the present boom will bring down unemployment to a level that could be considered even to approach full employment. And nobody assumes that there will not be a new recession, if not this year then the next. It is reasonable to expect that the unemployment rate will then reach a new high point. There are definite signs that the trend is rising.

For this there are explanations. I believe it is important to stress that none of the specific explanations put forward makes a rising trend of unemployment inevitable, or could by itself prevent the attainment of full employment. Only in conjunction with each other do these influences have the present disastrous result. If in the Sixties exceptionally many young workers enter the labor market, this should not necessarily mean more unemployment. Production could expand rapidly enough to absorb them, and all the new workers could have been properly educated and trained so that they fitted the demand for labor as it has been changing. Long ago, Professor Alvin Hansen and other economists, including myself, used to think that in rich countries, where capital is plentiful, a rapid population increase would rather act as a spur to expansion. It would stimulate

the demand for new housing, and for new schools, teachers, and productive capacity.

Likewise, automation should not by itself lead to unemployment if output expanded enough and the labor force were adjusted to fit the change in demand, caused by automation itself among other things. There are countries with full employment that have an equally rapid pace of automation. There, automation is viewed as driven forward by the scarcity of labor and as resulting in higher productivity of labor, higher earnings and a rising consumers' demand for products and services: in America, as a cause of unemployment.

Our Changing Society

What type of society are we moving toward in the modern rich countries? A continually smaller part of our total labor force will be needed in agriculture, manufacturing industry, heavy transport, distribution of commodities, banking and insurance. If we could countervail Parkinson's law, which for various reasons is working with particular force in America, even many sectors of public service would demand less labor.

It is the serious lag in adjusting the education and training of our labor force to the needs of this new society which is the general cause of the situation where we have serious overemployment in some sectors of our economy, at the same time as there is an uncomfortably large and growing residue of structural unemployment and underemployment that cannot be eradicated by an expansion of our production that is feasible.

Against this background it is easy to establish the broad lines of the policies that we will have to apply in order to cure our economic ailments. Huge efforts will have to go into education and vocational training, not only on the higher levels but on the level of grade schools and high schools. Particularly will we have to lift the level

of elementary education for the poor people in the urban and rural slums, who are not now getting an education that fits them to the labor market. We must at the same time undertake the retraining of the older workers who are continuously thrown out of jobs without having the abilities to find new ones in our changing society.

I see it as almost a fortunate thing that America has such vast slums in the big cities and smaller ones in the small cities; so many dwellings for poor people that are substandard; so many streets that need to be kept cleaner; such crying needs for improved transport. To train unskilled workers to do such jobs should be easier than to make them teachers or nurses.

Increased Public Spending

It should be stressed, however, that a primary condition for success is rapid and steady economic expansion of the national income. Without an increased demand for labor, no efforts for training and retraining workers on a mass scale can succeed. This is the important argument for the view that expanding the economy is the essential thing. Expansion is, in a sense, the necessary condition for any effort to readjust the supply of different types of labor to demand.

A common characteristic of all the reforms directed at raising the quality of the labor force and eradicating poverty in the midst of plenty is that the increased expenditure will be public expenditure. Even when poverty is gone, when there is little or no unemployment or underemployment, a relatively much larger part of the nation's needs will have to be met by collective means. In the future society toward which we are moving, where our productive efforts will increasingly have to be devoted to the care of human beings, health, education, research and culture, and to making our local communities more effective instruments for living and working, public spending will be an ever larger part of total spending. This is because it is not very practical and economical, and in most cases

not even possible, to rely on private enterprise for filling these types of demands.

This brings up the problem of balancing or not balancing the federal budget. Large sections of the public and Congress hold, on this question, an opinion that has no support in economic theory and is not commonly held in other advanced countries: that, in principle, expenditures of the federal budget should be balanced by taxation.

A recent experience from my own country Sweden must seem curiously up-side-down to Americans. In a situation of threatening overfull employment and inflationary pressure, the Swedish social democratic government, which has been in power almost a third of a century, felt that it needed to put on brakes, and decided to raise taxation to a level where, for a while, we actually had a balanced budget in the American sense. The political parties to the *right* of the party in power criticized the government fiercely for overtaxing the citizens, and insinuated that this was a design to move our economy in a socialistic direction, by robbing the citizens and private business of the funds they needed. So differently can the problem of balancing the budget appear in two otherwise very similar countries. In fact, you have examples nearer at hand. When the railroads were built in America, the federal government favored the railroad companies in various ways, which occasionally broke the rule of balancing the budget.

The analogy that a nation must handle its purse strings with the same prudence as an individual is false. An individual is not in the position to borrow from himself. Moreover, if the implication is that the government should not borrow even for productive purposes, it is a rule which no private householder follows, or should follow, if he is wise and prudent. And we know that there has been a huge increase, both absolutely and relatively, of private borrowing by business as well as by consumers.

This does not mean that Congress should not carefully weigh each dollar that is spent and each dollar that is taken in by taxation or other means. But the weighing should be in terms of progress and welfare for the nation. I can see no virtue in America having decreased its national debt in postwar years to half its size compared with the national income, while abstaining from undertaking a great number of public expenditures that would have been highly productive from a national point of view. America has been satisfied for a whole decade with a rate of growth of only a little more than one percent per head, and with unemployment rising to the present high level. In the interest of public enlightenment I would wish my American colleagues to spend a little more of their time disseminating some simple truths about budget balancing and related issues. America cannot afford to remain the rich country that has the highest rate of unemployment, and the worst and biggest slums, and which is least generous in giving economic security to its old people, its children, its sick people and its invalids.

Movie Brutalists

Pauline Kael

September 24, 1966

It's a struggle to find any commonalties in the New Republic *work of Stanley Kauffmann and Pauline Kael. Where Kauffmann spent fifty-five years reviewing films for the magazine, Kael bolted after two. She couldn't stand the editing, and in a way, she had a point. Her writing was somewhat uneditable: wild, thrillingly undisciplined, and full of bolts of sentiment. She left the magazine with her famous 9,000-word essay on Bonnie and Clyde in hand—which she took to* The New Yorker, *launching her long career there and giving shape to the cinematic revolution of the late sixties.*

The basic ideas among young American film-makers are simple: the big movies we grew up on are either corrupt, obsolete or dead, or are beyond our reach (we can't get a chance to make Hollywood films)—so we'll make films of our own, cheap films that we can make in our own way. For some, this is an attempt to break into the "industry"; for others it is a different approach to movies, a view of movies not as popular art or a mass medium but as an art form to be explored.

Much of the movie style of young American film-makers may be

explained as a reaction against the banality and luxuriant wastefulness which are so often called the superior "craftsmanship" of Hollywood. In reaction, the young become movie brutalists.

They, and many in their audiences, may prefer the rough messiness—the uneven lighting, awkward editing, flat camera work, the undramatic succession of scenes, unexplained actions, and confusion about what, if anything, is going on—because it makes their movies seem so different from Hollywood movies. This inexpensive, inexperienced, untrained look serves as a kind of testimonial to sincerity, poverty, even purity of intentions. It is like the sackcloth of true believers which they wear in moral revulsion against the rich in their fancy garments. The look of poverty is not necessarily a necessity. I once had the experience, as chairman of the jury at an experimental film festival, of getting on the stage in the black silk dress I had carefully mended and ironed for the occasion, to present the check to the prizewinner who came forward in patched, faded dungarees. He got an ovation, of course. I had seen him the night before in a good dark suit, but now he had dressed for his role (deserving artist) as I had dressed for mine (distinguished critic).

Although many of the American experimentalists have developed extraordinary kinds of technique, it is no accident that the virtuoso technicians who can apparently do almost anything with drawing board or camera are not taken up as the heroes of the youth in the way that brutalists are. Little is heard about Bruce Baillie or Carroll Ballard whose camera skills expose how inept, inefficient, and unimaginative much of Hollywood's self-praised work is, or about the elegance and grandeur of Jordan Belson's short abstract films, like *Allures*, that demonstrate that one man working in a basement can make Hollywood's vaunted special effects department look archaic. Craftsmanship and skill don't, in themselves, have much appeal to youth. Rough work looks in rebellion and sometimes it is: there's anger and frustration and passion, too,

in those scratches and stains and multiple super-impositions that make our eyes swim. The movie brutalists, it's all too apparent, are hurting our eyes to save our souls.

They are basically right, of course, in what they're *against*. Aesthetically and morally, disgust with Hollywood's fabled craftsmanship is long overdue. I say fabled because the "craft" claims of Hollywood, and the notion that the expensiveness of studio-produced movies is necessary for some sort of technical perfection or "finish," are just hucksterism. The reverse is closer to the truth: it's becoming almost impossible to produce a decent looking movie in a Hollywood studio. In addition to the corpses of old dramatic ideas (touched up here and there to look cute as if they were alive), big movies carry the dead weight of immobile cameras, all-purpose light, whorehouse decor. The production values are often ludicrously inappropriate to the subject matter, but studio executives, who charge off roughly 30 percent of a film's budget to studio overhead, are very keen on these production values which they frequently remind us are the hallmark of American movies.

In many foreign countries, it is this very luxuriousness that is most envied and admired in American movies: the big cars, the fancy food, the opulent bachelor lairs, the gadget-packed family homes, even the loaded freeways and the noisy big cities. What is not so generally understood is the studio executives' implicit assumption that this is also what American audiences like. The story may not involve more than a few spies and counterspies, but the wide screen will be filled. The set decorator will pack the sides of the image with fruit and flowers and furniture.

When Hollywood cameramen and editors want to show their expertise they imitate the effects of Japanese or European craftsmen and then the result is pointed to with cries of "See, we can do anything in Hollywood." The principal demonstration of art and ingenuity among these "craftsmen" is likely to be in getting their

sons and nephews into the unions and in resisting any attempt to make Hollywood movie-making flexible enough for artists to work there. If there are no cinematographers in modern Hollywood who can be discussed in the same terms as Henri Decae or Raoul Coutard or the late Gianni di Venanzo it's because the studio methods and the union restrictions and regulations don't make it possible for talent to function. The talent is strangled in the business bureaucracy, and the best of our cinematographers perform safe, sane academic exercises. If the most that a gifted colorist like Lucien Ballard can hope for is to beautify a John Michael Hayes screenplay—giving an old tart a fresh complexion—why not scratch up the image?

The younger generation doesn't seem much interested in the obstacles to art in Hollywood, however. They don't much care about why the older directors do what they do or whether some of the most talented young directors in Hollywood like Sam Peckinpah (*Ride the High Country, Major Dundee*) or Irvin Kershner (*The Hoodlum Priest, The Luck of Ginger Coffey, A Fine Madness*) will break through and do the work they should be doing. There is little interest in the work of gifted, intelligent men outside the industry like James Blue (*The Olive Trees of Justice*) or John Korty (*The Crazy Quilt*) who are attempting to make inexpensive feature-films as honestly and independently as they can. These men (and their films) are not flamboyant; they don't issue manifestos, and they don't catch the imagination of youth. Probably, like the students in film courses who often do fresh and lively work, they're not surprising enough, not different enough. The new film enthusiasts are, when it comes down to it, not any more interested in simple, small, inexpensive pictures than Hollywood is. The workmen's clothes and crude movie techniques may cry out, "We're poor and honest. They're rich and rotten." But, of course, you can be poor and not so very honest and, although it's harder to believe, you

can even be rich and not so very rotten. What the young seem to be interested in is brutalism. In certain groups, automatic writing with a camera has come to be considered the most creative kind of film-making.

Their hero, Jean-Luc Godard—one of the most original talents ever to work in film and one of the most uneven—is not a brutalist at so simple a level, yet he comprises the attitudes of a new generation. Godard is what is meant by a "film-maker." He works with a small crew and shifts ideas and attitudes from movie to movie and even within movies. While Hollywood producers straddle huge fences trying to figure out where the action is supposed to be—and never find out—Godard is in himself where the action is.

There is a disturbing quality in Godard's work that perhaps helps to explain why the young are drawn to his films and identify with them, and why so many older people call him a "coterie" artist and don't think his films are important. *His characters don't seem to have any future.* They are most alive (and most appealing) just because they don't conceive of the day after tomorrow; they have no careers, no plans, only fantasies of roles they could play, of careers, thefts, romance, politics, adventure, pleasure, a life like in the movies. Even his world of the future, *Alphaville*, is, photographically, a documentary of Paris in the present. (All of his films are in that sense documentaries—as were also, and also by necessity, the grade B American gangster films that influenced him.) And even before *Alphaville*, the people in *The Married Woman* were already science fiction—so blank and affectless no mad scientist was required to destroy their souls.

His characters are young; unrelated to families and background. Whether deliberately or unconsciously he makes his characters orphans who, like the students in the theatres, feel only attachments to friends, to lovers—attachments that will end with a chance word or the close of the semester. They're orphans, by extension, in a larger

sense, too, unconnected with the world, feeling out of relationship to it. They're a generation of familiar strangers.

An elderly gentleman recently wrote me, "Oh, they're such a bore, bore, bore, modern youth!! All attitudes and nothing behind the attitudes. When I was in my twenties, I didn't just loaf around, being a rebel, I went places and did things. The reason they all hate the squares is because the squares remind them of the one thing they are trying to forget: there *is* a Future and you must build for it."

He's wrong, I think. The young are not "trying to forget": they just don't think in those terms. Godard's power—and possibly his limitation—as an artist is that he so intensely expresses how they do feel and think. His characters don't plan or worry about careers or responsibilities; they just live. Youth makes them natural aristocrats in their indifference to sustenance, security, hard work; and prosperity has turned a whole generation—or at least the middle-class part of it—into aristocrats. And it's astonishing how many places they do go to and how many things they can do. The difference is in how easily they do it all. Even their notion of creativity—as what comes naturally—is surprisingly similar to the aristocratic artist's condescension toward those middle-class plodders who have to labor for a living, for an education, for "culture."

Here, too, Godard is the symbol, exemplar, and proof. He makes it all seem so effortless, so personal—just one movie after another. Because he is skillful enough (and so incredibly disciplined) that he can make his pictures for under $100,000, and because there is enough of a youthful audience in France to support these pictures, he can do almost anything he wants within those budgetary limits. In this achievement of independence, he is almost alone among movie directors: it is a truly heroic achievement. For a younger generation he is the proof that it is possible to make and go on making films your own way. And yet they don't seem aware of how rare he is or how hard it is to get in that position. Even if colleges and foun-

dations make it easier than it has ever been, they will need not only talent but toughness to be independent.

As Godard has been able to solve the problems of economic freedom, his work now poses the problems of artistic freedom—problems that few artists in the history of movies have been fortunate enough to face. The history of great film directors is a history of economic and political obstacles—of compromises, defeats, despair, even disgrace. Griffith, Eisenstein, Von Stroheim, Von Sternberg, Cocteau, Renoir, Max Ophuls, Orson Welles—they were defeated because they weren't in a position to do what they wanted to do. If Godard fails, it will be because what he wants to do—which is what he *does*—isn't good enough.

Maybe he is attempting to escape from freedom when he makes a beautiful work and then, to all appearances, just throws it away. There is a self-destructive urgency in his treatment of themes, a drive toward a quick finish. Even if it's suicidal for the hero or the work, Godard is impatient for the ending: the mood of his films is that there's no way for things to work out anyway, something must be done even if it's disastrous, no action is intolerable.

It seems likely that many of the young who don't wait for others to call them artists but simply announce that they are, don't have the patience to make art. A student's idea of a film-maker isn't someone who has to sit home and study and think and work—as in most of the arts—but go out with friends and shoot. It is a social activity, an extroverted and egotistic image of the genius-creator. It is the Fellini-Guido figure of *8½*, the movie-director as star. Few seem to have noticed that by the time of *Juliet of the Spirits* he had turned into a professional party-giver. Film-making, carried out the way a lot of kids do it, is like having a party. And their movie "ideas" are frequently staging and shooting a wild, weird party.

"Creativity" is a quick route to power and celebrity. The pop singer or composer, the mod designer says of his work, "It's a creative way to make a living"—meaning it didn't take a dull lot of study and planning, that he was able to use his own inventiveness or ingenuity or talent to get to the top without much sweat. I heard a young film-maker put it this way to a teen-age art student: "What do you go to life-class for? Either you can draw or you can't. What you should do is have a show. It's important to get exposure." One can imagine their faces if they had to listen to those teachers who used to tell us that you had to be able to do things the traditional ways before you earned the right to break loose and do it your way. They simply take short cuts into other art forms or into pop arts where they can "express themselves" now. Like cool Peter Pans, they just take off and fly.

Godard's conception of technique can be taken as a highly intellectualized rationale for these attitudes. "The ideal for me," he says, "is to obtain right away what will work—and without retakes. If they are necessary, it falls short of the mark. The immediate is chance. At the same time it is definitive. What I want is the definitive by chance." Sometimes, almost magically, he seems to get it—as in many scenes of *Breathless* and *Band of Outsiders*—but often, as in *The Married Woman*, he seems to settle for arbitrary effects.

And a caricature of this way of talking is common among young American film-makers. Some of them believe that everything they catch on film is definitive, so they do not edit at all. As proof that they do not mar their instinct with pedantry or judgment, they may retain the blank leader to the roll of film. As proof of their creative sincerity they may leave in the blurred shots.

Preposterous as much of this seems, it is theoretically not so far from Godard's way of working. Although his technical control is superb, so complete that one cannot tell improvisation from planning, the ideas and bits of business are often so arbitrary that they

appear to be (and probably are) just things that he chanced to think of that day, or that he came across in a book he happened to be reading. At times there is a disarming, an almost ecstatic, innocence about the way he uses quotes as if he had just heard of these beautiful ideas and wanted to share his enthusiasm with the world. After smiling with pleasure as we do when a child discovers the beauty of a leaf or a poem, enabling us to reexperience the wonder of responsiveness, we may sink in spirit right down to incredulity. For this is the rapture with "thoughts" of those whose minds aren't much sullied by thought. These are "thoughts" without thought: they don't come out of a line of thought or a process of thinking, they don't arise from the situation. They're "inspirations"—bright illuminations from nowhere—and this is what kids who think of themselves as poetic or artistic or creative think ideas are: noble sentiments. They decorate a movie and it is easy for viewers to feel that they give it depth, that if followed, these clues lead to understanding of the work. But if those who follow the clues come out with odd and disjunctive interpretations, this is because the "clues" are *not* integral to the movie but are clues to what else the artist was involved in while he was making the movie.

Putting into the work whatever just occurred to the artist is its own rationale and needs no justification for young Americans encouraged from childhood to express themselves creatively and to speak out whatever came into their heads. Good, liberal parents didn't want to push their kids in academic subjects but oohed and aahed with false delight when their children presented them with a baked ashtray or a woven doily. Did anyone guess or foresee what narcissistic confidence this generation would develop in its banal "creativity"? Now we're surrounded, inundated, by artists. And a staggering number of them wish to be or already call themselves "film-makers."

A few years ago a young man informed me that he was going to "give up" poetry and avant-garde film (which couldn't have been much of a sacrifice as he hadn't done anything more than talk about them) and devote himself to writing "art-songs." I remember asking, "Do you read music?" and not being especially surprised to hear that he didn't. I knew from other young men that the term "art" used as an adjective meant that they were by-passing even the most rudimentary knowledge in the field. Those who said they were going to make art movies not only didn't consider it worth their while to go to see ordinary commercial movies, but usually didn't even know anything much about avant-garde film. I did not pursue the subject of "art-songs" with this young man because it was perfectly clear that he wasn't going to do anything. But some of the young who say they're going to make "art movies" are actually beginning to make movies. Kids who can't write, who have never developed any competence in photography, who have never acted in nor directed a play, see no deterrent to making movies. And although most of the results are bad beyond our wildest fears, as if to destroy all our powers of prediction, a few, even of the most ignorant, pretentious young men and women, are doing some interesting things.

Yet why are the Hollywood movies, even the worst overstuffed ones, often easier to sit through than the short experimental ones? Because they have actors and a story. Through what is almost a technological fluke, 16 mm movie cameras give the experimental film-maker greater flexibility than the "professional" 35 mm camera user, but he cannot get adequate synchronous sound. And so the experimentalists, as if to convert this liability into an advantage, have asserted that their partial use of the capabilities of the medium is the true art of the cinema, which is said to be purely visual. But their visual explorations of their states of consciousness (with the usual implicit social protest) get boring, the mind begins

to wander, and though this lapse in attention can be explained to us as a new kind of experience, as even the purpose of cinema, our desire to see a movie hasn't been satisfied. (There are, of course, some young film-makers who are not interested in movies as we ordinarily think of them, but in film as an art-medium like painting or music, and this kind of work must be looked at a different way—without the expectation of story content or meaning.) They probably won't be able to make satisfying *movies* until the problems of sound are solved not only technically but in terms of drama, structure, meaning, relevance.

It is not an answer to toss on a spoofing semi-synchronous sound track as a number of young film-makers do. It can be funny in a cheap sort of way—as in Robert Downey's *Chafed Elbows* where the images and the sound are, at least, in the same style; but this isn't fundamentally different from the way George Axelrod works in *Lord Love a Duck* or Blake Edwards in *What Did You Do in the War, Daddy?*; and there's no special reason to congratulate people for doing underground what is driving us down there. Total satire is opportunistic and easy; what's difficult is to make a movie about something—without making a fool of yourself. Kenneth Anger did it with *Scorpio Rising*. Yet few others have taken that wonderful basic precaution of having a subject or of attempting to explore the world.

Is Hollywood interested in the young movement? If it attracts customers, Hollywood will eat it up, the way *The Wild Angels* has already fed upon *Scorpio Rising*. At a party combining the commercial and non-commercial worlds of film, a Hollywood screen writer watched as an underground filmmaker and his wife entered. The wife was wearing one of those classic filmmakers' wives' outfits: a simple sack of burlap in natural brown, with scarecrow sleeves. The screen writer greeted her enthusiastically, "I really dig your dress, honey," he said, "I used to have a dress like that once."

PART SEVEN
1970s

"Much of this may seem like ungrateful quibbling; but our stakes in self-scrutiny are great."

THE EDITORS
MAY 3, 1975

Power and Powerlessness

Decline of Democratic Government

Hans J. Morgenthau

November 9, 1974

This essay appeared in yet another symposium on the future of democracy. (For the previous one, see Benedetto Croce's contribution, p. 88). On the occasion of its sixtieth anniversary—and in the aftermath of Vietnam and Watergate—the magazine published a supplement with contributions from the likes of Irving Howe and Abe Fortas. The great theorist Hans Morgenthau delivered this dark jeremiad; while his thesis has thankfully crumbled over time, the particulars of his argument remain distressingly relevant.

If democratic government is defined as the choice by the people at large, according to preestablished rational procedures, of the personnel and, through it, of the policies of the government, then the decline of democratic government throughout the world is an observable fact. Most of the nations that still comply with the procedure of periodic elections are one-party states, where elections do not provide the electorate with a choice among different persons, and hence, policies. Rather they are in the nature of plebiscites through which the electorate, as a matter of course, confirms the

rulers in their power and gives them a mandate for whatever policies they wish to pursue.

Many of the nations that used to offer the people a genuine democratic choice or at least paid their respects to democratic legitimacy through plebiscitarian elections are governed by military dictatorships. Of the new African states only one, Gambia, can still be said to have a multiparty system offering the people a genuine choice of men and policies; close to half of them are governed by military dictatorships. In Latin America the number of military dictatorships has steadily increased at the expense of genuine democracies; more particularly the few attempts at return to democratic rule have met with seemingly insuperable difficulties. Even in countries such as France, Italy, Great Britain and the United States, where democratic procedures appear to be unimpaired, the substance of democratic rule has been diminished. France and Italy for a quarter of a century have, as a matter of principle, deprived one-quarter and close to one-third of the electorate, respectively, of any direct influence upon the personnel and the policies of the government by excluding the Communist party from it. In Great Britain a general political malaise has begun to crystallize in calls for non-democratic solutions to problems parliamentary democracy appears to be unable to solve.

Finally and most importantly, the United States has experienced two presidencies in succession whose arbitrary, illegal and unconstitutional rule tended to reduce democratic choice to exercises in futility. Those who voted in 1964 for one candidate because they preferred the policies for which he campaigned, found him, when he was elected, to pursue the policies of his defeated opponent with a ruthlessness and deception the latter might not have been capable of. Lyndon B. Johnson, whom I called in March 1966 "The Julius Caesar of the American Republic," was followed by Richard M. Nixon, who bids fair to become its Caligula. Nixon, as pointed out

in this journal on August 11, 1973, introduced into the American system of government four practices of a distinctly Fascist character: the deprivation of the minority of an equal chance to compete with the majority in the next elections; the establishment of the "dual state" in which the official statutory agencies of the government, subject to legal restraints, are duplicated by agencies performing parallel functions, which are organized by the ruling party and responsive only to the will of the leader; the invocation of "national security" as justification for any government action, however arbitrary, unconstitutional or illegal; and, finally, a nihilistic destructiveness, only thinly disguised by the invocation of conservative principles and patriotic and religious slogans.

Aside from the intangible damage these two presidencies have done to the practices of the American government and to the relations between that government and the people, they have given us the first President who owes his position not to a popular election but primarily to the choice by his predecessor (congressional approval having been a foregone conclusion), who had to leave office in order to escape impeachment for "high crimes and misdemeanors." They are likely to give us a Vice President, next in line to succeed to the presidency during the present incumbent's term of office, who owes his office primarily to the present incumbent's choice (congressional approval being in the nature of ratification rather than of genuine choice). Thus at the very least with regard to the incumbent President and Vice President the democratic processes of choosing among a number of candidates have been attenuated to the point of virtual disappearance. If one wants to give free rein to one's morbid imagination one can visualize the incumbent Vice President ascending to the presidency, who then will appoint a new Vice President, and so forth. But it requires nothing more than some knowl-

edge of ancient history to be reminded of the Roman emperors appointing their successors with the approval of the Senate, given either as a matter of course or under the threat of physical violence.

In order to understand the reasons for the decline of the democratic order throughout the world and, more particularly, in the United States, it is necessary to consider the fundamentals of government, regardless of the type, and its relations with the people over whom it rules. We leave out of consideration only the theocratic type of government, which derives its justification from divine origin or grace.

Men expect their governments to perform for them three basic functions: to protect them from themselves and from their fellow men, that is, to protect them from violent death; to give them the opportunity to put their abilities to the test of performance, that is, to protect a sphere of freedom, however defined; to satisfy at least some of their basic aspirations, that is, to fulfill the requirements of substantive justice, however defined. It is to these expectations that the Declaration of Independence referred as "Life, Liberty and the pursuit of Happiness." Not all men will expect at all times their governments to live up in the same measure to all these requirements. Yet it can be said that a government that consistently falls short of one or the other of these requirements loses its legitimacy in the eyes of its citizens: its rule will be suffered since it cannot be changed, let alone gotten rid of, but it will not be spontaneously supported.

Applying these standards to contemporary governments, one realizes that the crisis of democratic governments is but a special case of the crisis of government as such. That is to say, contemporary governments—regardless of their type, composition, program, ideology—are unable to govern in accord with the three requirements of legitimate government. They are no longer able to protect the lives, to guarantee the liberty, and to facilitate the pursuit of happiness of their citizens. Governments are thus incapacitated be-

cause their operations are hopelessly at odds with the requirements or potentialities of modern technology and the organization it permits and requires.

It has become trivial to say—because it is so obvious and has been said so often—that the modern technologies of transportation, communication and warfare have made the nation-state, as principle of political organization, as obsolete as the first industrial revolution of the steam engine did feudalism. While the official governments of the nation-states go through the constitutional motions of governing, most of the decisions that affect the vital concerns of the citizens are rendered by those who control these technologies, their production, their distribution, their operation, their price. The official governments can at best marginally influence these controls, but by and large they are compelled to accommodate themselves to them. They are helpless in the face of steel companies raising the price of steel or a union's striking for and receiving higher wages. Thus governments, regardless of their individual peculiarities, are helpless in the face of inflation; for the relevant substantive decisions are not made by them but by private governments whom the official governments are unwilling or unable to control. Thus we live, as was pointed out long ago, under the rule of a "new feudalism" whose private governments reduce the official ones to a largely marginal and ceremonial existence.

The global corporation (misnamed "multinational") is the most striking manifestation of this supercession of national governments not only in their functional but also territorial manifestations. For while the territorial limits of the private governments of the "new feudalism," as first perceived about two decades ago, still in great measure coincided with those of the nation-state, it is a distinctive characteristic of the global corporation that its very operations reduce those territorial limits to a functional irrelevancy.

The governments of the modern states are not only, in good measure, unable to govern, but where they still appear to govern (and appearances can be deceptive) they are perceived as a threat to the welfare and very existence of their citizens. National governments, once hailed as the expression of the common will, the mainstays of national existence, and the promoters of the common good, are now widely perceived as the enemy of the people, a threat to the citizen's freedom and welfare and to his survival. That is to say, the fear that governments have always inspired as a potential threat to the concerns of the citizens (*vide*: the philosophy of the *Federalist Papers*) has now become not only a reality of everyday life, but a reality that the citizen can neither counter nor escape. For it is the great political paradox of our time that a government, too weak to control the concentrations of private power that have usurped much of the substance of its power, has grown so powerful as to reduce the citizens to impotence.

That reduction, by an unchallengeable government, of the citizens to an impotent atom is, of course, most strikingly evident in authoritarian and totalitarian societies; Mandelstam and Solzhenitsyn bear eloquent testimony to the individual's helpless plight in such societies. Yet in liberal democracies, too, the capacity to maintain oneself and find redress against the government is markedly reduced. How many of the innocent public officials who were ruined socially and professionally by the government during the McCarthy era were able to restore their good name and recover their livelihood? What effective redress does a citizen have whose income tax returns are audited year after year for suspected but unprovable political reasons and with results both drastic and absurd?

Most importantly that drastic shift of power from the citizen to the government has rendered obsolete the ultimate remedy for the government's abuses—popular revolution. It is not by accident that the last popular revolutions occurred in Russia and China, then

technologically backward nations, and that this is the age of the coup d'état, especially its military variety, that is, the takeover of the government by an elite enjoying a monopoly of the modern technologies of transportation, communication and warfare. But a modern government that can count on the loyalty of the technological elites is immune to displacement by the wrath of the people. It is so not only for technological but also moral and intellectual reasons. The political consequences of Watergate are a case-in-point.

While we have a new President, we are still governed by the same people who governed us before Nixon's downfall. While the power of the Nixon administration was not sufficient to conceal all its misdeeds—thwarted by its own incompetence, scrutinized by a free press, and subject to the rule of independent courts—the individual citizen cannot help but wonder how many secrets will remain hidden forever; he cannot but marvel at the generosity of some of the judgments and sentences (a former Attorney General who appears to have committed perjury going for all practical purposes scot-free); and he cannot but be amazed at the chumminess between the disgraced former President and his successor. In ancient Athens politicians dangerous to the state were ostracized without any charge being brought against them. In America an administration whose prominent members are accused or convicted of common crimes and guilty of subverting the public order, blends easily into its honorable successor without a drastic change in personnel.

Shame, the public acknowledgment of a moral or political failing, is virtually extinct. The members of the intellectual and political elite whose judgments on Vietnam proved to be consistently wrong and whose policies were a disaster for the country remain members of the elite in good standing; a disgraced President moves easily into the position of an elder statesman receiving confidential information and giving advice on affairs

of state. Thus the line of demarcation between right and wrong, both morally and intellectually, is blurred. It becomes a distinction without lasting moral or political consequences. To be wrong morally or politically is rather like a minor accident, temporarily embarrassing and better forgotten. That vice of moral and intellectual indifference is presented and accepted as the virtue of mercy, which, however, as forgiveness and dispensation with the usual reaction to vice, supposes a clear awareness of the difference between vice and virtue.

The people are not only deprived of the traditional effective means of stopping the abuses of government, but they are also helpless in the face of the ultimate abuse, their own destruction. A government armed with the modern weapons of warfare, even of a nonnuclear kind, holds the life of the citizen in its hands. The weapons acquired for the purpose of defense or deterrence also serve as a provocation to a prospective enemy similarly armed, and that dialectic of defense-deterrence, threat and counterthreat seeks and assures the destruction of all concerned. The universal destructiveness of that dialectic is of course pushed to its ultimate effectiveness in the nuclear field where effectiveness is the equivalent of total destruction, obliterating the conventional distinction between defense and offense, victory and defeat.

The individual faces this prospect in complete helplessness. He cannot forestall it; he cannot hide from it; he cannot escape from it. He can only wait for the ultimate disaster. Looking, as is his wont, to the government for protection, he realizes that he continues to be alive only because his government and a hostile government threaten each other with total destruction and have thus far found the threats plausible. Thus his life is for all practical purposes the function of the will of two unprecedentedly mighty governments who have the

power and proclaim to have the will to destroy utterly their respective populations.

Man throughout the world has reacted to his attrition as the center of political concern—according to Aristotle, individual happiness is the purpose of politics—by political apathy, political violence and the search for new communities outside the official political structure.

Apathy can be a comprehensive reaction all by itself. It then manifests itself simply as a retreat from politics, nonparticipation in political activities and a contemptuous unconcern with traditional political procedures. Since the individual has no influence upon the policies of the government and his vote appears to be meaningless, providing normally only a choice between Tweedledee and Tweedledum, since more particularly political corruption appears to be endemic, regardless of the individuals and the parties in power and of the policies they embrace, the individual turns his back upon politics altogether and tends his own garden, trying to get as much advantage as possible for himself at the expense of his fellows and his government.

While this apathy as a self-contained attitude is widespread throughout the world, as expressed by popular political attitudes and, more particularly, large-scale abstention from voting, it can also form a backdrop for political activism, seeking by violence the destruction of the existing political order or the substitution of a new and radically different one for the existing one. The violence that we witness in the form of hijacking, kidnapping, torture, indiscriminate killing, differs from traditional violence in the form of political assassinations and the destruction of political institutions in that it is in general politically aimless. Rather than being a rational means to a rational end, it is an end in itself, as such devoid of political rationality.

One could argue that while this kind of violence, as isolated and sporadic acts, is indeed devoid of political rationality, it becomes en-

dowed with that quality when it is part of a concerted action seeking a clearly defined political change. Yet it is a common characteristic of individual violence throughout the world—Argentina, France, Germany, Great Britain, Italy, Japan, the United States—that it does not serve a rationally defined political aim, but finds its fulfillment in the act of destruction itself. It is an act born not of political concern but of political frustration and despair. Unable to change the political order from within through the procedures made available by that political order, unable likewise to overthrow that political order through concerted acts of violence, that is revolution, the political activist finds in indiscriminate destruction a substitute for the meaningful political act. He substitutes for the revolution, which aims at changing the world, the revolutionary tantrum, which for a fleeting moment satisfies him psychologically and frightens the supporters of the status quo without having any lasting effect upon the character and the distribution of power within society.

The individual, frustrated by his own loss of power and threatened by the unchallengeable power of the state, has still another avenue of escape. He can turn his back upon the existing social order and its institutions and search for and build a new society that makes him at home by giving meaning to his life and a chance for his abilities to prove themselves. Throughout long periods of history otherworldly religions have offered this alternative, and the monastery became the refuge of frustrated political man. In our period of history man thus frustrated must build his own monastery in the form of communes for living, political cooperation, esthetic pursuits and manual labor, searching for a "counterculture" of some kind that in time shall fill the void left by the disintegration of the old one.

It is against this background of general political decay and disintegration, affecting democratic and nondemocratic societies alike, but in different ways, that one must consider the decline of democratic governments. Democracy suffers from what ails all govern-

ments, but it does so in a specific way. Democratic government is sustained by two forces: consensus upon the political fundamentals of society, and government with the consent of the governed through the people's ability to choose from among several policies by choosing among different men. These two forces must be sharply distinguished both for diagnostic and therapeutic purposes.

All democratic societies take for granted that the fundamental issues bearing upon the nature and distribution of power in society have been settled once and for all. Such settlements are typically the result of revolutions and civil or international wars. They are generally codified in written constitutions, and, as such, they are not subject to public debate, let alone change by majority rule. They are the stable foundation upon which democratic institutions are erected, and the framework within which democratic processes operate. In other words men, if they can help themselves, will not allow the issues that are most important to them to be subjected to the vagaries of parliamentary or popular vote. They willingly submit to the vote of the majority only those issues that are not vital to them, that is, with regard to which they can afford to be outvoted. The really vital issues, which are, as it were, issues of political or economic life and death, are not susceptible to democratic settlement. Rather the viability of the democratic processes is predicated upon their settlement by the free interplay of military, economic and political forces.

It is the common character of the great issues, which have either wrecked or paralyzed democratic governments, that by their nature they are not susceptible to democratic settlement. They concern basically the distribution of economic and, through it, political power within the state. Thus it is that democratic elections appear not to settle anything of vital importance; for what needs to be settled cannot be settled by democratic procedures. In consequence democratic elections tend to resemble more and more charades, which at best result in adjustments within the status quo without even raising

the fundamental issues of the distribution of economic and political power. Democratic challenges to the economic and political status quo are staved off by the manipulation of the electoral and parliamentary procedures, as in France and Italy or, where that manipulation appears to be insufficient, by military force, as in Argentina, Brazil or Chile. Considering the attempts at changing the basic distribution of economic and political power in the United States from populism to the Great Society, one cannot but marvel at the staying power of the status quo, which has not only maintained itself against attempts at radical reform but also has co-opted its main enemies by transforming the main body of the labor movement into its defenders.

Insofar as the popular challenge to the status quo is feeble, the democratic procedures are irrelevant to the fundamental issues that agitate society. Insofar as that challenge is perceived as a genuine threat by the ruling elite, the democratic procedures will be shunted aside if it appears to be necessary for the defense of the status quo. Thus the lack of consensus on the fundamentals of power in society renders government with the consent of the governed, that is democracy, either irrelevant or obsolete. The opposition turns its back on democracy because democracy withholds the chance to get what it wants. The powers that be dispense with democratic procedures because they fear to lose what they have. Thus frustration causes political apathy in all its forms, and fear reduces democratic procedures to means to be used or discarded on pragmatic grounds.

However, as concerns the weakness of democracy, frustration and fear are not distinct social phenomena. But they are organically connected, one stimulating the other and both cooperating in weakening democracy. Each manifestation of alienation in the form of violence and competitive social structures of counterculture increases the fear for the viability of the status quo. That fear, in turn, translates itself into measures of defense which are chosen

primarily in view of their service to the status quo and without regard for the requirements of democracy. Thus democratic government, by dint of its political dynamics, comes to resemble more and more the plebiscitarian type of pseudo-democracy. The people have still the legal opportunity of registering their dissent, and the government still observes the more conspicuous restrictions of its power; but neither has a genuine choice. For the relevant decisions are made neither by the people at large nor by the official government, but by the private governments where effective power rests, and they are made not in deference to democratic procedures but in order to save the economic and social status quo.

The decline of official government, both in general and in its democratic form, has still another consequence, transcending the confines of politics. In a secular age men all over the world have expected and worked for salvation through the democratic republic or the classless society of socialism rather than through the kingdom of God. Their expectations have been disappointed. The charisma of democracy, with its faith in the rationality and virtue of the masses, has no more survived the historic experience of mass irrationality and the excesses of fascism and of the impotence and corruption of democratic government, than the charisma of Marxism-Leninism has survived the revelations of the true nature of Communist government and the falsity of its eschatological expectations. No new political faith has replaced the ones lost. There exists then a broad and deep vacuum where there was once a firm belief and expectation, presumably derived from rational analysis.

No civilized government that is not founded on such a faith and rational expectation can endure in the long run. This vacuum will either be filled by a new faith carried by new social forces that will create new political institutions and procedures commensurate with the new tasks; or the forces of the status quo threatened with disintegration will use their vast material powers to try to reintegrate

society through totalitarian manipulation of the citizens' minds and the terror of physical compulsion. The former alternative permits us at least the hope of preservation and renewal of the spirit of democracy. Neither alternative promises us the renewal of the kind of democratic institutions and procedures whose 200th anniversary we are about to celebrate.

Random Murder

The New Terrorists

Michael Walzer

August 30, 1975

Vietnam syndrome didn't infect The New Republic—*perhaps because it opposed that war. The magazine searched for a reasonable alternative to pacifism, an alternative that came in the form of the political philosopher Michael Walzer. He insisted that ethics play a central role in debates over military intervention. Over the years, he has provided a running interpretation of the moral justness of violence. His pieces for the magazine—on the Gulf Wars, the Arab-Israel conflagration, the advent of drones, the Bush administration's authorization of torture—could be culled into their own history of conflict in our times.*

Conceived as a form of political warfare against the established order, terrorism is now about 100 years old. The terrorism of governments, of course, is much older and, except in histories of the French Revolution, is rarely given its proper name. But the terrorism of dissident groups has its origins in the 1860s. It has been a feature of far left and ultra-nationalist politics ever since, though its legitimacy has been much debated and many leading leftists and nationalists have condemned it. Throughout

these debates it's been assumed that a single phenomenon was at issue: killing for a cause, strategic murder. In fact two very different activities are hidden here behind a single name, and in the years since World War II, terrorism has undergone a radical transformation.

Until about the middle of the 20th century, terrorism was most often a modernist version of the older politics of assassination—the killing of particular people thought to be guilty of particular acts. Since that time terrorism has most often taken the form of random murder, its victims unknown in advance and, even from the standpoint of the terrorists, innocent of any crime. The change is of deep moral and political significance, though it has hardly been discussed. It represents the breakdown of a *political code*, worked out in the late 19th century and roughly analogous to the laws of war, developed at the same time.

I can best describe this code by giving some examples of "terrorists" who acted or tried to act in accordance with its norms. I have chosen three historical cases, from different parts of the world. The first will be readily recognizable, for Albert Camus made it the basis of his play *The Just Assassins*.

- In the 1870s, a group of Russian revolutionaries decided to kill a Czarist official, the head of a police agency, a man personally involved in the repression of radical activity. They planned to blow him up in his carriage, and on the appointed day one of their number was in place along his usual route. As the carriage drew near, the young revolutionary, a bomb hidden under his coat, noticed that the official was not alone; on his lap he held two small children. The revolutionary looked, hesitated, decided not to throw his bomb; he would wait for another occasion. Camus

has one of his comrades say, accepting this decision: "Even in destruction, there's a right way and a wrong way—and there are limits."

* During the years 1938-39, the Irish Republican Army waged a bombing campaign in Britain. In the course of this campaign, a republican militant was ordered to carry a pre-set time bomb to a London power station. He traveled by bicycle, the bomb in his basket, took a wrong turn, and got lost in the maze of London streets. As the time for the explosion drew near, he panicked, dropped his bike, and ran off. The bomb exploded, killing five passers-by. No one in the IRA (as it was then) thought this a victory for the cause; the men immediately involved were horrified. The campaign had been carefully planned, according to a recent historian of the IRA, so as to avoid the killing of innocent bystanders.

* In November, 1944, Lord Moyne, British Minister of State in the Middle East, was assassinated in Cairo by two members of the Stern Gang, a right wing Zionist group. The two assassins were caught minutes later by an Egyptian policeman. One of them described the capture at his trial: "We were being followed by the constable on his motorcycle. My comrade was behind me. I saw the constable approach him . . . I would have been able to kill the constable easily, but I contented myself with . . . shooting several times into the air. I saw my comrade fall off his bicycle. The constable was upon him. Again I could have eliminated the constable with a single bullet, but I did not. Then I was caught."

What is common to these three cases is a moral distinction, a line drawn between people who can and people who cannot be killed—the political equivalent of the line between combatants and noncombatants. The obliteration of this line is the critical feature of contemporary terrorism. In former times children, passers-by and sometimes even policemen were thought to be uninvolved in the political struggle, innocent people whom the terrorist had no right to kill. He did not even claim a right to terrorize them; in fact his activity was misnamed—a minor triumph for the forces of order. But today's terrorists earn their title. They have emptied out the category of innocent people; they claim a right to kill anyone; they seek to terrorize whole populations. The seizure of hostages (barred now in wartime) symbolizes a general devaluation of human life, which is most clearly expressed when the terrorist's victims are not held for ransom but simply killed. A bomb planted on a street corner, hidden in a bus station, thrown into a cafe or pub: this is a new way of taking aim, and it turns groups of people, without distinction, into targets.

I don't want to recommend assassination. It is a vile politics; its agents are usually gangsters (and sometimes madmen) in political dress. But we do judge assassins to some degree by their victims, and when the victims are Hitler-like in character, agents of oppression and cruelty, we may even praise the assassin's work. It is at least conceivable, though difficult, to be a "just assassin," while just terrorism is a contradiction in terms. For the assassin fights a limited war: he aims at known individuals and seeks specific political and social changes.

The new terrorism, on the other hand, is a total war against nations, ethnic groups, religions. Its strategic goals are the repression, exile or destruction of entire peoples. Thus the victory of the FLN

in Algeria forced the emigration of the French *colons*, while the victory of the OAS would have brought savage repression for Algerian Arabs. If the Provisional IRA were ever to triumph in Northern Ireland, the majority of Protestants would have to leave. The PLO would destroy the Israeli state and force most of its citizens into exile, if it were able. Such goals cannot be kept secret; they are the unmistakable message of random murder—whatever the official program of the terrorist group. The line that marks off political agents from uninvolved men and women, officials from ordinary citizens, is critically important. Once it has been crossed, there is no further line to draw, no stopping place beyond which people can feel safe. Terrorism is the ultimate lawlessness, infinitely threatening to its potential victims, who believe (rightly, it seems to me) that no compromise is possible with their would-be murderers.

And yet terrorists operate today in what has to be called a permissive atmosphere. Statesmen rush about to make bargains with them; journalists construct elaborate *apologias* on their behalf. How is this indefensible activity defended? It is said that contemporary terrorists are not doing anything new; they are acting as revolutionaries and nationalists have always acted, which is demonstrably false. It is said that terrorism is the inevitable product of hardship and oppression, which is also false. Both these statements suggest a loss of the historical past, a kind of ignorance or forgetfulness that erases all moral distinctions along with the men and women who painfully worked them out. Finally it is said that random murder is an effective political strategy; the terrorist will win the day—which, if true, is the most frightening assertion of all, less a defense of the terrorist, than an indictment of the rest of us.

"The revolution," says one of Camus' characters, "has its code of honor." At least it once had. Political militants struggling against forms of oppression as cruel as anything in the contemporary world taught one another that there are limits on political action: every-

thing is not permitted. These were not necessarily gentle, or even good, people. Many of them were all too ready to kill officials, collaborators, traitors to the cause. In discussing means and ends, they were often ruthless and, once in power, they were often tyrannical. But except for a few deranged individuals, seizing hostages and killing children lay beyond their ken, outside the range of their strategic considerations. They did not want the revolution to be "loathed by the whole human race."

Today, in many parts of the world, radical politics has been taken over by thugs and fanatics. One of the reasons they are as strong as they are is that the rest of us have lost the courage of our loathing. To deal with terrorists, police work is necessary; so is intelligence work, and all the security devices of an advanced technology. But none of these will be enough unless we can also restore a collective sense of the moral ugliness of terrorism. For the moment we are only confused: frightened, defensive, weakly indignant. The American consul in Kuala Lumpur, released in Libya by the "Red Army" a few weeks ago, earnestly told reporters that his captors had been "perfect gentlemen." I suppose he was grateful not to have been beaten or shot, but the description could not have been more inaccurate. Prepared to kill some 50 hostages, already responsible for acts of murder in Japan, Western Europe and Israel, these were revolutionaries entirely without honor. Nothing is more important than to recall the code that they have consciously rejected. It is, to be sure, little more than the minimal standard of political decency. But reasserting minimal standards would right now be a great advance for civilization.

The Liberal's Dilemma

DANIEL P. MOYNIHAN

January 22, 1977

There have been two modern senators with true intellectual range who could invoke Renata Adler or recite early modern poetry from memory. One of those senators was Eugene McCarthy, who played an outsized role in the history of the magazine. He helped broker his friend Gilbert Harrison's sale of The New Republic *to his other friend Marty Peretz. Even if this deal hadn't provided him license to contribute at will, the magazine would have enthusiastically accepted his doggerel, satiric pieces, and book reviews. The other senator was, of course, Daniel Patrick Moynihan. Both men were unorthodox liberals, but Moynihan's unorthodoxy meshed perfectly with the magazine's ideological drift in the late seventies and early eighties. This essay captures the neoliberal's emerging crisis of faith in government, despair at the disintegration of the cities, and renewed interest in the cultural roots of social problems.*

In a transport, possibly, of Bicentennial excess, I ran in five elections during 1976. Each was contested; some were close. I ran, first, from the Bronx, to be a delegate to the Democratic National Convention. Then I ran for a place on the Platform Committee. My next "campaign" was for membership on the drafting committee

for the platform. Thence to the senatorial primary in New York, and finally to the Senate election itself.

In the end I won the Senate seat by 585,961 votes. Except for Robert Kennedy in 1964, I was the first Democrat to win a New York Senate race since 1950. Kennedy ran more than one million votes behind Lyndon Johnson in New York in 1964. Since I ran 300,000 votes *ahead* of Jimmy Carter, columnist John Roche, *The New Republic* and other disparate voices have suggested that my victory had more than merely statewide consequences.

If my success in wooing the voters of New York has a wider significance, what I said during those last two campaigns may be of some interest. What I wrote during that time was widely and accurately reported. But for the candidate as well as for the voters, the real campaign, the authentic experience, is almost wholly embodied in the stump speech. Morning and night, day after day, in—yes, just as the formula has it—in union halls in Tonawanda, in senior citizens centers in the Flatlands, by swimming pools in East Hampton, in drawing rooms high over Fifth Avenue, in basement halls in the South Bronx, in cafés in the Southern Tier, in taverns in the North Country, down to the last homecoming rally at Pindars Corners, this is what I said. The voters found it convincing.

The dilemma for liberals in New York, I said, is that we faced unprecedented government problems which however had come about under the auspices of impeccably liberal governments in New York City and in New York State. Not merely liberal, but most often patrician liberal. There had been a great coalescing of progressive forces, and government was truly given a free hand to do all that it could do. And all that it did was to go bust. New York City was in default. Its powers of self-government, intact since 1626 except for a brief spell under General Howe, had been taken away from it,

and given to persons unknown to us and certainly not chosen by us. Some, impervious to evidence, blamed this on Washington where a thermidor or worse was said to have set in. But such an evasion would not survive scrutiny of the federal budget which had grown enormously, and largely for purposes of solving problems New York was finding insoluble.

None of this, I said, was helping the reputation of liberalism. Indeed, during the Presidential primary when Mo Udall came to New York he disowned the label. This led Scoop Jackson to remark that he might not be a liberal, but he was the only candidate willing to call himself one. Jimmy Carter had won the primaries by speaking continuously of "the horrible, bloated, confused bureaucracy" in Washington. So it wouldn't do us too much good to blame tightwads in Washington. And there was no point getting nasty blaming ourselves. What we needed to do, I said, was to sort out our situation and to be as honest about it as we dared.

It was the Bicentennial, I continued, not just of the American Revolution, but also of Gibbon's *Decline and Fall*, and I cited the theme of the later chapters: "the leakage of reality." Something like that had been happening to public discourse in New York, and we must resist it—but not to the point of imprudence, because there are some realities that are simply too painful to confront.

I then described our situation in terms of three interconnected and reinforcing crises: a crisis of government, a crisis of the economy, and a crisis of social organization.

The essential of the government crisis was that New York City could no longer maintain its present level of operations. This situation threatened the state, and other jurisdictions already sufficiently shaky. Raising taxes to meet rising costs, as we had done in the past, would lead to the loss of taxpayers and reduced income. This the subway syndrome: higher fares, fewer riders, less revenue, greater deficit. In part this crisis derived from the honorable tradition of

New Yorkers making a decent provision for one another. In part it derived from folly. We have become a people who know the value of everything and the price of nothing. This posture presents itself as highly moral; but Reinhold Niebuhr, if alive, would soon enough reveal the coercion involved in all that preachiness. "If we can send a man to the moon . . ." In any event, it was a crisis very much of our own making. If we decide to pay twice what Texans pay for the same thing, we must expect to suffer twice the tax.

The decline of government is inexorably associated with the crisis of the economy. The economy of the Northeast is stagnant. In New York City itself there has been a crashing decline. Since 1969, 640,000 private-sector jobs have been lost—enough to sustain a metropolitan area of two million persons. The Hudson Valley is asleep, the Mohawk Valley is dying. Buffalo has lost more than one-fifth of its population in the past 20 years. New York State is losing population. We have only two percent of the nation's housing starts. An executive in Manhattan would increase his real income by almost a quarter merely by moving to Austin, most of the difference being in reduced taxes. But such an executive, firm or industry might want to move away, because the decline of government services in New York City is making our area a less attractive place to live; and the rise of social disorganization is making it a positively dangerous place. Even loyalists like George Kennan are declaring the city "no longer fit for civilized living."

The crisis of social organization is the easiest to describe, but the hardest to analyse. And even though it is easy to describe, few in public life care to do so, because it is now so far advanced that merely to raise the problem is to suggest how little it is likely to respond to public policy. I call it Weaver's Paradox, from a memorandum Paul Weaver wrote in 1968 on New York City. The social fabric of New York, he wrote, is coming to pieces. "A large segment of the population is becoming incompetent and destructive.

Growing parasitism, both legal and illegal, is the result; so, also, is violence."

This parasitism (I argued) is to be found at every level of society, and not least in the hoard of New Yorkers who live well looking after the poor. Feeding the sparrows by feeding the horses. But Weaver's point, and mine, is that no one senses the threat to freedom caused by this growing dependence.

> "Are we then witnessing the ultimate, destructive working out of . . . liberal thought? The viability of liberal thought rested on the ability of the country which adopted it to be largely self-regulating, self-maintaining, and self-improving. As long as the typical individual was formed and directed in socially useful ways by more or less autonomous operations of private subsystems of authority, a government which permitted great freedom and engaged largely in the negative and peripheral activity of the umpire was possible. It was also possible for citizen and statesman to live with a rhetoric which denied the existence, functions, and basis of those private subsystems. *The thoroughly liberal society, in short, cannot know what makes it work.* Now, in parts of New York City, those subsystems are absolutely breaking down. At the same time, the rhetoric is getting an ever stronger and more blinding grip on 'informed' opinion as well as on partisan opinion. The rhetoric leads to policies which actually hasten the dissolution of the subsystems."

I quoted Pigou: "Environments . . . as well as people have children." We therefore must expect our present situation to persist at least into the 21st century.

But this generational problem aside, the decline of the economy itself will increase dependency. Dependency of women and children probably will grow because of the shift in the job

market away from male-defined jobs. Of 11.2 million new jobs created in this country over the past eight years, eight million were white collar, 2.5 million service and 1.5 million blue collar. The number of farm jobs actually declined. Of the eight million white-collar jobs, 72 percent went to women. Women received 59 percent of new professional and technical jobs and 50 percent of new managerial and administrative jobs. Only among the blue-collar occupations—barely a tenth of the new jobs—did men get most of the new jobs.

The growth of government is beginning to divide the population. This is most readily seen in an upstate, rural county such as the one I have called home since the early Kennedy years, when the transformation began. The farmers there had been pretty much in the mud in those days, and pretty much still are. But a whole new class of public-sector employees has entered the scene, and it appears we are well on our way to becoming a society of public affluence and private squalor—until the crisis of government arrives and the future becomes more problematic.

That was my stump speech. Does it seem bearish? Despairing? Illiberal? It did not to my audiences. It seemed true. They told me so. I ran as a liberal willing to be critical of what liberals had done. If we did not do this, I contended, our liberalism would go soft, as Lionel Trilling warned a generation ago. I never yielded much on this. I even got close to belligerent when, in the primary debates, it was suggested that the budgetary crisis could be resolved by cutting $30 billion from defense appropriations. (Presumably the savings would be turned over to New York.) It would be the final corruption of our tradition, I said, to tilt the balance of world power in favor of the totalitarians in order to continue to pay for the subsidies we had voted one another.

This sort of talk caused convulsions in some West Side circles. But there was nothing illiberal about it except in the perspective of liberalism that has indeed gone soft. In the general election some perspective was restored when my opponent called for my defeat so that liberalism would never again show its "ugly head" in New York. Conservatives know.

I genuinely was concerned to identify the excessive moralizing of our politics, and to resist it. Everywhere I quoted Renata Adler: "Sanity . . . is the most profound moral option of our time."

I also tried to argue against the apocalyptic voices that have begun to be heard in circles once so overconfident. Murphy's law applies only in the short term, I said. I invited attention to the large complex of empty buildings on Wards Island in the East River that anyone using the Triborough Bridge will have seen, if not noticed. These were built in the 1950s to warehouse the mentally ill from Manhattan. At that time the rising resident population of New York State's mental hospitals—doubled in the previous quarter century, likely to quadruple in the next—was our most pressing social problem. But there seemed no answer except to build more hospitals, and then more, until half the state's population would be confined in them and the other half working in them. Then in 1955 Gov. Harriman authorized the large-scale use of the psychotropic drugs developed under Gov. Dewey. The next year and then every year for the rest of the decade the population of the mental hospitals went down. The new buildings never were occupied. What seemed at mid-century the most pressing crisis of state government—mental illness—today is nearly forgotten.

When there was time I went on a bit about what was at stake in sorting out our situation and becoming tough-minded about it. To begin with, our reputation is at stake. The reputation of New York, of an intelligent liberalism. Republican as much as Democratic. If it came to be judged in the nation that such politics lead to ruin,

how will we be judged? Judgment apart, it is time we recognize, even if no one else will, what New York means. Trying to describe what Venice meant to the Mediterranean world of the 15th or 16th century, the French historian Fernand Braudel writes: "Venice dominated the 'Interior Sea' as New York dominates the western world today." And if New York should collapse . . . what then of the West? What then of the Constitution? Of all the features of the American federal system, one of the most important (I would say) is one not at all provided for, but which evolved directly from the constitutional preoccupation with the separation of power. This is the separation between New York and Washington. Hamilton and Jefferson struck the agreement over madeira on a tavern in Broad Street. The political capital would move to Washington. For all the other purposes the first city of the nation would be New York. Those other purposes have been well served by New York, and none more faithfully than in preventing the behemothian amalgam of government, finance, business, industry and culture which the Founders most feared. It would not take much for Wall Street to move to Connecticut Avenue; for NBC and Time, Inc. to follow; for Broadway to give way to the Kennedy Center; for *The Washington Post* to become the national paper. In the long sequence of generations of New Yorkers, I would conclude (to audiences mostly first-generation like myself), the honor has fallen to us to defend the City against a collapse that would bring down so much else with it.

Program? Not much in the stump speech. I had drafted much of the urban portions of the Democratic platform and asked that my word be taken that it was all there. The one exception was welfare reform, which people genuinely wanted to hear about. (The fiscal condition of our cities has reached the point that if welfare meant a program to put arsenic in children's milk, most municipal officials would settle for full federal funding.) The platform called for "an

income floor both for the working poor and the poor not in the labor market. It must treat stable and broken families equally. It must incorporate a simple schedule of work incentives. . . ." Jimmy Carter endorsed this plan in his campaign. In my own, I emphasized the urgency of a single national welfare standard. The disparity between our level of support and those of states in the sunbelt was becoming fatal to our enterprise.

Clearly, I said, it was past time we made a legitimate claim on the rest of the nation for our share of federal expenditures. Neal R. Peirce has estimated a $10 billion "balance of payments" deficit between the mid-Atlantic states and the sunbelt. If we paid so little attention to our own interests, could we complain that others paid less? It has been a century since a New York Democrat was last on the Senate Finance Committee, half a century since any New Yorker served there. In each instance the tenure was a single term.

Apart from the total amount of Federal aid, there is the question of the mix. New York gets soft money; "they" get hard money. We get twice our share of welfare but one-quarter our share of the Corps of Engineers civil construction budget. Social services for us, infrastructure for "them." Muskogee, Oklahoma is a seaport. The Erie Canal (now the Barge Canal) is about the size it was when it was dug by Irishmen and mules a century and a half ago. So also is the population of some of the counties along the way.

We do not need more government in America, I said. We do need more national standards which is something federalism can produce, and would be different from more government. We already have a huge amount of government, and the real task is making it work. We have no incentive systems, nor even serious measures of efficiency. Franklin D. Roosevelt, as governor, hit upon the idea of "public yardstick," in this case a State Power Authority as a means by which to keep the private utilities honest, a concept later incor-

porated in the TVA. It is time we had "private yardsticks" to keep public operations honest as well.

For the rest, I said, there was one central issue, which was jobs. Jobs. Jobs. Jobs. Not government jobs, not jobs to make government bigger, but rather jobs to make government, for us, once more solvent, and once more our own.

Protégé Power

NICHOLAS LEMANN

April 7, 1979

The magazine was an insider's publication—but it never quite accepted that place in the Washington scene. Bantering at a cocktail party, after all, hardly represented the state of detachment that Herbert Croly had championed. The magazine has excelled at examining DC with anthropological bemusement, poking fun at the nakedly ambitious and ramming a skewer into the hypocrisies that run rampant here.

Even if you've never heard of such a thing as a special assistant, you probably have seen one or two of them. When a cabinet secretary or some other great man of government is shown on the evening news testifying before a congressional committee, you usually can see an earnest-looking and well-turned-out young man or woman positioned behind and slightly to the right of him, who whispers in his ear or passes a note every now and then. That's his special assistant. When, on the front page of your newspaper, you see a picture of an American official being shown around a factory in some foreign land and, again behind and slightly to the right strides a purposeful young person, that also is the special assistant. When photographers are allowed into Cabinet meetings at the White House, the

pictures show the secretaries of the departments arrayed around a table and an outer ring of special assistants sitting against the walls of the room.

A special assistant is generally someone between the ages of 25 and 35, intelligent and impeccably credentialed, whose job it is to work closely by the side of an important person—usually in government, and if not in government usually in Washington. The special assistant works a few short steps from the office of what he calls "the principal," or even, if he's as lucky as Alfred Kahn's special assistant, in the very same room. He usually sees the great man all day; inspects all incoming papers; writes speeches and testimony; relays information to and from the bureaucracy and the White House; and accompanies the great man on trips. The special assistant may get to be the architect of an earth-shattering new policy. He may also get to pick up the great man's suit at the cleaner's. He may do both in the course of the same long day. The special assistant need not be called a special assistant, and not everyone with the title of special assistant is really a special assistant. The real article is not a member of the civil service, does not have any single specific area of responsibility, and does not command a large staff of his own. His power and prestige, which can be considerable, come solely from proximity and access to, and influence upon, the boss. A real special assistantship is not a permanent job, but just a brief stop of a year or two along the route of a successful career.

What may not be obvious from the foregoing description, and the reason Washington special assistant jobs are particularly noteworthy, is that these jobs are terribly sought after. People will beg, wheedle, scheme for years to get them. And the people who do this aren't just anyone: They're Rhodes Scholars, law review editors, Supreme Court clerks, the best young people around by the standards of the meritocracy. "If you asked me to name the twelve brightest young people in Washington," says one ardent special

assistant-watcher, "about eight of them would be special assistants, handpicked personal aides to a high official. They are sort of an elite corps. You look at their resume and it boggles your mind." Special assistantdom appeals not just to natural-born sycophants, but to the most promising young people in America. This says something about those people and the paths our society sets before them. Their great ambition is fulfilled by being second banana, and without doing anything under their own name they can rise, yea, unto the point where they have their own special assistants.

Like private clubs and men's bikini underwear, special assistantdom is exhaustively discussed and deeply understood by those who are already in on it, and invisible to the rest of the world. A special assistant's most embarrassing moments often come on trips out of Washington, where people don't understand how important he is. Once James Thomson, now curator of the Nieman Foundation at Harvard but earlier in life a special assistant to Chester Bowles, then undersecretary of state, accompanied Bowles to a political dinner somewhere in the Midwest. The master of ceremonies gave Bowles a florid introduction, and then said he would also like to introduce a very bright and able young man, Jim Thomson, who was Mr. Bowles's secretary. Thomson, mortified, whispered to the MC, "assistant, assistant." "I'm sorry, ladies and gentlemen," the man said. "Jim is Mr. Bowles's assistant secretary."

Generally, it's those familiar with the ways of the Eastern establishment who know about special assistants. Bert Lance, for example, was the only member of President Carter's cabinet who didn't hire a special assistant. At the opposite extreme Joseph Califano (himself once special assistant to Cyrus Vance when Vance was secretary of the Army) immediately hired one executive assistant (Ben Heineman, of Harvard, Oxford, Yale Law School, and the United States Supreme Court, the possessor of the best resume in America) and a slew of special assistants.

Fortunately for ambitious young people, most new government officials aren't Bert Lance. Martin Kaplan, formerly special assistant to Ernest L. Boyer, the commissioner of education (and now a special assistant to Vice President Mondale), remembers getting a call from Boyer just after Boyer was appointed to the Carter administration. The two had met at the Aspen Institute for Humanistic Studies and had written a book together. "He told me everyone in Washington seemed to have a someone," Kaplan says, "and would I be his someone?" Both men were much-fellowshipped and well-credentialed, and, proving that similar backgrounds make the best matches, they worked fruitfully together.

Other pairings haven't worked out as well. Consider the sad case of a young man we'll call John. Because he's currently looking for a new special assistantship, he made me sign an affidavit pledging to keep him anonymous. Despite a stellar college record, a prestigious fellowship, and high-powered performance at a top law school, John, like most Americans, spent his early years in blissful ignorance of the existence of special assistants. Then, during his summer stint at a Washington law firm, a young lawyer took John aside and had a man-to-man talk about the logical next step. John decided that after law school he would become a special assistant. So he went to an assistant secretary of a cabinet department and asked to be his special assistant. What's that? said the assistant secretary, who, it should be said, went to a state school and is the kind of man who has a *Who's Who* listing but an extremely brief one. John explained, and the assistant secretary decided to give it a whirl.

The problem was that the assistant secretary, while intelligent and capable, didn't know *how* to have a special assistant. He wanted to see all memos addressed to him rather than letting John screen them first. John was spared both the highs and the lows of the job, and put to work rewriting speeches and testimony. In short, it was an ordinary staff job, not a special assistantship. John says frankly,

"I'd be willing to carry my boss's briefcase next time, if he'd also let me represent him at high-level meetings."

Those who feel that this great nation was built by rugged pioneers and self-reliant farmers and independent businessmen may bridle a bit at the idea that its fate will soon be in the hands of people who have special assistanted their way to the top. But in fact, a mentor-and-protégé system of upward mobility is an American tradition. In Horatio Alger's novels, the poor boy made good not just by luck and pluck, but also through the friendship of a kindly capitalist father figure. Tom Sawyer had something of the special assistant in him, and was obviously going places; Huck Finn didn't, and wasn't.

The 19th-century equivalent of the special assistant was the stenographer, who in those days was usually a man who intended to rise above his original rank. John Hay, later secretary of state, got his start in politics as secretary to Abraham Lincoln. Theodore Roosevelt had a male secretary, George Cortelyou, who was a lawyer but had come to Washington as "stenographer to President Cleveland." But in the 1920s and 1930s, as the telephone and the typewriter increased the clerical requirements of great men, the traditional secretary's job split in two: the modern "secretary," a dead-end typing, filing and phoning job for women; and the "assistant," an upwardly mobile hero-worshiping and policymaking job for men. In recent years special assistantships have opened up to women, too, and good secretaries have become harder than ever to find.

Probably the earliest prototype of the modern-day Washington special assistant was the Supreme Court clerk. This job had all the essential elements: great man (Supreme Court justice) handpicks promising young man (an editor of one of the Ivy League law reviews) who works closely by his side for a limited period (one or two

years) in order to learn about life at the top and get a wonderful credential. Like all special assistants, Supreme Court clerks generally aspire to hold the principal's job some day, though on the current Court there are only two former clerks, William Rehnquist and Byron White.

Now the institution has spread to the point where virtually everyone in government at the deputy assistant secretary level or above has at least one special assistant. So do some prominent businessmen, particularly those with some Washington experience, like Robert V. Roosa of Brown Brothers Harriman and George Ball of Lehman Brothers Kuhn Loeb. When Michael Blumenthal, a man of Washington, was chairman of the Bendix Corporation, he had a special assistant; but when Blumenthal left for the Treasury, his successor tried having a special assistant for a while and then dispensed with it. Eminent men of the press in Washington also sometimes have special assistants. James Reston hired his first in the 1950s after Felix Frankfurter told him over lunch one day how great it was to have one. Now David Broder and Hugh Sidey have them too. Supreme Court justices used to have one clerk each; now some have as many as four.

So far as all these great men are concerned, having a special assistant is appealing because it's lonely at the top. The bureaucracy is huge and uncontrollable. The political appointees with line authority become brainwashed by the civil servants under them and turn into special pleaders for their programs. Memos and phone calls stream in. Small fires break out. It's impossible to keep up on every detail and every interest group. The special assistant, as the only official in the department who is totally loyal to the boss, can help with these problems; he can be counted on to tell the truth and to carry out orders without putting any of his own spin on the ball. From the special assistant's point of view, the job is a chance to see policy being made and to have at least some influence at a level far

above that to which a person in his late 20s ordinarily could aspire.

That constitutes the practical case for special assistantdom. But it's only part of the reason why the institution's so widespread. These are practical disadvantages too. Special assistants are usually hated by the rest of the people in the department, who regard them as scheming and officious young punks shielding the boss from the truth. When Philip Heymann became head of the Justice Department's criminal division, he commissioned an efficiency study that recommended the abolition of special assistantships for this reason. But Heymann immediately hired five special assistants. This suggests that there are powerful psychological forces sustaining the institution as well.

For the boss, a special assistant is a status symbol. It impresses others that one has a bright young lawyer half a step behind and slightly to the right at all times. Perhaps more important, it impresses the boss himself. He can think, by God, I must be pretty good if I can have a Supreme Court clerk at my beck and call. He can pride himself on helping along someone promising, in addition to promoting his own career. He can feel in touch with the younger generation, sharp and critical as it can be. He can tell himself, this fine upstanding special assistant of mine kind of reminds me of myself when I was young.

As for the special assistant, his ardor for the job is a triumph over its many drawbacks. Even the most enthusiastic special assistant will admit that the excitement of the work comes at the price of some degree of sycophancy. There are those moments on trips out of town of having to check the principal's bags and whisper in his ear that it's time to move on to the next appointment. There are the bosses (William O. Douglas being a well-known example) who can turn the most pop-eyed admirers into sullen rebels in a year's time. There are the stories of people who stayed in special-assistant-type jobs for too long and, somewhere along the way, got a reputation

for being, well, very sound but not really the kind of person you'd consider for a job requiring *leadership*.

Special assistants nevertheless enthusiastically assist because it's the natural outgrowth of their experience in life to date. By and large, they believe in large institutions and great men—after all, large institutions and great men have smiled on them so far. Through the years, these young people have developed an odd combination of the self-assertion necessary to get a special assistantship and the self-effacement necessary to excel in one. Most of the special assistants I talked to gave their bosses boffo reviews: "a real pleasure . . . unassuming . . . humor . . . great strength" (Terry Adamson on Griffin Bell); "a great man" (John Kester on Harold Brown); "a master craftsman . . . an ace . . . brilliant . . . the best guy around" (Jim Brooke on James Reston).

More than that, special assistants have often built their lives around accumulating extremely impressive credentials, rather than doing any particular thing well. This opens up wonderful opportunities, of course, but at the same time entraps people. Someone who has been a Rhodes Scholar, a law review editor, and a Supreme Court clerk very likely has little interest in the one activity he has been specifically trained for, the practice of law. So once he has run the gauntlet through a clerkship, he often wants to put off joining a firm and settling in, but to do so in a way that will keep his credentials sterling and not close off any options. So a special assistantship is, for him, a wonderful opportunity—he learns a lot, he adds luster to his resume, he commits no more than a couple of years of his life, he makes valuable contacts, and he can continue to agonize over the choice between law and journalism, teaching and business, government service and investment banking.

Thus in Washington there is a sizable population of some of the most talented people in the country, who spend many of their most productive years in a series of one- or two-year billets in prestigious

government jobs. To really accomplish anything—and these are people who are genuinely capable of accomplishment—would take longer than that. But to stay more than two years would mean closing off options, getting all the possible resume value from one job and passing up the opportunity for the further resume value that would come from taking another one. The culture these people live in specifically guarantees that they won't accomplish all that they could.

In most places, somebody who switched jobs every two years would be suspected of having a drinking problem. But in Washington, if a promising young person doesn't switch jobs every two years, his friends become concerned and potential employers get suspicious. They begin to think what a shame it is that he hasn't lived up to early expectations. They wonder: has he become one of those fellows who hides a bottle in his desk drawer?

PART EIGHT
1980s

"This has been a golden age of intellectuals, except that not many of them could be trusted."

THE EDITORS
NOVEMBER 21, 1983

The Great Carter Mystery

ARTHUR SCHLESINGER JR.

April 12, 1980

Arthur Schlesinger was perhaps the quintessential New Republic *intellectual, in both his ideological and intellectual style. This entertaining fulmination against Jimmy Carter was absolutely true, if not entirely fair. It would have been obvious to most of the magazine's readers that the great historian had an ulterior motive. The target of his ire was locked in a struggle with Teddy Kennedy for the Democratic nomination that spring. Schlesinger had been one of the leading citizens of Camelot and a primary author of its posthumous mythology. He had, in other words, a strong rooting interest in the campaign. And the magazine had its own bias. In the 1980 general election, it endorsed John Anderson, a quixotic third-party candidate, rather than putting its weight behind the feckless incumbent.*

How does he do it?

Here is an administration in ruins. Here is a president who has nearly quadrupled the inflation rate at home, has produced the highest interest rates in American history, and now is deliberately steering the nation into a recession; abroad he has kicked away confidence among friends and foes alike in the sobriety, consistency, and reliability of American foreign policy. Six months ago he was

nowhere in the polls. Today, barring a rebirth of sanity in the Democratic party, Jimmy Carter seems headed for renomination; and, barring repression of a death wish in the Republican party, for reelection. Have we turned into a nation of masochists? Has our noble land fallen under some malign curse?

There are simpler explanations. In an irony not unknown to historians, Carter's very incompetence has been his salvation. He owes his resurrection to two international crises—Iran and Afghanistan—that he himself helped bring about.

The first crisis was surely one of the most needless in American history. British diplomats in Tehran had warned their government that the admission of the shah to the United Kingdom would provoke retaliation. The British government heeded those warnings. Carter received the same warnings from American diplomats—and rejected them. A specialist in tropical medicine employed by the Rockefeller interests claimed that the shah's life could be saved only by emergency treatment in New York. Carter, so far as one knows, did not even do what secretaries of Health, Education, and Welfare tell us should be routine in all surgery cases: ask for a second opinion. He let in the shah, and the Iranians, as predicted, stormed the American embassy. The medical pretext was quickly disproved when a Canadian doctor flew to New York from British Columbia to perform the critical operation. Even the good gray *New York Times* recently said, "The more we learn about the ailments of the deposed Shah of Iran, the more likely it seems that his health did not require him to come to the United States after all." If Carter had made intelligent decisions, the shah probably would still be undisturbed in Cuernavaca; the Canadian doctor would have flown to Mexico City rather than to New York City to remove the royal gallstones; and our diplomats would be going about their business as usual in Tehran.

Nonetheless, the national indignation over the appalling Iranian action fed the genial but dopey American instinct to rally behind

presidents in moments of adversity. People postponed inconvenient questions as to how we got into the fix. Carter's popularity soared. I could not but recall sitting in President Kennedy's office a few days after the Bay of Pigs. A secretary brought in an advance on a new Gallup poll. As he read it, an expression of intense disgust came over Kennedy's face. He threw it across his desk to me and said, "Take a look at that. The worse I do, the more popular I become."

Then, as Carter's free ride over the hostages was coming to an end, Moscow obliged with a new crisis: the invasion of Afghanistan. This brutal action too may be persuasively, if less directly, traced to Carter's prior bungling. Last summer the administration had blundered into the great "pseudo-crisis," as Senator Robert Byrd accurately termed it, over the Soviet brigade in Cuba. The brigade turned out to have been there since 1962; but Carter feebly permitted its presence to be defined as a mortal threat to the republic. Then, having grandly declared that the status quo was unacceptable, he went on to accept it. This capacity for tergiversation may well have convinced the Kremlin that Carter's readiness to accept the unacceptable was unlimited. The Cuban pseudo-crisis also prevented the SALT II treaty from coming up for a vote last fall, when it still might have been ratified; had it been in place, the Russians might have thought twice about invading Afghanistan; and, with SALT dead, they evidently figured they had nothing to lose by plunging ahead.

They plunged ahead, not, as Carter seemed to think, to gain Afghanistan, which they supposed they had gained two years ago in the pro-Soviet coup of April 1978, but to save the pro-Soviet government in Kabul from the Moslem insurgency and to prevent the establishment of a hostile regime on their southern frontier. Doubtless the Soviet government, like other governments at other times, feared to lose "credibility" if it failed to bail out a friend in distress.

How remote the brave days of Carter's response to Afghanistan now seem, 10 weeks later!—the American president crying that the

scales at last had fallen from his eyes about Soviet intentions; calling the Russian action "a steppingstone to their possible control over much of the world's oil supplies"; discerning a Soviet master plan "to consolidate a strategic position . . . that poses a grave threat to the free movement of Middle East oil"; pronouncing this "the most serious threat to world peace since the Second World War"; going on, as no American spokesman has since John Foster Dulles, about "atheism" as an international menace; and, with full flourish of trumpets, promulgating the Carter Doctrine.

This doctrine seemingly committed the United States to repel "any attempt by any outside force to gain control of the Persian Gulf region . . . by any means necessary, including military force." It was a moment of high machismo. But senators Jackson and McGovern asked whether the administration really thought the United States could foil a Soviet assault on the Persian Gulf area by military means short of nuclear war. Though this was the clear implication of Carter's original declaration, our president beat a hasty retreat. Soon he was volubly disclaiming any idea "that at this time or in the future we expect to have enough military strength . . . there to defend the region unilaterally."

If the Carter Doctrine could be enforced only with the aid of other states, a competent administration would have taken the elementary precaution to consult those other states before announcing the doctrine. It seems incredible, but the Carter administration had undertaken no such consultation. In the weeks since, the Persian Gulf states have made it abundantly clear that the last thing they want in present circumstances is an American expeditionary force in their midst. Carter even offered the Pakistanis $400 million in aid if they would only grant him the privilege of protecting them; they turned down the offer with contempt. The Carter Doctrine, in short, found little support among the countries it was intended to defend.

As for our European allies, Helmut Schmidt, Giscard d'Estaing, Lord Carrington have, with imperturbable courtesy, indicated their skepticism about the Carter theses—the Soviet master plan; the idea of fighting a conventional war in the Persian Gulf; the nonsense about the greatest world crisis since 1945 (subsequently reduced by Carter himself, when Schmidt visited Washington, to a "potential crisis"). They have hardly bothered to hide their dismay over Carter's charging ahead without discussing common interests or strategy, nor their frustration over the chronic waywardness and unpredictability of his reactions to world events. Their main doubt seems to be whether they are seeing a badly rattled president responding in an overwrought way to an outrageous but hardly uncharacteristic Soviet move; or an unscrupulous president exaggerating and exploiting international crises for domestic political benefit, at whatever cost to the interests of his allies. (This second thought evidently also has occurred in the Middle East, where, according to Mohammed Heikal, former editor of Cairo's *El Ahram*, "most people" believe American foreign policy these days is determined "by President Carter's tactical considerations in the presidential campaign.")

Certainly Carter's machismo hasn't helped the cause of peace. George Kennan may be unduly pessimistic; but he is, after all, an old hand in these matters, and, in his comments on Carter's overreaction to Afghanistan, Kennan observed that he could think of "no instance in modern history" where such a breakdown of communication and such a triumph of unrestrained military suspicion had not "led, in the end, to armed conflict." It does seem as if Carter hopes to ride a revived cold war into renomination and reelection. And no one can doubt the boost each new crisis has given him in the polls. For a time it seemed as if the ayatollah and

Brezhnev were going to decide whom Americans would choose as their next president. They still may.

Carter's political managers meanwhile sought to convert every primary into a referendum on whether voters were patriots enough to back the president in a national emergency. Carter himself, in order to consolidate his immunity, embarked in February on the rather sinister course of criticizing those who disagreed publicly with his conduct of foreign policy, especially Senator Kennedy, for "damaging" the country. It required considerable nerve, after Vietnam and Watergate, to disparage the role of debate in a democracy and to revive the doctrine of presidential infallibility. Carter's attempt to silence Kennedy should have led to widespread protest. It did not. For a while Carter got away with it. The nation that had debated foreign policy without inhibition when Adolf Hitler stood at the Straits of Dover—a somewhat greater threat to American security, one supposes, than a few Russians standing in Kabul—now fell into the mood articulated by, of all people, Carl Rowan: "The President has said to me that this situation is more perilous than the Cuban missile crisis, and you want me to tell him he is wrong?" (*Washington Star*, January 26). In short, once the president gives the word, it is the duty of all loyal citizens to shut up and march. Come on, Carl! As Dean Acheson remarked to Harry Truman in 1960 regarding the idea that in foreign policy the country must always back the president, "This cliché has become a menace . . . One might as well say 'Support the President,' if he falls off the end of a dock."

Carter's ineptitude in foreign policy has grown each year, thereby confounding the wistful hopes of those who thought he might learn on the job. 1980 has been his banner year for blunders; and what is finally destroying his immunity is less his confusion in grand strategy, impressive as this has been, than his incorrigible incompetence in detail. The mess over the vote on the UN resolution opposing

Israel's settlement policy reminded Americans what a hopeless bungler their president is. Having succeeded in angering Israelis and Arabs equally, Carter then claimed not to have read the resolution and, lacking the decency to accept the blame himself, let faithful Cyrus Vance take the fall. It is still not clear, a month later, whether, apart from the Jerusalem references, the administration endorses or disavows the resolution.

This is only the most spectacular of a succession of idiocies, from the macho decision last year, with a presidential declaration of emergency in order to waive the requirement of congressional consent, to rush arms to North Yemen—a country that soon proved to be dealing under the table with the Russians—to those on-again, off-again sanctions on Iran, to Carter's recent press conference explanation of his latest impasse with France ("We did not communicate adequately," our president said; he never does), to his adoption of a meaningless draft registration plan against the recommendation of his own Selective Service director, to the flat White House denial that Carter had sent a message to Khomeini, when in fact he had. It is little wonder that no one in the world can take a Carter foreign policy move seriously, expecting, as they must, that it will be reversed, recalled, disputed, or forgotten in another week. Even newspapers and magazines that built Carter up over Iran and Afghanistan can no longer contain their concern: "Error and Crisis: A Foreign Policy Against the Ropes" (*Washington Post*, March 16); "Flip-Flops and Zig-Zags" (*Time*, March 17); "A U.S. Foreign Policy in Deep Disarray" (*New York Times*, March 21).

I do not underestimate the problems of conducting foreign relations in this agitated and equivocal world. But tactical zig-zags against a background of strategic purpose are one thing; tactical zig-zags backed up by strategic incoherence another. Carter has

shown himself devoid of a consistent world view, incapable of conceiving or sticking by what Helmut Schmidt calls "a coherent sustainable western policy," and in consequence is buffeted hither and yon by emotional gusts of irritation, self-righteousness, and vainglory. Can the United States—can the world—afford four more years of this unsteady hand at the tiller?

There are, it may be said, only two reasons to shudder at the thought of four more years of Carter in the White House. One is foreign policy. The other is domestic policy. I began by recalling the economic consequences of President Carter. With his compulsion to dodge responsibility, Carter has tried to distance himself from inflation, high interest rates, looming recession, giving the impression that he, like the rest of us, is the victim of forces beyond human control. If prices were stable, interest rates low, and employment secure, one doubts that he would be so shy about accepting responsibility.

His economic policy, like his foreign policy, has been one of zig-zags and flip-flops. His goal, he said in 1976, was to reduce inflation to four percent by 1980. He was for standby controls in his campaign, but dumped them thereafter and proceeded to combat inflation by offering an economic stimulus package in 1977, a tax reduction package in 1978, and two separate budgets within six weeks in 1980. While recoiling from controls as if they were the handiwork of Satan, Carter at the same time favors voluntary guidelines, which, of course, are based on exactly the same economic theory as controls, the only difference being that guidelines, being voluntary, do not work, at least not without a good deal more personal presidential commitment than Carter ever gave them. "To the extent guidelines work," as *The New Republic* said recently ("Time For Controls?" *TNR*, February 3) "they create the same problems as controls; to the extent they avoid those problems, they don't work."

Carter underestimated inflation from the beginning. Nor has he

to this day offered a coherent account of the reasons for inflation. On "Meet the Press" two days before the Iowa caucuses in January, in one of his few sallies from the Rose Garden sanctuary, he seized the bully pulpit to say: "All the increases for practical purposes of inflation rates since I have been in office have been directly attributable to increased OPEC oil prices." In other words, don't blame me, fellows. The only trouble with Carter's self-exculpation was that it was flagrantly false, as the White House had to confess a few days later. Of the 13.3 percent inflation in 1979, only 2.2 percent was directly attributable to OPEC price rises. Carter's alibi was not even plausible. The United States buys less than half its oil from OPEC. West Germany and Japan buy virtually all their oil from OPEC. Yet inflation in West Germany and Japan runs a third that in the United States. As Helmut Schmidt dryly remarked to the *Wall Street Journal* when asked about the OPEC-inflation thesis, "It is clear that there are additional factors as well." Was Carter simply ignorant in his answer to this fairly crucial question? Or did he suppose he could get away with thus misinforming the electorate?

In fact, Carter's own policy of decontrolling crude oil has contributed more than OPEC to American inflation. And, having been forced to abandon his OPEC alibi, Carter now has adopted the old Republican thesis: government deficits are the cause of inflation, and a balanced budget is the remedy. Actually, history reveals no predictable relationship between deficits and inflation. West Germany today is running a deficit nearly three times as large as ours in relation to gross national product—and has about one-fourth the inflation. President Kennedy, in his Yale University speech nearly 20 years ago, carefully explained why the idea that deficits caused inflation was a "myth." Carter's fourth anti-inflation program, founded on this myth, will have the same effect on prices as his first three anti-inflation programs, under which inflation has steadily risen from 4.8 to 18 percent.

The only way his program will restrain inflation in the longer run is by throwing the whole economy into a recession—an objective Carter is pursuing grimly with the collaboration of Paul Volcker, the severe if jovial monetarist whom Carter chose, out of 220 million Americans, as chairman of the Federal Reserve Board. Now it is true that the lamented Gerald Ford, by inducing the worst recession in 40 years, brought inflation down from 12 percent in 1975-76 (while, incidentally, running deficits of $112 billion). But it would take about twice as grinding an economic squeeze to bring inflation down from 18 or 20 percent. The burden of such a draconian policy would fall disastrously on the poor, the unemployed, and the cities. And the effect of recession on such underlying sources of inflation as declining productivity would be only to compound disaster.

The reason for Carter's horrible failure in economic policy is plain enough. On such matters he is not a Democrat—at least in anything more recent than the Grover Cleveland sense of the word. Let him speak for himself: "Government cannot solve our problems. It can't set the goals. It cannot define our vision. Government cannot eliminate poverty, or provide a bountiful economy, or reduce inflation, or save our cities, or cure illiteracy, or provide energy." No, children, this is not from a first draft of Ronald Reagan's inaugural address. It is from Jimmy Carter's second annual message to Congress. Can anyone imagine Franklin D. Roosevelt talking this way? If he had taken Carter's view of government, we still would be in the Great Depression. Can anyone imagine Harry Truman, John Kennedy, Lyndon Johnson, Hubert Humphrey, or George McGovern uttering those words?

To take Carter's view of government is to deny the heritage of the modern Democratic party—the party that, with all its faults, has used government to humanize our industrial economy, establish the

rights of labor, assure the livelihood of the farmer, combat poverty, defend the city, and strive for racial justice. To deny that heritage is to disarm us all in the face of the great national problems. ("The Carter Administration has actually reduced the amount of Federal aid going to New York City"—Senator Daniel Patrick Moynihan.) And to reject the role of government is to deliver the direction of national policy to powerful and greedy private interests.

When I debate advocates of the administration, they tend, unable to defend Carter's record, to say that he should be reelected anyway because he is a "good and decent man." No doubt a congenital distrust of people who wear piety on their sleeve disqualifies me as an observer of those who like to tell the world how regularly they commune with the Almighty. But, pray five times a day as Carter may, he remains a smiler with a knife. No president has used the resources of incumbency with such a cynical aplomb to punish insurrection in the ranks—not Gerald Ford confronted by Ronald Reagan in 1976, not even the ferocious Lyndon Johnson confronted by Eugene McCarthy and Robert Kennedy in 1968. This is another factor in Carter's political comeback.

Can this miracle of levitation last? The Democratic presidents of this century, up to Carter, all communicated a sense of the direction in which they wanted to move the country. Carter seems to have no vision of America at all. "There is every sign," he told Congress on January 23, 1979, "that the state of our union is sound." Six months later, he suddenly discovered "a crisis that strikes at the very heart, soul and spirit of our national will . . . threatening to destroy the social and political fabric of America . . . These changes did not happen overnight." As usual, he was blaming someone else—this time the entire American people—for the failures of his presidency. This was the speech after his famous Camp David conclave when

he summoned 130 American worthies to provide him with the vision he could not find within himself.

"Carter believes fifty things," James Fallows, his first presidential speechwriter, has testified, "but no one thing. He holds explicit, thorough positions on every issue under the sun, but he has no large view of the relations between them, no line indicating which goal . . . will take precedence over which . . . when goals conflict. Spelling out these choices makes the difference between a position and a philosophy, but it is an act foreign to Carter's mind." Lacking any central vision, the Carter administration is alone among Democratic administrations of this century in failing to earn a popular label (New Freedom, New Deal, Fair Deal, New Frontier, Great Society), the effort to launch "New Foundation" proving a dismal and predestined flop. Lacking any central vision, Carter cannot impart consistency and coherence to his policies, whether at home or in the world.

And yet he is today the odds-on favorite for renomination and reelection. Reelect Jimmy Carter? Four more years for a president "whose record of ineptitude" (I quote Tom Wicker) "stands unmatched since Warren G. Harding, and whose campaign is based on foreign policy crises largely of his own making"? Someone must be kidding.

Liberals and Deficits

MICHAEL KINSLEY

December 31, 1983

Michael Kinsley pioneered and perfected the genre of comic wonkery—the jaunty elucidation of dense policy with a touch of wiseass. This essay is the locus classicus of the genre. As editor—actually he did the job twice—he presided over a golden age. With the magazine's criticism of liberal orthodoxy and brash humor, it didn't just feel fresh; it was transgressive. The magazine made famous enemies and attempted ludicrous stunts. (At the height of the crack epidemic, Kinsley sent a reporter off to smoke the drug and describe the high.) Some critics of the magazine found its style vacuous, an exercise in self-indulgent troublemaking. And perhaps sometimes it was that. But it also had genuine policy passions and a very clear agenda.

One of the most dizzying things they try to make you believe in first-year economics is that the national debt is no cause for alarm because "we owe it to ourselves." As late as the 1976 edition of Paul Samuelson's famous textbook, talk about burdening future generations and analogies between the government's budget and a family's budget were dismissed as "the clichés of old-fangled shirt-sleeve economics," at home "in any club locker room or bar." The message was, leave that talk to the old fogies.

Who would have thought that this fogyish talk about the national debt would become the mainstay of Democratic political rhetoric? The temptation for Democrats to attack President Reagan's budget deficits is irresistible, of course, and mostly warranted. But for reasons both of honesty and practical strategy, it's useful for Democrats to keep in mind exactly why Reagan's deficits are bad.

The basic Econ I point remains as true (albeit as hard to believe) as ever. A nation's debt to its own citizens is different from a family's debt to the bank. The debt itself doesn't make the nation any poorer, and deficit spending can even make the nation richer if used at the right time to stimulate a weak economy. Hysterical warnings about civic bankruptcy are just as silly now as they were when uttered by Republican fogies. But other things have changed since the glory days of Keynesianism.

One change is that we no longer just "owe it to ourselves." America will absorb about $30 billion of investment capital from abroad this year, and probably more than double that next year, a historic reversal from the days (two years ago) when America was a net capital exporter. All of this foreign capital doesn't go toward financing the national debt, but it replaces other money that does. This alleviates some of the problems that would otherwise be caused by huge deficits. But it means that this nation, just like a family, will have to pay off those loans with real resources some day.

There have been three other changes, two in the nature of the deficit and one in the nature of our thinking about it. First, the deficit has reached a size—$200 billion a year—that Samuelson never dreamed possible. Second, Keynes's idea was that deficits would give the economy a push in bad times; but this deficit will continue into good times. Right now, about half the deficit is caused by a still-weak economy, which reduces tax revenues and increases social welfare costs. This part is expected to shrink as the economy gets stronger over the next few years, but the other part—the

"structural" deficit—is expected to get larger, so that the deficit will still be $200 billion in 1988, even if things are booming.

Third, Keynes was concerned with the "paradox of thrift," the danger that people would save too much money and the economy would be anemic. In America today, for a variety of reasons, our problem is the opposite. We need to discourage consumption and encourage savings so there will be more money to invest in the future.

It's clear to any sensible and honest person that these huge, undiminishing deficits will hurt our economy. What's not clear is exactly how. They could re-ignite inflation by overstimulating demand as the economy reaches full capacity. If the Federal Reserve Board moves to prevent this by squeezing the money supply, we'll tumble back into recession. And in any event, the deficit swallows up huge piles of capital that would otherwise go to private investment, thus reducing our future prosperity.

I would not hazard to guess whether Representative Jack Kemp was being stupid or dishonest when he wrote in the December 11 *New York Times* that "there is still no convincing evidence that deficits raise either inflation or interest rates." Treasury Secretary Donald Regan, a smart fellow, has been bluffing with similar pronouncements, accompanied by flurries of studies. Ordinarily these gentlemen are great evangelists of the free market, but on this matter they wish to repudiate the law of supply and demand. Interest rates are the price of money. When someone enters the market to buy up a large part of the available supply at any price—which is essentially what the government is doing in the market for capital—the price goes up.

So why have inflation and interest rates come down during the Reagan megadeficit years? Inflation came down because the Federal Reserve Board created a recession. Anyone can do that. As for interest rates, they have *not* come down. Real interest rates—the

nominal rate minus the part that's just making up for erosion of the dollar—are higher than ever. Fifteen percent interest minus 12 percent inflation was a better deal than today's 9 percent minus 3 percent inflation. They would be even higher, except that the non-government demand for capital has been weak because of the recession. As private demand for capital increases, high interest rates will "crowd out" borrowers who (unlike the government) can't afford to pay any price or bear any burden for capital.

The biggest pile of government-issue malarkey on the subject of deficits has come from the President himself. On November 3, for example, Reagan told two lies he has repeated often: "We face those deficits because the Congress still spends too much." And, "I'm prepared to veto tax increases if they send them to my desk, no matter how they arrive."

Oh, really? And what if they arrive all gift-wrapped, with a little note that says, "Here, with love, is the tax increase you requested last year"? In the spring of 1983 the Reagan Administration proposed a "stand-by" tax increase for 1986, including a new energy tax and a 5 percent across-the-board income tax surcharge. "Stand-by" means that the tax will only be imposed if it proves to be necessary, based on statistical conditions only slightly more certain to occur than the sun rising tomorrow. All of the Administration's official predictions about future economic conditions *assume* this tax increase. Secretary Regan confirmed last week that a "contingent" tax increase will be proposed again this spring.

The transgression of Martin Feldstein, chairman of the President's Council of Economic Advisers, was not to propose a tax increase, but to point out that Reagan has already proposed one. That's why those who say Feldstein should resign if he disagrees with Administration policy miss the point. Feldstein agrees. It's

Reagan who disagrees, or pretends to, in a brilliant feat of political legerdemain.

Reagan's second lie is that continuing huge deficits are the fault of a recalcitrant Congress, which refuses to cut spending. John Berry of *The Washington Post* reported last week that the budget Congress approved for fiscal 1984 is only $1.17 billion bigger than the one Reagan submitted. There was some very minor juggling of domestic and military spending, but the $200 billion deficit was just about exactly what Reagan requested.

More important, Reagan has never proposed enough spending cuts to balance the budget, even in the distant future. A chart prepared by Feldstein makes this clear. It predicts the general shape of the budget every year through 1988. Assuming a buoyant economy by that time, and current spending plans, Feldstein foresees a $210 billion deficit. Another column on the chart, labeled "Administration Policy," is the 1988 budget if the Reagan Administration gets every change it wants between now and then. This column shows a deficit of a mere $82.2 billion. About half the improvement, though—$61 billion—is that now-you-see-it, now-you-don't tax increase. Even if Congress goes along with every additional spending cut Reagan plans to request between now and 1988, and even if the economy is booming, without new taxes there will *still* be a deficit of almost $150 billion, according to the Administration's own figures.

Lately Feldstein has been trying to re-ingratiate himself with his employer by pointing out in speeches that "nearly two-thirds of the current structural deficit was inherited from the Carter Administration." What this means is that if it weren't for the recession we're still coming out of, Reagan's current deficit would only be half again larger than Carter's deficit in fiscal 1980. This is a devastatingly modest claim. By the same tortured calculation, Carter

actually *reduced* the structural deficit by a quarter, from 2.7 percent of gross national product "inherited" from Gerald Ford in 1976 to 2.2 percent in 1980. Reagan has raised it to 3.4 percent.

What's worse, this comes despite Reagan's historic reversal of trends in spending for social welfare. Feldstein's second great offense against Reagan mythology has been to make clear that domestic spending is not to blame for the increasing chunk of the economy being swallowed by the federal deficit. Under the changes in law *already enacted*, the share of G.N.P. taken by social programs other than Medicare and Social Security will have dropped from 9.3 percent in 1980 to 6.3 percent in 1988. This is about the level of the early 1960s. In other words, apart from Medicare, we're back to where we were before the Great Society. Even including Social Security and Medicare, domestic spending under current law will have dropped from 15 percent of G.N.P. in 1980 to 13 percent in 1988. Defense, by contrast, will have increased from 5.3 percent of G.N.P. to 7.7 percent, and revenues will have dropped from 20 percent to 19.5 percent. A bit of subtraction, and here we sit.

Feldstein's numbers constitute the temptation for the Democrats, and also the trap. Having beaten Reagan over the head with this chart, how do they propose to rewrite it? There are only two ways: cut spending or raise revenues.

The gap that needs to be closed is $210 billion in 1988, or 4.2 percent of G.N.P. Cut defense spending? Holding defense to its current share of G.N.P. (6.9 percent)—a proposal few leading Democrats would be dovish enough to support—gets you less than one-fifth of the way there. Even cutting defense back to its share in the bad old Carter days would close less than half the gap. There is no way to make a serious dent in the deficit by spending cuts without more deep chops in domestic programs. Medicare is the most log-

ical target. Its share of G.N.P. is expected to rise from 1.2 percent in 1980 to 2 percent in 1988. But for a politician, the thought of publicly attacking Medicare takes most of the fun out of Reagan-bashing over the deficit.

The two leading Democratic Presidential candidates have already fallen into the biggest trap on the revenue side of the ledger. Both Walter Mondale and John Glenn have come out for delay or repeal of tax-bracket indexing, the only part of Reagan's tax cut that hasn't taken effect yet. It's due to start next year. Without indexing, inflation pushes people into higher tax brackets even if their real incomes don't increase. It's tempting, because the government gets extra revenues without an official tax increase. But repeal of indexing is a ludicrous stand for Democrats to take. Indexing is the tax break for *their* constituency.

Feldstein's figures show that despite Reagan's alleged tax cuts, the share of G.N.P. coming to the federal government in taxes has stayed at about 20 percent. That's because of "bracket creep" and because Reagan's cuts, which favored top brackets and income from capital, were offset by large increases in Social Security taxes, which fall only on wages up to middle-class levels. Most potential Democratic voters haven't gotten any tax cut. This powerful political message will be hard for Democrats to put across, though, if Republicans can accuse them of wanting to reinstitute bracket creep: a middle-class tax that barely affects the rich (because they are already in the top bracket), and doesn't affect corporations at all.

If political courage were in greater supply, there would be plenty of ways to help bring the budget into balance without being unfair, or risking our national security, or damaging the economy. (There were a few suggestions in the TRB column of October 10.) But all these ledger calculations reflect the same fallacy Samuelson attributes to the old fogies around the clubhouse—thinking of the government like a family in debt. If the real problem is finding more

capital for productive investment, then the proper focus is on all government policies that affect the supply of and demand for capital. In this, the budget itself plays a surprisingly small role.

For example, the personal interest deduction will cost the government $36 billion in 1984. But by encouraging people to borrow money for consumption, it will drain far more than that from the capital markets. According to Lester Thurow in the December 22, 1983, *New York Review of Books*, private consumer borrowing eats up two-thirds of private savings in this country. Three steps forward, two steps back. Reducing or eliminating this subsidy could have a huge payoff.

By contrast, cutting Medicare by reforms such as raising the deductible may be largely self-defeating. This will reduce the federal deficit, but if people pay the difference out of their savings, the supply of capital will be reduced by an equal amount. (And if people *can't* pay the difference out of their savings, that's a good reason for pause.) Only by using its power as a large buyer and regulator to reduce health care costs can the government hope to direct significant sums away from this form of consumption and toward productive investment.

Then there is government spending that actually increases private consumption spending, such as the ludicrous farm price support system that costs us billions both as taxpayers and as consumers. Phasing it out would reduce government costs and leave also more money in family budgets, some of which would get saved.

At little or no apparent cost to itself, the federal government guarantees or actually provides loans to individuals and companies for various purposes such as new housing, encouraging exports, aiding small business, and coddling farmers even more. The Congressional Budget Office estimates that by 1988 such government-sponsored borrowing will be absorbing new capital at a rate of $134 billion a year. That's almost two-thirds of the expected budget defi-

cit. These policies don't get nearly the scrutiny that direct federal spending gets, yet they are precisely the same drain on capital markets.

Finally, on a more positive note, Democrats shouldn't be afraid to note that a lot of government spending *is* productive investment. The proper analogy is not to a family but to a business. A business is not "living beyond its means" if it borrows money for investment that generates a higher return than the cost of credit. According to the General Accounting Office, almost a fifth of the 1982 federal budget—about $135 billion—was spent on capital investments, narrowly defined. This includes construction and repair of the nation's infrastructure, scientific research and development, and education and training. Our future prosperity depends on these investments just as much as on private outlays, and it is foolish to skimp on them just because they are paid for by the government.

Tory Days

HENRY FAIRLIE

November 10, 1986

Henry Fairlie lived in The New Republic *for a time—more specifically on a ratty old couch that somehow haunted the office for nearly two decades after his death. His love affair with America had drawn him from a distinguished career on Fleet Street, and some of his best pieces were mash notes to the land where he spent his final decades. But the émigré also wrote cutting, witty portraits of his new compatriots, most of whom had somehow eluded targeting by native scribblers. He took down, for instance, the columnist George Will and his pompous polemics. Because Fairlie was indisputably a Tory, this attack was doubly barbed. But as a classic hard-drinking hack, Fairlie was caught in a perpetual cycle of writing furiously to earn his next check, which he would promptly manage to squander—thus, the legendary couch.*

With this new volume, which covers the years (so far) of the Reagan presidency, George Will has given us three collections of his newspaper columns in eight years. He has also published one book whose title, *Statecraft as Soulcraft*, invites us to a work of political philosophy. Given that he is taken to be a conservative, and announces that he is a Tory, we can look to him for a clear statement of contem-

porary American conservatism, a definition of what an American conservative today should believe. And since Will's career as a syndicated columnist has coincided with the flamboyant rise to power of a cock-a-hoop conservatism of some stripe, this would seem to be a useful time to look, and Will would seem to be well equipped to point the way.

He is not modest in his claims to be our guide. "My aim," he writes in the preface to *Statecraft*, "is to recast conservatism in a form compatible with the broad popular imperatives of the day, but also to change somewhat the agenda and even vocabulary of contemporary politics." He should charge more for the tour. Will is "a lapsed professor of political philosophy," with "a continuing, even quickened interest in the state and standing of political philosophy" since his lapsing. As a writer, he tells us in the manner of the Smith Barney commercial, "I write (of course) the old-fashioned way, in longhand, with a fountain pen"; and prominently displayed in the photograph on the cover of this book is a fancy fountain pen that Will is holding. If we are uncertain why this recommends him, he informs us elsewhere of his "firm conviction that the rushing typewriter, with its clackety-clack rhythm, is an enemy of well-crafted sentences," and that congressmen during the first 30 years of the Republic wrote a stately prose because they "dipped quill pens in inkwells."

Armed with the authority of statecraft, soulcraft, and sentence-craft, he tells us he is not like other journalists who are "too proudly 'factual' to pay attention to anything but the nuts and bolts," and so "miss the element of mind"; his subject is "not what is secret but what is latent, the kernel of principle and other significance that exists, recognized or not, inside events, actions, policies and manners." (This last citation is from *The Pursuit of Happiness and Other Sobering Thoughts*, which appeared in 1978.) He assures us often that he will reveal "Conservatism properly understood . . . Real conser-

vatism . . . The truly conservative critique"—the opening words of three successive paragraphs in a single column (reprinted in *The Pursuit of Virtue and Other Tory Notions*, in 1982).

Will's most beguiling credential, however, is his claim to be a Tory, a word (when used with the "t" in the upper case) hard to fix with any meaning in the American scene after 1783 (as *Webster's Third International*, by the way, would seem to confirm). This vaunt assumes its most outlandish form in the preface to *The Pursuit of Virtue*. Will begins with a mildly amusing quotation from Stephen Leacock about the writer's craft: "Just get paper and pencil, sit down, and write as it occurs to you. The writing is easy—it's the occurring that's hard." But not for Will. "Actually," he at once says, "the 'occurring' is not hard for someone blessed with a Tory temperament."

The writer glides like a skater, and the reader can too easily glide with him. Will in his bow tie is an elegant Victorian skater on the pond, and the maiden on his arm feels blessed.

"Ah!" she sighs, "a Tory temperament—you do like to sound old-fashioned, Mr. Will." Mr. Will pats her muff and skates on: " . . . and sentenced to live in this stimulating era." The maiden begins to flutter, "Oh, to be sentenced . . . ," but realizes too late that they have been skating on not even thin ice, and she goes under, as the reader will many times, with no hand held out to rescue her.

But Will has jumped onto the op-ed bank to assert to the orchestra of his admirers that in his columns there are "continuities, and mine are conservative convictions. I call them 'Tory' because that is what they are. I trace the pedigree of my philosophy to Burke, Newman, Disraeli and others . . ." Will tracks this lineage of his ideas many times, throwing in an assortment of "others," and still adding "and others."

He even claims that their origin may be found in Aristotle, "a founder of conservatism, properly understood." The question is whether Aristotle has been properly understood. A liberal, after all,

may as easily draw on his philosophy; to call Aristotle a "founder of conservatism" is an anachronism as facetious as it is perverse.

Still, the most bizarre genealogical claim for his ideas appears in *Statecraft*, a slim book that we are nonetheless entitled to take—since he so presents it—as his testament. "When a kind reader calls me unpredictable [not the drowning maiden's word for him], I am tempted to respond: to anyone sufficiently familiar with the minds of the Oxford Movement, circa 1842, all my conclusions are predictable." Of course few Americans, even if Will were among them, are "sufficiently familiar" with the Oxford Movement to know what he is talking about. We can only ponder, not to his credit, why the claim is made. There is no explanation. It is thrown in. Nothing follows from it.

Even if the whole sentence were not a giveaway, there is a giveaway at its core. According to the founders of the Oxford Movement in 1833, its purpose was to uphold "the doctrine of the Apostolical Succession and the integrity of the Prayer Book." Which of Will's conclusions is predictable from that? And what does it have to do with America, or with American conservatism, or for that matter with the price of eggs? The Oxford Movement reached a crisis in 1841, when John Henry Newman, one of the ancestors most frequently claimed by Will, published his *Tract 90*, demonstrating to his own satisfaction that the Thirty-Nine Articles of the Church of England were compatible with Roman Catholicism. In 1843 Newman gave up his living, and shortly thereafter he went over to Rome; but men such as Pusey and Keble held on in the Church of England. Thus, when Will tells us to look to the Oxford Movement, "circa 1842," he is pointing to the exact year in which it was riven in two by *Tract 90*. Before we can find his conclusions in "the minds of the Oxford Movement," we need to know whose minds Will is talking about. Those who followed Newman to Rome? Or those who stayed with Pusey in the Anglican Church?

His admirers may say this is picky, but it is not. Will's pretensions to a wider and deeper learning than is possessed by his audience, by other journalists, and by American conservatives in general (who he mockingly suggests at one point appeal to Burke without having read the essay on *The Sublime and Beautiful*; has he?)—these pretensions are not a mere trapping, an adornment to his writing or to his "recasting" of conservatism. They are not playful. They are the pillars and struts of such thought as there is. Moreover, since the ancestors to whom he appeals are rarely Americans, not even the Founding Fathers, but European and especially English thinkers and politicians, it is not unimportant to point out that no Englishman "sufficiently familiar with the minds of the Oxford Movement" could explain how this familiarity makes "all" Will's conclusions predictable. If he had said that *some* of his ideas were akin to, or drew nourishment from, *some* of the ideas of *some* of the minds of the Oxford Movement, we could let it pass. But as it stands, in so prominent a place at the beginning of his testament, it is a conceit (in both senses) and an ill-mannered use of what looks suspiciously like a little learning.

So Will has appealed to Toryism, a peculiarly English political tradition; to the names of three English conservatives, if we overlook the fact that Burke was Irish; and to an English movement that was concerned with the defense of the creed and liturgy of the Anglican Church. But then we are confounded near the end of *Statecraft* by another grandiose assertion: "The conservatism for which I argue is a 'European' conservatism." And he hastens to inform us that "it is the conservatism of Augustine and Aquinas, Shakespeare and Burke, Newman and T. S. Eliot and Thomas Mann." (What happened to Aristotle?) But hardly anything that matters is held in common between any English and (continental) European conservatism. As for the list of names—why doesn't he throw in Uranus, the first ruler of the universe; or Cato the Elder; or Virgil (*arma*

virumque cano: he was clearly for a strong defense); or Jerome? And if he's going to rope in Shakespeare (what did he do to be card-filed as a European conservative?) why not Cervantes? (Of course, he can't have Rabelais. "Rabelais, the Hugh Hefner of his time," one can almost hear Will begin . . .)

Weird lists of names recur; perhaps this is why the "occurring" is easy. But the list upon which one must gaze most fondly is in Will's defense of Solzhenitsyn against his critics. Solzhenitsyn's "ideas about the nature of man and the essential political problem are broadly congruent with [watch the skater glide] the ideas of Cicero and other ancients, and those of Augustine, Aquinas, Richard Hooker, Pascal, Thomas More, Burke, Hegel and others." Even if we keep our seats at the mention of Hooker, a mild commonsense skeptical Englishman, and of Pascal, surely we must jump to the ceiling at the inclusion of Hegel. There is nothing about the thought and writing of Solzhenitsyn, absolutely nothing, that can be deduced from such a roster.

With these lists, with the individual names he is always tossing out, in, and over his shoulder, we come to Will's famous use of quotations. His critics are usually satisfied to call it intellectual and cultural name dropping. But Will's practice suggests a far more serious disorder. At times explicitly, but also implicitly in his whole posture, Will puts himself forward as an almost lone defender of our Western cultural heritage (but with support from William J. Bennett). And yet he rummages among its thought and literature like a bag lady. Commonly the quotations or references are introduced with parentheses that are leaden—"Arthur Koestler's *Darkness at Noon*, a classic of political literature"—but these seem designed to assure the reader of the author's familiarity with all of the culture. Or the parentheses are unforgivably tawdry; "Santayana and Plato,

both of them clever fellows"; "Dostoyevsky (who knew something about crime and punishment)"; "Willie Keeler, baseball's Plato"; elsewhere we are told that "baseball people are Pythagoreans."

Or take the beginnings of these consecutive sentences: "Like Moses, Humphrey was discovered early in his career . . . Like Moses, Humphrey was a bundle of opinions . . ." What discernible meaning could there possibly be in such an analogy? What discernible respect for either Moses or Humphrey? (Whatever Moses communicated, it was not "opinions.") Flaubert gets the same treatment as Moses; "Jim Wacker, professor of football at Texas Christian University, may have the finest sense of nuance in language since Flaubert." And again: Earl Long "had Flaubert's flair for bons mots." Yeah, that's why we read Flaubert, for his bons mots. (Has Will confused the bon mot with the mot juste?) "*The Bill James Baseball Abstract*, the most important scientific treatise since Newton's *Principia*"; and "The Bible, which devout baseball fans consider the *Sporting News* of religion." This is the manner of a talk-show guest, or of an entertainer on the lecture circuit. Or, more to the point, of a new kind of columnist.

What is absent from Will's lists of names, from his entire papier-mâché model of Western culture, is a recognition of struggle—of the struggle of idea against idea in the civilization as a whole, of the strenuous and tormented struggle within the individual thinkers and artists he so lightly robs, like a pickpocket. One would not know from Will's appropriation of Augustine, for example, that the latter's certitudes were a recovery from the anguish of sin; or that Pascal placed faith above reason only after, and because of, tremendous doubt. There is a profound sense, after all, in which Western culture has been built on the admission of sin and doubt. But temptation, error, sin, pleasure—and the struggle with all of them—are

absent from Will's smug defense of a placid cultural heritage. There is no evidence in his writing that he has ever fought with temptation or error. Civilization came to him gift-wrapped. It seems to have "occurred" to him, like the names. In this he reflects a persistent shallowness in American conservatism, not least in the alleged "revival" of conservative thought in recent years. There is no quest in it. It is quite remarkable that Will should quote with approval Jowett's question to D. G. Rossetti in Max Beerbohm's famous cartoon; "And what were they going to do with the Grail when they found it, Mr. Rossetti?" It is not any "true conservatism," but only the shallowest liberalism, that could ask that question.

In the new collection there are two essays extravagantly praising the columns of Miss Manners. Watch how he praises her: "Like Plato, . . . Miss Manners knows . . ."; "Not since Edmund Burke's *Reflections on the French Revolution* has there been a counterrevolutionary trumpet call as ringing as Miss Manners's"; "Miss Manners is like Lincoln . . ."; "Miss Manners deals like Metternich with . . ."; "[Her prose] is compounded of . . . an adamancy never achieved by Pope Pius IX, whose Syllabus of Errors was, compared with Miss Manners's syllabus, halfhearted . . . Actually, her book is the most formidable political book produced by an American since *The Federalist Papers* . . . As Plato understood . . ." All good clean fun, his admirers may say. But the fun is limp; and more important, it is an aping of any serious allusions to our cultural heritage, and so only belittles it. Will makes culture evaporate. In his hands it becomes a thing of no gravity. This columnist who so manfully shoulders the burden of upholding our culture is an Atlas bowed under a balloon.

There is in Will's attitude toward (and abuse of) culture a philistinism that is profoundly antithetical to any "true conservatism." It is a philistinism that can offer "Oscar Wilde . . . with the stiletto

of his cynicism." A stiletto, Wilde's weapon? Wilde's purpose was not to draw blood. And anyone who can speak of Wilde's cynicism, who can think even for a second that Wilde was cynical, must either not have read a page he wrote, or read with such obtuseness that he might as well not have bothered. It is the same philistinism that calls John Buchan "an unsurpassed memoirist" (not surpassed—whom shall we pick?—by Cellini, or by Gibbon, or by the author of *The Education of Henry Adams*?); the same philistinism that pronounces that "Mallarmé should have been a columnist," a comment of colossal ignorance and vulgarity that cannot be based on anything Mallarmé wrote, or on anything Will has read, but merely on one of Auden's teasing clerihews, which Will quotes; the same philistinism that echoes a line from "Prufrock" so ineptly as to say that Nixon "measured out his life in forkfuls of chicken à la king"; the same philistinism that declares no less inappositely that Whittaker Chambers's *Witness* is "comparable in depth and power to the memoir of another American alienated from his times, *The Education of Henry Adams*"—adding even then that "Adams is less unsettling." Oh?

This philistinism that extends in so many ways through Will's writing is not a peccadillo we may overlook. It undermines his whole claim to speak in defense of our civilization and its cultural heritage, or more specifically in defense of any conservative tradition. But his fitness to be the conservative guardian of our culture, so ready to arm it to its teeth and engage it in rash military adventure, looks quite as questionable if we take our stand in the present, and not on what Will imagines to be our heritage from the past. For example, Will ends his embarrassing paean of praise to Oxford, where he spent a brief but much-advertised time, with: "What I am trying to say is that Henry James was wrong. He said that 'youth'

is the loveliest word in the language. For those who favor 'old'—old ideas and institutions—this ancient community is the rainbow's end." ("Favor" is at least an honest word for the depth of his reverence for the past.)

But every "true conservative" knows that it is no service to the traditional culture to stand outside the contemporary culture, to separate himself so ostentatiously from its growing life that there is nothing to defend but a museum, a dictionary of quotations, and a conversation piece. If, as Will puts it, "2,500 years" of our civilization have brought us only to a wasteland, with the pitifully few blooms he finds in it, then there must have been something radically at fault with Western civilization's *past*, something so wrong that it is not even worth defending.

There is no need to show with more names and quotations how little Will finds to interest him or to enjoy in modern literature, art, or music. His condemnations of modern art are facile and unilluminating. He fastens his attention on some of the works easiest to ridicule, and most of the time he is not looking at the painting or sculpture, but clipping some of the more unintelligible pronouncements of contemporary criticism. That there is babble in much contemporary criticism does not mean the work of an individual artist, or the whole effort and achievement of modern art, is babble. Again, it is not a quibble, but an essential criticism of Will's attitude toward contemporary culture, to point out that when he roundly condemns Jackson Pollock (in 1978, and again in 1985), he says not a word about any Pollock painting, not to mention the whole body of his work, except the old-hat criticism that they are "canvases covered with drips." On both occasions he bases his criticism on the same silly tribute to Pollock by an unidentified art critic. *Blue Poles*, to take but one Pollock painting, cannot be described as a canvas "covered with drips," and only an eye uneducated not only in modern painting, but in all painting, could say so. In fact, one doubts whether he

knows what paint is, or for that matter what Raphael did with his "revolutionary" use of color.

It is an offense to the past, as well as to the present, to come down so clumsily on the experiment, the trial, the essay. But let us switch from "high" culture to "popular." Popular culture has always energized high culture in our civilization. In fact, that could be claimed as one of high culture's distinguishing merits; it has always kept itself open and receptive to what comes up from below. (This is not least true of our language, which Will's fountain pen affects to use and defend with a recovered stateliness denied to the rest of us.) And it is not rash to say that we live in a time, even a century, in which popular culture has energized high culture more consistently, and to greater benefit, than in any other. To Will, virtually the only emblem of that popular culture is (you guessed it) rock 'n' roll, and (you guessed it again) he condemns, rejects, and ejects it. Except for . . .

Will's famous takeover bid for Bruce Springsteen in September 1984, which provoked Reagan's own takeover bid during the election campaign, was written after a friend took him to a Springsteen concert. It was simply very brave of him to go at all, since "I may be the only 43-year-old American so out of the swim that I do not even know what marijuana smoke smells like . . . Many of his fans regarded me as exotic fauna . . . (a bow tie and double-breasted blazer is not the dress code)." But he is full of praise for Springsteen. "There is not a smidgen of androgyny in Springsteen . . . rocketing around the stage in a T-shirt and headband." He is a "wholesome cultural portent," and "affirms the right values." And "if this is the class struggle, its anthem—its 'Internationale'—is the song that provides the title of his 18-month, worldwide tour, 'Born in the USA.'"

What is absent from the whole piece is any interest in or concern for the music, except to say, "This is rock for the United Steelworkers, accompanied by the opening barrage of the battle of the Somme . . . I made it three beats into the first number before packing my ears" from a "pouch of cotton." Rock is now 30 years old. It has carried round the world, even penetrating the "evil empire" of the Soviet Union, crossed boundaries not only of nations and cultures but of classes and generations. It may be taken as a striking expression of the vitality of American culture. But it is the music that has done this. Will doesn't seem to know that what he is writing about is music, and not merely a "plague of messages about sexual promiscuity, bisexuality, incest, sadomasochism, satanism, drug use, alcohol abuse and, constantly, misogyny"—as if people go to rock for the lyrics and not the music. Will might do well to expose his prudishness to those rock stars of our venerated past, to the Goliard poets, the wandering scholars, the troubadour poets of the late Latin middle ages. He will discover the astonishing extent to which bawdiness gives to culture . . . life.

It was Disraeli, one of the English conservatives claimed by Will as an ancestor, who said in his rectorial address at the University of Glasgow that one must know the spirit of the times in which one lives, even if it is to resist it. One of the weaknesses of Will's conservatism is that he sets himself so vigorously and indiscriminately against the spirit of his times that he gives himself no chance to know it. Will's contempt for our culture, "high" or "popular," is evidence finally of an unexperiencing nature. Little in our culture seems to touch Will deeply, or often. Experience is hard, even the experience of reading; but the "occurring" not only comes easily in his writing, it seems to come as easily in his reading.

Does he read? If one goes back to one's "favorite" poem or paint-

ing or music in different moods, whether of exaltation, serenity, or gloom, there is always something more to find. Often such genuine reading leaves scars, marks of pain. Or, if you will, of sin. Before we go to God on proudly bended knee, as Will's writing suggests we should, we might at least acknowledge that he made us—once we were out of Eden, that "animal" place that Eve found as boring as Chevy Chase—the most revolting of his creatures. That is what Augustine, at least, should have taught Will: the strength of an experiencing nature. But it seems correct to say, on the evidence of Will's written work, that he has not *experienced* a feeling or thought, of guilt or of innocence, in his life.

In his self-appointed role of champion of our culture, Will naturally gives his attention to the parlous condition of American schools and education, not least as "transmitters" of our cultural heritage. Nobody will deny that there is cause for concern. But the slightly faddish alarm that is being voiced today—in Will's new book as well—carries its own danger. For if the American academy is also such a desolation, people may begin to think, when the faddish interest dies down, that it is beyond recovery, except for some enclaves for the privileged that will turn out the elites in whom Will exhorts us from time to time to place our trust.

For one thing, if the "core curriculum" is such a shambles—William Bennett recently made the point again at Harvard—why do American universities continue year after year to turn out such fine scholars, not least in the disciplines of the humanities that the conservative wishes to keep strong? Barely noticed, American classical scholarship has been leading the world for decades; and I know no British historian who does not pay tribute to the work of American historians, and to the generally high standard of historical scholarship in America, even in the fields of English and European history.

What is more, it is my observation that every profession in America has an abundance of good and well-educated minds. If all these are the exceptions, the survivors in the wasteland, one must ask how many such exceptions were produced by Oxford at whatever period Will imagines it to have been the noble institution he extols. As for the "transmission" of our cultural heritage, the great universities of Germany, Italy, and France did not produce a generation with enough understanding of, or care for, our culture to resist, for instance, its devastation by Hitler.

When the "brain drain" from Britain began in the 1950s, it included many graduate students. One of them, the writer Andrew Sinclair, later said that "America is today of course what the Grand Tour was to the 19th century." Another, the critic and novelist Malcolm Bradbury, declared that "America is intellectually attractive; not only as a sort of spell in the 'colonies' to get started, but as a real way of tuning in to advanced ideas, modern tendencies, intellectual excitements. So the pattern is likely to continue"—and of course it has. But it is precisely these *advanced* ideas, *modern* tendencies, intellectual *excitements* that Will disdains, and encourages his readers to disdain.

Far too much of Will's conservatism merely adds one more voice to the long whine of 20th-century conservatives against modernity. But the "true conservative" does not wish only to "transmit" the cultural heritage, as Will keeps saying, as if it were finished and could be wrapped and mailed to the future. He wants to bring it forward and to understand it, so that it will help to energize the present, as it has indeed energized more of modern literature and art than Will appears to know. Will makes our precious heritage lifeless, a corpse, embalmed and carried before the people, with the ultimate and hardly disguised purpose of keeping them quiet, and the society quiet, and above all the culture quiet. It is not only the past he puts in a museum, as if there is nothing

more left for the traditional culture to do. He puts the present in
a museum, too.

Thus it is not surprising that he traces the "European conser-
vatism" he says he loves to so few Americans, so few contempo-
raries. But one must ask: Which European conservatism, exactly?
The English Toryism he also claims would find it very hard to go
along, for example, with De Maistre. But it is the absence of more
than an occasional appeal to an American political tradition that is
most damaging. There are only scant and usually dismissive refer-
ences to the Founding Fathers, and even to *The Federalist Papers*. In
all the lists of names and rivers of quotations, there is only one idle
mention of Calhoun. Will's is a conservatism with the South left
out, which makes no sense. There is no examination, for example,
of the group of Southern writers who published a very conservative
manifesto, *I'll Take My Stand*, against the way American society and
its economy were going at the end of the 1920s—at the end of the
administrations of Harding and of Coolidge (who is praised by Will
because the "nation under his stewardship enjoyed a 45 percent
increase in the production of ice cream") and of Hoover.

In fact, to an extent astonishing in a journalist, America itself
is not very visible in Will's work. In all these volumes there is little
sense of any region, city, town, or place in America; little of what
its people actually do, feel, think, enjoy, and value, except going
to baseball games, driving automobiles, and of course listening
to obscene lyrics and reading pornographic magazines. ("[Hugh]
Hefner, the tuning fork of American fantasies"!) And there is little
of American history, either. We are entitled to ask Will to say, then,
precisely on what things American his conservatism stands. "Cars
and girls are American values" is not enough.

Still, Will has a difficulty with which one may sympathize. And
unlike many American conservatives, he is at least honest enough
to mention it, even if not quite to face it. His difficulty is with, well,

America; and it is at this point that he most clearly resembles the Tory he claims to be. "Capitalism means the liberation and incessant inflaming of appetites," he acknowledges. "Capitalist dynamism" dissolves "cultural conservatism." Business should rise "above the morals of the marketplace." American conservatism "tends complacently to define the public good as whatever results from the unfettered pursuit of private ends. Hence it tends to treat laissez-faire economic theory as a substitute for political philosophy, and to discount the importance of government." And from all this come "the somewhat barren and negative social prescriptions of American conservatism." These are genuine Tory sentiments, expressed by English Tories 200 years ago in voicing their early horror at the Industrial Revolution, and by Southern Agrarian writers 50 years ago. But it is hard to see where they can lead Will. This is the difficulty an English Tory feels in accommodating himself to American conservatism: the difficulty that there is in America itself so strong an attachment to, and presumption in favor of, "free enterprise" and the market and its values. One may almost say, deliberately leaning on the ambiguity in the word, that this capitalism is *constitutionally* part of the United States.

One may agree with Will in criticizing excessive individualism (libertarianism in its vulgar, contemporary form) and the opposition to strong government in American conservatism. But then there is another difficulty. Individualism is rooted in the culture, as well as in the political tradition, of the nation, even in its beginnings. Even if one does not question some of the purposes for which Will wishes to strengthen government—to "legislate morality," for example—an English Tory (or anybody else, for that matter) may still say he would not recognize an America in which there was not so strong a flavor of individualism in politics, in culture, in society.

In the end, it is not only American conservatism Will puts into question, dissociating himself from much of what most people un-

derstand it to mean. He rejects a great deal of America, too. When he argues not only against Thoreau, not only against Emerson and his transcendentalism, but (in this new collection) against Huckleberry Finn on his 100th birthday, one begins to wonder where his America may be found, now or in the past. One begins to understand why he sets himself on the shoulders of Augustine, Aquinas, the Oxford Movement, Oxford University, "and others," or at least borrows the support of their names. For what he discounts is nothing less than the liberation from political and theological oppression that has been the achievement of the United States and its inspiration to the world.

If I have not spoken of Will's columns on the topical issues of American politics, it is because in these volumes, and not least in his new collection, he republishes relatively few of them, preferring to give his readers his lighter and easier reflections on such matters as baseball (a great deal of that in the new book), child-rearing, and what are today called the "social issues," mainly pornography, obscenity, rampant sexuality, abortion, and the withdrawal of life supports from the retarded and the handicapped. In the political columns that he has chosen to reprint, there is a running, rather awkward, and not terribly damaging criticism of "Reaganite conservatism," as one would expect from Will's own brand of "conservatism"; and surprisingly little, given his concerns about capitalism, on either current economic policies or more long-term developments that are profoundly altering the character of capitalism, and even the claims it has made in the past to encourage such virtues as thrift, hard work, and prudence.

For the rest, there are the columns exhorting the administration to create an armory to which Will seems to set no limits, or even to imagine any; to be ready to use those weapons; and at last to resist

and even roll back the advance of the "evil empire"—an advance that always seems, when he lists the countries that have fallen since the division of Europe during the Second World War, to be far less menacing, or rather, far more carefully, quietly, and successfully resisted by America and its allies, than Will's rhetorical flourishes suggest.

What's more, just as Will offers few specific economic prescriptions, it is hard to see what he expects an American government to do when, for example, the Polish government with the Soviet Union behind it crushes an opposition movement—unless it is rashly to take up arms. On the 25th anniversary of the building of the Berlin Wall, Will asked, "What if the blockade begun in 1947 had been smashed by force? What if the Allies had used force to unseal East Berlin at dawn, August 13, 1961?" But those "what ifs" are too lightly asked and answered. What if war had resulted? The Soviet Union in 1947 was indeed a "shattered nation"; but Western Europe was a shattered half-continent, over which Soviet tanks would have swarmed with little resistance. And if one is going to count the Berlin blockade a terrible defeat for America, when in fact that blockade was broken and West Berlin was saved, why not count the Marshall Plan in 1947 a far greater American victory? Because it was peaceful?

Mr. Democrat

MICHAEL KINSLEY

March 21, 1988

Kinsley's specialty was the thousand-word column. Despite its limited size, it had maximal impact. His aphorisms were enshrined in the everyday parlance of political journalism. There was, most famously, the "Kinsley Gaffe," which "occurs not when a politician lies, but when he tells the truth." Despite his success, he kept attacking Washington's most sacrosanct figures. Bob Strauss was an eternal fixture of the establishment—an old pal of Lyndon Johnson's, a chair of the Democratic National Committee, a superlawyer, or, in the parlance of Washington, a wise man. He had amassed so much prestige that nobody could remember how he acquired it. His power could do nothing to insulate him from Kinsley's wit.

"Yes, that was Mr. Democrat, Robert Strauss, having a quiet lunch yesterday at the Jockey Club with First Lady Nancy Reagan . . ."

—*Washington Post*

Did I miss the primary where they elected Bob Strauss Mr. Democrat? Can we petition for a recall? Are Democrats allowed to vote, or is it entirely up to the likes of William Buckley and George Will?

Buckley selected Strauss as his Democratic co-questioner in last

year's candidate debates. Will has touted Strauss twice for president and once for secretary of state in the past few months.

When he's not being called "Mr. Democrat," Strauss, aged 69, is labeled an "elder statesman" or "wise man." In fact, he's "the Capital's Leading Wise Man," according to the headline on a recent *New York Times* puffer that was worth a pile to his influence-peddling operation. Strauss, oozed the *Times*, is "a senior statesman who bridges partisan rivalry and ideological factionalism. The capital needs such elders, people known for their straight talk and sound advice."

Strauss is being touted, not least by Strauss, as the potential broker of a deadlocked Democratic nomination fight. Even in the course of dismissing that idea, Albert Hunt of the *Wall Street Journal* says that the next Democratic president would "be a fool not to put Mr. Strauss in his Cabinet."

Why? Wherein, exactly, lies the greatness of Robert Strauss? Is it his devotion to liberal values? His deep insight into the issues facing our nation? Hardly. Strauss's rare public remarks on public issues are embarrassingly banal. For depth and passion, they make his pal Bob Dole (with whom he shares a Florida winter retreat) seem like Henry Kissinger. Writing on trade recently in the *Post*, Strauss opined: "The American people want something done about it . . . There is no time like the present to get the job done, and the key players all know it . . . There is nothing to prevent a good, sound bill from being worked out . . ." etc., etc. This is best translated as: "Goddammit, I want Bob Strauss's name in the paper tomorrow."

Strauss is not the sort to maintain a principled disagreement with anyone. I was astonished to read him quoted in the *Times* a few months ago saying that Ann Lewis, a far-left Democratic activist, was unfit to be party chairman. Not that he doesn't think this—he surely does—but why would he say it? Sure enough, the next day's paper carried an "Editor's Note" explaining that the quotation

from Strauss "omitted the context" and should have added, "I think she is one of the very creditable and sensible political voices in this town and country." It's a testament to Strauss's clout that he got the *Times* to print such a ridiculous correction, and a hint of how he got that clout that he wanted one.

Ordinarily, of course, Strauss's splendid ideological agnosticism tilts him to the right, not the left. It's not that Strauss has conservative beliefs. He has *no* beliefs, except for his cardinal principle that all the key players ought to sit down and work this sucker out, goddammit.

So what's the secret? Is it his record of devoted public service? Strauss was a successful fund-raiser and party chairman in the early 1970s. During the Carter years he built up his résumé on the George Bush model: a few months each as Special Trade Representative, President's Counselor on Inflation, Middle East negotiator, and chairman of the re-election campaign. His achievements in any of these posts were not remarkable (or even, regarding inflation and the Middle East, noticeable). But they got him the title of ambassador and lots of new clients when he returned to his law firm in 1981. Since then the firm has become one of Washington's largest and most profitable.

But, as the *Times* says, "His real influence in Washington derives not from his past titles, but from the forces of his personality and the quality of his judgment." "Judgment" has become the preferred euphemism these days for what Washington fixers offer, now that Michael Deaver (another Strauss pal) has discredited the formerly favored "access."

The idea that someone like Strauss is a great fount of "judgment" is about one-third humbug directed at potential critics, about one-third humbug directed at his customers themselves—business clients, presidents, journalists—and about one-third true. But it's judgment of a particular kind. As Carter's chief of staff, Hamilton Jordan, put it in his memoir: "It was always helpful for me to hear

what Strauss was saying, because I knew that his 'ideas' were more accurately an amalgam of the collective thoughts and opinions of the Washington political and media establishments." What Strauss really sells to outsider presidents like Carter and Reagan (payment in ego) and to corporate clients (payment in cash) is Washington's blessing.

What he sells to journalists is more subtle. Strauss "gives good quote," as they say, and leaks when he's got something to leak. But it's not as a source that reporters value Strauss. They generally know blarney when they hear it. Jordan describes Strauss's technique of inventing a reason to talk to Carter, however briefly, so he could lunch out on, "As I was saying to the president . . ." What seduces journalists into Strauss's conspiracy of hype is more Strauss's mastery of the peculiar Washington style of flattery-by-insult ("How the hell are you, you old pig-fucker?"); his genuine interest in *their* view of things (always a sure sign of wisdom in others), which he can recycle; in short, his warm embrace—his reassurance that there *is* a Washington establishment and they're in it.

Virtually everyone in Washington recognizes that Bob Strauss is 99 percent hot air, yet they all maintain this "elder statesman" and "Mr. Democrat" routine like some sort of elaborate prank on the rest of the world. Is it unsporting not to play along? I don't think so. It's a little too convenient for conservatives and Republicans that "Mr. Democrat" should be a man so obviously more interested in being seen as a friend of the president than in who the president happens to be. It's an insult to the Democratic Party—partly self-inflicted, to be sure—that its symbolic head should be a man whose political influence is out for hire to the highest bidder. And it's a telling comment on the Washington establishment that so laughably shallow a figure should be considered one of its "wise men."

Of course Strauss may be no different from the Democratic elder statesmen of the past. Someone like Clark Clifford worked

harder to keep a patina of "law office" on his lobbying business, and came on like a Brahmin, in contrast to Strauss's po'boy routine. But basically the scam was the same.

In fact, every great capital probably has a Mr. Fixit, a self-promoting middle-man who is a friend of all sides no matter how mutually opposed they may be. In Tehran, when you're in need of "judgment," you look up the elder statesman and wise man Manucher Ghorbanifar. He doesn't have much in common, spiritually, with the ruling ayatollahs. They let him make his millions and keep his body parts in one place because he's useful to them. But at least no one calls him "Mr. Shiite."

Here Comes the Groom

A (Conservative) Case for Gay Marriage

ANDREW SULLIVAN

August 28, 1989

This may not have been the first case for gay marriage to appear in the mainstream media, but it was nearly the first, and it was certainly the most influential. Opinion journalists tend to overestimate their own importance to society. But then there are moments when an exquisitely argued essay can indeed provide kindling for a social revolution.

Last month in New York, a court ruled that a gay lover had the right to stay in his deceased partner's rent-control apartment because the lover qualified as a member of the deceased's family. The ruling deftly annoyed almost everybody. Conservatives saw judicial activism in favor of gay rent control: three reasons to be appalled. Chastened liberals (such as the *New York Times* editorial page), while endorsing the recognition of gay relationships, also worried about the abuse of already stretched entitlements that the ruling threatened. What neither side quite contemplated is that they both might be right, and that the way to tackle the issue of unconventional relationships in conventional society is to try something both more

radical and more conservative than putting courts in the business of deciding what is and is not a family. That alternative is the legalization of civil gay marriage.

The New York rent-control case did not go anywhere near that far, which is the problem. The rent-control regulations merely stipulated that a "family" member had the right to remain in the apartment. The judge ruled that to all intents and purposes a gay lover is part of his lover's family, inasmuch as a "family" merely means an interwoven social life, emotional commitment, and some level of financial interdependence.

It's a principle now well established around the country. Several cities have "domestic partnership" laws, which allow relationships that do not fit into the category of heterosexual marriage to be registered with the city and qualify for benefits that up till now have been reserved for straight married couples. San Francisco, Berkeley, Madison, and Los Angeles all have legislation, as does the politically correct Washington, D.C., suburb, Takoma Park. In these cities, a variety of interpersonal arrangements qualify for health insurance, bereavement leave, insurance, annuity and pension rights, housing rights (such as rent-control apartments), adoption and inheritance rights. Eventually, according to gay lobby groups, the aim is to include federal income tax and veterans' benefits as well. A recent case even involved the right to use a family member's accumulated frequent-flier points. Gays are not the only beneficiaries; heterosexual "live-togethers" also qualify.

There's an argument, of course, that the current legal advantages extended to married people unfairly discriminate against people who've shaped their lives in less conventional arrangements. But it doesn't take a genius to see that enshrining in the law a vague principle like "domestic partnership" is an invitation to qualify at little personal cost for a vast array of entitlements otherwise kept crudely under control.

To be sure, potential DPs have to prove financial interdependence, shared living arrangements, and a commitment to mutual caring. But they don't need to have a sexual relationship or even closely mirror old-style marriage. In principle, an elderly woman and her live-in nurse could qualify. A couple of uneuphemistically confirmed bachelors could be DPs. So could two close college students, a pair of seminarians, or a couple of frat buddies. Left as it is, the concept of domestic partnership could open a Pandora's box of litigation and subjective judicial decision-making about who qualifies. You either are or are not married; it's not a complex question. Whether you are in a "domestic partnership" is not so clear.

More important, the concept of domestic partnership chips away at the prestige of traditional relationships and undermines the priority we give them. This priority is not necessarily a product of heterosexism. Consider heterosexual couples. Society has good reason to extend legal advantages to heterosexuals who choose the formal sanction of marriage over simply living together. They make a deeper commitment to one another and to society; in exchange, society extends certain benefits to them. Marriage provides an anchor, if an arbitrary and weak one, in the chaos of sex and relationships to which we are all prone. It provides a mechanism for emotional stability, economic security, and the healthy rearing of the next generation. We rig the law in its favor not because we disparage all forms of relationship other than the nuclear family, but because we recognize that not to promote marriage would be to ask too much of human virtue. In the context of the weakened family's effect upon the poor, it might also invite social disintegration. One of the worst products of the New Right's "family values" campaign is that its extremism and hatred of diversity has disguised this more measured and more convincing case for the importance of the marital bond.

The concept of domestic partnership ignores these concerns,

indeed directly attacks them. This is a pity, since one of its most important objectives—providing some civil recognition for gay relationships—is a noble cause and one completely compatible with the defense of the family. But the way to go about it is not to undermine straight marriage; it is to legalize old-style marriage for gays.

The gay movement has ducked this issue primarily out of fear of division. Much of the gay leadership clings to notions of gay life as essentially outsider, anti-bourgeois, radical. Marriage, for them, is co-optation into straight society. For the Stonewall generation, it is hard to see how this vision of conflict will ever fundamentally change. But for many other gays—my guess, a majority—while they don't deny the importance of rebellion 20 years ago and are grateful for what was done, there's now the sense of a new opportunity. A need to rebel has quietly ceded to a desire to belong. To be gay and to be bourgeois no longer seems such an absurd proposition. Certainly since AIDS, to be gay and to be responsible has become a necessity.

Gay marriage squares several circles at the heart of the domestic partnership debate. Unlike domestic partnership, it allows for recognition of gay relationships, while casting no aspersions on traditional marriage. It merely asks that gays be allowed to join in. Unlike domestic partnership, it doesn't open up avenues for heterosexuals to get benefits without the responsibilities of marriage, or a nightmare of definitional litigation. And unlike domestic partnership, it harnesses to an already established social convention the yearnings for stability and acceptance among a fast-maturing gay community.

Gay marriage also places more responsibilities upon gays: It says for the first time that gay relationships are not better or worse than straight relationships, and that the same is expected of them. And

it's clear and dignified. There's a legal benefit to a clear, common symbol of commitment. There's also a personal benefit. One of the ironies of domestic partnership is that it's not only more complicated than marriage, it's more demanding, requiring an elaborate statement of intent to qualify. It amounts to a substantial invasion of privacy. Why, after all, should gays be required to prove commitment before they get married in a way we would never dream of asking of straights?

Legalizing gay marriage would offer homosexuals the same deal society now offers heterosexuals: general social approval and specific legal advantages in exchange for a deeper and harder-to-extract-yourself-from commitment to another human being. Like straight marriage, it would foster social cohesion, emotional security, and economic prudence. Since there's no reason gays should not be allowed to adopt or be foster parents, it could also help nurture children. And its introduction would not be some sort of radical break with social custom. As it has become more acceptable for gay people to acknowledge their loves publicly, more and more have committed themselves to one another for life in full view of their families and their friends, A law institutionalizing gay marriage would merely reinforce a healthy social trend. It would also, in the wake of AIDS, qualify as a genuine public health measure. Those conservatives who deplore promiscuity among some homosexuals should be among the first to support it. Burke could have written a powerful case for it.

The argument that gay marriage would subtly undermine the unique legitimacy of straight marriage is based upon a fallacy. For heterosexuals, straight marriage would remain the most significant—and only legal—social bond. Gay marriage could only delegitimize straight marriage if it were a real alternative to it, and this is clearly not true. To put it bluntly, there's precious little evidence that straights could be persuaded by any law to have sex

with—let alone marry—someone of their own sex. The only possible effect of this sort would be to persuade gay men and women who force themselves into heterosexual marriage (often at appalling cost to themselves and their families) to find a focus for their family instincts in a more personally positive environment. But this is clearly a plus, not a minus: Gay marriage could both avoid a lot of tortured families and create the possibility for many happier ones. It is not, in short, a denial of family values. It's an extension of them.

Of course, some would claim that any legal recognition of homosexuality is a de facto attack upon heterosexuality. But even the most hardened conservatives recognize that gays are a permanent minority and aren't likely to go away. Since persecution is not an option in a civilized society, why not coax gays into traditional values rather than rail incoherently against them?

There's a less elaborate argument for gay marriage: it's good for gays. It provides role models for young gay people who, after the exhilaration of coming out, can easily lapse into short-term relationships and insecurity with no tangible goal in sight. My own guess is that most gays would embrace such a goal with as much (if not more) commitment as straights. Even in our society as it is, many lesbian relationships are virtual textbook cases of monogamous commitment. Legal gay marriage could also help bridge the gulf often found between gays and their parents. It could bring the essence of gay life—a gay couple—into the heart of the traditional straight family in a way the family can most understand and the gay offspring can most easily acknowledge. It could do as much to heal the gay-straight rift as any amount of gay rights legislation.

If these arguments sound socially conservative, that's no accident. It's one of the richest ironies of our society's blind spot toward gays that essentially conservative social goals should have the ap-

pearance of being so radical. But gay marriage is not a radical step. It avoids the mess of domestic partnership; it is humane; it is conservative in the best sense of the word. It's also practical. Given the fact that we already allow legal gay relationships, what possible social goal is advanced by framing the law to encourage these relationships to be unfaithful, undeveloped, and insecure?

PART NINE
1990s

"For the better part of two decades, it has been difficult to view the election of a Democrat to the White House as anything but a mixed blessing."

THE EDITORS, "CLINTON FOR PRESIDENT"

NOVEMBER 9, 1992

The Value of the Canon

IRVING HOWE

February 18, 1991

Only a handful of contributors stuck with the magazine over so many decades and wrote on such a wide variety of subjects (from Richard Nixon to Isaac Babel). Irving Howe's loyalty was especially touching since he edited his own little copy-starved magazine, Dissent. *He was both the perfect* New Republic *writer and an aberration. As a committed socialist, his theory of economics fell to the left of the magazine, especially as it entered its neoliberal phase in the Peretz era. But there was no denying the independence of Howe's thought. He had argued against the Stalinists and then the New Left. During the late eighties and early nineties, he joined the broad coalition that the magazine had assembled to challenge the ludicrousness of political correctness.*

I.

Of all the disputes agitating the American campus, the one that seems to me especially significant is that over "the canon." What should be taught in the humanities and social sciences, especially in introductory courses? What is the place of the classics? How shall we respond to those professors who attack "Eurocentrism" and advocate "multiculturalism"? This is not the sort of tedious quarrel

that now and then flutters through the academy; it involves matters of public urgency, I propose to see this dispute, at first, through a narrow, even sectarian lens, with the hope that you will come to accept my reasons for doing so.

Here, roughly, are the lines of division. On one side stand (too often, fall) the cultural "traditionalists," who may range politically across the entire spectrum. Opposing them is a heterogeneous grouping of mostly younger teachers, many of them veterans of the 1960s, which includes feminists, black activists, Marxists, deconstructionists, and various mixtures of these.

At some colleges and universities traditional survey courses of world and English literature, as also of social thought, have been scrapped or diluted. At others they are in peril. At still others they will be. What replaces them is sometimes a mere option of electives, sometimes "multicultural" courses introducing material from Third World cultures and thinning out an already thin sampling of Western writings, and sometimes courses geared especially to issues of class, race, and gender. Given the notorious lethargy of academic decision-making, there has probably been more clamor than change: but if there's enough clamor, there will be change.

University administrators, timorous by inclination, are seldom firm in behalf of principles regarding education. Subjected to enough pressure, many of them will buckle under. So will a good number of professors who vaguely subscribe to "the humanist tradition" but are not famously courageous in its defense. Academic liberalism has notable virtues, but combativeness is not often one of them. In the academy, whichever group goes on the offensive gains an advantage. Some of those who are now attacking "traditionalist" humanities and social science courses do so out of sincere persuasion; some, from a political agenda (what was at first solemnly and now is half-ironically called p.c.—politically correct); and some

from an all-too-human readiness to follow the academic fashion that, for the moment, is "in."

Can we find a neutral term to designate the anti-traditionalists? I can't think of a satisfactory one, so I propose an unsatisfactory one: let's agree to call them the insurgents, though in fact they have won quite a few victories. In the academy these professors are often called "the left" or "the cultural left," and that is how many of them see themselves. But this is a comic misunderstanding, occasionally based on ignorance. In behalf of both their self-awareness and a decent clarity of debate, I want to show that in fact the socialist and Marxist traditions have been close to traditionalist views of culture. Not that the left hasn't had its share of ranters (I exclude Stalinists and hooligans) who, in the name of "the revolution," were intent upon jettisoning the culture of the past; but generally such types have been a mere marginal affliction treated with disdain.

Let me cite three major figures. Here is Georg Lukacs, the most influential Marxist critic of the twentieth century:

> Those who do not know Marxism may be surprised at the respect for *the classical heritage of mankind* which one finds in the really great representatives of that doctrine. (Emphasis added.)

Here is Leon Trotsky, arguing in 1924 against a group of Soviet writers who felt that as the builders of "a new society" they could dismiss the "reactionary culture" of the past:

> If I say that the importance of *The Divine Comedy* lies in the fact that it gives me an understanding of the state of mind of certain classes in a certain epoch, this means that I transform it into *a mere historical document*. . . . How is it thinkable that there should be not a historical but *a directly aesthetic relationship* between us and a medieval Italian book? This is explained by the fact that in

class society, in spite of its changeability, there are certain common features. Works of art developed in a medieval Italian city can affect us too. What does this require? . . . That these feelings and moods shall have received such broad, intense, powerful expression as to have raised them above the limitations of the life of those days. (Emphasis added.)

Trotsky's remarks could serve as a reply to those American professors of literature who insist upon the omnipresence of ideology as it seeps into and perhaps saturates literary texts, and who scoff that only "formalists" believe that novels and poems have autonomous being and value. In arguing, as he did in his book *Literature and Revolution*, that art must be judged by "its own laws," Trotsky seems not at all p.c. Still less so is Antonio Gramsci, the Italian Marxist, whose austere opinions about education might make even our conservatives blanch:

Latin and Greek were learnt through their grammar, mechanically, but the accusation of formalism and aridity is very unjust. . . . In education one is dealing with children in whom one has to inculcate certain habits of diligence, precision, poise (even physical poise), ability to concentrate on specific subjects, which cannot be acquired without the mechanical repetition of disciplined and methodical acts.

These are not the isolated ruminations of a few intellectuals; Lukacs, Trotsky, and Gramsci speak with authority for a view of culture prevalent in the various brands of the Marxist (and also, by the way, the non-Marxist) left. And that view informed many movements of the left. There were the Labor night schools in England bringing to industrial workers elements of the English cultural past; there was the once-famous Rand School of New York City;

there were the reading circles that Jewish workers, in both Eastern Europe and American cities, formed to acquaint themselves with Tolstoy, Heine, and Zola. And in Ignazio Silone's novel *Bread and Wine* we have a poignant account of an underground cell in Rome during the Mussolini years that reads literary works as a way of holding itself together.

My interest here is not to vindicate socialism or Marxism—that is another matter. Nor is there anything sacrosanct about the opinions I have quoted or their authors. But it is surely worth establishing that the claims of many academic insurgents to be speaking from a left, let alone a Marxist, point of view are highly dubious. Very well, the more candid among them might reply, so we're not of the left, at least we're not of the "Eurocentric" left. To recognize that would at least help clear the atmosphere. More important, it might shrink the attractiveness of these people in what is perhaps the only area of American society where the label of "the left" retains some prestige.

What we are witnessing on the campus today is a strange mixture of American populist sentiment and French critical theorizing as they come together in behalf of "changing the subject." The populism provides an underlying structure of feeling, and the theorizing provides a dash of intellectual panache. The populism releases anti-elitist rhetoric, the theorizing releases highly elitist language.

American populism, with its deep suspicion of the making of distinctions of value, has found expression not only in native sages (Henry Ford: "History is bunk") but also in the writings of a long line of intellectuals—indeed, it's only intellectuals who can give full expression to anti-intellectualism. Such sentiments have coursed through American literature, but only recently, since the counterculture of the 1960s, have they found a prominent place in the universities.

As for the French theorizing—metacritical, quasi-philosophical, and at times of a stupefying verbal opacity—it has provided a buttress for the academic insurgents. We are living at a time when all the once-regnant world systems that have sustained (also distorted) Western intellectual life, from theologies to ideologies, are taken to be in severe collapse. This leads to a mood of skepticism, an agnosticism of judgment, sometimes a world-weary nihilism in which even the most conventional minds begin to question both distinctions of value and the value of distinctions. If you can find projections of racial, class, and gender bias in both a Western by Louis L'Amour and a classical Greek play, and if you have decided to reject the "elitism" said to be at the core of literary distinctions, then you might as well teach the Western as the Greek play. You can make the same political points, and more easily, in "studying" the Western. And if you happen not to be well informed about Greek culture, it certainly makes things still easier.

I grew up with the conviction that what Georg Lukacs calls "the classical heritage of mankind" is a precious legacy. It came out of historical circumstances often appalling, filled with injustice and outrage. It was often, in consequence, alloyed with prejudice and flawed sympathies. Still, it was a heritage that had been salvaged from the nightmares, occasionally the glories, of history, and now we would make it "ours," we who came from poor and working-class families. This "heritage of mankind" (which also includes, of course, Romantic and modernist culture) had been denied to the masses of ordinary people, trained into the stupefaction of accepting, even celebrating, their cultural deprivations. One task of political consciousness was therefore to enable the masses to share in what had been salvaged from the past—the literature, art, music, thought—and thereby to reach an active relation with these. That

is why many people, not just socialists but liberals, democrats, and those without political tags, kept struggling for universal education. It was not a given: it had to be won. Often, winning proved to be very hard.

Knowledge of the past, we felt, could humanize by promoting distance from ourselves and our narrow habits, and this could promote critical thought. Even partly to grasp a significant experience or literary work of the past would require historical imagination, a sense of other times, which entailed moral imagination, a sense of other ways. It would create a kinship with those who had come before us, hoping and suffering as we have, seeking through language, sound, and color to leave behind something of enduring value.

By now we can recognize that there was a certain naïveté in this outlook. The assumption of progress in education turned out to be as problematic as similar assumptions elsewhere in life. There was an underestimation of human recalcitrance and sloth. There was a failure to recognize what the twentieth century has taught us: that aesthetic sensibility by no means assures ethical value. There was little anticipation of the profitable industry of "mass culture," with its shallow kitsch and custom-made dreck. Nevertheless, insofar as we retain an attachment to the democratic idea, we must hold fast to an educational vision somewhat like the one I've sketched. Perhaps it is more an ideal to be approached than a goal to be achieved: no matter. I like the epigrammatic exaggeration, if it is an exaggeration, of John Dewey's remark that "the aim of education is to enable individuals to continue their education."

This vision of culture and education started, I suppose, at some point in the late eighteenth century or the early nineteenth century. It was part of a great sweep of human aspiration drawing upon

Western traditions from the Renaissance to the Enlightenment. It spoke in behalf of such liberal values as the autonomy of the self, tolerance for a plurality of opinions, the rights of oppressed national and racial groups, and soon, the claims of the women's movements. To be sure, these values were frequently violated—that has been true for every society in every phase of world history. But the criticism of such violations largely invoked the declared values themselves, and this remains true for all our contemporary insurgencies. Some may sneer at "Western hegemony," but knowingly or not, they do so in the vocabulary of Western values.

By invoking the "classical heritage of mankind" I don't propose anything fixed and unalterable. Not at all. There are, say, seven or eight writers and a similar number of social thinkers who are of such preeminence that they must be placed at the very center of this heritage; but beyond that, plenty of room remains for disagreement. All traditions change, simply through survival. Some classics die. Who now reads Ariosto? A loss, but losses form part of tradition too. And new arrivals keep being added to the roster of classics—it is not handed down from Mt. Sinai or the University of Chicago. It is composed and fought over by cultivated men and women. In a course providing students a mere sample of literature, there should be included some black and women writers who, because of inherited bias, have been omitted in the past. Yet I think we must give a central position to what Professor John Searle in a recent *New York Review of Books* article specifies as "a certain Western intellectual tradition that goes from, say, Socrates to Wittgenstein in philosophy, and from Homer to James Joyce in literature. . . . It is essential to the liberal education of young men and women in the United States that they should receive some exposure to at least some of the great works of this intellectual tradition."

Nor is it true that most of the great works of the past are bleakly retrograde in outlook—to suppose that is a sign of cultural illiter-

acy. Bring together in a course on social thought selections from Plato and Aristotle, Machiavelli and Rousseau, Hobbes and Locke, Nietzsche and Freud, Marx and Mill, Jefferson and Dewey, and you have a wide variety of opinions, often clashing with one another, sometimes elusive and surprising, always richly complex. These are some of the thinkers with whom to begin, if only later to deviate from. At least as critical in outlook are many of the great poets and novelists. Is there a more penetrating historian of selfhood than Wordsworth? A more scathing critic of society than the late Dickens? A mind more devoted to ethical seriousness than George Eliot? A sharper critic of the corrupting effects of money than Balzac or Melville?

These writers don't necessarily endorse our current opinions and pieties—why should they? We read them for what Robert Frost calls "counterspeech," the power and brilliance of *other minds*, and if we can go "beyond" them, it is only because they are behind us.

What is being invoked here is not a stuffy obeisance before dead texts from a dead past, but rather a critical engagement with living texts from powerful minds still very much "active" in the present. And we should want our students to read Shakespeare and Tolstoy, Jane Austen and Kafka, Emily Dickinson and Leopold Senghor, not because they "support" one or another view of social revolution, feminism, and black self-esteem. They don't, in many instances; and we don't read them for the sake of enlisting them in a cause of our own. We should want students to read such writers so that they may learn to enjoy the activity of mind, the pleasure of forms, the beauty of language—in short, the arts in their own right.

By contrast, there is a recurrent clamor in the university for "relevance," a notion hard to resist (who wishes to be known as irrelevant?) but proceeding from an impoverished view of political life, and too often ephemeral in its excitements and transient in its impact. I recall seeing in the late 1960s large stacks of Eldridge

Cleaver's *Soul on Ice* in the Stanford University bookstore. Hailed as supremely "relevant" and widely described as a work of genius, this book has fallen into disuse in a mere two decades. Cleaver himself drifted off into some sort of spiritualism, ceasing thereby to be "relevant." Where, then, is *Soul on Ice* today? What lasting value did it impart?

American culture is notorious for its indifference to the past. It suffers from the provincialism of the contemporary, veering wildly from fashion to fashion, each touted by the media and then quickly dismissed. But the past is the substance out of which the present has been formed, and to let it slip away from us is to acquiesce in the thinness that characterizes so much of our culture. Serious education must assume, in part, an adversarial stance toward the very society that sustains it—a democratic society makes the wager that it's worth supporting a culture of criticism. But if that criticism loses touch with the heritage of the past, it becomes weightless, a mere compendium of momentary complaints.

Several decades ago, when I began teaching, it could be assumed that entering freshmen had read in high school at least one play by Shakespeare and one novel by Dickens. That wasn't much, but it was something. These days, with the disintegration of the high schools, such an assumption can seldom be made. The really dedicated college teachers of literature feel that, given the bazaar of elective courses an entering student encounters and the propaganda in behalf of "relevance," there is likely to be only one opportunity to acquaint students with a smattering—indeed, the merest fragment—of the great works from the past. Such teachers take pleasure in watching the minds and sensibilities of young people opening up to a poem by Wordsworth, a story by Chekhov, a novel by Ellison. They feel they have planted a seed of responsiveness that, with time and luck, might continue to grow. And if this is said to be a missionary attitude, why should anyone quarrel with it?

II.

Let me now mention some of the objections one hears in academic circles to the views I have put down here, and then provide brief replies.

By requiring students to read what you call "classics" in introductory courses, you impose upon them a certain worldview—and that is an elitist act.

In some rudimentary but not very consequential sense, all education entails the "imposing" of values. There are people who say this is true even when children are taught to read and write, since it assumes that reading and writing are "good."

In its extreme version, this idea is not very interesting, since it is not clear how the human race could survive if there were not some "imposition" from one generation to the next. But in a more moderate version, it is an idea that touches upon genuine problems.

Much depends on the character of the individual teacher, the spirit in which he or she approaches a dialogue of Plato, an essay by Mill, a novel by D. H. Lawrence. These can be, and have been, used to pummel an ideological line into the heads of students (who often show a notable capacity for emptying them out again). Such pummeling is possible for all points of view but seems most likely in behalf of totalitarian politics and authoritarian theologies, which dispose their adherents to fanaticism. On the other hand, the texts I've mentioned, as well as many others, can be taught in a spirit of openness, so that students are trained to read carefully, think independently, and ask questions. Nor does this imply that the teacher hides his or her opinions. Being a teacher means having a certain authority, but the student should be able to confront that authority freely and critically. This is what we mean by liberal education— not that a teacher plumps for certain political programs, but that the teaching is done in a "liberal" (open, undogmatic) style.

I do not doubt that there are conservative and radical teachers

who teach in this "liberal" spirit. When I was a student at City College in the late 1930s, I studied philosophy with a man who was either a member of the Communist Party or was "cheating it out of dues." Far from being the propagandist of the Party line, which Sidney Hook kept insisting was the necessary role of Communist teachers, this man was decent, humane, and tolerant. Freedom of thought prevailed in his classroom. He had, you might say, a "liberal" character, and perhaps his commitment to teaching as a vocation was stronger than his loyalty to the Party. Were such things not to happen now and then, universities would be intolerable.

If, then, a university proposes a few required courses so that ill-read students may at least glance at what they do not know, that isn't (necessarily) "elitist." Different teachers will approach the agreed-upon texts in different ways, and that is as it should be. If a leftist student gets "stuck" with a conservative teacher, or a conservative student with a leftist teacher, that's part of what education should be. The university is saying to its incoming students: "Here are some sources of wisdom and beauty that have survived the centuries. In time you may choose to abandon them, but first learn something about them."

Your list of classics includes only dead, white males, all tied in to notions and values of Western hegemony. Doesn't this narrow excessively the horizons of education?

All depends on how far forward you go to compose your list of classics. If you do not come closer to the present than the mid-eighteenth century, then of course there will not be many, or even any, women in your roster. If you go past the mid-eighteenth century to reach the present, it's not at all true that only "dead, white males" are to be included. For example—and this must hold for hundreds of other teachers also—I have taught and written about Jane Austen, Emily Brontë, Charlotte Brontë, Elizabeth Gaskell, George Eliot, Emily Dickinson, Edith Wharton, Katherine Anne

Porter, Doris Lessing, and Flannery O'Connor. I could easily add a comparable list of black writers. Did this, in itself, make me a better teacher? I doubt it. Did it make me a better person? We still lack modes of evaluation subtle enough to say for sure.

The absence of women from the literature of earlier centuries is a result of historical inequities that have only partly been remedied in recent years. Virginia Woolf, in a brilliant passage in *A Room of One's Own*, approaches this problem by imagining Judith, Shakespeare's sister, perhaps equally gifted but prevented by the circumstances of her time from developing her gifts:

> Any woman born with a great gift in the sixteenth century would certainly have gone crazed, shot herself, or ended her days in some lonely cottage outside the village, half witch, half wizard, feared and mocked at . . . A highly gifted girl who had tried to use her gift for poetry would have been so thwarted and hindered by other people, so tortured and pulled asunder by her own contrary instincts, that she must have lost her health and sanity . . .

The history that Virginia Woolf describes cannot be revoked. If we look at the great works of literature and thought through the centuries until about the mid-eighteenth century, we have to recognize that indeed they have been overwhelmingly the achievements of men. The circumstances in which these achievements occurred may be excoriated. The achievements remain precious.

To isolate a group of texts as the canon is to establish a hierarchy of bias, in behalf of which there can be no certainty of judgment.

There is mischief or confusion in the frequent use of the term "hierarchy" by the academic insurgents, an emulation of social and intellectual uses. A social hierarchy may entail a (mal)distribution

of income and power, open to the usual criticisms; a literary "hierarchy" signifies a judgment, often based on historical experience, that some works are of supreme or abiding value, while others are of lesser value, and still others quite without value. To prefer Elizabeth Bishop to Judith Krantz is not of the same order as sanctioning the inequality of wealth in the United States. To prefer Shakespeare to Sidney Sheldon is not of the same order as approving the hierarchy of the nomenklatura in Communist dictatorships.

As for the claim that there is no certainty of judgment, all tastes being historically molded or individually subjective, I simply do not believe that the people who make it live by it. This is an "egalitarianism" of valuation that people of even moderate literacy know to be false and unworkable—the making of judgments, even if provisional and historically modulated, is inescapable in the life of culture. And if we cannot make judgments or demonstrate the grounds for our preferences, then we have no business teaching literature—we might just as well be teaching advertising—and there is no reason to have departments of literature.

The claim that there can be value-free teaching is a liberal deception or self-deception; so too the claim that there can be texts untouched by social and political bias. Politics or ideology is everywhere, and it's the better part of honesty to admit this.

If you look hard (or foolishly) enough, you can find political and social traces everywhere. But to see politics or ideology in all texts is to scrutinize the riches of literature through a single lens. If you choose, you can read all or almost all literary works through the single lens of religion. But what a sad impoverishment of the imagination, and what a violation of our sense of reality, this represents. Politics may be "in" everything, but not everything is politics. A good social critic will know which texts are inviting to a given approach and which it would be wise to leave to others.

To see politics everywhere is to diminish the weight of politics. A serious politics recognizes the limits of its reach; it deals with public affairs while leaving alone large spheres of existence; it seeks not to "totalize" its range of interest. Some serious thinkers believe that the ultimate aim of politics should be to render itself superfluous. That may seem an unrealizable goal; meanwhile, a good part of the struggle for freedom in recent decades has been to draw a line beyond which politics must not tread. The same holds, more or less, for literary study and the teaching of literature.

Wittingly or not, the traditional literary and intellectual canon was based on received elitist ideologies, the values of Western imperialism, racism, sexism, etc., and the teaching of the humanities was marked by corresponding biases. It is now necessary to enlarge the ration so that voices from Africa, Asia, and Latin America can be heard. This is especially important for minority students so that they may learn about their origins and thereby gain in self-esteem.

It is true that over the decades some university teaching has reflected inherited social biases—how, for better or worse, could it not? Most often this was due to the fact that many teachers shared the common beliefs of American society. But not all teachers! As long as those with critical views were allowed to speak freely, the situation, if not ideal, was one that people holding minority opinions and devoted to democratic norms had to accept.

Yet the picture drawn by some academic insurgents—that most teachers, until quite recently, were in the grip of the worst values of Western society—is overdrawn. I can testify that some of my school and college teachers a few decades ago, far from upholding Western imperialism or white supremacy, were sharply critical of American society, in some instances from a boldly reformist outlook. They taught us to care about literature both for its own sake and because, as they felt, it often helped confirm their worldviews. (And to love it even if it didn't confirm their worldviews.) One high

school teacher introduced me to Hardy's *Jude the Obscure* as a novel showing how cruel society can be to rebels, and up to a point, she was right. At college, as a fervent anti-Stalinist Marxist, I wrote a thoughtless "class analysis" of Edmund Spenser's poetry for an English class, and the kindly instructor, whose politics were probably not very far from mine, suggested that there were more things in the world, especially as Spenser had seen it, than I could yet recognize. I mention these instances to suggest that there has always been a range of opinion among teachers, and if anything, the American academy has tilted more to the left than most other segments of our society. There were of course right-wing professors too; I remember an economics teacher we called "Steamboat" Fulton, the object of amiable ridicule among the students who nonetheless learned something from him.

Proposals to enlarge the curriculum to include non-Western writings—if made in good faith and not in behalf of an ideological campaign—are in principle to be respected. A course in ancient thought might well include a selection from Confucius: a course in the modern novel might well include a work by Tanizaki or Garcia Marquez.

There are practical difficulties. Due to the erosion of requirements in many universities, those courses that survive are usually no more than a year or a semester in duration, so that there is danger of a diffusion to the point of incoherence. Such courses, if they are to have any value, must focus primarily on the intellectual and cultural traditions of Western society. That, like it or not, is where we come from and that is where we are. All of us who live in America are, to some extent, Western: it gets to us in our deepest and also our most trivial habits of thought and speech, in our sense of right and wrong, in our idealism and our cynicism.

As for the argument that minority students will gain in self-esteem through being exposed to writings by Africans and black

Americans, it is hard to know. Might not entering minority students, some of them ill-prepared, gain a stronger sense of self-esteem by mastering the arts of writing and reading than by being told, as some are these days, that Plato and Aristotle plagiarized from an African source? Might not some black students feel as strong a sense of self-esteem by reading, say, Dostoyevsky and Malraux (which Ralph Ellison speaks of having done at a susceptible age) as by being confined to black writers? Is there not something grossly patronizing in the notion that while diverse literary studies are appropriate for middle-class white students, something else, racially determined, is required for the minorities? Richard Wright found sustenance in Dreiser, Ralph Ellison in Hemingway, Chinua Achebe in Eliot, Leopold Senghor in the whole of French poetry. Are there not unknown young Wrights and Ellisons, Achebes and Senghors in our universities who might also want to find their way to an individually achieved sense of culture?

In any case, is the main function of the humanities directly to inculcate self-esteem? Do we really know how this can be done? And if done by bounding the curriculum according to racial criteria, may that not perpetuate the very grounds for a lack of self-esteem? I do not know the answers to these questions, but do the advocates of multiculturalism?

One serious objection to "multicultural studies" remains: that it tends to segregate students into categories fixed by birth, upbringing, and obvious environment. Had my teachers tried to lead me toward certain writers because they were Jewish, I would have balked—I wanted to find my own way to Proust, Kafka, and Pirandello, writers who didn't need any racial credentials. Perhaps things are different with students today—we ought not to be dogmatic about these matters. But are there not shared norms of pride and independence among young people, whatever their race and color?

The jazz musician Wynton Marsalis testifies: "Everybody has two heritages, ethnic and human. The human aspects give art its real enduring power . . . The racial aspect, that's a crutch so you don't have to go out into the world." David Bromwich raises an allied question: Should we wish "to legitimize the belief that the mind of a student deserves to survive in exactly the degree that it corresponds with one of the classes of socially constructed group minds? If I were a student today I would find this assumption frightening. It is, in truth, more than a license for conformity. It is a four-year sentence to conformity."

What you have been saying is pretty much the same as what conservatives say. Doesn't that make you feel uncomfortable?

No, it doesn't. There are conservatives—and conservatives. Some, like the editor of *The New Criterion*, are frantic ideologues with their own version of p.c., the classics as safeguard for the status quo. This is no more attractive than the current campus ideologizing. But there are also conservatives who make the necessary discriminations between using culture, as many have tried to use religion, as a kind of social therapy and seeing culture as a realm with its own values and rewards.

Similar differences hold with regard to the teaching of past thinkers. In a great figure like Edmund Burke you will find not only the persuasions of conservatism but also a critical spirit that does not readily lend itself to ideological coarseness. Even those of us who disagree with him fundamentally can learn from Burke the disciplines of argument and resources of language.

Let us suppose that in University X undergoing a curriculum debate there is rough agreement about which books to teach between professors of the democratic left and their conservative colleagues. Why should that trouble us—or them? We agree on a given matter, perhaps for different reasons. Or there may be a more

or less shared belief in the idea of a liberal education. If there is, so much the better. If the agreement is momentary, the differences will emerge soon enough.

A Little Epilogue

A *New Republic* reader: "Good lord, you're becoming a virtuoso at pushing through open doors. All this carrying on just to convince us that students should read great books. It's so obvious . . ."

I reply: "Dear reader, you couldn't be more right. But that is where we are."

Highway to Hell

MICHAEL KELLY

April 1, 1991

Reporting from the first Gulf War established Michael Kelly's reputation and began the path that ultimately led to his editing the magazine. His subsequent short stint in the top job reflected his personal style; the weekly he put out was both hotheaded and irresistibly warm. In this piece, the finest foreign coverage the magazine ever ran, he describes following the corpse-strewn path of the defeated Iraqi Army. Years later, covering the second Gulf War, he was traveling along a similar route when enemy fire caused his Jeep to fatally run off the road.

Along the Kuwait-Iraq Border Captain Douglas Morrison, 31, of Westmoreland, New York, headquarters troop commander of 1st Squadron, 4th Cavalry, 1st Division, is the ideal face of the new American Army. He is handsome, tall and fit, and trim of line from his Kevlar helmet to his LPCS (leather personnel carriers, or combat boots). He is the voice of the new American Army too, a crisp, assured mix of casual toughness, techno-idolatrous jargon, and nonsensical euphemisms—the voice of delivery systems and collateral damage and kicking ass. It is Tom Clancy's voice, and the voice of the military briefers in Riyadh and Washington. Because

the Pentagon has been very, very good in controlling the flow of information disseminated in Operation Desert Shield/Storm, it is also the dominant voice of a war that will serve, in the military equivalent of stare decisis, as the precedent for the next war.

In the 100-hour rout, Captain Morrison's advance reconnaissance squadron of troops, tanks, and armored personnel carriers destroyed seventy Iraqi tanks and more than a hundred armored vehicles. His soldiers killed many Iraqi soldiers and took many more prisoner. In its last combat action, the company joined three other American and British units to cut in four places the road from Kuwait City to the Iraqi border town of Safwan. This action, following heavy bombing by U.S. warplanes on the road, finished the job of trapping thousands of Saddam Hussein's retreating troops, along with large quantities of tanks, trucks, howitzers, and armored personnel carriers. Standing in the mud next to his humvee, Morrison talked about the battle.

"Our initial mission was to conduct a flank screen," he said, as he pointed to his company's February 26 position on a map overlaid with a plastic sheet marked with the felt-tip patterns of moving forces. "We moved with two ground troops [companies] in front, with tanks and Bradleys. We also had two air troops, with six 0-H50 scouts and four Cobra attack helicopters. It is the air troops' mission to pick up and ID enemy locations, and target handoff to the ground troops, who then try to gain and maintain contact with the enemy and develop a situation."

The situation that developed was notably one-sided. "We moved into the cut at 1630 hours on Wednesday [February 27, the day before the cease-fire]," Morrison said. "From 1630 to 0630, we took prisoners. . . . They didn't expect to see us. They didn't have much chance to react. There was some return fire, not much. . . . We destroyed at least ten T-55s and T-62s. . . . On our side, we took zero casualties."

There hadn't been much serious ground fighting on the two roads to Iraq because, as Morrison put it, "the Air Force had previously attrited the enemy and softened target area resistance considerably," or, as he also put it, "the Air Force just blew the shit out of both roads." In particular, the coastal road, running north from the Kuwaiti city of Jahra to the Iraqi border city of Umm Qasr, was "nothing but shit strewn everywhere, five to seven miles of just solid bombed-out vehicles." The U.S. Air Force, he said, "had been given the word to work over that entire area, to find anything that was moving and take it out."

The next day I drove up the road that Morrison had described. It was just as he had said it would be, but also different: the language of war made concrete. In a desperate retreat that amounted to armed flight, most of the Iraqi troops took the main four-lane highway to Basra, and were stopped and destroyed. Most were done in on the approach to Al-Mutlaa ridge, a road that crosses the highway twenty miles or so northwest of Kuwait City. There, Marines of the Second Armored Division, Tiger Brigade, attacked from the high ground and cut to shreds vehicles and soldiers trapped in a two-mile nightmare traffic jam. That scene of horror was cleaned up a bit in the first week after the war, most of the thousands of bombed and burned vehicles pushed to one side, all of the corpses buried. But this skinny two-lane blacktop, which runs through desert sand and scrub from one secondary city to another, was somehow forgotten.

Ten days after what George Bush termed a cessation of hostilities, this road presented a perfectly clear picture of the nature of those hostilities. It was untouched except by scavengers. Bedouins had siphoned the gas tanks, and American soldiers were still touring through the carnage in search of souvenirs. A pack

of lean and sharp-fanged wild dogs, white and yellow curs, swarmed and snarled around the corpse of one soldier. They had eaten most of his flesh. The ribs gleamed bare and white. Because, I suppose, the skin had gotten so tough and leathery from ten days in the sun, the dogs had eaten the legs from the inside out, and the epidermis lay in collapsed and hairy folds, like leg-shaped blankets, with feet attached. The beasts skirted the stomach, which lay to one side of the ribs, a black and yellow balloon. A few miles up the road, a small flock of great raptors wheeled over another body. The dogs had been there first, and little remained except the head. The birds were working on the more vulnerable parts of that. The dead man's face was darkly yellow-green, except where his eyeballs had been; there, the sockets glistened red and wet.

For a fifty- or sixty-mile stretch from just north of Jahra to the Iraqi border, the road was littered with exploded and roasted vehicles, charred and blown-up bodies. It is important to say that the thirty-seven dead men I saw were all soldiers and that they had been trying to make their escape heavily laden with weapons and ammunition. The road was thick with the wreckage of tanks, armored personnel carriers, 155-mm howitzers, and supply trucks filled with shells, missiles, rocket-propelled grenades, and machine-gun rounds in crates and belts. I saw no bodies that had not belonged to men in uniform. It was not always easy to ascertain this because the force of the explosions and the heat of the fires had blown most of the clothing off the soldiers, and often too had cooked their remains into wizened, mummified charcoal-men. But even in the worst cases, there was enough evidence—a scrap of green uniform on a leg here, an intact combat boot on a remaining foot there, an AK-47 propped next to a black claw over yonder—to see that this had

been indeed what Captain Morrison might call a legitimate target of opportunity.

The American warplanes had come in low, fast, and hard on the night of February 26 and the morning of the 27th, in the last hours before the cease-fire, and had surprised the Iraqis. They had saturated the road with cluster bombs, big white pods that open in the air and spray those below with hundreds of bomblets that spew at great velocity thousands of razor-edged little fragments of metal. The explosions had torn tanks and trucks apart—the jagged and already rusting pieces of one self-propelled howitzer were scattered over a fifty-yard area—and ripped up the men inside into pieces as well.

The heat of the blasts had inspired secondary explosions in the ammunition. The fires had been fierce enough in some cases to melt windshield glass into globs of silicone that dripped and hardened on the black metal skeletons of the dashboards. What the bomb bursts and the fires had started, machine-gun fire finished. The planes had strafed with skill. One truck had just two neat holes in its front windshield, right in front of the driver.

Most of the destruction had been visited on clusters of ten to fifteen vehicles. But those who had driven alone, or even off the road and into the desert, had been hunted down too. Of the several hundred wrecks I saw, not one had crashed in panic; all bore the marks of having been bombed or shot. The bodies bore the marks too.

Even in a mass attack, there is individuality. Quite a few of the dead had never made it out of their machines. Those were the worst, because they were both exploded and incinerated. One man had tried to escape to Iraq in a Kawasaki front-end loader. His remaining half-body lay hanging upside down and out of his exposed seat, the left side and bottom blown away to tatters, with the charred leg ful-

ly fifteen feet away. Nine men in a slat-sided supply truck were killed and flash-burned so swiftly that they remained, naked, skinned, and black wrecks, in the vulnerable positions of the moment of first impact. One body lay face down with his rear high in the air, as if he had been trying to burrow through the truckbed. His legs ended in fluttery charcoaled remnants at mid-thigh. He had a young, pretty face, slightly cherubic, with a pointed little chin; you could still see that even though it was mummified. Another man had been butterflied by the bomb; the cavity of his body was cut wide open and his intestines and such were still coiled in their proper places, but cooked to ebony.

As I stood looking at him, a couple of U.S. Army intelligence specialists came up beside me. It was their duty to pick and wade through the awfulness in search of documents of value. Major Bob Nugent and Chief Warrant Officer Jim Smith were trying to approach the job with dispassionate professionalism. "Say, this is interesting right here," said one. "Look how this guy ended up against the cab." Sure enough, a soldier had been flung by the explosion into the foot-wide crevice between the back of the truck and the driver's compartment. He wasn't very big. The heat had shrunk all the bodies into twisted, skin-stretched things. It was pretty clear some of the bodies hadn't been very big in life either. "Some of these guys weren't but 13, 14 years old," said Smith, in a voice fittingly small.

We walked around to look in the shattered cab. There were two carbonized husks of men in there. The one in the passenger seat had had the bottom of his face ripped off, which gave him the effect of grinning with only his upper teeth. We walked back to look at the scene on the truckbed. The more you looked at it, the more you could imagine you were seeing the soldiers at the moment they were fire-frozen in their twisted shapes, mangled and shapeless. Smith pulled out a pocket camera and got ready to take a picture. He

looked through the viewfinder. "Oh, I'm not gonna do this," he said, and put the camera away.

Small mementos of life were all around, part of the garbage stew of the road. Among the ammunition, grenades, ripped metal, and unexploded cluster bomblets lay the paltry possessions of the departed, at least some of which were stolen: a Donald Duck doll, a case of White Flake laundry soap, a can of Soft and Gentle hair spray, squashed tubes of toothpaste, dozens of well-used shaving brushes, a Russian-made slide rule to calculate artillery-fire distances, crayons, a tricycle, two crates of pecans, a souvenir calendar from London, with the House of Lords on one side and the Tower on the other; the dog tags of Abas Mshal Dman, a noncommissioned officer, who was Islamic and who had, in the days when he had blood, type O positive.

Some of the American and British soldiers wandering the graveyard joked a bit. "Crispy critters," said one, looking at a group of the incinerated. "Just wasn't them boys' day, was it?" said another. But for the most part, the scene commanded among the visitors a certain sobriety. I walked along for a while with Nugent, who is 43 and a major in the Army's special operations branch, and who served in Vietnam and has seen more of this sort of thing than he cares for. I liked him instantly, in part because he was searching hard to find an acceptance of what he was seeing. He said he felt very sad for the horrors around him, and had to remind himself that they were once men who had done terrible things. Perhaps, he said, considering the great casualties on the Iraqi side and the extremely few allied deaths, divine intervention had been at work—"some sort of good against evil thing." He pointed out that there had not been much alternative; given the allied forces' ability to strike in safety from the air, no commander could have risked the lives of his own men by

pitching a more even-sided battle on the ground. In the end, I liked him best because he settled on not a rationalization or a defense, but on the awful heart of the thing, which is that this is just the way it is. "No one ever said war was pretty," he said. "Chivalry died a long time ago."

The Child Monarch

HENDRIK HERTZBERG

September 9, 1991

During the eighties, the magazine had thrown itself behind the Reagan Doctrine, supporting aid for the Contra rebels in Nicaragua and more generally endorsing the administration's aggressive foreign policy. Hendrik Hertzberg, who edited the magazine for two different tours during that decade, wasn't fully on board with that editorial line. (It was a curiosity of the magazine's structure that the editor wasn't entirely responsible for The New Republic's *editorial position; that was ultimately decided by the owner and editor-in-chief, Marty Peretz.) This review of Reagan's biography may not have been intended as payback, but it had that kind of bile, not to mention wit and vigor.*

I.

Maybe the local time just seems slower because the current occupant of the White House is a hyperactive gland case. Anyhow, it's hard to believe that only a couple of years have passed since the Reagans went away. It was a touching moment, we now learn. "Look, honey," Ronnie whispered tenderly to Nancy as the helicopter banked back for one more sweep across the South Lawn, "there's our little shack." That's according to *An American Life*. Ac-

cording to *President Reagan: The Role of a Lifetime*, he whispered tenderly, "There's our little bungalow down there." Whatever.

It's taken a while for the full weirdness of the Reagan years to sink in. Not that the unnerving facts weren't available; but nobody—not even Reagan's political opponents—really wanted to face them. We've known for some time, for example, that Reagan's schedule was drawn up in consultation with an astrologer. Reagan's sacked chief of staff, Donald T. Regan, told us so in a book published a full eight months before the administration left office. Thanks to Nancy Reagan, Kitty Kelley, and now Lou Cannon, we've since learned about the weekly astrology classes Nancy took during the 1950s and '60s, the "zodiac parties" the Reagans attended in Hollywood, Nancy's annoyance when the White House astrologer insisted on being paid for her horoscopes, and the humiliation felt by aides such as James Baker, Richard Darman, and Michael Deaver at having to explain away absurd and arbitrary changes in the schedule that they knew were being made on the basis of supersecret astrological prognostications.

Cannon finds no evidence that astrology had any direct effects on substantive policy. But he finds plenty of evidence that this was a government of, by, and for the stars. And astrology, as it happens, is a pretty good metaphor for the peculiar qualities of that government and its peculiar central character.

Reagan, as portrayed in Cannon's book and in his own, is a childlike and sometimes childish man. His head is full of stories. He is unable to think analytically. He is ignorant. He has notions about the way things work, but he doesn't notice when these notions contradict each other. He has difficulty distinguishing between fantasy and reality. He believes fervently in happy endings. He is passive and fatalistic. He cannot admit error.

Within the White House, Reagan himself was consulted precisely as one consults a horoscope. To his frazzled assistants he had mystical power, but was not quite real. Like a soothsayer's chart, he required deciphering. "Reaganology," Cannon writes, "was largely based on whatever gleanings could be obtained from body language." The president's pronouncements in meetings, which usually took the form of anecdotes that might or might not be relevant to the matter at hand, were open to various interpretations. When the conversation ranged beyond the handful of *Animal Farm*-type certainties that made up what Cannon calls Reagan's "core beliefs" (taxes bad, defense good; government bad, markets good) Reagan was lost. Though the people who served with him respected him for his occult powers—his rapport with the television audience, his ability to read a text convincingly, the powerful simplicity of the core beliefs—they viewed his intellect with contempt. They thought he was a big baby, and they were right.

This is a point that Cannon makes over and over, in one way and another. His book is devastating and superb. He has covered Reagan for twenty-five years and is looked upon by Reagan's friends and enemies alike as a fair witness and an impartial judge. Having read not only Cannon's new blockbuster but also several thousand of his stories and columns in *The Washington Post*, I still have no idea if he is pro-Reagan or anti-Reagan. His only discernible ideological predisposition is that he has no ideological predisposition (though this ideologically pre-disposes him to underestimate ideology's importance, as well as to be more sympathetic to the administration's "pragmatists" than to its movement conservatives).

Cannon's book braids a biography of Reagan together with a detailed and lively account of Reagan's presidency. Much of it is necessarily about Reagan's advisers and Cabinet secretaries, for it

was on them that the day-to-day burdens of the presidency actually fell. A good deal of what Cannon shows us about Reagan is seen through their eyes. It's quite a spectacle:

> The sad, shared secret of the Reagan White House was that no one in the presidential entourage had confidence in the judgment or capacities of the president.

> Pragmatists and conservatives alike treated Reagan as if he were a child monarch in need of constant protection.

> Reagan's reliance on metaphor and analogy for understanding made him vulnerable to arguments that were short on facts and long on theatrical gimmicks.

> He made sense of foreign policy through his long-developed habit of devising dramatic, all-purpose stories with moralistic messages, forceful plots, and well-developed heroes and villains.

> The more Reagan repeated a story, the more he believed it and the more he resisted information that undermined its premises.

> Ronald Reagan's subordinates often despaired of him because he seemed to inhabit a fantasy world where cinematic events competed for attention with reality.

And so on. Cannon stresses the movie angle as a way of understanding Reagan, which is interesting in light of how little public discussion of this angle there was during Reagan's twenty-five years as an active politician. Governor Pat Brown of California, whom Reagan unseated in his first bid for public office in 1966, humorously likened him to John Wilkes Booth. The joke backfired, but

the "actor issue" was a perfectly legitimate one. If it is fair to examine how a candidate's background as a soldier or a corporate lawyer or a civil rights agitator might affect his habits of mind, then surely it was fair to ask if the mental habits instilled by spending most of one's time until the age of 53 dressing up in costumes and playing out elaborately mounted wish-fulfillment fantasies was good preparation for high office. But partly because it hadn't worked for Brown and partly because mentioning Reagan's profession somehow got classified as bigotry ("jobism," it might be called nowadays), the actor issue was never aired in any of Reagan's subsequent campaigns.

As president, Reagan spent a lot of time at the movies. According to Cannon, he saw some 350 feature films at Camp David alone. He also saw several more a month at the White House family theater, plus an unknown number in the private screening rooms of rich friends. And those were just the ones requiring the services of a projectionist. In addition, the Reagans watched TV every night they were free. Reagan loved war pictures. He had starred in several during World War II (*International Squadron, Rear Gunner,* and *For God and Country,* among others) and had absorbed hundreds more. Some of his best anecdotes—the B-17 pilot who cradles his wounded gunner's head in his arms as they ride their crippled plane down together; the black sailor who saves his white shipmates by grabbing a machine gun and swiveling to shoot a Japanese fighter out of the sky; the American Army officer (Reagan himself) who helps liberate the death camps—were twisted, hoked-up, or falsified versions of experiences that Reagan had encountered in movie theaters, not in real life.

We knew about Reagan and war movies. What Cannon adds is that Reagan loved peace movies, too. He couldn't stop talking about *War Games,* a Matthew Broderick vehicle about a teenage

hacker who breaks into the NORAD computer and saves the world from being destroyed by trigger-happy Pentagon generals. He watched *The Day After*, the 1983 made-for-TV nuclear holocaust weepie that his own people spent weeks trying to discredit, and found it powerful and affecting. His strategic defense proposal was strikingly reminiscent of one of his own movies, *Murder in the Air* (1940), in which the future president, playing Secret Service agent Brass Bancroft, foils a foreign plot to steal the "Inertia Projector," an American army gun that can shoot down distant enemy aircraft. And according to Colin Powell, Reagan's last national security adviser, Reagan's proposal to share strategic defense technology with the Soviets was inspired by *The Day the Earth Stood Still*, a gripping 1951 science fiction movie in which a flying saucer descends on Washington. The saucer disgorges Michael Rennie, the urbane representative of an advanced civilization, who warns earthlings to put aside their petty quarrels among themselves or face the consequences.

If the war-movie side of Reagan had been all there was to him, as many of us feared in the early 1980s, all of us might now be radioactive ash. But because he also had his peace-movie side, he turned out to be a somewhat less predictable and altogether less frightening character. He was, in fact, a precursor, a kind of spiritual grandfather, of what has become a standard Hollywood type: the autodidactic, self-righteous, "issue-oriented" star who is full of opinions about politics and who also dabbles in, and is fascinated by, "New Age" phenomena. These last, in Reagan's case, include (besides astrology) extrasensory perception, precognition, sci-fi, people from other planets, and prophecies about Armageddon. It was only natural for him to be interested in such things, given that the Reagans spent most of their lives (as Nancy puts it with screwball reasonableness in *My Turn*) "in the company of show-business people,

where superstitions and other non-scientific beliefs are wide-
spread and commonly accepted."

Reagan's staff kept most of the wigginess from spilling over into
the public arena. "Here come the little green men again," Powell
used to tell his staff whenever the subject arose of Reagan's preoc-
cupation with how an alien invasion would unify the earth. Powell,
Cannon writes dryly, "struggled diligently to keep interplanetary
references out of Reagan's speeches." They couldn't be kept out
of informal conversations, though—much to the bafflement of
Mikhail Gorbachev, who, when Reagan started in about invasions
from outer space at the 1985 summit in Geneva, politely changed
the subject.

The wildest aspect of Reagan's premature New Agery was his
obsession with the Battle of Armageddon. The closest anyone
ever came to flushing out this particular bit of Reaganuttiness
came during the second televised campaign debate in 1984, when
Marvin Kalb asked Reagan if the matter of Armageddon had
had any effect on American nuclear planning. Reagan just made
it through his answer safely, saying that while he had engaged
in "philosophical discussions" on the subject, "no one knows"
whether "Armageddon is a thousand years away or the day after
tomorrow," and therefore he had never "said we must plan accord-
ing to Armageddon."

Had Walter Mondale picked up on this opening and used the
rest of the debate, and maybe the rest of the campaign, to harass
Reagan on what could have become the "Armageddon issue," the
election might have been less one-sided. A little more drilling in Ar-
mageddon territory could have yielded a political gusher. Cannon
has conducted his own archaeological dig into the matter and un-
earthed enough shards to warrant the conclusion that "Reagan

is hooked on Armageddon." In 1968 Billy Graham visits Reagan and they talk about portents of the end of days. In 1970 Pat Boone brings a couple of radio evangelists to see Reagan in Sacramento, and one of them, seized by a supposed visitation of the Holy Spirit, prophesies rapturously that Reagan will be president and tells him about the approaching mother of all battles, and then listens as Reagan ticks off modern events, such as the founding of the State of Israel, that seem to fulfill the biblical preconditions for the big one. In 1971 Reagan tells his dinner partner, the president pro tem of the California Senate, that the end is nigh and that one of the portents is that Libya has gone Communist. In 1980 Reagan announces on Jim Bakker's TV show that "we may be the generation that sees Armageddon."

The obsession continues after Reagan is president. His national security aides grow used to hearing him talk about it. Robert McFarlane becomes convinced, in Cannon's words, "that Reagan's interest in anti-missile defense was the product of his interest in Armageddon." When Frank Carlucci tries to persuade Reagan that nuclear deterrence is a good thing, Reagan astonishes Carlucci by telling him about Armageddon. When Caspar Weinberger tries to make the same case, Reagan gives him the same Armageddon lecture. On March 28, 1987, at the Gridiron Club dinner, Reagan tells James McCartney of Knight Ridder that because Chernobyl is the Ukrainian word for "wormwood" and Wormwood is the name of a flaming star in the Book of Revelation, the accident at the Soviet nuclear plant was a harbinger of Armageddon. (In a hilarious footnote, Cannon adds that Reagan, in telling the story to McCartney, misremembered the name of the star and called it "Wedgewood." Shades of Nancy's china!) On May 5, 1989, Reagan tells Cannon that Israel's possession of the Temple Mount is a sign that Armageddon looms. There are other omens, too, he tells Cannon. What, for example? "Strange weather things."

II.

The book titled *An American Life* omits any mention of strange weather things. It is as much a star autobiography as a presidential memoir, but star autobiography of the pre-Geraldo type. There are no shocking confessions, no harrowing addictions, no twelve-step recoveries. This is *Photoplay* circa 1940, not *National Enquirer* circa 1990.

Has Reagan read this book? Besides the printed tome, there is also an audio version—two cassettes with a total running time of 180 minutes, on which Reagan, in his seductive announcer's voice, recites excerpts aloud. According to my calculation, the tapes represent about 32,000 of the roughly 260,000 words in the printed text. The evidence, then, is that Reagan has read at least 12 percent of his book. Trust, but verify.

The actual author of *An American Life*, as the opening acknowledgments more or less proclaim, is a "thoroughly professional team" of about two dozen people headed by Robert Lindsey, who has written several readable best-sellers. "Even though I am glad to have this book finished, I will miss my conversations with Bob," writes Reagan, or writes Bob, or writes somebody. There's no way, really, to be sure. Anyway, the conversations with Bob didn't yield much. Almost everything in the book could have been gleaned, perhaps was gleaned, from the public record—from newspapers, old speech and interview transcripts, other books, and White House news releases.

But if there are no revelations, there is a portrait—no, there are two portraits. On the surface is the golden personification of the American dream: the small-town lifeguard who saved seventy-seven people from drowning, the movie star who saved the girl and the day in many a B picture, the citizen-politician who saved the conservative movement from sullen irrelevance, the triumphal president who saved his country from drift and decline. Below the

surface—but only a little below, since these depths are not very deep—is the child monarch, a person of stunning narcissism and unreflectiveness.

Reagan, as all the world knows, is a big-picture man. His famous "hands-off management style" seems to have evolved early and to have extended to the smallest details of his own life. His most politically potent qualities—the placidity of his temperament, the smooth-surfaced simplicity of his politics, the magical ease with which he waves away inconsistency and irresponsibility—are all related, first, to his ability to ignore contradictions (more precisely, his inability to notice them), and, second, to the effortlessness that has attended all his achievements.

"I was raised to believe that God has a plan for everyone and that seemingly random twists of fate are all a part of His plan," he writes. "My mother—a small woman with auburn hair and a sense of optimism that ran as deep as the cosmos—told me everything in life happened for a purpose. She said all things were part of God's Plan, even the most disheartening setbacks, and in the end, everything worked out for the best." But then, a few sentences later, he tells us what his father taught him: "that individuals determine their own destiny; that is, it's largely their own ambition and hard work that determine their fate in life."

Reagan is untroubled by the stark incompatibility of these two conceptions of will and destiny. He just forges blithely ahead, and before long it becomes clear which of the two views he finds more congenial:

Then one of those series of small events began that make you wonder about God's Plan.

Once again fate intervened—as if God was carrying out His plan with my name on it.

Then one of those things happened that makes one wonder about God's having a plan for all of us.

If ever God gave me evidence that He had a plan for me, it was the night He brought Nancy into my life.

And finally, as he and his wife emerge from the elevator on the second floor of the White House on the evening of the inaugural:

I think it was only then, as Nancy and I walked hand in hand down the great Central Hall, that it hit home that I was president . . . it was only at this moment that I appreciated the enormity of what had happened to me.

Even the presidency was something that happened to Reagan. This is more than just the affectation of a becoming modesty. The political philosophy that Reagan adopted in his 40s may have stressed ambition and hard work, but Reagan himself has never had to do much more than go with the Plan. Even in his own telling, it is striking how easy he has had it (which makes his denunciations of "giveaway welfare programs" especially unattractive).

After graduating from Eureka College in 1932, he tells us, he was bitterly disappointed when someone else beat him out for a job running the sporting goods department at the local Montgomery Ward in Dixon, Illinois, for $12.50 a week. That's about it as far as reversals go. A few months later he was making $25 a week as a radio

announcer, and then $75, and then, after a quick screen test taken during a trip to California to cover the Chicago Cubs in spring training for his radio station in 1937, $200 a week as a contract player at Warner's—the equivalent today, after taxes, of well over $100,000 a year.

Reagan was 26 when he arrived in Hollywood in the depths of the Depression, and after that it was just a matter of adding zeroes to his income. Even World War II was easy for him. Lieutenant Reagan spent it narrating training films for the Army Air Force at a movie studio in Culver City. His first picture after his discharge involved riding horses, which made it, he writes, "like a welcome-home gift." Of course, he was already home. He had been home all along—though he genuinely believed, at the time and after, that he had been to war.

In 1954, after Reagan's movie career had begun to falter, the Plan intervened in the form of an offer to serve as the host of a television series, "General Electric Theater," and to give speeches at GE plants as a company spokesman. Taking this job, perhaps more than any other decision Reagan ever made, was what made him president. Reagan had turned down other TV offers because, as he notes shrewdly in *An American Life*, "most television series expired after two or three years, and from then on, audiences— and producers—tended to think of you only as the character you'd played in the TV series." Being the host, however, was different. It put him before the public every week for eight years (plus another two years as the host of "Death Valley Days"), not as a cowpoke or a private eye or a bumbling husband, but as a congenial, dignified man in a business suit called Ronald Reagan.

Cannon's book stresses Reagan's pride in his acting and his movie career, but Reagan's book confirms Christopher Matthews's insight that Reagan's real calling in life was not as an actor but as an announcer—and, by extension, as a giver of speeches. Reagan

offers no reflections on the craft of acting, but plenty on the craft of announcing and speechmaking. (Can you picture the young Reagan waiting on tables for a chance to play Hamlet? Neither can I.) The speeches for GE became The Speech, a compendium of free enterprise bromides and fabulous anecdotes about government waste that he polished to a high gloss in hundreds of repetitions, and which, when he delivered it on national television in 1964 on behalf of Barry Goldwater, led to the governorship of California and eventually the presidency of the United States.

III.

Characteristically, Reagan sees no contradiction between the cozy cartel system of the Hollywood studios in which he prospered and the cutthroat laissez-faire doctrine he would later espouse. On the contrary, he deplores the antitrust suit that forced producers "to make movies purely on the speculation theaters would want to show them." This kind of ideological incoherence contributes to Reagan's opacity about just when and how he became a conservative. His wife is more straightforward on this point. Referring to Reagan's years shilling for GE in the middle and late 1950s, she wrote in *My Turn*: "It was during this period that Ronnie gradually changed his political views."

From Nancy's account, and from Cannon's, it seems clear that during his GE spokesman days Reagan became persuaded by the sound of his own voice, which was also his master's. More flatteringly to himself, Reagan depicts the change as starting much earlier. He pretends to recall, anachronistically, that as a small-town boy he learned "to know people as individuals, not as blocs or members of special interest groups." He claims, improbably, that his support for Franklin D. Roosevelt was a function of FDR's call in 1932 for a cut in federal spending. While making a picture in England in 1949 he observes, omnisciently, "how the welfare state sapped incentive

to work from many people in a wonderful and dynamic country."
He makes much of having called on the Democrats to nominate
Dwight D. Eisenhower for president, but this was a popular posi-
tion within Americans for Democratic Action, the leading liberal
pressure group of the day. (The ADA ticket was Ike and William
O. Douglas.)

Reagan also portrays his battles with Hollywood Communists in
the Screen Actors Guild, the United World Federalists, the Amer-
ican Veterans Committee, and other organizations as a factor in
his conversion to conservative Republicanism. This makes a nice,
heroic-sounding story, but it's demonstrably untrue. He writes that
"after the war, I'd shared the orthodox liberal view that Commu-
nists—if there really were any—were liberals who were temporar-
ily off track, and whatever they were, they didn't pose much of a
threat to me or anyone." But this was not the "orthodox," i.e., main-
stream, liberal view. By 1946, and unmistakably by 1950, the great
majority of American liberals, leftists, and Democrats were firmly
anti-Communist. This was the case even in Hollywood, where a
fair amount of poolside Stalinism (like today's hot-tub Sandinismo)
persisted right through the mid-1950s.

Reagan after the war was a dupe, an enthusiastic joiner of Com-
munist front groups. He expresses no remorse about this. On the
contrary, in his memoir you can almost hear the fond, indulgent
chuckle in his voice as he describes himself during this period. He
was "speaking out against the rise of neofascism in America." He
"joined just about any organization I could find that guaranteed to
save the world." But heck, he just "hadn't given much thought to the
threat of communism." Darn that headstrong, idealistic Reagan kid
anyway—somebody forgot to tell him about the Moscow trials. In
any case, he doesn't mention such things in explaining his awaken-

ing to the problem of communism. Instead he recounts a visit from a couple of FBI agents and his agreement to become an informer for them. ("They asked if they could meet with me periodically to discuss some of the things that were going on in Hollywood. I said of course they could.")

Whatever his reasons for turning against communism, he remained left of center long after he did so. As late as 1952, by which date he had been publicly denouncing Communists for six years, the Los Angeles County Democratic Central Committee declined to endorse him for an open House seat because they thought he was *too* liberal. It's tantalizing to speculate on what might have been had the Democrats of Los Angeles not made this bonehead decision. Would Representative Reagan have become Senator Reagan? Might he have ended up as JFK's running mate? Would he have drifted to the right and become a marginal crank like Sam Yorty? Or would he have stayed left and won the White House four or eight years earlier than he did? And—most delicious thought of all—would the ultimate sneer-word of today's conservatives be not McGovernism or Carterism, but Reaganism?

The fact that Reagan converted to anti-communism long before he converted to conservatism may have had an important consequence. Evil though he thought the empire was, his conservatism did not depend on an emotional attachment to a permanent, Manichaean East-West struggle. This may be one reason why he was so much readier than were the ideologues among his aides when Gorbachev came along and announced that the struggle was over.

' Reagan is not, nor has he ever been, ideologically sophisticated. He was a sentimental liberal who became a sentimental conserva-

tive. His liberalism was a product of inertia combined with a vague sympathy for the little guy; his conservatism was a product of convenience combined with sympathy for guys who weren't so little— the GE managers and executives who had his ear for eight years. ("By 1960, I realized the real enemy wasn't big business, it was big government.") This lack of intellectual sophistication—an inability to think, really—is one of the themes of Cannon's book that manifests itself over and over again in Reagan's book. For example, when he becomes governor of California, two years after the Watts Riots. Reagan decides to "find out what was going on" by paying secret visits to black families around the state:

> One of the first things I heard was a complaint that blacks weren't being given a fair shot at jobs in state government. I looked into it and confirmed that virtually the only blacks employed by the state were janitors or those working in other menial positions, largely because state civil service tests were slanted against them.

His response was to change "the testing and job evaluation procedures" to make up for the fact that "blacks just hadn't had the opportunity to get the same kind of schooling as other Californians"—in other words, to rewrite the tests and the qualifications so as to guarantee equality of outcome. A good-hearted act, no doubt about it; but Reagan shows absolutely no awareness that this aggressive instance of affirmative action is precisely the sort of thing that his Justice Department would soon enough denounce as an affront to American values.

Another example. A lodestar of the Reagan administration's foreign policy was the distinction between authoritarian regimes, which are by nature reformable because they permit competing centers of social power to exist, and totalitarian regimes, which are by nature unreformable because all power has been seized, or is in

the process of being seized, by a party-state professing a messianic ideology that claims a total monopoly on truth. This analysis was the heart of a famous article by Jeane Kirkpatrick in *Commentary* in 1980. Reagan was so impressed by this piece that he made Kirkpatrick his ambassador to the United Nations.

The doctrine of the immutability of totalitarian regimes has turned out to have no predictive power, and it was therefore a poor basis for long-term policy; but the analytic distinction between the two types of dictatorship was sound enough. The idea that there's a difference between plain old undemocratic governments, however brutal, and those with totalitarian pretensions is not hard to grasp. Furthermore, this idea underlay some of the Reagan administration's most important foreign policy innovations. Even so, it comes as no real surprise that the authoritarian-totalitarian distinction was utterly lost on Reagan. Discussing polity options for the hemisphere in *An American Life*, he writes:

> Sure, we could send in the troops, but the threat of communism wouldn't diminish until the people's standard of living was improved and the totalitarian countries of Latin America gave them more freedom.

Discussing the Falklands War, he writes:

> Margaret Thatcher, I think, had no choice but to stand up to the generals who cynically squandered the lives of young Argentineans solely to prolong the life of a corrupt and iron-fisted totalitarian government.

The Argentine military junta, remember, was Kirkpatrick's beau ideal of authoritarian government. And the totalitarian prototype in the Kirkpatrick scheme was pre-Gorbachevian Soviet

communism, which Reagan describes as a system of—what else?—"authoritarian rule."

Or perhaps it isn't Reagan but his "thoroughly professional team" that is confused. I must acknowledge that the sentences quoted above are not recited on the cassettes, so there is no hard proof that Reagan was ever familiar with them. But *An American Life* does have passages that Reagan can be credited not only with having read, but with having written. These are excerpts from a diary that he seems to have kept as president, of which a total of about forty pages are scattered through the ghosted text.

To appreciate fully the flavor of these diary entries, one needs to sample more than one or two. The three entries below are given in their entirety. They are typical. I categorically deny that I am being unfair:

Feb. 22

Launch on issues. I'm convinced of the need to address the people on our budget and the economy. The press has done a job on us and the polls show its effect. The people are confused about economic program. They've been told it has failed and it has just started.

June 30

Word came that the hostages were going to leave in a Red Cross motorcade for Damascus. It was a long ride. We then were told that celebrations in small villages along their route were delaying them. About a quarter to three our time, they arrived at the Sheraton hotel in Damascus.

Out to George Shultz's home for dinner with George and O'Bie. A very nice and finally relaxed dinner. Before that,

however, I spoke to the nation on TV from the Oval Office, then George took questions in the press room. When I spoke our people were just leaving Syrian air space in a military aircraft.

Sept. 26

High spot was swearing in of Chief Justice Rehnquist and Justice Scalia in the East Room. After lunch meeting with George S., Cap W., and Bill Casey plus our White House people, Don R., John P., etc. It was a sum up of where we stand in the negotiations between George and Shevardnadze. The difference between us is their desire to make it look like a trade for Daniloff and their spy Zakharov. We'll trade Zakharov but for Soviet dissidents. We settled on our bottom line points beyond which we won't budge. Then we picked up Nancy and helicoptered to Ft. Meade for the opening of the new National Security Agency complex. I spoke to the NSA employees. Then we helicoptered to Camp David and topped the day with a swim.

The entries from the diary that were chosen for publication in *An American Life* are presumably the best of the lot, and this is as good as they get. One can imagine the sick disappointment of Lindsey and the rest of the team when they got their first look at them. There are no portraits of friends and enemies, no thumbnail sketches, no gossip, no peeves, no wisecracks, no outbursts of principle, no anecdotes—no nothing, really, except simpleminded digests of news bulletins and appointment logs. For authenticity's sake, the team has left in a few grammatical howlers and preserved a Reagan habit, which some will find endearing, of taking the hyphens out of compound phrases like "tight rope," "plane side," and "heart breaking" and saving them up for use in low-octane swear words, such as "h—l" and "d—m" (hang on, shouldn't that be "d-m-"?).

Many entries combine childish diction with childish thinking, as in this reflection on the flap over the visit to the Waffen SS cemetery at Bitburg, Germany:

> I still think we were right. Yes. The German soldiers were the enemy and part of the whole Nazi hate era. But we won and we killed those soldiers. What is wrong with saying, "Let's never be enemies again"? Would Helmut be wrong if he visited Arlington Cemetery on one of his U.S. visits?

And then this follow-up, after Kohl suggested that they balance the Bitburg ceremony with a tour of Dachau:

> Helmut may very well have solved our problem re the Holocaust.

And then there is this innocuous reference to a negotiation on the budget:

> The big thing today was a meeting with Tip, Howard Bohling, Jim Wright, Jim Baker, Ed Meese, Don Regan, and Dave Stockman.

The problem is that Howard Bohling wasn't at the meeting, or on the planet. Our diarist is conflating two of the actual attendees, Howard Baker and Richard Bolling. Are the identities of these men a mere detail? You could say that about Bolling, a mere representative (though a prominent one) and a Democrat to boot. But Senator (and Majority Leader) Baker was the second-most-powerful figure in the Republican Party. He would later become Reagan's chief of staff. It is deeply weird that the president was so vague about who he was.

The emptiness of Reagan's diary is one of many indications that the president's narcissism was of the babyish, not the Byronic, variety. And a happy baby he was. His perfect obliviousness to the feelings and the thoughts of others protected him from emotional turmoil. And his emotional tranquillity in turn helped to cushion him from what otherwise might have been the political impact of the contrast between his beliefs and his life. He listed "family" first among his public values, yet his emotional remoteness so wounded his own children that during the White House years three of them published books attacking him. And he treated his closest aides, Cannon tells us, "as indifferently as he did his children." Once they left his employ, they would never hear from him again.

There were times when Reagan's lack of self-awareness was merely goofy. At other times, however, his inability to see himself clearly takes on a somewhat more unpleasant edge. Consider this anecdote:

> I've never liked hunting, simply killing an animal for the pleasure of it, but I have always enjoyed and collected unusual guns; I love target shooting, and have always kept a gun for protection at home. As I had done when I was governor, I sometimes did some target shooting with the Secret Service agents who accompanied us to the ranch, and occasionally managed to amaze them with my marksmanship. We have a small pond on the ranch that sometimes attracts small black snakes, and every now and then, one would stick its head up out of the water for a second or two. After I'd see one, I'd go into the house and come back with a .38 revolver, go into a little crouch, and wait for the next snake to rise up. Then I'd shoot.
>
> Well, since I was thirty feet or more from the lake, the Secret Service agents were shocked that I was able to hit the snake every time. They'd shake their heads and say to each other, "How the hell does he do it?"

What they didn't know was that my pistol was loaded with shells containing bird shot—like a shotgun—instead of a conventional slug. I kept my secret for a while, but finally decided to fess up and tell them about the bird shot.

This little story has a chilling, brightly lit creepiness, like something out of David Lynch. Its trajectory, from Reagan's pious and no doubt sincere disavowal of killing animals for pleasure to his almost sensuous description of the fun of blowing the heads off unoffending water snakes (and doing it in an unsporting manner, too), suggests an obliviousness that is potentially sinister. One begins to suspect that, for all his generic charm, Reagan may not be such a nice guy after all. We are dealing here with the same insensibility that enables Reagan to believe that he never traded arms for hostages, that the deficit was all the Democrats' fault, that his economic policies helped the poor at the expense of the rich.

IV.

But wait. If he was dumb, superstitious, childish, inattentive, passive, narcissistic, and oblivious, how come he won the cold war?

Good question. The answer, in two words, is Mikhail Gorbachev. Reagan, always lucky, was never luckier than to find himself president of the United States at just the moment when a Soviet leader decided to lift the pall of fear and lies from his empire, thus permitting the system's accumulated absurdities and contradictions to come into plain view and to shake it to pieces.

Everyone agrees that the West, led by the United States, deserves credit for creating the conditions under which this could happen. But in order to assign to Ronald Reagan the lion's share—that is, to assign to this particular president more than the equal slice of credit that is due each of the eight postwar presidents who carried out the Western policies of containment, nuclear deterrence, conventional

military readiness, support for NATO, support for non-Communist economic development, and political and diplomatic opposition to Soviet expansionism—you have to believe that the *marginal* differences between Reagan's policies and his predecessors' were the ones that brought about the Gorbachev breakthrough.

These marginal differences included bigger increases in military spending; intransigence in, if not outright hostility to, arms control negotiations; an emphasis on ideological attacks on Leninism in American public diplomacy; suspension of the anti-Soviet grain embargo; assistance to the guerrillas fighting the Soviet-supported Sandinista regime in Nicaragua; a somewhat more aggressive program of military aid to the Afghani *mujaheddin* than might otherwise have been pursued (though this program was begun under the Democrats and was popular with both parties); the anti-missile defense proposal; and the military interventions in Lebanon and Grenada. The effect, such as it was, of these policies on changes within the Soviet Union was probably mixed.

Reagan's admirers argue that the American military buildup encouraged Soviet reform by persuading Gorbachev that the arms race was a pointless rathole. Still, it could also be argued that the buildup retarded reform by strengthening the worst-case paranoids within the Soviet military. More plausible than either argument is the view that Gorbachev's determination to disengage from the cold war was the product of forces far deeper and stronger than whether American military spending increased a lot or a little during the early 1980s, that the forces that made and unmade Gorbachev were indigenous, historical, Russian.

Nor were the other Reagan policy innovations—whether "hawkish" like the contra obsession or "dovish" like the grain-embargo cancellation, whether wise like the president's vigorous rhetorical opposition to Leninist ideology or foolish like the Lebanon fiasco—truly central to the epochal decisions being made in the Kremlin.

And the argument that these innovations were decisive requires us to believe that without them Gorbachev would not have come to power; or that he would have come to power, but would not have embarked on the path of glasnost and perestroika; or that he would have embarked on this path, but would have been deflected or replaced long before he could follow it as far as he did. None of these propositions seems plausible to me.

The issue of nuclear weapons increasingly occupied Reagan's attention, and it presents a special case. How much he knew about the topic was the subject of much speculation while he was in office. Cannon shows that Reagan's ignorance was actually more comprehensive than many of us suspected. The president did not know that submarines carried nuclear missiles, or that bombers carried them. He did not know that land-based ballistic missiles made up a much larger proportion of the Soviet nuclear force than the American one, and therefore he did not realize that his proposal for halving the numbers of such missiles on both sides was far from being the even-handed basis for serious negotiation he believed it to be. Though he had campaigned against the "window of vulnerability"—the alleged ease with which a Soviet first strike could destroy America's land-based missiles—he did not know that his own plan to put such missiles in stationary silos would open the "window" wider.

Throughout Reagan's first term his strings were being pulled by officials who privately opposed the whole idea of arms control agreements with the Soviet Union because they thought such agreements weakened the West's will to resist. These officials concocted bargaining positions that the Soviets could be relied upon to reject, which is exactly what the Soviets did under Brezhnev, Andropov, and Chernenko. Then along came Gorbachev. He wanted a deal so badly that he systematically probed until he found a question Washington was unable not to take yes for an answer to. And so the "zero option" for European-based intermediate-range

missiles—a proposal that the Defense Department had crafted to be unacceptable—became, presto chango, the great and crowning achievement of Ronald Reagan's foreign policy.

Whatever happens in the aftermath of the coup in Moscow, the central achievements of the Gorbachev years—the dissolution of the Soviet Union's Eastern European empire, the demolition of Leninist ideology, and the defusing of East-West confrontation—will almost certainly remain. Could Gorbachev have done all this without Reagan? Probably, yes—but he probably couldn't have done it without accepting Reagan's (that is, the West's) view of the cold war. Gorbachev recognized that the cause of the cold war was not superpower tensions or capitalist encirclement or the arms race, let alone the international class struggle. The cause of the cold war was simply the Soviet Union's refusal to become a "normal" country. As a corollary, Gorbachev recognized that the Soviet Union faced no military threat from the West, however bulging Western arsenals might be. So he knew he could accept what his predecessors would have seen as preposterously disadvantageous arms control deals without putting his country's physical security at risk.

There was another point of agreement between Gorbachev and Reagan. They both thought Gorbachev's country was redeemable. Reagan had a recurring daydream that someday he would take a Soviet leader up in his helicopter and together they would fly low over an American suburb. The Soviet leader would see the tidy little houses of American workers, with their plastic pools out back and a car or two out front, and he would decide that maybe it was time to scrap communism and try a little democracy and free enterprise instead. Is this sentimental fantasy really so different from what actually happened?

When Reagan called the Soviet Union an "evil empire" and "the form of evil in the modern world," conservative op-ed writers expressed their satisfaction that at last we had a president who had a moral vocabulary and a tragic sense of history, a president who recognized that some political systems are irredeemably tyrannical and aggressive, a president who rejected the contemptible claptrap that attributes every international conflict to "lack of understanding." These commentators, and many of their friends inside the Reagan administration, saw Gorbachev as simply cleverer than his predecessors, and therefore more dangerous. Reagan did not agree. When he said "evil," he just meant bad. He didn't really believe in immutable malevolence. The villains of Reagan's world were like the ones in Frank Capra's movies: capable of change once they saw the light. Reagan thought that Gorbachev was a pretty good guy.

As president, of course, Reagan was the ex officio high priest of the nuclear cult. He was followed everywhere he went by a military aide hand-cuffed to the "football," the sacred object containing the codes that would enable him to launch the final conflagration. And the propinquity of the thermonuclear Excalibur gave him, in this one area of policy, a consciousness of personal power unparalleled in history and shared only with his Soviet counterpart. By the same token, the rituals of nuclear summitry required his personal participation, and he found the drama irresistible.

Resplendent in the vestments of the nuclear episcopate, Reagan announced his astonishing heresies. In 1983, just when the whole of the conservative foreign policy establishment, and many centrist and liberal nuclear worthies besides, had geared up to defend the morality of nuclear deterrence against freezeniks, Catholic moralists, Euro-accommodationists, and other unsound elements, the president proclaimed that nuclear deterrence was . . . immoral. To

replace it, he proposed an exotic space shield that would protect America (and why not Russia, too?) against nuclear attack.

Whatever progress is ultimately made in anti-missile defense technology, the idea of an impenetrable space shield was then, and remains today, a lunatic notion. The notion's provenance was lunatic, too. "The dream," writes Cannon, "was the product of Reagan's imagination, perhaps of Brass Bancroft and the Inertia Projector and *The Day the Earth Stood Still*, and certainly of the vivid prophecy of Armageddon that Reagan accepted as a valid forecast of the nuclear age." SDI was pure Reagan.

Useless as SDI would be as a shield against a determined missile attack, it would not be at all useless as a supplement to a first strike launched by the side that possessed it. This—plus a superstitious awe of American technology—was why SDI alarmed the Russians. Reagan did not understand this. He thought they were lying when they said they were worried about Americans attacking them with nuclear weapons, because they had to know Americans would never do such a thing. McFarlane, who didn't think they were lying, saw how the dross of Reagan's "dream" could be turned into gold. In a negotiating ploy so one-sided that he privately called it "The Sting," United States would abandon SDI—a research program of dubious practicability—in exchange for the destruction of thousands of actually existing Soviet nuclear weapons. McFarlane didn't mind that Reagan kept saying SDI was not a bargaining chip, because every such avowal drove up its value as a bargaining chip.

McFarlane didn't realize that the old boy meant what he said. And Reagan had another dream, which prompted him to utter another heresy, the most dangerous one that the priesthood could imagine. He said he wanted to rid the world of nuclear weapons altogether. Total nuclear disarmament was a silly old chestnut of cold war propaganda,

especially Soviet propaganda. But Reagan believed in it. He had said so in a number of speeches before he became president, but no one paid any attention because everyone assumed that it was just drivel that he'd thrown in to soften his right-wing image. As president, Reagan continued to believe in the desirability of complete nuclear disarmament, even after it was explained to him that nuclear weapons were good because they had kept the peace for forty years. His advisers, he writes in *An American Life*, included "people at the Pentagon who claimed a nuclear war was 'winnable.' I thought they were crazy."

Reagan knew that his own secretary of defense, for example, was "strongly against" nuclear disarmament. Still, he told Gorbachev that he wanted exactly that. In October 1986, at the Reykjavik summit, the principals agreed on principles: the Soviet Union and the United States would scrap all their ballistic missiles within five years and all the rest of their nukes within ten. The only thing that stood in the way of the deal was SDI. Gorbachev wanted it confined to the laboratory, and he simply refused to take seriously Reagan's offer to share it. Reagan, all accounts agree, became angry—so angry he stalked out of the room while Gorbachev was still talking to him. The session, and the summit, ended. Reagan's "dreams" had fratricided, like incoming missiles bunched too closely together. He and Gorbachev had to settle for the Euromissile treaty, which would be signed a year later.

Cannon blames Reagan for the failure at Reykjavik. "Reagan," Cannon writes, "clung to his competing dreams of a world without nuclear weapons and a world in which people would be protected from nuclear war by an antimissile defense." But were these "dreams" really so inherently contradictory? If both sides still had nuclear arsenals, then SDI would indeed be "destabilizing," because it would create an obvious, if conjectural, temptation to strike first: smash the other side's forces, and even a leaky defense might be enough to repel what was left. But if "a world without nuclear

weapons" was actually to be achieved, then might not shared anti-missile defenses (of a suitably modest kind) be just what Reagan was saying they'd be—insurance against cheaters or crazies?

In retrospect, it's clear (at least to me) that both Reagan and Gorbachev blundered at Reykjavik. If one of them had given in, both superpowers might be dismantling the last of their ballistic missiles right now. But Gorbachev's stubbornness was less excusable than Reagan's. Gorbachev should have realized that it didn't much matter what he conceded about SDI: once nuclear disarmament was a reality, there would be little political support in the United States for spending hundreds of billions of dollars on exotic space lasers designed to shoot down weapons that were being eliminated anyhow. Gorbachev should have tried to understand why Reagan was so angry: SDI was Reagan's baby, Reagan's pride was at stake, and therefore Reagan was the one who was overvaluing it. Gorbachev should also have realized that Reagan meant what he said about sharing the technology, that on this point, as on the space shield itself, Reagan was willing to brave ridicule and the weight of expert opinion.

All this is, admittedly, a little moot. Once Gorbachev decided to forgo rule by terror, the arms race was going to melt away no matter what anyone else did. The peace that reigns between the United States and the Soviet Union is obviously more of Gorbachev's making than of Reagan's, whereas Reagan alone is responsible for a domestic legacy that includes, besides a wonderful revival of the American Spirit, a soul-crushing national debt, an ignoble Supreme Court, stark economic stratification, mounting racial fear, the impoverishment of public institutions, and a make-my-day brand of social discourse that revels in ugly contempt for losers. Yet none of that (except the debt) is a surprise. We—those of us who voted against him—knew he was going to be that way from the start.

Reagan was the plaything of whichever of his aides most deftly pushed his hot buttons, but on the nuclear question he lurched into

leadership—and that was a surprise. The same ignorance that made him a pawn in the struggles among his advisers also made him a savant—an idiot savant, to be sure—in the surreal universe of nuclear strategy. He may not have known which end of the missile has the warhead on it, but he was an expert on the end of the world.

It was Reagan's genius to paste a smiley-face on Armageddon's grinning skull. It turned out he didn't view the biblical account of Armageddon as a prophecy of something inevitable, let alone desirable. He viewed it as a sci-fi story, a cautionary tale about a big awful disaster that could and should be prevented. This is a misreading of the text of the Book of Revelation, but Hollywood always rewrites the classics. Too many downbeat endings.

And how was Armageddon to be prevented—or, rather, who was to prevent it? Something McFarlane observed about Reagan is instructive on this point. "He sees himself as a romantic, heroic figure who believes in the power of a hero to overcome even Armageddon," McFarlane told Cannon. "I think it may come from Hollywood. Wherever it came from, he believes that the power of a person and an idea could change the outcome of something even as terrible as Armageddon. . . . He didn't see himself as God, but he saw himself as a heroic figure on earth." Not as God, but maybe as God's sidekick.

Perhaps, in true Hollywood style, there will be a sequel. The happy ending was not the only unusual feature of our hero's interpretation of the tale of Armageddon. "As Reagan understood the story," Cannon notes, deadpan, "Russia would be defeated by an acclaimed leader of the West who would be revealed as the Antichrist." Residents of Pacific Palisades, beware of strange weather things. What rough and chuckling beast, its hour come round at last, slouches toward Beverly Hills to be born?

After Memory

LEON WIESELTIER

May 3, 1993

One of the unusual features of the modern New Republic *has been the depth of its writing about Judaism. That is the handiwork of literary editor Leon Wieseltier, with his scholarly intimacy with Jewish history, theology, and a sprawling, almost comprehensive, set of Jewish texts. But his gift as an editor has been to take this particular knowledge and to universalize its teachings, to carefully work it over and, in his own writings, elevate it to philosophy.*

Dear God, let us exchange our memories—
I will recall the beginning, you will remember the end.

—A. SUTZKEVER

I.

Once upon a time the past was the danger. It stifled, with all its dictates and demands, all its presumptions upon the present; and so it came to be identified as a "burden" that had to be resisted. We are still living in the culture of that resistance. The instruments of resistance to the "burden" were many. There were

fantasies of the past's destruction, which became plans, which became revolutions. (Which became the past, which inspired fantasies of the past's destruction, which became plans, which became revolutions.) Perhaps the unlikeliest method of beating back the past, however, was the study of history. The critical scrutiny of sacred texts that began in earnest in the seventeenth century and flourished in the nineteenth century taught a powerful lesson: that knowledge is a form of mastery. Objectivity, the principled dissociation from one's circumstances that history took from the sciences, seemed to give the knower power over the known; or at least it stole from the past some of the mystery to which it owed its authority. The detachment that originated as an ideal of science was swiftly promoted into an ideal of life. And so for a while the terror went out of the past.

But almost immediately the costs of detachment were plain. The shiny, secular, unhaunted contemporaneity that was to have remained in the wake of "the burden of the past" turned out not to inspire or to incite in quite the strenuous old way. And the deposing of the sacred in the name of history ended in the sacralization of history. History became God, the nineteenth and twentieth century's paltry contribution to the ranks of the divine; but this was a God that did not address, that could not be addressed, that was trapped in time, that never intervened except as "development," that seemed to justify any conceivable human outcome. Historical awareness became merely a modern kind of dogma; and the scholarly study of history came to seem like a desiccating activity, a means for depleting the primal energies of individuals and peoples. History seemed to lack the vitality of memory. Historiography seemed unable to nourish, to transmit the traditions that it studied to the generations that awaited them. Suddenly the past was not the danger, the past was itself in danger. And the "burden of the past" was not the problem; the real problem was the burden of the burden

of the past: the dourness and the duress of the historical attitude, the sense that all that remains for the heirs of the past is to recover and to record, to be grateful and custodial.

And so there arose, in reaction to the transports of historical consciousness, the modern romance of memory. Memory would battle history, for the prize of a living past. Of course, this was ironic, insofar as historiography had developed precisely as a response to the inadequacies of annals and chronicles based substantially on memory, or as a response to the fear that memories were being lost. The modern discovery of memory as a superior avenue of access to the past was made first in philosophy and literature and psychology, in Bergson and Proust and Freud, and came later to professional historians; but in recent decades it has thrown the historians, too, into a condition of crisis. Pierre Nora has nicely described the contradiction between memory and history:

Memory is life, borne by living societies founded in its name. It remains in permanent evolution, open to the dialectic of remembering and forgetting, unconscious of its successive deformations, vulnerable to manipulation and appropriation, susceptible to being long dormant and periodically revived. History, on the other hand, is the reconstruction, always problematic and incomplete, of what is no longer. Memory is a perpetually actual phenomenon, a bond tying us to the eternal present; history is a representation of the past. Memory, insofar as it is affective and magical only accommodates those facts that suit it. . . . History calls for analysis and criticism. . . . Memory takes root in the concrete, in spaces, gestures, images and objects; history binds itself strictly to temporal continuities, to progressions and relations between things. Memory is absolute, while history can only conceive the relative. At the heart of history is a critical discourse that is antithetical to spontaneous memory. History

is perpetually suspicious of memory, and its true mission is to suppress and destroy it.

Nora is a historian who takes the side of memory. It is, as I say, a romantic view, even an elegiac one, which longs for organic communities with seamless traditions that retain their meanings in practices and settings that sufficiently approximate the original practices and the original settings to make genuine continuity possible. There is a mystical quality to such a view of memory. About collective memory, certainly, there will always be a mystical quality, since it consists in the unaccountable capacity to remember—not to know, but to remember—things that happened to others. The Jews in particular pioneered these refreshing abolitions of time and space: it may be said that memory, in its ritual and legal and liturgical expressions, protected the Jews from history. (And from historiography, too: it was not until the spectacular dislocations of the sixteenth century that the Jewish obsession with the past issued in a methodologically strict and secularizing study of it.) A generation ago the Jew was the alienated one. Now the Jew is the one who remembers. Thus Nora, in a typical simplification: "In [the Jewish] tradition, which has no other history than its own memory, to be Jewish is to remember that one is such." Of course, there is something brackish and circular (and historically incorrect) about such a characterization of Jewish identity; but the contemporary prestige of memory appears to carry all before it. In the view of many historians and critics, it was the interference with memory, by means of the critical study of history and the reform of the ritual and liturgical carriers of memory, that left modern Judaism with a rupture that has not yet healed.

The contest between memory and history becomes acute, even excruciating, when the subject of the backward look is catastrophe. One of

the many ways in which the Nazi war against the Jews was unprece-
dented was that it occurred in the age of historical consciousness. The
savage assaults on the Jewish communities in Ashkenaz, or the Rhine-
land, during the Crusades of 1096 and 1146 were the first significant
attempt (there was a similar attempt at extermination in Visigothic
Spain, about which little is known) to wipe out an entire Jewry physi-
cally; yet the Ashkenazic literature in the wake of the atrocities is stun-
ning for its reticence about the events. Liturgical lamentations were
written, and chronicles of the events were produced that were probably
also intended for liturgical use; but otherwise Jewish literature in the
aftermath of the trauma is remarkable for the absence from it of any
extended expression of a documentary impulse.

The atrocities of 1933-45, by contrast, were perpetrated in a
culture that was drenched in historicity. Indeed, the killers them-
selves, animated by a philosophy of history, had a pathologically
documentary mentality; they left a great deal of paper and film.
(The killers' films of the killings, some of which may be seen at the
United States Holocaust Memorial Museum in Washington, are a
rape of the eye.) And lying in wait for the historical consciousness of
the killers was the historical consciousness of the survivors and the
scholars. They proceeded swiftly to produce a body of evidence of
the genocide that is staggering in its size and its sophistication. The
historiography of the Holocaust was an act of intellectual heroism,
not least because it was the intention of the Nazis to make precisely
such a historiography impossible. They weirdly believed that they
could cover the traces of their crime, that the evidence of the death
of the Jews would die with the Jews. "Among ourselves it should be
mentioned quite frankly," Himmler told a group of S.S. officials in
Poznan in 1943,

> and yet we will never speak of it publicly. . . . Most of you must
> know what it means when a hundred corpses are lying side by

side or five hundred or a thousand. To have stuck it out and at the same time—apart from exceptions caused by human weakness—to have remained decent men, that is what has made us hard. This is a page of glory in our history, which has never been written and is never to be written.

But some of Himmler's victims were, in their way, also hard. The historiographical labor was begun by the victims themselves, in the Warsaw Ghetto and elsewhere. The page was written, though not quite as Himmler would have written it. In the war between History and history, history won.

In assembling the record of the Nazi war against the Jews, moreover, history and memory worked together. The survivors brought precise pain and the scholars brought painful precision. Without betraying its own methods, history approached memory's proximity to its subject. It was, in Nora's admiring term, "concrete." To be sure, the rise of "Holocaust Studies" and its professionalization has had a certain anesthetizing effect; the chat of these experts can chill your bones. (In the historian of evil, however, intellectual poise is a spiritual accomplishment.) Yet soon the survivors will be gone, and only the scholars will remain. It is no longer true, as the ancient Indian saying has it, that an event lives only as long as the last person who remembers it; the historians have stalled oblivion. Still, it will not be long before we find ourselves in a more customary, more distant, more mediated, more indirect relationship to the Holocaust.

Will we mourn the loss of memory? Will the loss of memory mean the loss of the past? "We speak so much of memory," Nora writes ruefully, "because there is so little of it." Well, yes; the elders die. The slippage of immediacy is inevitable. (For the survivors of the catastrophe, of course, this slippage is an easing, a passing into

peace.) Not least for this reason, we had better be careful about the idealization of memory, and the disparagement of the historical attitude.

But there are other reasons, too. Remembering is the twin of forgetting. Memory is not retention, it is selection. (Memory is precisely what a computer does *not* have.) The memory of an event is an interpretation of an event; and the interpretation may be beautiful, or moving, or necessary for a certain end, but it leaves the mind with work to be done. The traffic between memory and history is a traffic between magic and doubt. Without magic, there is no continuity; without doubt, there is no contemporaneity. Traditions decay or disappear if they are not remembered, but they do not flourish in the hands of those who live in the past. And memory, too, may cloud or clog one's view of one's time. Even when it is true, memory is demagogic. It compels; but the world is not suffering from too little compulsion. And so the brake of history is not a bad thing.

And sometimes memory alienates more powerfully than history or rather, it is too inalienable to be of any use. Memory is not always, or only, an instrument of knowledge: it is also a confinement, an irreversible sentence of individuation. Listen to a survivor, say, at a kitchen table in Brooklyn recall her experiences of Poland, 1943. If you grasp the meaning, you will grasp the distance. You are being addressed across a gulf, through a thick wall of glass, from the farthest corner of a banished heart. You listen carefully, but an approximation of her experience is the best you can hope for. And the love that you feel for this woman makes the sense of impassability even harder to bear. You begin to understand that there are situations in which memory is not a privilege, in which history is preferable to memory: if history is your only source of knowledge about the darkness, then you are one of the lucky ones. You look at this woman in the work of recollection and you no longer remark on the beauty of memory, or on its utility for the perpetuation of the

knowledge of the disaster, you wish only that memory would falter and die, and you bless the moments of forgetfulness and all the divagations of ordinary life after the end of the world.

Memory, in sum, is not only authentic, and radiant, and poetic. It is also hurtful, and fragile ("Who, after all," asked Hitler, "speaks today of the annihilation of the Armenians?"), and, in a strict sense, untransmittable. Therefore it needs the fortifyings of history: the corrections, the comparisons, the conclusions. (Memory is color, history is line.) The first of the many accomplishments of the United States Holocaust Memorial Museum, which opens this week on the Mall in Washington, is the paradox of its name: a memorial museum, a house of memory *and* history. Here the vividness of recollection joins the sturdiness of research. The stinging subjectivity of the testimonies of the survivors is met in these galleries by the tart objectivity of photographs, films, maps, statistics and objects.

In the creation of a memorial, moreover, there is another reason that memory must be accompanied by history, and feeling must be annotated by fact; and that is the fickleness of memorials themselves. These things shed their meanings with almost cynical alacrity. The public spaces of modern cities are littered with figures and markers that are more or less illegible. Their opacity is itself a kind of release from the particulars of the past. Instead of history, they give a warm sensation of historicity. They say only: once there was someone who wanted something remembered here. Before these figures and markers nobody any longer stops, or thinks, or shudders. They are bulwarks against thought, devices for the prevention of any intrusion of the past into the present. "There is nothing in this world as invisible as a monument," wrote Robert Musil. "They are no doubt erected to be seen—indeed, to attract attention. But at the same time they are impregnated with something that repels attention, causing the glance to roll right off, like water droplets off an oilcloth, without even pausing for a moment. . . . This can no

doubt be explained. Anything that endures over time sacrifices its ability to make an impression. Anything that constitutes the walls of our life, the backdrop of our consciousness, so to speak, forfeits its capacity to play a role in that consciousness."

The proliferation of Holocaust memorials in the United States poses the problem starkly. The banality of the memory of evil, you might call it. According to James E. Young, in an interesting survey of Holocaust memorials called *The Texture of Memory*, just published by Yale University Press, "Today, nearly every major American city is home to at least one, and often several, memorials commemorating aspects of the Holocaust." This is affecting, and this is revolting. It certainly makes the fear that the Holocaust will be forgotten seem faintly ridiculous. And worse, it ensures that if the Holocaust is forgotten, or if it is pushed to the peripheries of consciousness and culture, then it will be partly owing to the memorials themselves, which will have made the horror familiar and thereby robbed it of its power to shock and to disrupt. Of the memorial in Tucson, Young writes that "the monument now functions as the architectural entryway visitors pass through on their way into a stunning complex of auditoriums, cavernous gymnasiums, weight rooms, swimming pools and tennis courts. Built as it is into the wall and the plaza, the memorial houses and thus lends a certain cast to all the activities that take place in the center." The Raoul Wallenberg Tennis Classic?

Remembering saves; but it also salves. Too little memory dishonors the catastrophe; but so does too much memory. In the contemplation of the death camps, we must be strangers; and if we are not strangers, if the names of the killers and the places of the killing and the numbers of the killed fall easily from our tongues, then we are not remembering to remember, but remembering to forget. Of course, the banalization of the memory serves many purposes. It suits the poverty of American

Jewishness. "It's a sad fact," said the principal philanthropist of the grotesque Simon Wiesenthal Center in Los Angeles, "that Israel and Jewish education and all the other familiar buzz-words no longer seem to rally Jews behind the community. The Holocaust, though, works every time." His candor was refreshing, even if it was obscene. On the subject of the extermination of the Jews of Europe, the Jews of America are altogether too noisy. They need the subject too much. Those Jews of the Rhineland in the twelfth and thirteenth centuries who omitted their experience of atrocity from so many of their liturgical verses and legal rulings and pietistic sermons and mystical speculations had not forgotten it. Indeed, they were, in their commemorations of their martyrs, the inventors of Jewish morbidity in the Diaspora. But their Jewishness was too great for their morbidity to overwhelm.

Between 14th Street and 15th Street in Washington, the memorial will be saved from the fate of memorials by the museum, and the museum will be saved from the fate of museums by the memorial. The designers of this institution have made a provision for shock. One of the achievements of the Holocaust Memorial Museum is that it leads its visitors directly from history to silence. Its exhibition ends in a Hall of Remembrance, a six-sided, classically proportioned chamber of limestone, a chaste vacancy, seventy feet high, unencumbered by iconography, washed in a kind of halting light, in a light that seems anxious about its own appropriateness. There are steps all around the cold marble floor that will most likely serve as seats. The least that you can do, after seeing what you have just seen, is sit down and be still.

The Hall of Remembrance is a temple of ineffability. This, then, is the plot, the historical and spiritual sequence got right, of the infernal display on the Mall: memory, stiffened by history, then struck dumb.

II.

The museum is a pedagogical masterpiece. It begins at the beginning and it ends at the end. It illustrates the sufferings of all who suffered. It resists the rhetoric about *Shoah v'Gvurah*, Holocaust and Heroism, as if there was as much heroism as there was holocaust. It does not prettify or protect the visitor from the worst. (Nazi footage of killings in the pits, and of medical experiments in the camps, is shown on monitors behind walls that are too high for children to see over. Adults may wish that the walls were higher still.) And it does not conclude its narrative in triumph. There was no triumph, at least for the Jews. There was a narrow escape, that is all. The Nazis did not win their war against the Jews. But they did not lose it, either.

The building itself teaches. It seems to have been distilled, but not abstracted, from its subject. Its principal materials are brick and steel and brick bolted with steel. The exhibits are located in eight towers, each topped by a kind of sentry box, which surround a huge atrium, into which you enter. The impression is elegant and oppressive. The industrial atmosphere is ominous. This is an atrium without air; it holds the opposite of air, the end of air. A staircase that looks like a railroad track rises into a wall of black marble, into which a doorway has been cut and set in brick in the shape of the entrance to Birkenau, which was the killing center at Auschwitz. The skylight, too, puts you in mind of a train station, until you begin to notice that this gigantic frame of steel is warped, twisted, a derangement of rational design. Above the skylight, from one of the glass bridges that connect the towers, the deformity is truly terrifying. The building seems to be held together by what is tearing it apart. Like survivors; like Jews.

A large part of the instruction that this museum imparts is tactile. Alongside the maps and the charts and the films and the photo-

graphs, there are the objects, the stuff, the things of the persecutions and the murders. The museum is a kind of reliquary. The relics are sacred and profane; and while there are things in the world more sacred, there surely are none more profane. Here is the blackened metal chassis on which corpses were burned at Mauthausen when the ovens were too full to receive them, and here are the canisters and the crystals of Zyklon-B gas. Here is a pile of umbrellas and tea strainers and can openers and toothbrushes that Jews brought to Auschwitz. Here is the wooden frame of the ark that held the Torah scrolls in the synagogue at Essen, stabbed and scratched and scarred across the words that warned the worshiper to remember before Whom he stood, provoking now an almost Christian desire to touch the wound. Here is a madly detailed model of the Lodz Ghetto sculpted out of a suitcase by a Jew in hiding. Here is what remains of a Mauser rifle and a Steyr pistol used by Jewish fighters in the Warsaw Ghetto. Here is a Danish fishing boat that carried hundreds of Jews to safety. (Here you smile. It is the only spot in the building where you do.)

Perhaps the most startling passage in Claude Lanzmann's *Shoah* was its reconstruction of the trajectory of a killing van in Chelmno, because it was filmed in real time: nothing was abridged or abbreviated, the van was filmed along the local roads for exactly as long as it would have taken for the gas in the van to kill the people inside it. In the Holocaust Memorial Museum, there is real space. Here is a railway car, of the Karlsruhe kind, number 31599-G, and in this railway car Jews were carried to the death camps. The freight car weighs fifteen tons; its ceiling is mean and low, with four small slatted windows and iron bolts on its doors. It carried about a hundred Jews every time it traveled. Now, in the semidarkness of an exhibition hall in America, you stand inside it, and are defeated. Its wooden walls are thoroughly scratched and splintered, and to every scratch and splinter you ascribe a panicked hand. Though

it is empty, it feels crowded and cramped. You wish that you could smell a human smell, but there is only the smell of old wood, and a general stench of technocratic efficiency. It occurs to you that you are standing in a coffin. It also occurs to you that there are survivors visiting this museum who may find themselves in this coffin for the second time.

And here are barracks from Auschwitz. More real space. More old wood. The living quarters of the dying. The prisoners slept, whatever that means, six in a row, on three levels. You realize, looking at these structures, that they may have given respite, but they never gave rest. The wood is hard, and unexpectedly smooth to the touch; it appears to have been polished by all the flesh that passed over it. There is no room to sit up or to stretch out. Here men, or what was left of men, were merely stored in rows for the night. You try to imagine the desolation of returning in the evening to these planks. And you keep running your hands over them, because their materiality wakens you. It reminds you that all this dying was lived.

But lived by whom? The conventional answer is: by Jews, Gypsies, homosexuals, Communists, Jehovah's Witnesses and so on. But those appellations describe groups, not individuals; and when, in the remembrance of the catastrophe, the victims are seen as individuals, it is usually in the period between the completion of their life and the completion of their death, in the purgatory between the camp and the oven, as starved, naked, shaved, numbered, emaciated men and women whose physical extremity, and its fearful inscription in their faces, makes you stop before the photographs and consider them one by one. By that time, however, these people were already gone; they were just not yet dead. The victims of the Holocaust are known too much by the manner of their death.

In the museum on the Mall, however, there is a tower of photographs, three stories high. They are photographs of the Jews of

Ejszyszki, a town in Lithuania. Jews lived in Ejszyszki for 900 years, until 1941, when the Jewish community of Ejszyszki was shot to death in two days. (There were more than 4,950 cities, towns, villages, and hamlets in which the Nazis and their Polish, Ukrainian, Latvian, Lithuanian, Estonian, Slovakian, Hungarian, and Croatian accomplices destroyed the Jewish population.) In the years before the war, four local photographers set out to produce a pictorial record of the Jews of Ejszyszki; and now their pictures rise high into the tranquil brick tower, rows and rows of them, all around you, in black and white and sepia, and finally you see *who died*.

There are gymnasts and teachers and merchants and rabbis and nannies and writers and carpenters. There are preening male bathers by the sea; humorless Zionist activists of the right and the left; families in gloomy, paneled interiors, gathered around tables heavy with cutlery and cakes; cantors, looking silly in the cantorial way, assembled for their graduation; a girl and a boy lazing on a hammock in the woods; a rabbi in wrinkled gabardine strolling up a hill, his hands behind his back and his text in his hand; a man in a Mickey Mouse suit on bended knee before a slightly startled girl in a park; a group of young women smartly turned out to ski; a father propping his son up on his shiny new car.

One picture crushed me. A girl sits, her legs crossed, on a sofa. She wears a woolen cap and a plaid shirt and a long skirt pulled tightly over her thighs and (in Ejszyszki!) cowboy boots. She is in her teens. In her hand is a cigarette. On the wall above her hangs a picture of a dashing, medieval-looking cavalier. And close to her, very close to her, sits a young man in a rocking chair. He looks nothing like the cavalier. He seems a little bookish, in glasses and jacket and tie. She bends toward him confidently and confidently he lights her cigarette. They do not look like they are lovers, though they might be lovers. They do not look like they are going to die, though they are going to die.

That is what is missing from so many accounts of the end of Jewish life in Europe: the eros of Jewish life in Europe before the end. These slaughtered Jews loved the world. They were at home in it, exile or no exile. The melancholy in the tradition that they inherited seems not to have sapped them. Their piety and their impiety were equally robust. Around the thousands of people in these hundreds of photographs there is not a trace of the angel of death. Only the contemporary viewer sees it hovering, impatiently, in every frame. And for that reason there is no room in this great and grisly building that you visit more bitterly. In the other rooms, the ones that show death, you learn the lesson of finality. In this room, the one that shows life, you learn the lesson of perishability. I am not sure which lesson is the harder one. How do you choose between sorrow and fear?

III.

In the weeks leading up to the opening of the Holocaust Memorial Museum in Washington, Germany was nervous. According to Marc Fisher in *The Washington Post*, the German government offered the museum "millions of dollars" to include an exhibit on postwar Germany and its decades of democracy. The government's press spokesman immediately denied that such an offer was made, but he added that "the federal government would have welcomed it if the museum had included information on German resistance to National Socialism [it does] as well as on the successful construction of a state based on the rule of law and of a liberal democracy in postwar Germany." A historian in Munich who acts as an informal adviser to Helmut Kohl observed that "it would have been good for educational reasons to show that Germany has changed since 1945. It was a mistake for the museum not to include other cases of genocide." A writer in the *Frankfurter Allgemeine Zeitung* observed that the museum's emphasis on gas chambers and death camps "has less

to do with the German past than with the American present"; and the paper's Washington correspondent wondered whether "half a century after war's end it is advisable to lead millions of visitors through a museum that ends in 1945 and thereby may leave the lasting impression [that] these are the Germans and this is Germany."

There is something comic about the Germans asking the Jews to help them with the image of what the Germans did to the Jews. Finally, though, the comedy is thin. This complaint, that a true depiction of the German war against the Jews is an expression of hostility to Germany, has been heard before. When *Shoah* appeared, it was attacked for its uncomplicated attitude toward the killers, for its unembarrassed hatred of the Germans it filmed. Now, in the dark halls of the museum on the Mall, as you file by these pictures of German doctors in their laboratory coats posing over their fascinating corpses, and German soldiers politely escorting women into the woods, and German officers smiling as they put a bullet into the head of a Jew perched at the edge of a pit, the problem of hatred will be posed again. And so I would like to say a few things in defense of hatred.

First, that hatred is not always the enemy of, or the obstacle to, understanding. Sometimes, and certainly in the instance of radical evil, hatred may be evidence that a state of affairs has been properly understood. I will give, as an example, the report of an atrocity that broached this problem for me many years ago. When I was a boy, I was told of a Nazi satrap in Galicia, in Poland, in the early 1940s, who picked up a Jewish baby by its legs and tore it apart. My sense of the world has not yet recovered from that anecdote. I remember vividly my response. It was hatred: hatred of the man, hatred of the deed, hatred of the circumstances in which the deed could have been committed.

I was, as I say, a boy; but when I reflect now upon that man, and that deed, and those circumstances, I do not conclude that my hatred was something that I must overcome, for the purpose of a more accurate or a more humane analysis. Quite the contrary. Were I not to hate that man, and that deed, and those circumstances, or were I left in confusion about whether or not I should hate them, there would be reason to wonder whether I had understood what I had been told, I mean the plain meaning of the story, or worse, whether I had understood what we mean by understanding, that is, the axioms by which our civilization orders and evaluates human experience. There would have been reason to wonder, in short, whether I was what we call a moral idiot.

That epithet quite properly links judgment to intelligence. Not to recognize moral idiocy, however, is itself a form of moral idiocy. If, by hatred, we mean an attitude of condemnation accompanied by an intensity of feeling, then the absence of hatred in the face of radical evil would not have understood them. The relations between knowing and judging are complicated; the empirical and the moral cannot be easily disentangled. It is not always true that *tout comprendre c'est tout pardonner*. Comprehension does not always lead to forgiveness. In certain cases, indeed, forgiveness may signify the absence of comprehension. The hatred of the Jew for the Nazi was not just a feeling, it was the emotional expression of a correct analysis of the position of the Jew in the Nazi world.

Nor is all hatred like all other hatred. There is, I suppose, a similarity of the surface—a man who hates is more like a man who hates than a man who loves—just as there is a similarity of the surface between the Nazi who killed a Jew and the Jew who killed a Nazi. They were, both of them, killers. But distinctions must be made. There was a difference between the hatred of the Nazi for the Jew and the hatred of the Jew for the Nazi. The Nazi hated the Jew because he believed that the Jew was not human. The Jew hated

the Nazi because he believed that the Nazi was human, but had betrayed his humanity. The Jewish hatred, Lanzmann's hatred, the hatred that you feel in this museum before, say, the German film of the massacre at Libau in Lithuania, is premised finally on the assumption of a commonality between the oppressed and the oppressor, and it amounts to a defense of that commonality against those who would deny it.

There were also decent and brave Germans who tried to resist the Nazis and to assist the Jews. The failure to acknowledge and to honor those Germans amounts to a notion of collective guilt, which is a very Nazi notion. Contrary to its German critics, the Holocaust Memorial Museum acknowledges the German heroes and honors them. In this respect, moreover, Lanzmann's critics were right: it *was* disgraceful that none of the dissenters and the rescuers appeared in his film. But, I hasten to add, it was only a little disgraceful. There is the matter of proportions. The few, however admirable, were not the equal, or the exoneration, of the many. The historical truth is brutal. It may be simplistic, but it is not false, to describe these events in Europe between 1933 and 1945 as an attempt by a people called the Germans to destroy a people called the Jews. The assault on the Jews was, actively and passively, a collective assault. It is a distortion of the past to deny the dissenters and the rescuers a place in the history of the catastrophe; but it is also a distortion to give them a pride of place.

There is more. Just as hatred is not necessarily an intellectual failure, it is not necessarily a moral failure. In the debate about *Shoah*, it was suggested that Lanzmann's hatred of the evildoers made him resemble them. He, too, it was said, was making absolute distinctions between human beings. As one of the critics wrote, "If one sees no resemblance between self and other, and believes all evil to be in the other and none in oneself, one is (tragically) condemned to imitating one's enemy. If, on the other hand, one discovers one's

resemblance to the enemy, and recognizes the evil in oneself as well as the good in the other, then one is truly different from the enemy." There is nobility in these words, and perversity: the executed had about as much in common with the executioners as the dead had in common with the living.

It is odd, this worry about the virtue of the victims. ("It would have been more fair and more open," wrote the historian from Munich about the museum in Washington, "to show that Jews care about other acts of genocide.") I wonder how many of those who preach this loftiness about the evil in all of us have considered the extent to which it would damage the capacity for resistance to evil. What, exactly, does the evil of another time or another place have to do with the evil of this time and this place, except to inhibit the fight against it? Can devils be opposed only by saints? The conclusion of such reasoning is *fiat justitia pereant Judeii*: let justice be done and the Jews perish. In 1943 such reasoning led Simone Weil to the outrageous insistence that France's colonies robbed it of the moral authority to fight Germany. Surely the difference between the man who points the gun and the man at whom the gun is pointed is greater, at least at the moment of their encounter, than the similarity between them. It is trivial at any moment, and it is grotesque at that moment, to point out that one day the relation may be reversed because there is evil in all of us. Of course there is evil in all of us; but not all of us act on our evil.

On April 13, 1943, in the Warsaw Ghetto, Emanuel Ringelblum entered these words in his diary:

Spent the two Passover nights at Schachna's. There was an interesting discussion about vengeance. Mr. Isaac, who had been interned in a prison camp in Pomerania, demonstrated that vengeance would never solve anything. The vanquished would in turn plan their own vengeance, and so it would go on forever.

There was talk that raising the moral level of humanity was the
only solution.

Mr. Isaac's idealism is heartbreaking. But Ringelblum was skep-
tical. His gloss on the discussion at the seder introduces a differ-
ent moral voice. "The Jewish revenge [is] that the Jews are very
forgiving. The Germans are only people after all"—and then he
adds, "except for the Gestapo!" Do those final four words diminish
Ringelblum ethically? Do they catch him in a resemblance to his
enemy? I do not think so. For the Gestapo were not "only people."
His exclusion of them from his sense of humanity indicated only
that he had understood them properly.

It also allowed him to act against them. If knowing did not run
into judging, if critical thought did not make way for moral action,
then the triumph of the Nazis over the Jews would have been total.
But Ringelblum became one of the organizers of the revolt in the
Warsaw Ghetto, which took place ten days later. And on March 7,
1944, he was executed, with his wife and his son, in the ruins of the
ghetto. The Holocaust Memorial Museum opened in Washington
on the fiftieth anniversary of the Warsaw Ghetto revolt, and the
milk can that hid Ringelblum's archive of the ghetto may be found
on the second floor. For its faithfulness, its color of rust has turned
a color of gold.

IV.

But why this museum, and this memorial, on the Mall?

The question is not a new one. In 1946, A. R. Lerner, a Vien-
nese journalist who fled the Nazis and came to New York, where he
tirelessly spread the news of what the Nazis had done to the Jews,
proposed that a monument to the "Heroes of the Warsaw Ghetto
and the Six Million Jews Slain by the Nazis" be established in New
York. Mayor O'Dwyer and Parks Commissioner Moses agreed,

and the sculptor Jo Davidson chose a spot in Riverside Park. (I take this tale from Young's book.) On October 10, 1947, thousands of people came to Riverside Park to dedicate the site. *The New York Times* wrote the following day that "it is fitting that a memorial to 6 million victims of the most tragic mass crime in history, the Nazi genocide of Jews, should rise in this land of liberty." But the monument was never raised, not least because the opinion of the *Times* was not shared by everyone. In 1964, when a design for the monument was submitted to the city's Arts Commission, one of the commissioners, the sculptor Eleanor Platt, declared that it would "set a highly regrettable precedent. How would we answer other special groups who want to be similarly represented on public land?" And Newbold Morris, the city's parks commissioner, further objected that "monuments in the parks should be limited to events of American history."

The proposal to create a museum and a memorial to the Holocaust on the Mall in Washington, on the hallowed ground of the American republic, was similarly controversial. In 1987 the architecture critic of *The Washington Post*, in a churlish column called "In Search of a Delicate Balance," repeated Morris's objection, and worried about "the symbolic implications of the memorial's placement—that the Nazi extermination of 6 million Jews [could be considered] an integral part of the American story." Of course, nobody ever suggested that the Holocaust was an event in American history. What the delicate balancer seems to have forgotten, however, is that this is a country of immigrants. The past of America is elsewhere. (Here the past *is* a foreign country.) The collective memory of this country will always include names and dates foreign and far away. Pluralism makes demands on the imagination.

And yet the objection is not hard to understand. This is a tolerant country, but it is not an innocent country. It is permanently stained with the fate of the Native Americans and the African Americans;

and neither the memories nor the histories of those wretched Americans may be met on the Mall. And there are still other genocides that haunt still other Americans—the Armenians, for example— that are unacknowledged. (A home to all the peoples of the world is a home to all the scars of the world.) For a time there was talk of a separate wing in the Holocaust Memorial Museum that would document and commemorate all the catastrophes, but the wing was never built.

It is now clear that a Hall of Genocide would have been a ghastly mistake, a macabre multiculturalist insult to the memories of all. For the most lasting impression that the Holocaust Memorial Museum leaves is of human foulness. This building interferes not only with your opinion of Germany, or Europe, or Western civilization; it interferes with your opinion of the human world. A Jew who wanders through these galleries feels pity for his people turn into pity for his race. There occurs a general darkening of outlook. For there is a sickening sense in which a corpse is a human being that has been returned to its sheerest humanity; there is something truly universal about a corpse. Anybody who looks at these images of corpses and sees only images of Jews has a grave moral problem.

It is true, as Jewish historians and theologians have argued, that the Holocaust was in some way "unique"; but it was in no way so "unique" that it does not press upon the souls of all who learn of it. The story of the life and the death of the Jews in Europe is one of the great human stories (which, by the way, is also one of the reasons that Jews should study it). I am not sure that the memory of that story, or the history of it, will suffice to stay the hand of the malicious and the murderous, or that a museum and a memorial will stand much in the way of prejudice and its appetite for power. The world fifty years later does not seem especially restrained by the

world fifty years before. Still, it is not just Jews who will be warned by what they see in this building on the Mall. All are warned. Here is the precedent. Just because it was the worst does not mean that it will be the last.

And so it is right that the first thing you notice, when you leave the Hall of Remembrance, is the figure of Thomas Jefferson. Across the calming waters of the Tidal Basin he presides perdurably over his own memorial, an architect of the only political system in the history of the world that made men free without thinking too highly of them. You think, in the light of what you have just seen, that it was no small achievement to found a democracy upon a pessimistic view of human nature. And you think, in the light of what you have just seen, that it was just as well.

Beyond Words

Fouad Ajami

August 7, 1995

The magazine made the case for military intervention in the Balkans, persistently and passionately. It was a model of activist journalism, demonstrating how to step on the soapbox without turning into a bore. It didn't hurt that the case was made by the likes of Samantha Power, who got her journalistic start with pieces on Bosnia, as well as the scholar Fouad Ajami. These articles helped shape the template for liberal hawkishness, a doctrine of humanitarian interventionism that aspired to enshrine the post-Holocaust admonition of Never Again. But the success of the Balkans did nothing to set a precedent. When we devoted a special issue to the crisis in Darfur, Leon Wieseltier wrote an editorial that began: "Never again? What nonsense. Again and again is more like it."

"It's beyond words," a man of Tuzla said of the refugees who have been herded out of Srebrenica. "These people have lived through an unbelievable terror. Something completely evil happened in Srebrenica." That is where we are, beyond words, where every good and urgent thing has been said and has scattered into the wind and been trampled by the killers and knights of Greater Serbia. There, amid those columns of misery on the road out of Srebrenica, lies

the promise of American primacy and benevolent power, which in Bill Clinton's hands had turned into a tarnished and uncertain inheritance.

We shall, of course, never know for certain whether the callousness toward the people of Bosnia would have been the same had these men and women and children taking to the road not been people of the Muslim faith. In the vast expanses of Islam, the inescapable conclusion has been drawn: the Bosnians have been marked for destruction because of their adherence to Islam. For those who love their civilizational and racial lines straight and unambiguous, the people of Bosnia must be a bit odd. There is a jarring quality to those columns of misery: the head-scarves of the women speak of Islam, the pigmentation and the features are those of Europe. The rituals of grief and bereavement have an Islamic echo to them in a crowd neither decidedly "Eastern" nor wholly European. Ours must be reckoned a terrible time for miscegenation.

We can exonerate the Clinton administration and its Bosnia policy of any civilizational bias or prejudice or religious favor. Ideology of any kind, a moral passion, is alien to this crowd. They are equal opportunity shirkers. Judging by their entire attitude toward America's role in the world, the Clintonites would let down people of any color and creed and faith and national origin. They are a decidedly ecumenical lot.

Though we think of the president and his closest advisers as forever seared and defined by Vietnam, it is another, a far more proximate intervention, that has shaped much of what they have done in Bosnia: the expedition to Somalia. It is the lessons of Mogadishu that the Clinton White House have projected onto the Balkans. Somalia was the poisoned chalice handed the Clintonites by their predecessors, the Bush people, and by Boutros Boutros-Ghali, who was keen to use the cant of multilateralism to hunt down Mohammed Farah Aidid and settle an old account with the Somali warlord

from his time in the Egyptian bureaucracy. The trauma of Somalia happened on Clinton's watch. We had rushed unaware into a place we did not fully understand, into a war of clans and bandits. With the gear we carried on that expedition we carried fantasies about reconstituting a place that had broken beyond repair. When we were rebuffed and exited with nothing to show for the effort, the expedition became a warrant for abdication elsewhere. It would be easy, henceforth, to project Somalia onto other foreign commitments. (Haiti was the exception. But that was a police operation forced on Clinton by a tide of refugees.)

For thirty long, cruel months, the thrust of the Clinton Bosnia policy would be reduced to what truly mattered: damage control. The one thing we would never grant the Bosnians was our candor. The one thing the Clinton people would not do was stand up in broad daylight and assert that, for them, Bosnia was a place of no consequence to America's vital interests. The cavalry was always on the way. We would always promise to be there, with our guns and our war tribunals, after the next massacre. We would lift the arms embargo on the Bosnians if only we could, if only the Europeans and Boutros Boutros-Ghali would permit it. We would unleash the terrifying air power that broke the will of the Iraqis in the Gulf, if only we would be asked to do it. We would roll back the Serbian gains if only that division of authority (the "dual key," in official-speak) between NATO and the United Nations were to be resolved. Genocide is always handled by the next desk.

Power—great political, military and moral power—had passed to these men, but they don't wish to use it. It is odd, this ambition and yearning for power and the reluctance to deploy it. Something Clinton himself said in accepting the Democratic nomination in the summer of 1992 is a fitting description of his own administration. In staking the claim of his generation to power, he ridiculed George Bush's lethargic presidency by quoting Abraham Lincoln's

admonition to General George B. McClellan, the commander of the Army of the Potomac, who was forever refusing to engage the Confederacy: "If you're not going to use your army, may I borrow it?" That is where the Clinton presidency now finds itself. Its Bosnia policy is but an embodiment on cruel display of its general abdication of America's leadership in the world. In Lincoln's words, the bottom is out of this tub.

It is easy to see the method in the mix of abdication and spin that constitutes Clinton's policy toward Bosnia. The words would tire, the Clinton advisers reasoned, the outrage of the critics would be spent, the safe-havens would fall and Bosnia would be consigned to memory, a victim felled by those famed Balkan ghosts that are said to haunt that peninsula: the curse of the place having its way. Now all would be well if the conquest of Bosnia were to be completed before the 1996 campaign kicked in.

There have been endless pretexts and warrants for the American abdication. Most shamefully, we passed off our acquiescence to the Serbian project of conquest as something we owed Russia, an act of deference to the pan-Slavic spirit that was said to be blowing through that land. We fell for this great legend because it suited our needs. There is a Russianist, and a Russophile at that, in the inner circle, Deputy Secretary of State Strobe Talbott. But no Russianist was needed to see through that shameless pretense. Pan-Slavism has never run deep in that presumably mystical Russian soul. It was the calling of a few romantics and priests and literati; the Russian state looked at the pan-Slavic sentiment with cold-blooded disdain and caution. A cursory reading of the Congress of Berlin's diplomacy, which settled the first great Balkan Crisis in 1878, ought to put an end to the legend of Russia's commitment to the Serbs. Alexander II hated Balkan revolutionaries and their ruinous radicalism; St. Petersburg played the game of the Great Powers when the scramble for the Ottoman Empire's European domains had begun.

Serbia got very little of its grandiose ambitions fulfilled; the Serbs had no sponsor among the powers. They had wanted Bosnia; it was ceded to the Habsburgs. They had wanted Novi Pazar, a territory separating Serbia from Montenegro; it, too, was denied them.

We gave currency to the pan-Slavic idea, summoned it from the world of the dead, when it should have been blatantly clear that the Russians were in this enterprise as a way of simple financial blackmail, of squeezing the best for themselves out of the industrial democracies. There was never an explanation why a ruined society on the ropes like Russia, riddled with all kinds of troubles, struggling to keep a political center alive amid plunder and chaos, was owed favors in the Balkans. That our concern for Russia had to be demonstrated by sanctioning genocide in Bosnia carried "Russia-firstism" beyond the call of duty. Were we serious about helping Russia get beyond autocracy and failure and chaos on that road toward political democracy and market reform that we say we want for her, the last thing we would do for Russia would be to indulge the darker, more atavistic part of her temperament. We ought to have given the Russians a choice: the company of outlaws and pariahs or the decent company of nations at peace.

A policy of spin and appeasement with thirty months on its hands gets to be good at playing the game of exculpation. It finds the pretexts and squeezes them as they come. Nor is this policy above seeing hidden victories and accomplishments in the ruins. The Clinton advisers have taken to claiming for the Bosnia policy an amazing defense: whatever its faults and cruel harvest in Bosnia, their policy, they say, has prevented the spread of a wider war in the Balkans. The killing rages in the northern Balkans, but peace (of sorts) reigns in the southern end of the peninsula. Greece, Turkey and Albania, we are told by the Clintonites on the Sunday talk shows, have stayed out of the fight, and all is quiet in Kosovo and in Macedonia between the Slavs and the Albanians. But the trou-

bles in the southern Balkans haven't happened simply because they haven't happened, not because the southern Balkans have been incorporated into our zone of peace or been awed by the display of our might. The Serbs have no interest in a wider war. They have secured the submission of Kosovo and disinherited its Albanian population. Why risk a wider war when you can get what you want with a smaller, less costly enterprise? The warlords of Belgrade and Pale may be cruel, but they will take victories on the cheap when they come their way.

Future chroniclers of this Balkan crisis will puzzle over the disparity of (real) power between Pax Americana at the zenith of its influence in the aftermath of its twin victories in the cold war and in the Persian Gulf and the Serbian revanchists who stepped forth to challenge it and got away with their brazen defiance. They will be at a loss, the historians: they will have to write the history of this Bosnia calamity either as an epic of Serbian bravery or as one long chronicle of a generation's failure to see that there were things that truly mattered in these sad hills and towns of Bosnia.

In one of the best scholarly accounts and histories of the former Yugoslavia, *Bosnia and Hercegovina: A Tradition Betrayed*, historians Robert Donia and John Fine tell us that America's performance in the Gulf War made a deep impression on the Serbs. An analysis and a strategic review by the general staff of the Serb-dominated Yugoslav People's Army, the two historians observe, concluded that Desert Storm was a "true paradigm" for interventions after the cold war but still held out the possibility that the Serbs could pursue their project of conquest without triggering the kind of response that thwarted the Iraqi bid. Grant the warlords of Greater Serbia their due: they read the world as it was. Luck came their way in the Western leaders they drew. Pity the man in his bunker in Baghdad: he must envy the Serbs' exquisite sense of timing. Hitherto there had been a strong element of martyrology and self-pity at the core

of Serbian history, their narrative of their history one long tale of sorrow and denial, material for the folk poets and the singers with their guslas (the one-string musical instruments). In their annals, they must make room now for the great change in their fortunes, for that one long season when they rode out and left a trail of misery and high crimes behind them and were never made to pay a price.

The Griz

Michael Lewis

February 5, 1996

In the pre-Internet era, I would sit by my mailbox, waiting for Michael Lewis's campaign dispatches to arrive. They weren't the deepest pieces of political journalism. But it turned out that the Trail provided Lewis with the nearly perfect set of elements for his Twain-like storytelling—monomaniacal characters with big hearts and a capacity to see through the absurdities thrust upon them. (During that campaign, he was the first Washington journalist to discover and mythologize John McCain's straight-talking jokester persona.) Of his cast of eccentrics, the most memorable was undoubtedly the Griz.

January 11

Within minutes of landing in Des Moines you know that you have arrived in the American Midwest. The Midwest is the straight man of the Western world, millions and millions of square miles peopled with Abbotts without their Costellos. It's not that Midwesterners lack a sense of humor; it's just that they regard humor as second-rate behavior, the opposite of, rather than a complement to, seriousness. It's no wonder that professional Midwestern humorists—Garrison

Keillor, David Letterman—have the feel of men who have spun out of some orbit.

I've come to Iowa to find Morry Taylor, the man who by a landslide won the hearts of the United We Stand delegates at Ross Perot's convention last fall. (After hearing him speak, 400 of the 2,000 people present signed up to work on his campaign.) Taylor has spent his entire life in the Midwest and counts as the only bona fide commercial success story out of the nine candidates in the Republican field. He started out as a tool and die maker, attended Michigan Tech and in the early 1980s, in his mid-40s, after a career selling wheels for farm equipment, began to buy distressed tire and wheel plants and turn them around. Today he is the chief executive of Titan Tire and Wheel International, which finished last year with $620 million in revenues, no debt and one of the highest profit margins of any company listed on the New York Stock Exchange.

The strange thing about Taylor is that he hasn't gotten more play in the press or the polls. He's the real thing: an extremely successful businessman who has behaved about as well as an extremely successful businessman can. He employs 5,500 people—1,200 of them in Des Moines—at a wage rate of $12 to $17 an hour, all of whom are included in a profit-sharing plan. He pays himself a modest salary and argues forcefully and often that CEOs of publicly held corporations should never be paid more than about twenty times the wages of their most menial workers. Actually, that's probably one of the reasons no one has heard of him until now.

January 12

We start our day just before 8:00 inside a motor home plastered all over with Morry's favorite screaming eagle logo—the one his campaign staffers plead with him to abandon. A ferocious-looking bird flies out of the T in Morry's last name, which is painted in huge let-

ters across the side of the colossal machine. Morry's campaign manager tried to talk him out of the expense, but Morry insisted that the best way to start running for president was to buy six RVs—land yachts, they are called—and race them in a convoy across each of Iowa's ninety-nine counties and through every New Hampshire hamlet: six monstrosities all jammed together and churning down the highway at eighty miles per hour, with the Pointer Sisters blaring out of the lead vehicle, drowning out everything but Morry. Morry figured that he'd roll them into a town, surround the courthouse, flip on the loud speakers, tap a few kegs of beer, and everyone for miles would be talking about Morry Taylor for the next two weeks. (He was right.)

Today like every other day Morry is wearing his American flag tie. He's shouting over music and the roar of the land yacht into a telephone at a radio talk-show host. "Anyone who wants to come and help call 1-800-USA-BEAR." The talk-show host asks him some question. "Well," replies Morry, "I use the bear number because my nickname is the Griz."

"Why do they call you the Griz?" I ask, after he hangs up. It seems the natural next question.

"I got that when I took the company public," he shouts. "At the closing they gave me this plaque. It says—and they did it in Latin, which language I can't speak—but this is what it says: IN NORTH AMERICA THERE IS NO KNOWN PREDATOR TO THE GRIZZLY. So I became the Griz. Then I thought about it. Up until that time I kind of liked my other nickname, Attila. 'Cause of Attila the Hun, you know. People think Attila the Hun was a barbarian but he's not. He's the guy who ran the Roman Legion out of town."

Morry then shouts back at Lenny, an extremely resourceful young man whose job is to race around sorting out the chaos that Morry creates wherever he goes in Iowa and New Hampshire.

"Hey piss-boy. Are we in the Connecticut primary?"

There's some shuffling in the back of the land yacht. "I'm not sure," says Lenny.

"I'm on about the same as Dole," says Morry. "Dole and I are on the most ballots." Which is true. Although Morry's strategy is to focus on Iowa and New Hampshire ("If I win Iowa, New Hampshire's mine, too"), the United We Stand people have created a truly national organization for him. And while the other marginal candidates in the field—Alan Keyes and Bob Dornan—are running to win their 2 or 3 percent of the vote, which they can then cash in like chips in a casino for prestige and appointments, Morry has no interest in anything short of total victory. He is also the only candidate who is the least bit persuasive when he says he has no interest in being president for more than four years. "Why the hell would I want to do that?" he says. "I like my life." And he does.

At 9:00 the land yacht rolls up beside the front door of the Ames High School and disgorges Morry. Morry then does his usual trick of startling the locals. He bursts through both double doors leading into the school, which, like all the doors he will open for the rest of the day, slam violently against the wall behind them. He marches off down a long corridor with the rest of us trying to keep up, leaving a trail of startled adolescents in his wake. He swaggers like a quarterback on the way to a huddle.

"Did you play sports in high school?" I ask Morry, or rather, the back of Morry's head. He doesn't even look around. He's shaking his head; I have no trouble imagining the scorn on his face. My question is plainly ridiculous. "*Did I play sports?*" he asks. "I am the biggest jock who ever ran for president. I can beat you in anything." And with that he blows through the double doors leading into the auditorium.

High school probably was not prepared for Morry Taylor the first time he passed through, and it most certainly is no match for him now that he's sitting on $40 million-plus of Titan stock and a

fully fueled presidential campaign. About thirty kids file in, slump down into their seats and settle in for a snooze they'll never have.

"Your school is too big," booms Morry, and as the kids jolt and stir he enters his stream of consciousness. "This is what is wrong with America," he says, pointing at the kids. "Big, big, big. You don't see no little kids in here. No little kids with the big kids so that the little kids don't have anyone to look up to. When I was in school the third-graders looked up to the eighth-graders, and the eighth-grade boys were in love with the senior girls. The senior girls just thought they were cute little twerps, but it was good for them. Some kid comes to school with orange hair, you don't have to call the parents. Hell, we'll take care of the orange hair. A place like this breeds weirdos."

The students are now fully alert.

"I never could enjoy going to a school like this," concludes Morry. The kids seem to concur.

"How many of you ever take accounting?" he asks. The kids are now squirming and ducking: he's breaking down their resistance, making them nervous. Two hands go up. Morry shakes his head, a little sadly. His tone changes. "I know you got a lot of these teachers"—he waves nonchalantly at a couple of uneasy-looking older men in the rafters—"and they tell you a lot of . . ." (he doesn't use the word "crap" but he might as well) "*things* . . . but in your whole entire life you are only going to use one or maybe two of those things. Hell, I took 257 engineering courses, and I never *used* one of them."

He pauses and seems to reconsider. I wonder if he's about to make a little plea for the joy of learning for its own sake, the importance of a liberal education, that sort of thing. He isn't. "Now we all agree that the most important thing in your life is your family," he says. "Your momma and your daddy, your brothers and your sisters. But right after that there's something else. We all know what it is, and it's . . . GREEN."

With that he reaches into his pocket and produces a fat roll of $100 bills. He holds it high so that everyone can see. Five grand. Cash. The kids are now perched on the edge of their seats, giggling nervously, probably wondering what they feed presidential candidates.

"It all comes down to accounting," says Morry. "Accounting and money. You can't live without it. And the minute you make it someone is trying to take it away from you. So FOR GOD'S SAKE, find out about money!"

"Can I have some?" asks a kid in the front row.

"It's mine!" shouts Morry, and puts the money back in his pocket, a nice illustration of some general business principle. The teachers are now frowning, but the kids are unable to preserve their original detachment.

It's time to talk politics.

Morry's positions are somewhat quixotic: he's pro-choice (rousingly so, if asked), for the death penalty (ditto), against sending troops to Bosnia. No economics professor is a match for his dissection of Steve Forbes's plan to cut the capital gains tax rate to zero. "I sold $15 million worth of stock to get into this thing," he says. "I paid $5 million to Uncle Sam. Under Steve Forbes's plan I wouldda paid nuthin. The guys who work for me would pay 17 percent on what they earn, and I would have paid no tax at all. And that's wrong." But even this is subordinate to his outrage at the inefficiency of our government. He's running on a platform of balancing the budget in eighteen months not by eliminating programs but by firing a third of the best-paid government employees. Having balanced the budget he will then cut both programs and taxes.

"How many of you want to give the government 40 percent of what you earn after you get outta here?" he asks the crowd. One of the kids—a "weirdo" with a wispy beard—raises his hand. "Mark his name down," says Morry. "An institution needs him. We're

going to study his brain. He's not human. He's an alien."

And so it goes until Morry ends with a rousing call to arms: "This is it folks! This is the only time you have a choice: by November the only choice for president is between light grey and medium grey."

January 13

Tonight we flew in one of Morry's private planes to a Republican county dinner at Storm Lake, in northwestern Iowa. It was held in a large warehouse disguised as a convention hall. Morry, who is sitting at the head table, pops up and beats the crowd to the buffet table, where he snags a fried chicken breast, green beans, mashed potatoes and an anemic-looking salad. Surveying the crowd upon his return he says, "This is going to be wild tonight. That guy at the end of the table—crazier than hell. He writes for the conservative paper. There's going to be some smiles and some people pissed-off." I point out that, out of 150 people, two have availed themselves of the cash bar. All the rest are drinking iced tea. "If you were a Democrat you'd have a lot more fun," I say.

"You know something about these people?" he says. "Your wife gets sick, and every one of these people would visit her. They'd take turns bringing meals by your house. Maybe not that many of them dance,"—a Cheshire Cat smile—"but they would *love* watchin' me dance."

A bit later Morry rises to speak. He's on: within minutes he has the crowd laughing and clapping. They agree with him about everything, especially the lunacy of the Forbes tax plan. Then in the midst of the fun a woman rises and challenges his pro-choice position. "It's a religious issue," Morry says, "not a matter for the federal government." She presses him: you can see she's used to making public speakers either come around to her way of thinking or regret ever opening their mouths. She's picked the wrong

guy today. Instead of backing down or wiggling, Morry goes on the attack: "Look ma'am, I think 99 percent of women never want an abortion. They go through a lot of mental anguish. They suffer a lot. I say leave it to them." She tries to speak. Morry interrupts: "I said, LEAVE . . . IT . . . TO . . . THE . . . WOMEN."

And there, at a banquet filled with Republican Party hacks, the sort of people who are meant to be rabidly pro-life, who Morry *expected* to be rabidly pro-life, a volcano of spontaneous applause erupted. All over the room women were clapping so hard I thought they'd break their hands. Here, I thought, is the benefit of having someone around who feels free to speak his mind. He liberates, however momentarily, those who don't.

January 14

I was waiting at the front desk of the Des Moines YMCA when Morry arrived just before 9 a.m.: "What, you thought I wouldn't show?" The racquetball game took just under twenty-two minutes. Morry won: 15-0, 15-5. I had figured that between the twenty-five extra pounds he's carrying around and the sixteen years he has on me I could outhustle him. I was wrong. He knew every angle and trick on the court and played each one with relish. "Too good!" he'd shout after he'd dropped the ball into the corner for the tenth time. As the rout progressed he shouted to his aides—who had at length turned up—to come and watch. "Fourteen to zip, not bad for an old guy," he shouted. And then, under his breath, "Some of my guys are betting on you. Dipshits." As we crawl through the hole out the back of the court he says, "Don't you go write that you lost because you were nervous the presidential candidate was going to have a heart attack." Camus identified the love of winning at games as one of the prerequisites of happiness in the modern world. And he did that without ever meeting Morry.

I went over to Titan Tire about an hour before the big debate—*The Des Moines Register* forum, it is called—and found Morry still in his sweat clothes with his feet up on his desk scratching out his two-minute closing statement. On the other side of his desk his campaign manager looks on with a mixture of affection and anxiety. "Hey," Morry says when he sees me, "tell me what you think of this," and over his manager's protests he reads his remarks aloud. Half of it isn't bad, but the other half is a series of wisecracks about Bob Dole that don't seem to belong in a presidential debate.

I offer my first strategic political advice: cut the Dole stuff, stress the unfairness of Forbes's tax plan compared to his own by using his own experience and find a place to let people know that he's pro-choice. His manager winces. The Taylor campaign feels the surest way to turn off Republican primary voters is to be loudly pro-choice, and it's true that it didn't exactly work for Arlen Specter. I make two points: (a) half the people at the Storm Lake event—party hacks every one—had to restrain themselves from leaping to their feet and cheering when Morry came out with his beliefs; and (b) it's not as if Morry has any votes to lose.

Outside the Des Moines television station there were two chanting mobs of about 200 people divided by a street. One held bright orange signs that said EXPOSE THE RIGHT; the other jabbed signs for Dole, Gramm and Morry. I slid past and into the studio, where I presented myself as attached to the Taylor campaign. They signed me in but did not quite believe me—the woman insisted on walking me down to Morry's studio. As we entered the back corridor we bumped into Morry on his way to the stage. He's strutting. Both arms are swinging, and a cluster of six people are failing to keep up with him.

Morry was seated exactly where he wanted to be, between Dole and Gramm. After the last debate, in South Carolina, he complained of being seated next to Keyes ("the guy nearly blew out

my eardrums"). His situation facilitates one of his best lines, "I got a couple of million bucks of government pensions sitting on either side of me." The studio loves it, but it was probably lost on the TV audience, since the camera keeps to tight shots of the candidates. No one has any idea who Morry is sitting next to.

Very little separates the other candidates—it's merely a matter of emphasis. Light grey and medium grey, as Morry put it. Keyes and Buchanan stress their pro-life message. All the other candidates except Morry agree or at least refuse to disagree. The exchanges feel tentative, provisional. It's like one of those pick-up basketball games in which everyone who loses pretends he wasn't trying. About midway through it becomes clear that only the spinners will be truly pleased. Because no one clearly won or lost, their job of clearing up the ambiguity for reporters becomes more important. Still, one thing is clear: how organic and fluid the process is. Every one of the candidates stands a chance of shaping future policy. Anyone who lands upon an issue and proves its electoral merit is likely to have his issue poached by the winner. If Morry succeeds in making Forbes's tax plan look ridiculous, for instance, he will have struck one of the great blows for fairness, even though no one will remember his name. And he might: the other candidates are starting to pick up on his rap.

As we near the ninety-minute mark Morry is invited to offer his closing remarks. He has cut the jokes about Dole, stressed his views about the Forbes tax plan with a personal anecdote. As I realize what is happening a little shiver of concern runs down my spine. No, I think, he couldn't be so foolish as to take my advice. But then he says, "Since it has come up so often I think I should say a few words about a woman's choice."

"Time's up, Mr. Taylor," says the moderator.

"Okay," says Morry. He actually was going to do it, he tells me after the debate. But he's too busy telling reporters about his racquetball triumph to spin his performance.

I rush to the airport with one more bag than I came with to carry all the stuff Morry gave me: t-shirts, baseball caps, candy, literature. The American Airlines ticket counter is empty. As I stand there, up rushes a man who looks a little like Bob Dornan and asks if there are any seats left on the Chicago flight. He *is* Bob Dornan. B-1 Bob. The ladies behind the counter fail to recognize him. Dornan drops a hint: "I was just participating in the presidential debate," he says. This means nothing to the women behind the counter, who have found a seat but are now demanding a ticket and identification, which Dornan can't find. "I'm a congressman," he says, as if this explains anything. The women fail to be impressed by this fact. "I think I won the presidential debate," he says. They ignore him completely.

It is a nice illustration of a general principle: if a celebrity falls in the woods and the witnesses do not know who he is, no one hears him. Finally I say, "You did really well," which is only a slight exaggeration, and then explain to the ladies behind the counter who Bob Dornan is. His credibility skyrockets. They treat him as a big shot. You never can tell who might be president one day.

Dornan and I walk together to the end of the concourse. There we are nearly alone with a clear view of a row of private jets across the tarmac. He points to a Lear Jet. I tell him it belongs to Dole. Dornan is clearly upset. "You'd think the guy could give me a ride back," he says. "When I quit doing this he'll expect me to endorse him and act as a surrogate, and he can't even give me a ride back." The prospect lingers in the air between us. Then perhaps by way of explanation he says: "If I get 2 percent in New Hampshire I'll have done well."

Les Très Riches Heures de Martha Stewart

MARGARET TALBOT

May 13, 1996

During its early years, the magazine enjoyed swimming in the pool of popular culture, but the magazine also went decades where it barely engaged with television or other artifacts of the masses. That changed in the eighties and nineties. Editor Andrew Sullivan was a famous fan of The Simpsons *and the Weather Channel, the sort of obsessions that infiltrated the magazine. And Leon Wieseltier, an unmistakable highbrow, had no compunction about assigning pieces about the lowest subjects. The trick was that these pieces had to employ the very same rigor the magazine would apply to French symbolist poetry.*

Every age gets the household goddess it deserves. The '60s had Julia Child, the sophisticated French chef who proved as permissive as Dr. Spock. She may have proselytized for a refined foreign cuisine from her perch at a Boston PBS station, but she was always an anti-snob, vowing to "take a lot of the la dee dah out of French cooking." With her madras shirts and her penumbra of curls, her 6'2" frame and her whinny of a voice, she exuded an air of Cambridge eccentricity—faintly bohemian and a little tatty, like a yellowing

travel poster. She was messy and forgiving. When Julia dropped an egg or collapsed a souffle, she shrugged and laughed. "You are alone in the kitchen, nobody can see you, and cooking is meant to be fun," she reminded her viewers. She wielded lethal-looking kitchen knives with campy abandon, dipped her fingers into creme anglaise and wiped her chocolate-smeared hands on an apron tied carelessly at her waist. For Child was also something of a sensualist, a celebrant of appetite as much as a pedant of cooking.

In the '90s, and probably well into the next century, we have Martha Stewart, corporate overachiever turned domestic super-achiever, Mildred Pierce in earth-toned Armani. Martha is the anti-Julia. Consider the extent of their respective powers. At the height of her success, Child could boast a clutch of bestselling cookbooks and a *gemütlich* TV show shot on a single set. At what may or may not be the height of her success, here's what Stewart can claim: a 5-year-old magazine, *Martha Stewart Living*, with a circulation that has leapt to 1.5 million; a popular cable TV show, also called "Martha Stewart Living" and filmed at her luscious Connecticut and East Hampton estates; a dozen wildly successful gardening, cooking and lifestyle books; a mail-order business, Martha-by-Mail; a nationally syndicated newspaper column, "Ask Martha"; a regular Wednesday slot on the "Today" show; a line of $110-a-gallon paints in colors inspired by the eggs her Araucana hens lay; plans to invade cyberspace—in short, an empire.

Julia limited herself to cooking lessons, with the quiet implication that cooking was a kind of synecdoche for the rest of bourgeois existence; but Martha's parish is vaster, her field is all of life. Her expertise, as she recently explained to *MediaWeek* magazine, covers, quite simply, "Beautiful soups and how to make them, beautiful houses and how to build them, beautiful children and how to raise them." (From soups to little nuts.) She presides, in fact, over a phenomenon that, in other realms, is quite familiar in American society and culture: a cult, devoted to her name and image.

In the distance between these two cynosures of domestic life lies a question: What does the cult of Martha mean? Or, to put it another way, what have we done, exactly, to deserve her?

If you have read the paper or turned on the television in the last year or so, you have probably caught a glimpse of the waspy good looks, the affectless demeanor, the nacreous perfection of her world. You may even know the outlines of her story. Middle-class girl from a Polish-American family in Nutley, New Jersey, works her way through Barnard in the early '60s, modeling on the side. She becomes a stockbroker, a self-described workaholic and insomniac who by the '70s is making six figures on Wall Street, and who then boldly trades it all in . . . for life as a workaholic, insomniac evangelist for domesticity whose business now generates some $200 million in profits a year. (She herself, according to the *Wall Street Journal*, makes a salary of $400,000 a year from Time Inc., which generously supplements this figure with a $40,000 a year clothing allowance and other candies.) You may even have admired her magazine, with its art-book production values and spare design, every kitchen utensil photographed like an Imogen Cunningham nude, every plum or pepper rendered with the loving detail of an eighteenth-century botanical drawing, every page a gentle exhalation of High Class.

What you may not quite realize, if you have not delved deeper into Stewart's oeuvre, is the ambition of her design for living—the absurd, self-parodic dream of it. To read Martha Stewart is to know that there is no corner of your domestic life that cannot be beautified or improved under careful tutelage, none that should not be colonized by the rhetoric and the discipline of quality control. Work full time though you may, care for your family though you must, convenience should never be your watchword in what Stewart likes to call, in her own twee coinage, "homekeeping." Convenience is the enemy of excellence. "We do not pretend that these are 'conve-

nience' foods," she writes loftily of the bread and preserves recipes in a 1991 issue of the magazine. "Some take days to make. But they are recipes that will produce the very best results, and we know that is what you want." Martha is a kitchen-sink idealist. She scorns utility in the name of beauty. But her idealism, of course, extends no further than surface appearances, which makes it a very particular form of idealism indeed.

To spend any length of time in Marthaland is to realize that it is not enough to serve your guests homemade pumpkin soup as a first course. You must present it in hollowed-out, hand-gilded pumpkins as well. It will not do to serve an Easter ham unless you have baked it in a roasting pan lined with, of all things, "tender, young, organically-grown grass that has not yet been cut." And, when serving a "casual" lobster and corn dinner al fresco, you really ought to fashion dozens of cunning little bamboo brushes tied with raffia and adorned with a chive so that each of your guests may butter their corn with something pretty.

To be a Martha fan (or more precisely, a Martha adept) is to understand that a terracotta pot is just a terracotta pot until you have "aged" it, painstakingly rubbing yogurt into its dampened sides, then smearing it with plant food or "something you found in the woods" and patiently standing by while the mold sprouts. It is to think that maybe you could do this *kind* of thing, anyway—start a garden, say, in your scruffy backyard—and then to be brought up short by Martha's enumeration, in *Martha Stewart's Gardening*, of forty-nine "essential" gardening tools. These range from a "pole-saw" to a "corn fiber broom" to three different kinds of pruning shears, one of which—the "loppers"—Martha says she has in three different sizes. You have, perhaps, a trowel. But then Martha's garden is a daunting thing to contemplate, what with its topiary mazes and state-of-the-art chicken coop; its "antique" flowers and geometric herb garden. It's half USDA station, half Sissinghurst.

And you cannot imagine making anything remotely like it at your own house, not without legions of artisans and laborers and graduate students in landscape design, and a pot of money that perhaps you'll unearth when you dig up the yard.

In *The Culture of Narcissism*, Christopher Lasch describes the ways in which pleasure, in our age, has taken on "the qualities of work," allowing our leisuretime activities to be measured by the same standards of accomplishment that rule the workplace. It is a phenomenon that he memorably characterizes as "the invasion of play by the rhetoric of achievement." For Lasch, writing in the early '70s, the proliferation of sex-advice manuals offered a particularly poignant example. Today, though, you might just as easily point to the hundreds of products and texts, from unctuous home-furnishings catalogs to upscale "shelter" magazines to self-help books like *Meditations for Women Who Do Too Much*, that tell us exactly how to "nest" and "cocoon" and "nurture," how to "center" and "retreat," and how to measure our success at these eminently private pursuits. Just as late-nineteenth-century marketers and experts promised to bring Americans back in touch with the nature from which modern industrial life had alienated them, so today's "shelter" experts—the word is revealingly primal—promise to reconnect us with a similarly mystified home. The bourgeois home as lost paradise, retrievable through careful instruction.

Martha Stewart is the apotheosis of this particular cult of expertise, and its most resourceful entrepreneur. She imagines projects of which we would never have thought—gathering dewy grass for our Easter ham, say—and makes us feel the pressing need for training in them. And she exploits, brilliantly, a certain estrangement from home that many working women feel these days. For women who are working longer and longer hours at more and more demanding

jobs, it's easy to think of home as the place where chaos reigns and their own competence is called into doubt; easy to regard the office, by comparison, as the bulwark of order. It is a reversal, of course, of the hoary concept of home as a refuge from the tempests of the marketplace. But these days, as the female executives in a recent study attested, the priority they most often let slide is housekeeping; they'll abide disorder at home that they wouldn't or couldn't abide at the office. No working couple's home is the oasis of tranquility and Italian marble countertops that Marthaism seems to promise. But could it be? Should it be? Stewart plucks expertly at that chord of doubt.

In an era when it is not at all uncommon to be cut off from the traditional sources of motherwit and household lore—when many of us live far from the families into which we were born and have started our own families too late to benefit from the guidance of living parents or grandparents—domestic pedants like Martha Stewart rightly sense a big vacuum to fill. Stewart's books are saturated with nostalgia for lost tradition and old moldings, for her childhood in Nutley and for her mother's homemade preserves. In the magazine, her "Remembering" column pines moralistically for a simpler era, when beach vacations meant no television or video games, just digging for clams and napping in hammocks. Yet Stewart's message is that such simplicity can only be achieved now through strenuous effort and a flood of advice. We might be able to put on a picnic or a dinner party without her help, she seems to tell us, but we wouldn't do it properly, beautifully, in the spirit of excellence that we expect of ourselves at work.

It may be that Stewart's special appeal is to women who wouldn't want to take their mother's word anyway, to baby-boomer daughters who figure that their sensibilities are just too different from their stay-at-home moms', who can't throw themselves into housekeeping without thinking of their kitchen as a catering business and

their backyards as a garden show. In fact, relatively few of Martha's fans are housewives—72 percent of the subscribers to *Martha Stewart Living* are employed outside the home as managers or professionals— and many of them profess to admire her precisely because she isn't one, either. As one such Martha acolyte, an account executive at a Christian radio station, effused on the Internet: "[Stewart] is my favorite independent woman and what an entrepreneur! She's got her own television show, magazine, books and even her own brand of latex paint. . . . Martha is a feisty woman who settles for nothing less than perfection."

For women such as these, the didactic faux-maternalism of Martha Stewart seems the perfect answer. She may dispense the kind of home-keeping advice that a mother would, but she does so in tones too chill and exacting to sound "maternal," singling out, for example, those "who will always be too lazy" to do her projects. She makes house-keeping safe for the professional woman by professionalizing house-keeping. And you never forget that Stewart is herself a mogul, even when she's baking rhubarb crisp and telling you, in her Shakeresque mantra, that "It's a Good Thing."

It is tempting to see the Martha cult purely as a symptom of anti-feminist backlash. Though she may not directly admonish women to abandon careers for hearth and home, Stewart certainly exalts a way of life that puts hearth and home at its center, one that would be virtually impossible to achieve without *somebody's* full-time de-votion. (Camille Paglia has praised her as "someone who has done a tremendous service for ordinary women—women who identify with the roles of wife, mother, and homemaker.") Besides, in those alarming moments when Stewart slips into the social critic's mode, she can sound a wee bit like Phyllis Schlafly—less punitive and more patrician, maybe, but just as smug about the moral uplift of a well-ordered home. Her philosophy of cultivating your own walled garden while the world outside is condemned to squalor bears the

hallmarks of Reagan's America—it would not be overreading to call it a variety of conservatism. "Amid the horrors of genocidal war in Bosnia and Rwanda, the AIDS epidemic and increasing crime in many cities," Stewart writes in a recent column, "there are those of us who desire positive reinforcement of some very basic tenets of good living." And those would be? "Good food, gardening, crafts, entertaining and home improvement." (Hollow out the pumpkins, they're starving in Rwanda.)

Yet it would, in the end, be too simplistic to regard her as a tool of the feminine mystique, or as some sort of spokesmodel for full-time mommies. For one thing, there is nothing especially June Cleaverish, or even motherly, about Stewart. She has taken a drubbing, in fact, for looking more convincing as a businesswoman than a dispenser of milk and cookies. (Remember the apocryphal tale that had Martha flattening a crate of baby chicks while backing out of a driveway in her Mercedes?) Her habitual prickliness and Scotchgard perfectionism are more like the badges of the striving good girl, still cut to the quick by her classmates' razzing when she asked for extra homework.

Despite the ritual obeisance that Martha pays to Family, moreover, she is not remotely interested in the messy contingencies of family life. In the enchanted world of Turkey Hill, there are no husbands (Stewart was divorced from hers in 1990), only loyal craftsmen, who clip hedges and force dogwood with self-effacing dedication. Children she makes use of as accessories, much like Parisian women deploy little dogs. The books and especially the magazine are often graced with photographic spreads of parties and teas where children pale as waxen angels somberly disport themselves, their fair hair shaped into tasteful blunt cuts, their slight figures clad in storybook velvet or lace. "If I had to choose one essential element for the success of an Easter brunch," she writes rather menacingly in her 1994 *Menus for Entertaining*, "it would be children." The

homemade Halloween costumes modeled by wee lads and lasses in an October 1991 issue of *Martha Stewart Living* do look gorgeous— the Caravaggio colors, the themes drawn from nature. But it's kind of hard to imagine a 5-year-old boy happily agreeing to go as an acorn this year, instead of say, Batman. And why should he? In Marthaland, his boyhood would almost certainly be overridden in the name of taste.

If Stewart is a throwback, it's not so much to the 1950s as to the 1850s, when the doctrine of separate spheres did allow married or widowed women of the upper classes a kind of power— unchallenged dominion over the day-to-day functioning of the home and its servants, in exchange for ceding the public realm to men. At Turkey Hill, Stewart is the undisputed chatelaine, micromanaging her estate in splendid isolation. (This hermetic pastoral is slightly marred, of course, by the presence of cameras.) Here the domestic arts have become ends in themselves, unmoored from family values and indeed from family.

Stewart's peculiar brand of didacticism has another nineteenth-century precedent—in the domestic science or home economics movement. The domestic scientists' favorite recipes—"wholesome" concoctions of condensed milk and canned fruit, rivers of white sauce—would never have passed Martha's muster; but their commitment to painstakingly elegant presentation, their concern with the look of food even more than its taste, sound a lot like Stewart's. And, more importantly, so does their underlying philosophy. They emerged out of a tradition: the American preference for food writing of the prescriptive, not the descriptive, kind, for food books that told you, in M. F. K. Fisher's formulation, not about eating but about what to eat. But they took this spirit much further. Like Stewart, these brisk professional women of the 1880s and '90s believed

that true culinary literacy could not be handed down or casually absorbed; it had to be carefully taught. (One of the movement's accomplishments, if it can be called that, was the home ec curriculum.)

Like Stewart, the domestic scientists were not bent on liberating intelligent women from housework. Their objective was to raise housework to a level worthy of intelligent women. They wished to apply rational method to the chaos and the drudgery of housework and, in so doing, to earn it the respect accorded men's stuff like science and business. Neither instinct, nor intuition, nor mother's rough-hewn words of advice would have a place in the scientifically managed home of the future. As Laura Shapiro observes in *Perfection Salad*, her lively and perceptive history of domestic science, the ideal new housewife was supposed to project, above all, "self-sufficiency, self-control, and a perfectly bland facade." Sound familiar?

It is in their understanding of gender roles, however, that the doyennes of home ec most closely prefigure Marthaism. Like Stewart, they cannot be classified either as feminists or traditionalists. Their model housewife was a pseudo-professional with little time for sublimating her ego to her husband's or tenderly ministering to his needs. She was more like a factory supervisor than either the Victorian angel of the home or what Shapiro calls the courtesan type, the postwar housewife who was supposed to zip through her chores so she could gussy herself up for her husband. In Martha's world, too, the managerial and aesthetic challenges of "homekeeping" always take priority, and their intricacy and ambition command a respect that mere wifely duties never could. Her husbandless hauteur is rich with the self-satisfactions of financial and emotional independence.

In the end, Stewart's fantasies have as much to do with class as with gender. The professional women who read her books might find

themselves longing for a breadwinner, but a lifestyle this beautiful is easier to come by if you've never needed a breadwinner in the first place. Stewart's books are a dreamy advertisement for independent wealth—or, more accurately, for its facsimile. You may not have a posh pedigree, but with a little effort (okay, a lot) you can adopt its trappings. After all, Martha wasn't born to wealth either, but now she attends the weddings of people with names like Charles Booth-Clibborn (she went to his in London, the magazine tells us) and caters them for couples named Sissy and Kelsey (see her *Wedding Planner*, in which their yacht is decorated with a "Just Married" sign).

She is not an American aristocrat, but she plays one on TV. And you can play one, too, at least in your own home. Insist on cultivating only those particular yellow plums you tasted in the Dordogne, buy your copper cleaner only at Dehillerin in Paris, host lawn parties where guests come "attired in the garden dress of the Victorian era," and you begin to simulate the luster of lineage. Some of Stewart's status-augmenting suggestions must strike even her most faithful fans as ridiculous. For showers held after the baby is born, Martha "likes presenting the infant with engraved calling cards that the child can then slip into thank you notes and such for years to come." What a great idea. Maybe your baby can gum them for a while first, thoughtfully imprinting them with his signature drool.

The book that best exemplifies her class-consciousness is *Martha Stewart's New Old House*, a step-by-step account of refurbishing a Federal-style farmhouse in Westport, Connecticut. Like all her books, it contains many, many pictures of Martha; here she's frequently shown supervising the work of plasterers, carpenters and other "seemingly taciturn men." *New Old House* establishes Stewart's ideal audience: a demographic niche occupied by the kind of people who, like her, can afford to do their kitchen countertops in "mottled, gray-green, hand-honed slate from New York state, especially cut" for them. The cost of all this (and believe me, countertops are

only the beginning) goes unmentioned. If you have to ask, maybe you're not a Martha kind of person after all.

In fact, Stewart never seems all that concerned with reassuring her readers of their ability to afford such luxuries or of their right to enjoy them. She's more concerned with establishing her own claims. Her reasoning seems to go something like this: the houses that she buys and renovates belong to wealthy families who passed them down through generations. But these families did not properly care for their patrimony. The widowed Bulkeley sisters, erstwhile owners of Turkey Hill, had let the estate fall "into great disrepair. All the farms and outbuildings were gone. . . . The fields around had been sold off by the sisters in 2-acre building lots; suburbia encroached." The owner of the eponymous New Old House was a retired librarian named Miss Adams who "had little interest in the house other than as a roof over her head. Clearly a frugal spirit, she had no plans to restore the house, and she lived there until she could no longer cope with the maintenance and upkeep of the place. The house was in dire need of attention, and since no other family member wanted to assume responsibility, Miss Adams reluctantly decided to sell her family home. I wanted very much to save the Adams house, to put it to rights, to return its history to it, to make it livable once again."

It's a saga with overtones of Jamesian comedy: a family with bloodlines but no money is simultaneously rescued and eclipsed by an energetic upstart with money but no bloodlines. The important difference—besides the fact that Martha is marrying the house, not the son—is that she also has taste. And it's taste, far more than money, she implies, that gives her the right to these splendid, neglected piles of brick. Unlike the "frugal" Misses Bulkeley, she will keep suburbia at bay; unlike the careless Miss Adams, she would never resort to "hideous rugs" in (yuck) shades of brown. They don't understand their own houses; she does, and so she *deserves* to

own their houses. But leave it to Martha to get all snippy about these people's aesthetic oversights while quietly celebrating their reversion to type. They're useful to her, and not only because their indifference to decor bolsters her claim to their property. Like the pumpkin pine floors and original fixtures, these quaintly cheese-paring New Englanders denote the property's authenticity.

The fantasy of vaulting into the upper crust that Martha Stewart fulfilled, and now piques in her readers, is about more than just money, of course. Among other things, it's about time, and the luxurious plenitude of it. Living the Martha way would mean enjoying a surfeit of that scarce commodity, cooking and crafting at the artisanal pace her projects require. Trouble is, none of us overworked Americans has time to spare these days—and least of all the upscale professional women whom Stewart targets. Martha herself seemed to acknowledge this when she told *Inside Media* that she attracts at least two classes of true believers: the "Be-Marthas," who have enough money and manic devotion to follow many of her lifestyle techniques, and the "Do-Marthas," who "are a little bit envious" and "don't have as much money as the Be-Marthas."

To those fulsome categories, you could surely add the "watch Marthas" or the "read Marthas," people who might consider, say, making their own rabbit-shaped wire topiary forms, but only consider it, who mostly just indulge in the fantasy of doing so, if only they had the time. There is something undeniably soothing about watching Martha at her absurdly time-consuming labors. A female "media executive" explained the appeal to Barbara Lippert in *New York* magazine: "I never liked Martha Stewart until I started watching her on Sunday mornings. I turn on the TV, and I'm in my pajamas, still in this place between sleep and reality. And she's showing you how to roll your tablecloths in parchment paper. She's like a

character when she does her crafts. It reminds me of watching Mr. Green Jeans on *Captain Kangaroo*. I remember he had a shoebox he took out that was filled with craft things. There would be a close-up on his hands with his buffed nails. And then he would show you how to cut an oaktag with a scissor, or when he folded paper, he'd say: 'There you go, boys and girls,' and it was very quiet. It's like she brings out this great meditative focus and calm."

The show does seem strikingly unfrenetic. Unlike just about everything else on TV, including the "Our Home" show, which follows it on Lifetime, it eschews Kathie Lee-type banter, perky music, swooping studio shots and jittery handheld cameras. Instead there's just Martha, alone in her garden or kitchen, her teacherly tones blending with birdsong, her recipes cued to the seasons. Whimsical recorder music pipes along over the credits. Martha's crisply ironed denim shirts, pearl earrings, and honey-toned highlights bespeak the fabulousness of Connecticut. Her hands move slowly, deliberately over her yellow roses or her Depression glasses. Martha is a Puritan who prepares "sinful" foods—few of her recipes are low-fat or especially health-conscious—that are redeemed by the prodigious labors, the molasses afternoons, involved in serving them. (She preys upon our guilt about overindulgence, then hints at how to assuage it.) Here at Turkey Hill, time is as logy as a honey-sated bumblebee. Here on Lifetime, the cable channel aimed at baby-boom women, Martha's stately show floats along in a sea of stalker movies, Thighmaster commercials and "Weddings of a Lifetime" segments, and by comparison, I have to say, she looks rather dignified. Would that we all had these très riches heures.

But if we had the hours, if we had the circumstances, wouldn't we want to fill them with something of our own, with a domestic grace of our own devising? Well, maybe not anymore. For taste is no longer an expression of individuality. It is, more often, an instrument of conformism, a way to assure ourselves that we're living by

the right codes, dictated or sanctioned by experts. Martha Stewart's "expertise" is really nothing but another name for the perplexity of her cowed consumers. A lifestyle cult as all-encompassing as hers could thrive only at a time when large numbers of Americans have lost confidence in their own judgment about the most ordinary things. For this reason, Martha Stewart Living isn't really living at all.

He Is Finished

JAMES WOOD

May 12, 1997

Poor Norman Mailer happened to write a very bad book on James Wood's animating subject, religion—a transgression that earned him one of the most negative reviews in The New Republic's *distinguished history of negative reviews. The piece was supplemented with a cover that plastered the harsh title of the piece across Mailer's face. When the aging novelist happened to encounter the magazine's owner, Marty Peretz, on Cape Cod later that summer, he attempted to disprove the headline by punching Peretz in the belly.*

Jesus warned us about Norman Mailer. There will be imitators, false prophets, fake messiahs, he said. Here is Mailer, who has been crying in the wilderness, and preparing the way with boasts: "I'm one of the fifty or one hundred novelists in the world who could rewrite the New Testament," he told an interviewer. He has written the life of Christ as if told by Christ, and he feels that, like Christ, he is half man and half something else—a kind of celebrity-centaur. Mailer can identify with the son of God:

And I thought this one [*The Gospel According to the Son*] was fine because I have a slight understanding of what it's like to be half a man and half something else, something larger. Believe it if you will, but I mean this modestly. Every man has a different kind of life, and mine had a peculiar turn. It changed completely at twenty-five when *The Naked and the Dead* came out. Obviously, a celebrity is a long, long, long, long way from the celestial, but nonetheless it does mean that you have two personalities you live with all the time.

So the nonsense has begun early. With Mailer's better books, it is easy to separate the nonsense from the talent. It is like playing only the white keys on a piano. But the very melody of this book is foolish. "For those who would ask how my words have come to this page," Mailer has Jesus say in the novel's prologue, "I would tell them to look upon it as a small miracle. (My gospel, after all, will speak of miracles.)" Everything that is wrong with *The Gospel According to the Son* is concentrated in this promise: in that phrase "after all," which is blithely compact about something that should be felt and explained, and suggests to us that Jesus will wink and nudge his way through his own life; in the verb "speak of," whose antiqued veneer pledges a book of reproduction language; above all, in the implication that Mailer will not write a novel, but carve a gospel.

In a sense, the four gospels of the New Testament are enemies of the novel. They are not narratives, they are witnessings that occasionally fall into narrative. The life of Jesus is not conceived by the writers of the gospels as the story of an individual whose fate, unknown until the moment of reading, may interest us. Jesus did not live the life of a character in a modern novel. He was a story already told, and he felt this. He existed to fulfill the prophets; he is the completion of evidence. The whole machine of persuasion that is the secular, modern novel—verisimilitude, a believable character,

an uncertainty about meanings and endings, the pacing of time, the description of place—is irrelevant. The task of the gospels is not to persuade novelistically, but to convince forensically. In the eighteenth book of *The City of God*, Augustine writes that Jesus, "in order to make known the godhead in his person, did many miracles, of which the gospel Scriptures contain as many as seemed enough to proclaim his divinity." "As many as seemed enough to proclaim his divinity": there were other miracles, suggests Augustine, but the gospel writers picked enough to win their case. Reality was merely the court of the sublime.

The proclamation of divinity has nothing to do with the establishment of credibility as we understand it in literature—the stoking of interest in the belly of the reader. We cannot be persuaded to believe in divinity as we are persuaded to believe in a work of art, and Christian art does not, on the whole, attempt to do this. The halo seen so often above the head of Jesus marks the moment at which verisimilitude, the persuasion of reality, has not just broken down, but has become irrelevant: he is holy, and that is the end of it. A verbal equivalent of the halo, in the gospels, is the ellipsis between verses. The "And" or "Then" with which so many biblical verses begin is not merely abrupt; it demotes fullness of storytelling as beside the point. The narrative does not progress realistically; it is snatched from reality to reality. There is no reality between the verses, just a constant divinity. The effect is like watching, as a child, one of those big institutional clocks whose minute hand does not invisibly coast but jerks at intervals:

> When he was come down from the mountain, great multitudes followed him. And behold, there came a leper and worshipped him, saying, Lord, if thou wilt, thou canst make me clean. And Jesus put forth his hand, and touched him, saying, I will; be thou clean. And immediately his leprosy was cleansed.

Disastrously, Mailer borrows this style that is so inimical to the movement of a novel. Many of his sentences begin with "And" or "Then." The pith of reality has been spat away, and in its place is a spastic simulacrum of biblical style. Mailer uses a strange, abandoned version of King James English, as if a rival monarch had broken into the text and stolen all its gold. His "biblical English" is simple modern prose with occasional attacks of nostalgia: "I hardly knew why, but I said to Peter, 'Do not enter into temptation.' My soul was sorrowful unto death." Or this: "Then the two fish gave up more than twice two hundred small morsels."

Mailer has decided—not without reason—that the crooked vitality of King James English lies partly in its gross specificities, the little whorls of metaphorical detail that enable the Psalmist, for instance, to write that the eyes of the rich "stand out with fatness." Mailer strives to compress the language into fierce oddity, but the effect is often gibberish: "His face was like a ravine and small creatures would live within," Jesus reports to us, about the face of John the Baptist. "His breath was as lonely as the wind that passes through empty places," again of John. "Still, I could hear laughter creep out of their feet," Jesus says of a crowd in the temple. When the Devil comes to tempt him in the wilderness, Jesus can smell his evil: "I could also perceive how greed came forth from his body. For that was kin to the odor that lives between the buttocks." (If this is what greed smells like, think what the product of greed smells like.) The key to the bad smell of that sentence is not the idea of greed having an odor, nor even the odor's drastic placement, but the words "kin" and "lives"—both swirlingly portentous.

Mailer's Jesus, hobbled by this deprived patois, emerges as a simpleton. He is the Prince Myshkin of Judea. He sounds like an antique imbecile. Mailer is forever plunging his Jesus into platitudes—an attempt, presumably, at biblical "wisdom." "Rare is the calm that is long free of disturbance" is one of his ponderings. "I

thought of how King Herod had wished to kill me. What a bloody creature was man." "How I hoped that the angel spoke the truth! For then I would be like a light sent into the world. Yet men seemed to love darkness more than light." This may be Mailer's idea of how a truly good man thinks.

The problem is the whole conception of the book. In Mailer's plan, Jesus is telling us this story from heaven; what he recounts has already happened to him. Indeed, in the book's most absurd moment, Jesus provides a kind of epilogue—as in those movies that, just before they roll the credits, tell what happened to everybody after the story ended—in which he lets us know that everyone, including himself, is doing fine:

> I remain on the right hand of God, and look for greater wisdom than I had before, and I think of many with love. My mother is much honored. Many churches are named for her, perhaps more than for me. And she is pleased with her son. My Father, however, does not often speak to me.

But retrospection—Jesus looking back on his life from the safety of heaven—is an especially bad way to tell a familiar story whose momentousness is already known to most people. It is hard enough for a novelist to find a fresh cutting from this story. When Jesus first said that it was harder for a camel to go through the eye of a needle than for a rich man to enter heaven, the phrase was not rusty. Mailer's Jesus further removes the novelistic from the book. It is unwise, given the dangers inherent in this enterprise, to have Jesus say, of his own birth, "As all know by now, there was no room at the inn." Yes, we all know—and so the writer must do something new with it, not complain lazily at its familiarity.

Freed from the pretense of telling a tale that is unfamiliar to him, or a tale full of adventures that have to be shared for the first

time, Mailer's Jesus is constantly anticipating and foreshortening his story. "I was yet to learn that I would care about sinners more than for the pious," he hints early on. At Cana, having turned water into wine, he turns aside and confides: "That was the first of my miracles. . . ." This is sheer ineptitude on Mailer's part. It destroys what tang of discovery the narrative might have had, and makes it impossible for us to believe Jesus's self-doubt. For Jesus has already marked his route. About halfway through the book, Peter says to Jesus, "You are the Christ," and Jesus tells us: "I shook my head. Even at this moment, I could not be certain." At this, we laugh in disbelief. Mailer's Jesus has been dropping hints everywhere: "I could hardly see myself as the Son." Mailer's Jesus does not act like a man suddenly chosen by God to be the Messiah. He acts like a fool who cannot keep a secret.

Suddenly one realizes why *The Gospel According to the Son* reads like a children's book. Jesus lived and died, but he survived to tell the tale! No real harm came to him. At the book's climax, as Jesus hangs on the cross, he has a little thought: "God was my Father, but I had to ask: Is He possessed of all Powers? Or is He not? . . . If I had failed Him, so had He failed me. Such was now my knowledge of good and evil. Was it for that reason that I was on the cross?" This is a moment at which Matthew is powerful, like a true storyteller: the Roman centurions dividing up Jesus's garments; the soldier offering Jesus a vinegar-soaked sponge; the thieves and bystanders challenging him to prove himself by coming down from the cross. But Mailer mangles it; mangles it as a novelist should not. These calm clouds are not the thoughts of a man going through his final agony. We do not believe Mailer's Jesus here, any more than we believe him a few pages later when he insouciantly tosses out: "Indeed, it is true that I rose on the third day." At such moments, a baldness of narration that at first merely hinders plausibility seems the emblem of something else: a baldness of mind, an idleness, a vacancy.

Mailer's novel has been criticized, in *The New York Times*, for reducing Jesus, for knocking him off his "celestial throne." But this is to criticize the book for being a novel, something it is not enough of. It would have been perfectly proper if Mailer had knocked Jesus off his throne, as a serious writer should try to do. But perhaps one celebrity cannot do this to another celebrity. So instead Mailer has attempted a "gospel," full of holy wind. His Jesus is not a human being; he exists only in the frail rigging of Mailer's insistence that he is alive.

How might Jesus the man be portrayed? Ernest Renan, in 1862, wrote a biography of Christ in his *Life of Jesus*, which had a powerful impact on modern secular thought:

> He is tempted—he is ignorant of many things—he corrects himself—he is cast down, discouraged—he asks his Father to spare him trials—he is submissive to God as a son. He who is to judge the world does not know the day of judgment. . . . In his miracles we are sensible of painful effort—an exhaustion as if something went out of him. All these are simply the acts of a messenger of God. . . . He was not sinless; he has conquered the same passions that we combat; no angel of God comforted him, except his good conscience; no Satan tempted him, except that which each one bears in his heart.

This is, essentially, Mailer's Jesus. Renan was a Catholic who lost his faith. His book is a piece of learned kitsch, soft with surmise and invention. It is a disingenuous book, in which Renan, conscious that he is dismantling Christianity as he turns it into a myth, nervously compensates by idealizing Jesus. Stripping him of supernaturalism, and of his claim to be God's son, Renan turns the worship of this diminished orphan into a sickly poetry: "The highest consciousness of God which has existed in the bosom of humanity was that of

Jesus . . . that which all elevated souls will practise until the end of time." (A similar nervousness can be felt in Matthew Arnold's idealizations of Jesus.)

But Renan's portrait does allow for a man to emerge from the gospels. It is a picture that the doctrine of the incarnation must allow, of course. If Jesus was man as well as God, then he doubted, was tempted, was provoked into anger. Mark tells the story of Jesus cursing a fig tree because he wanted to eat and it had no fruit. The tree withered. Bertrand Russell took this as one of several examples of Jesus's imperfection. But what enrages the atheist should sting the novelist.

The rise of historical biblical criticism, of which Renan's book is a late bloom, generated an interest in the lean Jesus of reality, as opposed to the fuller Jesus of worship. There was a secular tilt, which freed the writer. Balzac wrote an extraordinary story in 1831 called "Christ in Flanders," set in the Middle Ages, in which Christ appears as a mysterious stranger on a boat, and calms a storm. In *De Profundis* (1897), Oscar Wilde apotheosized Jesus as the greatest artist, and described the gospels as "the four prose-poems about Christ." D. H. Lawrence wrote "The Man Who Died," a Nietzschean fantasy in which Jesus does not die on the cross but survives at the last minute. Alive, he realizes that he has never really lived, that his philosophy has been life-denying and death-obsessed.

These visions, some pious, some not, are characterized by their great interest in the real; that is the rich looseness of modernity for such artists. Indeed, the genre of the "mysterious stranger," the Christ-like figure who suddenly appears and shatters domestic reality (a genre that includes Tolstoy's "What Men Live By"), takes the interaction of the divine and the real as its very subject. Insofar as the men and women in these stories spend their time trying to uncover the true identity of their visitor, they are actually applying themselves to the "mystery" of incarnation, that impossible imbri-

cation of the godly and the human. That is the true mystery of these visitations.

But Mailer has, apparently, no interest in reality. Whole scenes disappear in a sneeze. Mailer is so besotted with phony grandeur of diction that he refuses to animate. Here is the scene, in full, in which Jesus, just before his death, is being abused by the guards: "The guards beat upon me. These words by Caiaphas had removed all fear that I might yet bear witness against mistreatment. So they felt free to beat my face." Nothing more! Far from knocking Jesus off a throne, Mailer is blindly, gratuitously, unwittingly reverent. He follows the gospels at times word for word, scene for scene, inventing or changing little. His Jesus is born in Bethlehem; is saved from Herod's slaughter of the children of Bethlehem; is found by his parents, at the age of 12, speaking with the elders in the temple; is baptized by John; turns water into wine at Cana; raises Lazarus from the dead; heals the leprous and the blind; anoints Peter as the rock of his church to come; walks on water and calms a storm; is crucified and rises on the third day. This is the Jesus of the gospels, but the gospels tell it much better, and they spare us the devil's odors. Mailer's imitation is a kind of poor understudy for a performer who is never sick.

Mailer's loyalty to holiness is what is wrong with this book. Recently he was asked if he believed if Jesus was the Son of God. "As a novelist, I do. I believe Jesus was the Son of God. You can't be a serious writer of fiction unless you believe the story you are telling. . . . Intellectually, I don't feel that miracles are impossible—if I did, I could never have entered the imaginative framework in which the book is written. . . . I was able, as a novelist, to believe that the events in the New Testament occurred. So I could write about them as if they were real." Mailer seems to think that, in effect, he became a Christian while writing this novel. But this is a curious idea of imaginative belief, a misguided literary equivalent of method acting, which severs the novelist's connection with his ev-

eryday imagination. While writing, he is a Christian. While break-fasting, he is a Jew. But why can a writer not describe something that he does not believe? This is surely the very principle of other-ness in fiction. In what way did Stendhal believe in Jesuit priests, or Woolf believe in the lighthouse? Those were actualities whose reality was a kind of temptation, not a belief, and whose reality had to be explained in fiction.

Perhaps Mailer is simply being noisy. Perhaps he is confusing identification with belief. But notice that what is holy to Mailer are not miracles, but writing: it is the "imaginative framework in which the book is written" that becomes sacred, and writing a kind of religion. In order to write, says Mailer, one must "believe." This is in keeping with his generally athletic and operatic approach to literature, which he has always seen as a prizefight of the spirit. Yet the failure of his novel is precisely its inability to make real such things as miracles. An artist struggles to make something real when he is not sure that others will believe. Is it not possible that Mailer's "belief" short-circuited that struggle, made it irrelevant? If mira-cles exist, then why labor to evoke them? If Jesus is the Son of God, then why convince anyone?

Mailer is not a novelist here; he is a very late, very bad pseud-epigraphist. Though he does not mean to, he returns the novel to a piece of biblical writing. His belief turns him into a religious "en-thusiast" for fiction at the very moment at which he should be a novelist. It is a dereliction familiar in Mailer's career. In order to write about these events "as if they were real," he tells us, he had to believe that they were real. Believing them to be real, he does not labor to make them real. He has already done the imagina-tive sweating at home. Why share it? But of course he has done no sweating at all.

It is possible to credit Jesus's humanity without irreverence. Equally, it is possible to credit Jesus's divinity without believing in

it. Two great works of our time, both by non-believers, demonstrate this. They are Pasolini's film, *The Gospel According to St. Matthew* (1964), and a novel by the Portuguese novelist Jose Saramago, *The Gospel According to Jesus Christ* (1991). Both works embarrass Mailer's earnest fraudulence. Both present a Jesus who resembles, at first sight, Mailer's, or Renan's: tetchy, confused at times, a fallible gatherer of men, a revolutionary. Both artists are unafraid of the supernatural: their Jesus speaks with God, is visited by angels, walks on the water. Yet both artists wrestle with the biblical texts they have inherited, seeing them almost as a devilish challenge to artistic originality.

It is because their stories already exist as stories that these artists sink themselves so heavily in the real. The real is their great modern advantage as artists, over their inheritance. "Belief" may be surrendered, but the real must be guarded. Pasolini, using Calabrian peasants and non-actors, lets the camera browse beautifully over the faces of poor men and women. He makes the camera explore a physiognomic skepticism: an innocent sarcasm stares from these peasants' faces as Jesus preaches to them. Animals snuffle in the mud. There are children everywhere, shouting and begging. Jesus moves in a cloud of urchins. There is dirt and noise. At one moment, Jesus strides past a group of men working in the fields. As he passes them, he tells them to repent, for the kingdom of God is at hand. They turn and look at him as if he is a madman. The camera slows. The deep irrelevance of Jesus to their lives is made manifest. And while they look suspicious, their faces also have a kind of sanctity, for they cannot be touched. Mailer's entire novel is not worth that one scene.

Saramago does not mimic the gospel stories like Mailer, he bounces off them. He novelizes. Mary is a poor wife, Joseph is a mediocre carpenter. (Mailer makes Joseph a sage of carpentry.) While Matthew tells us that Joseph sees in a dream that he and his

family must escape Herod and flee to Egypt, Saramago has Joseph overhear two of Herod's soldiers talking about the dread orders that they have just received, and must soon obey. Terrified, he runs home. Unlike Mailer, who accepts the biblical absence, Saramago makes Joseph a real father to Jesus. Saramago's Joseph is captured by mistake, rather as Pierre is captured in *War and Peace*, and crucified by the Romans as a rebel. When Jesus, who is only a little boy, hears of his father's death, he cries out: "Father, Father, why have you forsaken me?" The irony is not forced, and it humanizes the later identical lament, enriches it. Jesus becomes Mary Magdalene's lover. The two are inseparable, and she is one of the few who truly believes in him. When Jesus is on the verge of raising Lazarus from the dead, Mary Magdalene stops him, saying, "No one has committed so much sin in his life that he deserves to die twice."

It is in such swerves, such disobedience, that a great novelist refreshes himself. The gorgeous paradox of Pasolini's film and Saramago's novel is the paradox of the incarnation made animate: the more real Jesus becomes, the more divinely he shines. The more skeptical these works of art, the more reverence is in their skepticism. The more reverent they are, the more it is a reverence for the real. Mailer cannot show us a real Jesus, and so he cannot tempt us with the expensive lure of the incarnation. Besides, would Mailer, once so talented at scouring the actual, even recognize the greatness of these two versions of the gospels? Each new book by him is worse than the last: he has become a bibliographer's definition of nostalgia. He remembers that one must be daring as an artist, but he has forgotten to what end. His Jesus blusters, in Mailer fashion, about the importance of boldness, and despises "the timid heart." But a timid heart might have flinched, properly, at sounding this worthless echo.

PART TEN
2000s

"Over the last 25 years, liberalism has lost its good name and its sway over politics. But it's liberalism's loss of imagination that is most disheartening . . . Liberals have grown chastened and confused, afraid to think big ideas. Such reticence has its time and place; large-scale political and substantive failures demand introspection, not to mention humility. But it is time to be ambitious again."

THE EDITORS, "MORAL IMPERATIVE"

MARCH 20 & 27, 2006

Disgrace

JEFFREY ROSEN

December 25, 2000

This was written quickly and angrily—and despite all the time that has elapsed since it first appeared, it remains a thoroughly satisfying act of venting against one of history's worst Supreme Court decisions. Even casual readers of our legal correspondent, Jeffrey Rosen, a paragon of civility, understood that this splenetic writing was uncharacteristic, and therefore justly dispensed.

On Monday, when the Supreme Court heard arguments in *Bush v. Gore*, there was a sense in the courtroom that far more than the election was at stake. I ran into two of the most astute and fair-minded writers about the Court, who have spent years defending the institution against cynics who insist the justices are motivated by partisanship rather than reason. Both were visibly shaken by the Court's emergency stay of the manual recount in Florida; they felt naive and betrayed by what appeared to be a naked act of political will. Surely, we agreed, the five conservatives would step back from the abyss.

They didn't. Instead, they played us all for dupes once more. And, by not even bothering to cloak their willfulness in legal ar-

guments intelligible to people of good faith who do not share their views, these four vain men and one vain woman have not only cast a cloud over the presidency of George W. Bush. They have, far more importantly, made it impossible for citizens of the United States to sustain any kind of faith in the rule of law as something larger than the self-interested political preferences of William Rehnquist, Antonin Scalia, Clarence Thomas, Anthony Kennedy, and Sandra Day O'Connor.

This faith in law as something more than politics has had powerful opponents throughout the twentieth century. For everyone from legal realists and critical race theorists to contemporary pragmatists, it has long been fashionable to insist that the reasons judges give are mere fig leaves for their ideological commitments. Nevertheless, since its founding, *The New Republic* has resisted this cynical claim. From Learned Hand and Felix Frankfurter to Alexander Bickel, the editors of this magazine have insisted that, precisely because legal arguments are so malleable, judges must exercise radical self-restraint. They should refuse to second-guess the decisions of political actors, except in cases where constitutional arguments for judicial intervention are so powerful that people of different political persuasions can readily accept them.

This magazine has long argued that the legitimacy of the judiciary is imperiled whenever judges plunge recklessly into the political thicket. And this has led editors of different political persuasions to oppose the judicial invalidation of laws we disagreed with as well as those we supported—from Progressive-era labor laws to the New Deal administrative state to laws restricting abortion and permitting affirmative action. In all these cases, we argued that judges should stay their hand. Our views about judicial abstinence have been those of Oliver Wendell Holmes: "If my fellow citizens want to go to hell, I will help them," he said. "It's my job." But in *Bush v.*

Gore, as in *Dred Scott* and *Roe v. Wade*, the justices perceived their job differently. They foolishly tried to save the country from what they perceived to be a crisis of legitimacy. And they sent themselves to hell in the process.

The unsigned per curiam opinion in *Bush v. Gore* is a shabby piece of work. Although the justices who handed the election to Bush—O'Connor and Kennedy—were afraid to sign their names, the opinion unmasks them more nakedly than any TV camera ever could. To understand the weakness of the conservatives' constitutional argument, you need only restate it: Its various strands collapse on themselves. And, because their argument is tailor-made for this occasion, the conservatives can point to no cases that directly support it. As Justices John Paul Stevens, Ruth Bader Ginsburg, and Stephen Breyer write in their joint dissent this "can only lend credence to the most cynical appraisal of the work of judges throughout the land."

What, precisely, is the conservatives' theory? "Having once granted the right to vote on equal terms, the State may not, by later arbitrary and disparate treatment, value one person's vote over that of another," they declare. The citation is *Harper v. Virginia Board of Elections*, the case that invalidated the poll tax in 1966 on the grounds that it invidiously discriminated against the poor. But there is no claim here that Florida's recount law, shared by 32 other states, discriminates against the poor. Indeed, Florida argued that its scheme is necessary to *avoid* discrimination against the poor, because a uniform system of recounting that treated the punch-card ballots used in poor neighborhoods the same as the optically scanned ballots used in rich ones would systematically undercount the votes of poorer voters. By preventing states from correcting the counting errors that result from different voting technologies, the conservatives have precipitated a violation of equal treatment far larger than the one they claim to avoid.

"The fact finder confronts a thing, not a person," write the conservatives in a clumsy and perverse inversion of the famous line from *Reynolds v. Sims*, the great malapportionment case, which noted that "legislators represent people, not trees." But things do not have constitutional rights; people have constitutional rights. It is absurd to claim that the "right" of each ballot to be examined in precisely the same manner as every other ballot defeats the right of each individual to have his or her vote counted as accurately as possible. Were this theory taken seriously, many elections over the past 200 years would have violated the equal protection clause, because they were conducted using hand counts with different standards. The effect of the majority's whimsical theory is to fan the suspicion, which now looks like a probability, that the loser of both the popular vote and the electoral vote has just become president of the United States. At least the ballots can sleep peacefully.

The conservatives can rustle up only two cases that purportedly support their theory that Florida's recount scheme gave "arbitrary and disparate treatment to voters in its different counties." (Both were written in the 1960s by liberal activist Justice William Douglas, which must have given the conservatives a private chuckle.) The first case, *Gray v. Sanders*, held that Georgia's county-based scheme of assigning votes in the Democratic U.S. senatorial primary discriminated against voters in urban counties, whose votes were worth less than those in rural counties. The same logic, applied to this case, would hold that the Florida legislature could not adopt a county-based scheme for assigning votes in presidential elections. But this conclusion is completely inconsistent with the conservatives' earlier argument, the one that emboldened them to stop the manual recount in the first place: that Article 2 of the Constitution allows the Florida legislature to structure its presidential electing system however it chooses. The second case, *Moore v. Ogilvie*, held that applying "a rigid, arbitrary formula to sparsely settled counties and

populous counties alike . . . discriminated against the residents of the populous counties of the State in favor of rural sections." That case, in other words, does not support the conservatives' claim that ballots in rural and urban counties must be counted and recounted in precisely the same manner. It suggests the opposite.

The reason the Conservatives can find not a single precedent to support their equal protection theory is because the theory is made up for this case only. But the damage is not so easily limited. The Supreme Court has called into question not only the manual-recount procedure adopted by the legislature of Florida but our entire decentralized system of voting—in which different counties use different technologies to count different ballots designed differently and cast at different hours of the day. In addition to throwing the presidential election and destroying the legitimacy of the Supreme Court, *Bush v. Gore* will spawn an explosion of federal lawsuits after every close election, lawsuits arguing that different counties used different ballot designs and voting systems and counted the ballots in different ways.

In this way, *Bush v. Gore* is a ludicrous expansion of cases like *Shaw v. Reno*, in which the same five-member conservative majority, led by the addled and uncertain Sandra Day O'Connor, held that federal courts must second-guess each legislative exercise in state and federal redistricting to decide whether or not race was the "predominant purpose" in drawing district lines. The idea that this usurpation of our democratic electoral system by the federal judiciary has been precipitated by a group of conservatives who once posed as advocates of judicial restraint and champions of state legislatures can only be met with what the legal scholar Charles Black called the sovereign prerogative of philosophers: laughter.

But the majority asks us not to worry about the implications of its new constitutional violation. "Our consideration is limited to the

present circumstances, for the problem of equal protection in election processes generally presents many complexities," the justices write. It certainly does. But a mobilized nation is now far less likely to tug its collective forelock and wait for the preening O'Connor and Kennedy to sort out the confusion on our behalf. We've had quite enough of judicial saviors.

In a poignant attempt to split the difference between the two camps, Justices Breyer and David Souter tried to prevent the Court from destroying itself. They agreed that applying different counting standards to identical ballots in the same county might violate the equal protection clause, and they proposed sending the ballots back to Florida and letting its courts apply a uniform counting standard. But their attempt at statesmanship was crudely rejected by O'Connor and Kennedy, which left Breyer and Souter with their hands extended, played for dupes like everyone else who naively believed the conservatives were operating in good faith. "Because the Florida Supreme Court has said that the Florida Legislature intended to obtain the safe-harbor benefits of 3 U.S.C. Sec. 5," O'Connor and Kennedy wrote in the tortuous punch line of their opinion, "Justice Breyer's proposed remedy—remanding to the Florida Supreme Court for its ordering of a constitutionally proper contest until December 18—contemplates action in violation of the Florida election code." With this feint at deference to the state court at precisely the moment there was nothing left to defer to, the jig was up. O'Connor and Kennedy had converted the Florida courts passing reference to the federal law telling Congress which electoral slate to count in the event that a controversy was resolved before December 12 into a barrier, now mysteriously embedded in state law, that prevented the Florida Supreme Court from completing manual recounts after December 12. And for the Court to announce this rule at ten o'clock at

night on December 12, after having stopped the count two precious days earlier, only added to the gallows humor.

It will be impossible to look at O'Connor, Kennedy, Scalia, Rehnquist, and Thomas in the same light again, much as it was impossible to look at President Clinton in the same light after seeing him exposed in the Starr Report. But this time the self-exposure is also a little bracing. Conservatives have lectured us for more than 30 years about the activism of the Warren and Burger Courts. Those tinny and hypocritical lectures are now, thankfully, over. By its action on December 12, the Supreme Court has changed the terms of constitutional discourse for years to come. Just as *Roe v. Wade* galvanized conservatives a generation ago to rise up against judicial activism, so *Bush v. Gore* will now galvanize liberals and moderates for the next generation. But, unlike the conservative opponents of *Roe*, liberals must not descend to the partisanship of the current justices; they must transcend it. The appropriate response to *Bush v. Gore* is not to appoint lawless liberal judges who will use the courts as recklessly as the conservatives did to impose their sectarian preferences on an unwilling nation. The appropriate response, instead, is to appoint genuinely restrained judges, in the model of Ginsburg and Breyer, who will use their power cautiously, if at all, and will dismantle the federal judiciary's imperious usurpation of American democracy. Those of us who have consistently, if perhaps naively, opposed liberal and conservative judicial activism throughout the years can now point to *Roe* and *Bush* as two sides of the same coin. (How fitting that Bush is now a dubious president *and* a dubious precedent.)

In his dissent in *Casey v. Planned Parenthood*, the abortion case that reaffirmed *Roe* in 1992, Scalia recalled the portrait of Chief Justice Taney that hangs in the Harvard Law School library. Taney had led a bitterly divided Supreme Court to strike down the Missouri Compromise; but, instead of saving the nation from

its partisan divisions, his reckless intervention precipitated the Civil War:

> There seems to be on his face, and in his deep-set eyes, an expression of profound sadness and disillusionment. Perhaps he always looked that way, even when dwelling upon the happiest of thoughts. But those of us who know how the luster of his great Chief Justiceship came to be eclipsed by *Dred Scott* cannot help believe that he had that case—its already apparent consequences for the Court and its soon-to-be-played-out consequences for the Nation—burning on his mind. I expect that two years earlier he, too, had thought himself "call[ing] the contending sides of national controversy to end their national division by accepting a common mandate rooted in the Constitution." It is no more realistic for us in this litigation, than it was for him in that, to think that an issue of the sort they both involved . . . can be "speedily and finally settled" by the Supreme Court. Quite to the contrary, by foreclosing all democratic outlet for the deep passions this issue arouses, by banishing the issue from the political forum that gives all participants, even the losers, the satisfaction of a fair hearing and an honest fight, by continuing the imposition of a rigid national rule instead of allowing for regional differences, the Court merely prolongs and intensifies the anguish.

Who would have dreamed that in describing Taney's portrait Scalia imagined his own?

Saint Gerhard of the Sorrows of Painting

JED PERL

April 1, 2002

One of the sad facts of writing well about our culture is that it requires viewing an unending parade of dreck—unworthy objects rewarded with undeserved praise. The critic is faced with the choice of joining the chorus of praise or resisting it. Despite the integrity of dissidence, that course has its perils, too. The task of unmasking poseurs over and over can become tedious. Jed Perl, our longtime art critic, manages to muster genuine anger at the charlatans, without succumbing to the professional hazards that accompany a slashing style. That's because he doesn't just aim to expose the frauds; he believes fervently in "painting's hellbent magic." For all the necessary negative reviews he has written, he has never lost the capacity for tender explication.

Gerhard Richter is a bullshit artist masquerading as a painter. His retrospective, at the Museum of Modern Art until May, is a colossal bummer—a hymn to deracination, a visual moan. This seventy-year-old artist works in paint on canvas, but what he sends out into the world are not paintings so much as they are Neo-Dadaist puzzles engineered to inspire philosophical flights of fancy among art professionals who are more interested in massaging their world-

weary minds than in using their jet-lagged eyes. The Modern, that inner sanctum of art-world officialdom, has gone all out for Richter, bringing together some one hundred eighty-eight canvases that span forty years, so that museumgoers can see how he has packaged and repackaged his hold-everything-at-a-distance pose, serving up both realist and abstract images, both blurred gray photorealist scenes and coarsely colored rehashes of Abstract Expressionist brushwork. Robert Storr, the senior curator in the department of painting and sculpture who organized this show, will tell you that there is beauty in this chilly stuff, but all I see in Richter and his supporters is a loathing for painting's hellbent magic.

Everything in Richter's work is muffled, distanced, impassively ironic, as if it were being seen through a thick, murky sheet of glass. What some observers regard as the signs of hope that Richter sprinkles through his work—a photorealist image of a candle, or a blurry rendering of his young son—are witheringly calculated, like stills from an avant-garde soap opera in which the feelings are overcooked and bland. This vast show is an experience, all right: an experience of visual deprivation. At the Museum of Modern Art, Richter is presented as the painter-who-kept-painting-in-spite-of-the-death-of-painting; and to an art world that was once brainwashed into believing that painting was dead, he represents the newer painting-is-not-dead form of brainwashing. He plays the role of Saint Gerhard of the Sorrows of Painting. And a weird ennui, a kind of shared psychosis, hovers in the gallery air.

The exhibition begins with gray canvases done from photographs in the mid-1960s, after Richter, who was born and studied art in East Germany, moved to the West. Storr makes much of this linkage between Richter's coming-of-age in wartime and postwar Germany and those woozy monochromatic images of smiling relatives and humdrum household objects and figures in news photos, as if the dispiriting times in which an artist lives justify the creation

of inert art. In his catalogue essay, Storr brings a honey-toned portentousness to a text that covers some seventy-five tightly packed pages. He is writing the life of the saint. The art world is Richter's wilderness. The mood is deprivation chic. "Transposing the frozen action of the photograph into the enduring but temporally ambiguous realm of painting," Storr explains, "Richter fastened on the emblems and ephemera of postwar life and distilled their often bitter essence in tonal pictures whose poetry is a combination of matter-of-fact watchfulness and unrelieved uncertainty." This sounds augustly metaphysical, but what Storr's distillations and "uncertainty" actually amount to are Richter's chilly moods. Gray can be one of the greatest weapons in a painter's arsenal, of course, *if* the restrained hues are mixed from rich colors so that they have fiery undercurrents, or *if* they are spaced and proportioned to create a visual music. But gray is just a logo for Richter—an advertisement for the tedium of postwar existence.

Richter presents his murky images with the certainty of scientific proofs. These paintings have a technological veneer. They are handmade objects with a weirdly mechanized gleam. And this effect turns Richter's canvases into the ultimate buyables for hip collectors who want something that fits right in with their electronic gadgetry and sparely expensive décor. The curators, the dealers, the collectors, the critics, and the artists who admire Richter's work— and they are legion—believe that he is showing them how we live now, as sensitive sad sacks in a manicured minimalist bubble. And of course the fact that Richter is German is supposed to guarantee the authenticity of his experience.

Although this show has been accompanied by mea culpas to the effect that we Americans are too slow to recognize new European art, the truth is that Richter is only the most recent in a series of European artists, and especially German artists, who have received a kind of manic adulation in the States; they include Joseph Beuys, Anselm

Kiefer, Georg Baselitz, Sigmar Polke, and the photographer Andreas Gursky, who was the subject of a show at the Modern last season. For an audience whose attitude toward the very idea of art is one of fashionable doubt, an artist who can associate himself with the calamitous history of Germany takes on an extra-artistic importance. Richter has no interest in the visual histrionics that Kiefer once used to bulk up his shallow thoughts about the War and the Leader and the Homeland; but Richter's more restrained and veiled approach to German history is perfect now, when there seems to be some embarrassment about the lunatic fervor with which people fell all over themselves in praise of Kiefer a decade ago.

There is an analytical chill to Richter's work: if Kiefer was phony Wagner, Richter is phony Kafka. One of Richter's quixotic remarks (they come by the truckload) goes like this: "The picture [I guess he is referring to photography] is the depiction, and painting is the technique for shattering it." That little nugget takes you to the core of Richter's blandly nihilistic attitude. It is difficult to be impressed by all this talk about painting's being a destructive force, since the talk is being done by an artist who demonstrates no ability to construct a painting in the first place. Richter never escapes from the wanly monochromatic atmosphere of the paintings in those early galleries at the Modern, even when he is using raucous color in some of the abstractions done in more recent years. Color in Richter's work, red and green or black and white, has no contrapuntal effect. There is no sense of how a particular amount of color creates an emotional impact. The sizes of the paintings are arbitrary, and the color is all localized and trivialized, dispiritingly descriptive in most of the realist paintings and blandly emblematic in some of the abstract ones.

There is much talk about the range of Richter's work. He does paintings after news photographs and family snapshots, he does landscapes and seascapes and still lifes, he does abstractions with

bold brushwork and others with viscous rivulets of paint. Yet every-thing that Richter paints brings us back to the same tepid, tamped-down vision. Each image looks as if it were excerpted from some vast, undifferentiated stock of images. In fact Richter owns such a collection of images, a compendium of snapshots and pictures taken from newspapers and magazines that he calls his *Atlas*; it was ex-hibited at the Dia Center in 1995. And Richter's compositions have the perfunctoriness of clippings. Where an image begins or ends is utterly arbitrary. And his brushwork—which is all trickery and gimmickry—never serves to structure the space.

You may wonder how Richter achieves those blurry, smudged effects in the photorealist works, or those layers of rumpled paint in the abstract ones. This is idle curiosity. Technique is just a form of visual static that disrupts—and confers a false importance upon—banal images. One of the motifs in the early part of the show is a roll of toilet paper. This inspires Storr to muse, in an interview with Richter: "What happens when the subject is not Titian but a toilet paper roll?" (Richter has taken an interest in an *Annunciation* by the Venetian master.) The talk that Richter's work inspires can sound like a skit on *Saturday Night Live*, except that nobody is laughing.

The Museum of Modern Art does not give living artists retro-spectives so much as it gives them sainthood, and Storr has done such a thorough job on Richter's behalf that even a skeptic would say that there is a weird fascination in the proceedings. There is a kind of diabolical logic to Storr's writing, so that anything that has ever been said about Richter's paintings, positive or negative, becomes a form of praise. Argue that his work is boring, and Storr explains that this is a beautiful boredom. Describe his work as anti-painting, and your comment becomes a way of insisting on the im-portance of the work as painting.

Richter's "contribution to the medium," Storr acknowledges, has been described as that of a "lethal parodist, dour undertaker,

dry-eyed mourner, systematic debunker of clichés, demystifying conjurer of illusions, or as tenacious seeker of ways to make visible the longing and queasy uncertainty inherent in our hunger for pictures." Yet through it all Richter has, "paradoxically or stealthily, demonstrated painting's resiliency." Richter, Storr writes, believes that painting can be " 'everything' shadowed by the fear of 'nothing.' " He "has managed to straddle the divide between conceptual and perceptual art," not by "hedging his bets" but by "bridging the gap." Storr's catalogue essay is written with the intricate twists and turns of the expert courtier. The reader is lulled into believing that the entire history of art in the past fifty years flows straight into these stupefyingly lifeless paintings.

I do not dislike one or another of Gerhard Richter's paintings. I reject the work on fundamental grounds, as a matter of principle. I do not accept the premise on which his entire career is based: that in the past half-century painting has become essentially and irreversibly problematical, a medium in a condition of perpetual crisis. This is a counterfeit crisis, as far as I am concerned. This crisis is the invention of cynical marketers who, disguised as fashion-conscious nihilists, have managed to bulk up the essentially marginal figure of Duchamp until he overshadows Matisse, Mondrian, and all the hard-working makers and finders of the century just passed. Although he is quick to express his reservations about Duchamp, Richter would be nowhere without the Dadaist deity telling us that art has failed. Remove the phony crisis, remove the aura of oh-so-elegiac loss, and Richter's work dissolves right before your eyes.

The fundamentally unanalyzed fact of Richter's career is his slavish dependency on photographic images. We would do well to remember that only four years ago Robert Storr organized at the Modern a retrospective of Chuck Close, another contemporary

artist whose career is grounded in a slavish dependency on photographic images. These are not artists who from time to time take an interest in the particular qualities of certain photographic images, or who find compositional or structural ideas in photographs that intrigue them and that they think of bringing into their work as painters. They cling to the two-dimensional images that the camera produces in order to concoct their own two-dimensional painted images. True, many of Richter's abstract paintings are done without reference to photographs. But even in these cases he reaches for the smoothed-out glossiness of a color Xerox, and in other cases, the abstractions are based on photographs—some seem to be painted replicas of photographs of abstract brushwork. I think Richter wants all his non-objective images to have the melancholy feeling that adheres to coarse reproductions of Abstract Expressionist classics.

Basically, Richter and Close have ceded the act of creation to the camera. After which they dither around with notions of facture and style—they give their photographic material a personalized "artistic" spin. Yet there is always a deadness to this work: the deadness of their dependency on the photograph, of their inability to make anything on their own. They want us to believe that that deadness is a form of hipness.

Richter and Close are far from being the only contemporary artists who are hardpressed to respond to nature if they do not have a camera to do the looking for them. Countless academic portrait painters, who will never garner any attention at the Museum of Modern Art, depend on photographs when they do their work; and they are dismissed as sentimental hacks. With Richter and Close, however, photorealism has an avant-gardist éclat, as if their own inability to reconstruct the world could be blamed on modern art, which has left them photo-dependent. Richter spouts banalities about photography's taking on "a religious function. Everyone has produced his own 'devotional pictures.'" And Storr trots out the

old cliché about "photography's historical usurpation of painting's function of representing reality," as if great painters had not been working directly from nature straight through the twentieth century. There is no crisis in the artist's relationship with reality.

A few days after the Richter show opened I was in London, where the big event at Tate Modern is a Warhol retrospective. I do not regard Warhol as a great artist, but at least his early Marilyns and Lizes, which come out of the same years as the first works in the Richter show, have a funny punch. For a time in the early 1960s, Warhol was using the silkscreen process and his overheated color sense to give photographic images a boisterous graphic impact. After that, his work is nothing at all; but what really bothered me in London was not the assembly-line vacuity of the paintings that filled the gloomy halls of Tate Modern so much as the many groups of school-age kids who were being shepherded through the show. There are by now several generations of museumgoers who have been trained to regard photo-dependency as a fact of artistic life. And they may ultimately be unable to understand that the act of creation can be a genuinely independent act. They may find themselves going through the Richter retrospective at the Modern—or at museums in Chicago, San Francisco, and Washington, where the show is headed in the coming year—and feeling an emptiness in the work, but they will have no way of understanding this emptiness, since they have been taught to believe that there is no alternative to this photo-derived junk.

Gerhard Richter is a post-Duchampian message artist. The curators and the critics who embrace his work are the same ones who long ago accepted the most visually and intellectually impoverished forms of Minimal and Conceptual art as key late-twentieth-century achievements. They may still like that stuff, or at least they say that

they like it, but art professionals know instinctively that the end-of-art pose may eventually threaten their very livelihoods. That's where Richter comes in. He is one of a number of artists who can get the art world beyond the nihilistic poses while aggrandizing the endgame attitudes. Richter is presented as the way out of our troubles, and it is truly extraordinary how many people are eager to climb on the bandwagon. Weeks before the show opened, *The New York Times Magazine* ran a huge profile of Richter by Michael Kimmelman, the paper's chief art critic, and when the work was up Kimmelman was at it again, praising Richter for maintaining "a kind of cruel faith" in painting.

There is something cruel about the Richter retrospective: it is cruel to see what it does to painting. Richter's work is preachy in a dry, quixotic way that many people mistake for seriousness incarnate. In place of structural dynamics, he offers mingy technical precision; the work has the cool fussiness of a lesson plan. I am reminded that Richter went to art school in East Germany at a time when Socialist Realism was still the order of the day, and in his twenties he actually did some murals of the Happy Worker variety. Half a century later Richter is still preaching to the converted, only to a different congregation. Everything he has done since coming to the West remains polemical, in a kind of après-postmodernism, art-is-over-long-live-art way. He gives a Socialist Realist rigidity to post-modernism's most cherished hopes and dreams. The work has a get-with-the-program sullenness.

That Richter does both representational and abstract paintings, and does them sometimes more or less simultaneously, may strike some people as a heartfelt response to the sense of multiplying possibilities of modern art. There is, after all, an inherent unity between representation and abstraction, and this may turn out to be

the essential discovery of twentieth-century art, a discovery that is lodged deep in the achievements of Picasso, Matisse, and Klee. But Richter makes a mockery of this unity. His abstract and realist works may hang in close proximity, but they are locked in an intellectual face-off, as disconnected from one another as they are from any meaningful sense of structure, of paint quality, of metaphor, of poetry. He gives the giddy possibilities of modern art a hectoring, polemical presentation.

Richter gives us nothing to look at, but the chatter that swarms around his work is full of brain crushers. In the early 1970s Richter created *48 Portraits*, a series of black-and-white photorealist renderings of the faces of modern worthies, ranging from Einstein to Stravinsky to Dos Passos to Hindemith. (It also includes artists who seem to have wandered into the twentieth century by accident, such as Puccini.) *48 Portraits*, which hangs above a stairway at the Modern, may well be the most visually inert set of canvases ever displayed in this museum. That will seem like a criticism, until you read what Richter says about *48 Portraits*: "Those were the typical neutral pictures that one finds in an encyclopedia," he explains to Storr. "The issue of neutrality was my wish and main concern. And that's what they were. That made them modern and absolutely contemporary."

When I look at a photograph of a modern artist whom I admire, such as Stravinsky, I do not find it neutral at all. I am excited by what I can learn about a person from a photograph. And I believe others are too. So why does anybody accept Richter's neutralist bilge? The only thing that I find more depressing than this charlatan is the passivity of the museumgoers who pass before his works: they may have an inkling that they are being had, but they are unable to trust the evidence of their eyes.

These paintings do not give off anything, but they are manipulative to a truly extraordinary degree. They hang there on the wall

and insist on your making something of them. At times Richter wants us to make something out of nothing, as in the *Color Charts*, vast paintings dating from the 1960s and 1970s in which each rectangle is filled in with something like a commercial color mixture. (Even Storr doesn't know what to say.) At other times Richter aims to produce an intellectual chowdown. A prime example here is *October 18, 1977*, a series of fifteen black-and-white paintings from 1988 based on photographs and video footage related to the story of the Baader-Meinhof gang. This series, in which scenes from the misadventures of the legendary leftist group are given a grainy black-and-white elegance, are a dictionary definition of radical chic. As art, they are numb. As conversation starters, they are just the thing. You can wonder if several prison deaths were suicides, as the official accounts had it, or something else. You can wonder at what the murderous activities of these radicals tell you about German society. Storr has already devoted an exhibition and a book to these works; they are in the Modern's permanent collection.

Storr believes that these silly paintings reflect Richter's complicated political vision, as a man who has rejected the ideological extremism of communism (hasn't everybody?) but is also skeptical about the liberal society of West Germany. Storr looks at Richter's pallid exercises in political noir and thinks what he imagines are big, subtle thoughts. Richter makes him realize that "truth is fragmentary, that its enemy—ideology—is ultimately murderous, and that history is irremediable and, for the most part, irretrievable." Maybe what Storr and Richter are really saying is that the appropriate photographer was not at the scene.

There is a kind of self-help, twelve-step-program atmosphere around the Richter retrospective. From room to room, Richter confronts hard truths, and grows as a man and as an artist. Having begun with tough love, he is now said to have become a poet of an old-fashioned sort of romantic love. There is a Hallmark-card

sentimentality about the excitement with which critics are saluting the recent portraits of his youthful wife and his young son, both of whom he paints in a soft-focus, dime-store-Vermeer style that is apparently easily mistaken for the real thing. The sourpuss conceptualist has matured into a Wordsworthian elder. Storr sees in Richter's paintings of his young son "an elusive mix of fascination, bemusement, and uneasiness, which is an adult manifestation of the devoted, puzzled, and wary gaze a child might direct at its parents." The vacuum-packed tenderheartedness of these recent works is seen as Richter's apotheosis; but the apotheosis turns out to be just another photo-op.

A little over twenty years ago, Richter and Warhol, these two artists who are currently the subjects of enormous retrospectives in New York and London, were among some three dozen artists included in an exhibition called "A New Spirit in Painting" at the Royal Academy in London. The show, which mingled the work of several generations, was hailed by Christos M. Joachimides, one of the curators, as telling the world that "the artists' studios are full of paint pots again and an abandoned easel in an art school has become a rare sight." "A New Spirit in Painting" featured the work of Neoexpressionists such as Schnabel, Baselitz, and Kiefer, and of harder-to-categorize artists such as Balthus, Kitaj, Auerbach, Freud, Twombly, and Helion, as well as established modern masters such as de Kooning and Picasso.

The London show generated a good deal of excitement, in part because it presented a broader range of work than you might normally expect from a trendsetting exhibition. But in the twenty years since 1981 there can be little doubt that the artists who have received the most attention are the ones who always remained open to the possibility that the paint pots might again be empty and that

the easels might again be abandoned. True, Freud has had a phenomenal success, and Twombly has enjoyed a retrospective at the Modern. But among the representational painters included in "A New Spirit in Painting" who felt no need to slavishly mimic photographs, three who have had retrospectives in New York—Balthus, Freud, and Kitaj—have had those shows not at the Modern but at the Metropolitan. My point is not that Robert Storr and his colleagues at the Museum of Modern Art prefer certain artists while some of us prefer others. My point is that there is an ideology to their preferences, an ideology that is determined to deny the freedom that is inherent in the very act of painting.

As it happens, just a few days after the Richter show opened at the Modern to a round of thunderous applause, Balthus's last two figure paintings went on display at C&M Arts in Manhattan. (They will be there until sometime in April.) This extraordinary event has provoked barely a flicker of publicity, and yet these two canvases, done by one of the twentieth century's greatest artists when he was in his early nineties, instantaneously overshadow everything about the appalling Richter retrospective.

A Midsummer Night's Dream, completed in 2000 and first exhibited at the National Gallery in London, is a moonlit vision of a girl asleep in a rocky landscape. Painted with the delicate, flickering hand of a very old man, this dusky reverie, in purples and greens and golds, has already taken its place (at least in my judgment) among the Venuses and the nymphs and the enigmatic lovers of Titian, Correggio, Rubens, and Watteau. The second, unfinished composition shows a girl reclining on a daybed in a room where Balthus's final cat dreams a final dream while a dog lifts its head to a window and looks out at a mountainous landscape in which every curve echoes the young woman's angular body. Taken together, these two works show us the world that Balthus was conquering at the time of his death, a world in which the figures have a new kind of rococo at-

tenuation and the jewel-like richness of the color is sometimes given a muffled padding of chiaroscuro. There can be no question that Balthus needed more time to bring the second painting, here called *The Waiting*, to the perfected state of *A Midsummer Night's Dream*. But *A Midsummer Night's Dream*, all by itself, constitutes one of the greatest gallerygoing experiences that New York has ever offered.

In London, *A Midsummer Night's Dream* found virtually no admirers. In New York, C&M Arts has been host to a small following of fanatical artists, but they are the fringe. I am sad about this, but I am not surprised. In an art world in which people are trained to admire Richter's techno-chic impersonality and Warhol's ghoulish exuberance, the painterly riskiness of Balthus's technique is going to be incomprehensible. And for anybody who is open to the experience of Balthus's *A Midsummer Night's Dream*, the whole argument about the end of painting, the argument on which Richter has been feeding for forty years, is immediately reduced to a howling absurdity.

The Gerhard Richter retrospective is the Museum of Modern Art's current definition of what matters in contemporary art. Of course no single exhibition can be said to define a museum's viewpoint, but considering the enormous size of this retrospective, and the fact that it is the second show that the Modern has devoted to Richter in recent years, and the critical position that Storr currently holds at the museum, there is reason to believe that we are in the presence of a signal event. The Richter retrospective is also one of the last shows that we are going to see in the museum's current quarters, which will close in May, at which point the museum will move its operations to Long Island City so that a vast expansion program that is slated to be completed in 2005 can go forward on West 53rd Street.

Thus the Richter exhibition takes on a Janus-faced aspect. We see the people who are in charge at the museum laying their bets on what has mattered in the past forty years, even as they suggest what will be remembered in the years to come. And what have they come up with? This painting without savor, without warmth, without life. The Museum of Modern Art used to be accused of developing and promoting a one-track way of thinking about twentieth-century art. This approach, which emphasized the logical development of a modern language of form, had a visionary power that museumgoers could accept as the whole truth or as some part of the truth, but in either case this vision gave the museum its fascination—and certainly its integrity. In recent years, however, that vision has eroded until it is unrecognizable, and by now all that the powers that be at the Museum of Modern Art want to do is blend in with whatever is happening in the art world at large. The Modern, for all its unrivaled collections and international clout, has become a wanna-be institution. The Richter retrospective is one more grim reminder that this museum that once led taste now only follows.

The Museum of Modern Art now imagines that the way to succeed is to join in and go along, so it accepts the standard-issue international art stars and whatever incoherent catch-as-catch-can view of the history of twentieth-century art will give that work its shaky legitimacy. This is the kind of tactical thinking that lay behind "MoMA2000," the recent overview of the museum's collections, which offered a variety of anti-chronological and non-chronological and thematic approaches, and was conceptually indistinguishable from the theoretical caprices that have turned so many European surveys of modern art into forgettable sideshows. It was during "MoMA2000" that I began to hear artists saying that they felt increasingly dispirited about the very prospect of going to the museum.

Critics of the Museum of Modern Art receive a standard response, which is that the museum has always had its critics, and that the biggest game in town is always going to take some big hits. Yet the entire question of content may be increasingly irrelevant at the Modern. The museum's attention has shifted from the development of a truly loyal public to the brute dollars-and-cents questions involved in figuring out how to get enough people through the doors to meet revenue goals and to satisfy the public and private funders who are supporting a vast expansion plan. There can be little doubt that, despite the downturn in museum attendance since September 11, the Modern will in the long run bring in the crowds. Richter is said to be a hit. And the museum has a blockbuster, "Matisse/ Picasso," scheduled for Long Island City in 2003.

Yet when it comes to the issues that once animated this museum— how tradition relates to innovation and how both relate to the experience of the eye—there is a small but growing number of museum-goers who see the Modern as an institution that has not only lost its way but also lost its mind. No retrospective in recent years has had the inviolable lucidity of the great shows that William Rubin once organized. And nothing that the museum has done about contemporary art in recent years has really been daring or engaged: it has all been art-world business as usual. When I consider what has been going on at the museum and then realize that Richter's parched vision is what the museum is offering as its temporary farewell to West 53rd Street, I cannot help but wonder whether the Museum of Modern Art will ever again be capable of properly presenting the great feast of twentieth-century art that it once set before the people of New York City and the world.

Mad About You

The Case for Bush Hatred

JONATHAN CHAIT

September 29, 2003

Jonathan Chait was the magazine's truest successor to Michael Kinsley—only he swung even harder at his opponents and in the name of a far-less conflicted spirit of liberalism. It was a spirit suited to his times, as conservatism shifted ever further to the right and toward its present-day nihilism. The scourge that needed combating was no longer the unthinking tendencies of liberals but the mindless centrism of pundits, who failed to see the true radical nature of the Bush agenda until it was too late.

I hate President George W. Bush. There, I said it. I think his policies rank him among the worst presidents in U.S. history. And, while I'm tempted to leave it at that, the truth is that I hate him for less substantive reasons, too. I hate the inequitable way he has come to his economic and political achievements and his utter lack of humility (disguised behind transparently false modesty) at having done so. His favorite answer to the question of nepotism—"I inherited half my father's friends and all his enemies"—conveys the laughable implication that his birth bestowed more disadvantage than advantage. He reminds me of a certain type I knew in high

school—the kid who was given a fancy sports car for his sixteenth birthday and believed that he had somehow earned it. I hate the way he walks—shoulders flexed, elbows splayed out from his sides like a teenage boy feigning machismo. I hate the way he talks—blustery self-assurance masked by a pseudopopulist twang. I even hate the things that everybody seems to like about him. I hate his lame nickname-bestowing—a way to establish one's social superiority beneath a veneer of chumminess (does anybody give their boss a nickname without his consent?). And, while most people who meet Bush claim to like him, I suspect that, if I got to know him personally, I would hate him even more.

There seem to be quite a few of us Bush haters. I have friends who have a viscerally hostile reaction to the sound of his voice or describe his existence as a constant oppressive force in their daily psyche. Nor is this phenomenon limited to my personal experience: Pollster Geoff Garin, speaking to *The New York Times*, called Bush hatred "as strong as anything I've experienced in 25 years now of polling." Columnist Robert Novak described it as a "hatred . . . that I have never seen in 44 years of campaign watching."

Yet, for all its pervasiveness, Bush hatred is described almost exclusively as a sort of incomprehensible mental affliction. James Traub, writing last June in *The New York Times Magazine*, dismissed the "hysteria" of Bush haters. Conservatives have taken a special interest in the subject. "Democrats are seized with a loathing for President Bush—a contempt and disdain giving way to a hatred that is near pathological—unlike any since they had Richard Nixon to kick around," writes Charles Krauthammer in *Time* magazine. "The puzzle is where this depth of feeling comes from." Even writers like David Brooks and Christopher Caldwell of *The Weekly Standard*—the sorts of conservatives who have plenty of liberal friends—seem to regard it from the standpoint of total incomprehension. "Democrats have been driven into a frenzy of illogic by

their dislike of George W. Bush," explains Caldwell. "It's mystifying," writes Brooks, noting that Democrats have grown "so caught up in their own victimization that they behave in ways that are patently not in their self-interest, and that are almost guaranteed to perpetuate their suffering."

Have Bush haters lost their minds? Certainly some have. Antipathy to Bush has, for example, led many liberals not only to believe the costs of the Iraq war outweigh the benefits but to refuse to acknowledge any benefits at all, even freeing the Iraqis from Saddam Hussein's reign of terror. And it has caused them to look for the presidential nominee who can best stoke their own anger, not the one who can win over a majority of voters—who, they forget, still like Bush. But, although Bush hatred can result in irrationality, it's not the *product* of irrationality. Indeed, for those not ideologically or personally committed to Bush's success, hatred for Bush is a logical response to the events of the last few years. It is not the slightest bit mystifying that liberals despise Bush. It would be mystifying if we did not.

One reason Bush hatred is seen as inherently irrational is that its immediate precursor, hatred of Bill Clinton, really did have a paranoid tinge. Conservatives, in retrospect, now concede that some of the Clinton haters were a little bit nutty. But they usually do so only in the context of declaring that Bush hatred is as bad or worse. "Back then, [there were] disapproving articles—not to mention armchair psychoanalysis—about Clinton-hating," complains Byron York in a *National Review* story this month. "Today, there appears to be less concern." Adds Brooks, "Now it is true that you can find conservatives and Republicans who went berserk during the Clinton years, accusing the Clintons of multiple murders and obsessing how Vince Foster's body may or may not have been moved. . . . But the Democratic mood is more pervasive, and potentially more self-destructive."

It's certainly true that there is a left-wing fringe of Bush haters whose lurid conspiracy-mongering neatly parallels that of the Clinton haters. York cites various left-wing websites that compare Bush to Hitler and accuse him of murder. The trouble with this parallel is, first, that this sort of Bush-hating is entirely confined to the political fringe. The most mainstream anti-Bush conspiracy theorist cited in York's piece is Alexander Cockburn, the ultra-left, rabidly anti-Clinton newsletter editor. Mainstream Democrats have avoided delving into Bush's economic ties with the bin Laden family or suggesting that Bush invaded Iraq primarily to benefit Halliburton. The Clinton haters, on the other hand, drew from the highest ranks of the Republican Party and the conservative intelligentsia. Bush's solicitor general, Theodore Olson, was involved with *The American Spectator*'s "Arkansas Project," which used every conceivable method—including paying sources—to dig up dirt from Clinton's past. Mainstream conservative pundits, such as William Safire and Rush Limbaugh, asserted that Vince Foster had been murdered, and GOP Government Reform Committee Chairman Dan Burton attempted to demonstrate this theory forensically by firing a shot into a dummy head in his backyard.

A second, more crucial difference is that Bush is a far more radical president than Clinton was. From a purely ideological standpoint, then, liberal hatred of Bush makes more sense than conservatives' Clinton fixation. Clinton offended liberals time and again, embracing welfare reform, tax cuts, and free trade, and nominating judicial moderates. When budget surpluses first appeared, he stunned the left by reducing the national debt rather than pushing for more spending. Bush, on the other hand, has developed into a truly radical president. Like Ronald Reagan, Bush crusaded for an enormous supply-side tax cut that was anathema to liberals. But, where Reagan followed his cuts with subsequent measures to reduce revenue loss and restore

some progressivity to the tax code, Bush proceeded to execute two *additional* regressive tax cuts. Combined with his stated desire to eliminate virtually all taxes on capital income and to privatize Medicare and Social Security, it's not much of an exaggeration to say that Bush would like to roll back the federal government to something resembling its pre-New Deal state.

And, while there has been no shortage of liberal hysteria over Bush's foreign policy, it's not hard to see why it scares so many people. I was (and remain) a supporter of the war in Iraq. But the way Bush sold it—by playing upon the public's erroneous belief that Saddam had some role in the September 11 attacks—harkened back to the deceit that preceded the Spanish-American War. Bush's doctrine of preemption, which reserved the right to invade just about any nation we desired, was far broader than anything he needed to validate invading a country that had flouted its truce agreements for more than a decade. While liberals may be overreacting to Bush's foreign policy decisions—remember their fear of an imminent invasion of Syria?—the president's shifting and dishonest rationales and tendency to paint anyone who disagrees with him as unpatriotic offer plenty of grounds for suspicion.

It was not always this way. During the 2000 election, liberals evinced far less disdain for Bush than conservatives did for Al Gore. As *The New York Times* reported on the eve of the election, "The gap in intensity between Democrats and Republicans has been apparent all year." This "passion gap" manifested itself in the willingness of many liberals and leftists to vote for Ralph Nader, even in swing states. It became even more obvious during the Florida recount, when a December 2000 ABC News/*Washington Post* poll showed Gore voters more willing to accept a Bush victory than vice-versa, by a 47 to 28 percent margin. "There is no great ideological chasm

dividing the candidates," retiring Democratic Senator Pat Moyni-han told the *Times*. "Each one has his prescription-drugs plan, each one has his tax-cut program, and the country obviously thinks one would do about as well as the other."

Most Democrats took Bush's victory with a measure of equa-nimity because he had spent his campaign presenting himself as a "compassionate conservative"—a phrase intended to contrast him with the GOP ideologues in Congress—who would reduce partisan strife in Washington. His loss of the popular vote, and the disputed Florida recount, followed by his soothing promises to be "president of all Americans," all fed the widespread assumption that Bush would hew a centrist course. "Given the circumstances, there is only one possible governing strategy: a quiet, patient, and persistent bipartisanship," intoned a *New Yorker* editorial written by Joe Klein.

Instead, Bush has governed as the most partisan president in modern U.S. history. The pillars of his compassionate-conservative agenda—the faith-based initiative, charitable tax credits, additional spending on education—have been abandoned or absurdly un-derfunded. Instead, Bush's legislative strategy has revolved around wringing out narrow, party-line votes for conservative priorities by applying relentless pressure to GOP moderates—in one case, to the point of driving Vermont's James Jeffords out of the party. Indeed, when bipartisanship shows even the slightest sign of life, Bush usually responds by ruthlessly tamping it down. In 2001, he convinced GOP Representative Charlie Norwood to abandon his long-cherished pa-tients' bill of rights, which enjoyed widespread Democratic support. According to a *Washington Post* account, Bush and other White House officials "met with Norwood for hours and issued endless appeals to party loyalty." Such behavior is now so routine that it barely rates notice. Earlier this year, a column by Novak noted almost in passing that "senior lawmakers are admonished by junior White House aides to refrain from being too chummy with Democrats."

When the September 11 attacks gave Bush an opportunity to unite the country, he simply took it as another chance for partisan gain. He opposed a plan to bolster airport security for fear that it would lead to a few more union jobs. When Democrats proposed creating a Department of Homeland Security, he resisted it as well. But later, facing controversy over disclosures of pre-September 11 intelligence failures, he adopted the idea as his own and immediately began using it as a cudgel with which to bludgeon Democrats. The episode was telling: Having spent the better part of a year denying the need for any Homeland Security Department at all, Bush aides secretly wrote up a plan with civil service provisions they knew Democrats would oppose and then used it to impugn the patriotism of any Democrats who did—most notably Georgia Senator Max Cleland, a triple-amputee veteran running for reelection who, despite his support for the war with Iraq and general hawkishness, lost his Senate race thanks to an ugly GOP ad linking him to Osama bin Laden.

All this helps answer the oft-posed question of why liberals detest Bush more than Reagan. It's not just that Bush has been more ideologically radical; it's that Bush's success represents a breakdown of the political process. Reagan didn't pretend to be anything other than what he was; his election came at the crest of a twelve-year-long popular rebellion against liberalism. Bush, on the other hand, assumed office at a time when most Americans approved of Clinton's policies. He triumphed largely because a number of democratic safeguards failed. The media overwhelmingly bought into Bush's compassionate-conservative facade and downplayed his radical economic conservatism. On top of that, it took the monomania of a third-party spoiler candidate, plus an electoral college that gives disproportionate weight to GOP voters—the voting population of Gore's blue-state voters exceeded that of Bush's red-state voters—even to bring Bush close enough that faulty ballots in Florida could put him in office.

But Bush is never called to task for the radical disconnect between how he got into office and what he has done since arriving. Reporters don't ask if he has succeeded in "changing the tone." Even the fact that Bush lost the popular vote is hardly ever mentioned. Liberals hate Bush not because he has succeeded but because his success is deeply unfair and could even be described as cheating.

It doesn't help that this also happens to be a pretty compelling explanation of how Bush achieved his station in life. He got into college as a legacy; his parents' friends and political cronies propped him up through a series of failed business ventures (the founder of Harken Energy summed up his economic appeal thusly: "His name was George Bush"); he obtained the primary source of his wealth by selling all his Harken stock before it plunged on bad news, triggering an inconclusive Securities and Exchange Commission insider-trading investigation; the GOP establishment cleared a path for him through the primaries by showering him with a political war chest of previously unthinkable size; and conservative justices (one appointed by his father) flouted their own legal principles—adopting an absurdly expansive federal role to enforce voting rights they had never even conceived of before—to halt a recount that threatened to put his more popular opponent in the White House.

Conservatives believe liberals resent Bush in part because he is a rough-hewn Texan. In fact, they hate him because they believe he is *not* a rough-hewn Texan but rather a pampered frat boy masquerading as one, with his pickup truck and blue jeans serving as the perfect props to disguise his plutocratic nature. The liberal view of Bush was captured by *Washington Post* (and former *TNR*) cartoonist Tom Toles, who once depicted Bush being informed by an adviser that he "didn't hit a triple. You were born on third base."

A puzzled Bush replies, "I thought I was born at my beloved hard-scrabble Crawford ranch," at which point his subordinate reminds him, "You bought that place a couple years ago for your presidential campaign."

During the 1990s, it was occasionally noted that conservatives despised Clinton because he flouted their basic values. From the beginning, they saw him as a product of the 1960s, a moral relativist who gave his wife too much power. But what really set them off was that he cheated on his wife, lied, and got away with it. "We must teach our children that crime does not pay," insisted former California Representative and über-Clinton hater Bob Dornan. "What kind of example does this set to teach kids that lying like this is OK?" complained Andrea Sheldon Lafferty, executive director of the Traditional Values Coalition.

In a way, Bush's personal life is just as deep an affront to the values of the liberal meritocracy. How can they teach their children that they must get straight A's if the president slid through with C's—and brags about it!—and then, rather than truly earning his living, amasses a fortune through crony capitalism? The beliefs of the striving, educated elite were expressed, fittingly enough, by Clinton at a meeting of the Aspen Institute last month. Clinton, according to *New York* magazine reporter Michael Wolff, said of the Harken deal that Bush had "sold the stock to buy the baseball team which got him the governorship which got him the presidency." Every aspect of Bush's personal history points to the ways in which American life continues to fall short of the meritocratic ideal.

But perhaps most infuriating of all is the fact that liberals do not see their view of Bush given public expression. It's not that Bush has been spared from any criticism—far from it. It's that certain *kinds* of criticism have been largely banished from mainstream discourse. After

Bush assumed office, the political media pretty much decided that the health of U.S. democracy, having edged uncomfortably close to chaos in December 2000, required a cooling of overheated passions. Criticism of Bush's policies—after a requisite honeymoon—was fine. But the media defined any attempt to question Bush's legitimacy as out-of-bounds. When, in early February, Democratic National Committee Chairman Terry McAuliffe invoked the Florida debacle, *The Washington Post* reported it thusly: "Although some Democratic leaders have concluded that the public wants to move past the ill will over the post-election maneuvering that settled the close Florida contest, McAuliffe plainly believes that with some audiences—namely, the Democratic base of activists he was addressing yesterday—a backward-looking appeal to resentment is for now the best way to motivate and unite an often-fractious party." (This was in a *news* story!) "It sounds like you're still fighting the election," growled NBC's Tim Russert on "Meet the Press." "So much for bipartisanship!" huffed ABC's Sam Donaldson on "This Week."

Just as mainstream Democrats and liberals ceased to question Bush's right to hold office, so too did they cease to question his intelligence. If you search a journalistic database for articles discussing Bush's brainpower, you will find something curious. The idea of Bush as a dullard comes up frequently—but nearly always in the context of knocking it down. While it's described as a widely held view, one can find very few people who will admit to holding it. Conservatives use the theme as a taunt—if Bush is so dumb, how come he keeps winning? Liberals, spooked, have concluded that calling Bush dumb is a strategic mistake. "You're not going to get votes by assuming that, as a party, you're a lot smarter than the voters," argued Democratic Leadership Council President Bruce Reed last November. "Casting Bush as a dummy also plays into his strategy of casting himself as a Texas common man," wrote *Washington Post* columnist E. J. Dionne in March 2001.

Maybe Bush's limited brainpower hasn't hampered his political success. And maybe pointing out that he's not the brightest bulb is politically counterproductive. Nonetheless, however immaterial or inconvenient the fact may be, it remains true that Bush is just not a terribly bright man. (Or, more precisely, his intellectual incuriosity is such that the effect is the same.) On the rare occasions Bush takes an extemporaneous question for which he hasn't prepared, he usually stumbles embarrassingly. When asked in July whether, given that Israel was releasing Palestinian prisoners, he would consider releasing famed Israeli spy Jonathan Pollard, Bush's answer showed he didn't even know who Pollard is. "Well, I said very clearly at the press conference with Prime Minister [Mahmoud] Abbas, I don't expect anybody to release somebody from prison who'll go kill somebody," he rambled. Bush's unscripted replies have caused him to accidentally change U.S. policy on Taiwan. And, while Bush's inner circle remains committed to the pretense of a president in total command of his staff, his advisers occasionally blurt out the truth. In the July issue of *Vanity Fair*, Richard Perle admitted that, when he first met Bush, "he didn't know very much."

While liberals have pretty much quit questioning Bush's competence, conservatives have given free rein to their most sycophantic impulses. Some of this is Bush's own doing—most notably, his staged aircraft-carrier landing, a naked attempt to transfer the public's admiration for the military onto himself (a man, it must be noted, who took a coveted slot in the National Guard during Vietnam and who then apparently declined to show up for a year of duty). Bush's supporters have spawned an entire industry of hagiographic kitsch. You can buy a twelve-inch doll of Bush clad in his "Mission Accomplished" flight suit or, if you have a couple thousand dollars to spend, a bronze bust depicting a steely-eyed "Commander-in-Chief" Bush. *National Review* is enticing its readers to fork over $24.95 for a book-length collection of Bush's post-September 11,

2001, speeches—any and all of which could be downloaded from the White House website for free. The collection recasts Bush as Winston Churchill, with even his most mundane pronouncements ("Excerpted Remarks by the President from Speech at the Lighting of the National Christmas Tree," "Excerpted Remarks by the President from Speech to the Missouri Farmers Association") deemed worthy of cherishing in bound form. Meanwhile, the recent Showtime pseudo-documentary "DC 9/11" renders the president as a Clint Eastwood figure, lording over a cringing Dick Cheney and barking out such implausible lines as "If some tinhorn terrorist wants me, tell him to come on over and get me. I'll be here!"

Certainly Clinton had his defenders and admirers, but no similar cult of personality. Liberal Hollywood fantasies—"The West Wing," *The American President*—all depict imaginary presidents who pointedly lack Clinton's personal flaws or penchant for compromise. The political point was more to highlight Clinton's deficiencies than to defend them.

The persistence of an absurdly heroic view of Bush is what makes his dullness so maddening. To be a liberal today is to feel as though you've been transported into some alternative universe in which a transparently mediocre man is revered as a moral and strategic giant. You ask yourself why Bush is considered a great, or even a likeable, man. You wonder what it is you have been missing. Being a liberal, you probably subject yourself to frequent periods of self-doubt. But then you conclude that you're actually not missing anything at all. You decide Bush is a dullard lacking any moral constraints in his pursuit of partisan gain, loyal to no principle save the comfort of the very rich, unburdened by any thoughtful consideration of the national interest, and a man who, on those occasions when he actually does make a correct decision, does so almost by accident.

There. That feels better.

The Limited Circle Is Pure

Zadie Smith

November 3, 2003

Quite simply, one of the finest essays on Kafka ever written.

I.

Kafka is the novel's bad conscience. His work demonstrates a purity of intention, a precision of language, and a level of metaphysical commitment that the novel partially comprehends but is unable to replicate without, in the process, ceasing to be a novel at all. Consequently, Kafka makes novelists nervous. He doesn't seem to write like the rest of us. Either he is too good for the novel or the novel is not quite good enough for him—whichever it is, his imitators are very few.

Now, why is that? Where *are* Kafka's descendants? Only a handful—Borges, W. G. Sebald, Thomas Bernhard—have successfully "channeled" the Kafkaesque in any meaningful way. The result has been queer. His influence seems to cause a mutation in the recipient, metamorphosing the novel into something closer to a meditation, a fantastical historiography, an essay, a parable. What is it about Kafka's lessons for the novel that

cannot be contained within the novel in the form as we have come to know it? How does Kafka lead novelists away from the novel?

Clearly, the intentions of most novels are not Kafka's intentions. The American writer Wallace Stegner tells us that "if fiction isn't people it is nothing," and this is a usefully succinct version of the novel's story about itself, as a form. By this account, the novel's achievement is to offer us so many "splinters" of consciousness, so many intimate portraits of people. The complexity and the psychological depth of these portraits—Anna Karenina, David Copperfield, Madame Bovary, Herzog, Holden Caulfield, and on and on—perform a service of variousness. Singularly, they are that interior communication with human otherness that Aristotle thought essential to our ethical development. Collectively, as "Literature," they are the description of a struggle against those more dogmatic and therefore deceitful versions of self generated by church, by state, by ourselves at our weakest, and now by our rapacious televisions.

At its most metaphysical, the novel might go as far as to investigate how selves are made, their superficial unity and hidden fragmentation, as Virginia Woolf did; or it might investigate the extreme porousness of certain borders between self and world, as James Joyce did. But when it comes to a discussion of—as Kafka put it—"the impossibility of being alive," well, the novelist cannot go quite as far as this. Novelists as a breed are broadly Hegelian: they assume at least some kind of rational relationship between the individual and the world. Then they proceed accordingly, unpacking their intimate vision of that relationship, assonant or dissonant depending on their temperaments. Kafka is the exception. He has no interest in psychology, not as something that individuates our tastes, desires, needs, opinions. Only the first half of that fetishistic modern word "lifestyle" could

mean anything to Kafka. The novelist's question "What does he *do* with his life?" is made strange in Kafka's parabolic world, where "life" is not a fact but a transitive state; not something one could do things with but rather a process (*Der Prozess* is the title of *The Trial* in the original) to which we submit. Kafka's question is harder to listen to and harder to answer: "Is it possible to be alive?"

Most novelists are just not up for these kinds of ontological shenanigans. As a rule they are—as surely everyone has noticed by now—intuitive people rather than truly intellectual. It would be comforting, then, for novelists to call Kafka a philosopher, or a theologian, and thus strip him of any further power to trouble our consciences. But Kafka was no philosopher, no theologian. Literature was, or so he believed, his entire existence and his life's work. In a letter to his first fiancée, Felice Bauer, whom he would leave for this very reason (he was in the habit of leaving chicks for books), he explained: "I *am* literature." If this were true, of course, we could not pick out five practitioners of literature in the past five hundred years. But Kafka seems to mean something very different by "literature" than the rest of us mean.

I am literature! Bloody *hell*. Fearing the truth of this statement, novelists shrink from Kafka. Like the cast of a gaudy musical, they hide in the wings, looking on nervously at this solitary man who, with less to work with than even his beloved Yiddish actors—no props, no costume, not a scrap of makeup—steps onto the flood-lit stage. Confronted with this purity, the humbled novelist cannot help but think of Mary McCarthy's famous put-down of Lillian Hellman ("Everything she writes is a lie, including 'and' and 'the'") and reflect that here, in Kafka's crystalline prose, we discover its exact inversion. It is prose unlike any other. It rejects so many of the "things of the novel": its tools, tricks, machinery. It is as if he is at war with the novel itself.

When we turn to Kafka's own real life, as everything he wrote induces us to do, there is still no respite. The comparison between Kafka and the rest of us is pretty damn harsh. Here Milena Jesenská, the second woman he left for literature, offers us a précis of the essential differences between a man such as Kafka and people such as you and me:

> Obviously, we are capable of living because at some time or other we took refuge in lies, in blindness, in enthusiasm, in optimism, in some conviction or others, in pessimism or something of the sort. But he has never escaped to any such sheltering refuge, none at all. He is absolutely incapable of lying, just as he is incapable of getting drunk. He possesses not the slightest refuge. . . . He is like a naked man among a multitude who are dressed. And his asceticism is altogether unheroic . . . he is compelled to asceticism by his terrible clarity of vision, purity and incapacity for compromise. . . . I know he does not resist life, but only this kind of life: that is what he resists.

All novelists who are worth anything at all resist a version of life as it has been presented to them. What Flaubert meant by bourgeois life is not what his age meant by bourgeois life, and what Austen meant by the word "woman" was subtly at odds with the usage of that word in her time. But it is a rare and scary man who takes it upon himself to resist what the entire Western world since the birth of Jesus has meant by "life." Novelists simply do not resist life in this fashion. Life, in its shared social form, is, for lack of a less vulgar term, their material. They cannot say, as Kafka did, "Never again psychology!" Psychology is where they begin their work of the novel. And consciousness is the portal through which they explore the validity or otherwise of this shared social "life" that we speak of every day.

Make no mistake: Kafka fully understood the isolation of his position; he lived it. As the son of a Czech Jew he was isolated in a Germanic culture, but as a German speaker, without any Yiddish, he felt isolated from many of his fellow Jews. As a Prague resident he was on the edge of the Austro-Hungarian Empire; as an intellectual, an antisocial vegetarian, he distanced himself from his own petit-bourgeois family; and as a novelist he knew his work existed at a remove from those novelists whose public readings he attended every week. Here he attempts to delineate this sense of extreme alterity: "I completely dwell in every idea, but also fill every idea. . . . I not only feel myself at my boundary, but at the boundary of the human in general."

Of course one must take into account Kafka's solipsism, which in his diaries makes singular that which in the fiction is more clearly the condition of all our lives. (Kafka wrote not only because it was impossible for him to live but also because it is impossible for all of us to live, though his point was that most of us do not grasp this.) But it is certainly the case that Kafka alone brought us to the very boundary of the novel, rejecting any interest in a writer's "subject"—a place, a culture, a community, a group of people—and replacing it with a dismantling of the very idea of subjects and subjecthood. In this regard both the overtly Freudian and the overtly religious interpretations of Kafka are misguided, insofar as they identify a definitive "subject," a final point or a "bottom line," of a prose that has no final destination, only a journey. They miss what David Foster Wallace has described as "the central Kafka joke—that the horrific struggle to establish a human self results in a self whose humanity is inseparable from that horrific struggle. That our endless and impossible journey towards home is in fact our home."

I suppose such an awfully rigorous joke loses much of its humor in the telling (though we should keep in mind the lovely autobiographical fact that Kafka could not contain his own laughter

when reading *The Trial* out loud to his uncomprehending family). The laughs get even thinner when we try to employ "Kafka's joke" for our own aesthetic practice or as a way to comprehend our daily lives. This is black humor indeed, and the punch line is not that Kafka hated his father or that God does not exist. These are not the center of Kafka, because Kafka has no center. Kafka avoided every telos, all termini, purposes, meaningful endings, and resting spots the way most of us avoid the dentist, as Max Brod reminds us:

> He rejected anything that was planned for effect, intellectually or artificially thought up. . . . As an example of what he himself liked Kafka quoted a passage from Hofmannsthal, "the smell of damp flagstones in a hall." And he kept silent for a long while, said no more, as if this hidden, improbable thing must speak for itself.

What freaks out the novelists among us is that Kafka's rejection of the central in favor of the resonant particular on the periphery also happens to exclude that rather central matter of "other people." For it is, of course, not flagstones but people who are not in earnest, people who perform public versions of themselves, people who are frequently "planned for effect" and artificial. This aspect of our humanity may be vulgar, and it may be untrue in relation to some absolute idea of "being-as-truth"; but this "self-making," as we see it done every day, is precisely the novelist's fascination. Kafka, by contrast, had a horror of it. In his life and in his work, the artificial human relationship made Kafka despair: "In me, by myself, without human relationship, there are no visible lies. The limited circle is pure." And again: "Everything that is not literature bores me and I hate it, for it disturbs me or delays me, if only because I think it does. I lack all aptitude for family life except, at best, as an observer. I have no family feeling and visitors make me feel almost as though

I were maliciously being attacked. A marriage could not change me, just as my job cannot change me."

What is this literature of Kafka's that is so absolute that it exists as the opposite of life and other people? It is a limited circle, to be sure, and it is pure—but can it contain a novel? On the evidence of what Brod saved from the fire, the answer is no, not quite. In fact it is here that we find partial consolation for the envious novelist and the true subject of this essay, namely, Kafka's failure. "To do justice to the figure of Kafka in its purity and peculiar beauty," Walter Benjamin wrote, "one must never lose sight of one thing: it is the purity and beauty of a failure."

At its simplest, this refers to Kafka's output. Although he completed hundreds of letters and fragments and stories, he never finished a novel. Writing a complete novel proved impossible, intellectually and practically. *The Castle*, *The Trial*, and *Amerika* are all unfinished; the versions we have were cobbled together by Brod after the fact and against the author's wishes. They are fragmented internally, too, the order of chapters rarely more significant than the order of parables in a collection of Hasidic stories. If part of what it is to be a novel (rather than a collection of short stories) is to have significant sequence in a narrative, then Kafka's miraculous novels fail to fulfill one of the novel's defining criteria.

But Benjamin's diagnosis is also of a more profound failure. The peculiar beauty of Kafka lies in the very impossibility of his project, which was, I think, to express concretely—in the most precise language available—those things in life that fall outside of the concretely explicable or expressible. It is this project of Kafka's that we approach with rightful awe, and which induced Brod to identify his friend's work as "religious." But Kafka's work is analogous to religion only in its process, not in its content. It does ask you to put

your faith in absolute contradiction, as God asked of Job when he punished him, and it does ask you to locate your ethics outside of the social world as you know it, as God asked of Abraham when he commanded Isaac's sacrifice; but these requests are not religious in themselves. They are part of our modern moment exactly because they commit themselves to a new transcendency, as yet undefined: "I was not led into life by the sinking hand of Christianity, like Kierkegaard, nor did I catch the last tip of the Jewish prayer-shawl before it flew away, like the Zionists. I am the end or the beginning."

If Kafka ended the possibility of the novel, the death throes have been strangely long and loud. Nabokov came after Kafka. Graham Greene came after Kafka. The reassertion of the Great American Novel came after Kafka. It seems more likely that he began something, that he helped to trigger a radical doubt in the form which then rippled throughout his century and continues to ripple rather more banally through ours, making its weekly appearances in the literary pages of newspapers and in sophomore essays on campuses. Whenever we ask whether the novel is dead, we prove ourselves the inheritors of Kafka's doubt.

In the end, however, Kafka's doubt affected nobody as much as himself. The high metaphysical seriousness of his project is what drew him to the form of the Jewish parable—that focused jolt of spiritual attention—and away from the form of the novel. In his diary, while writing the most "novelistic" of his novels, *Amerika*, a book that betrays the improbable influence of Dickens, he questioned the suitability of the novel for the work that he needed to do, describing the form as "the shameful lowlands of writing."

Kafka—the poet laureate of shame in all its delineations—felt sure that the shame of the novel would outlive him. Most novelists ask you to pay sustained attention to something outside of your-

self, something in the world on which they have placed value. Frequently this is "other people," in all their shameful, worldly vulgarity. But Kafka directs your attention inward, momentarily and with great force—as Emerson did, as Kierkegaard did, as some poets frequently do—in search of a kind of pure being for which the world has no precise name. And this, too, this inexpressible thing, is also a part of our experience on this planet. We all know this; most good novelists know this, too; I believe they begin to write for this very reason. They know that some portion of this life is not adequately expressed in our newspapers, in our daily conversations, in our most intimate relationships, not even in our truth-seeking fairy-tales.

Novelists have some hint of the inexpressible—otherwise they wouldn't even try. But at a certain point in their development, consumed with a great delight at their ability to express almost everything about life, they forget this other thing, the inexpressible, which is the thing that Kafka meant by "life." "I am always trying to convey something that can't be conveyed," he writes to Milena, "to explain something which is inexplicable, to tell something I have in my bones, something which can be experienced only in these bones." The novel as a form revels in the shared world, exploring how individuals partake of that sharedness or rebel against it. Kafka concentrates on what is not shared, what is profoundly unshareable. As a result, the novel did not quite fit him. He extracted from it those things that he couldn't use, and made them strange. Two of those things were time and ethics.

II.

Our favored idea of the Kafkaesque is of a "labyrinthine bureaucracy." We think of thin corridors that lead only to doors that in turn lead to other doors. In fact, Kafka wrote very few scenes of this kind. What is bureaucratic and labyrinthine in *The Trial* is not

the rooms in which Josef K. finds himself, nor even the people who obstruct him, but rather the infinite time it takes to get anywhere at all. What is labyrinthine, in Kafka, is time itself.

Before the law a door is meant only for one man, but "not at the moment." Consequently he will die waiting. How long is this moment? In an office supply closet, a man prepares to whip two people, and Josef K. looks in. The next day he returns to the door, opens it once more, and finds that "everything was unchanged. . . . The printed forms and inkpots just over the threshold, the whipper with his cane, the warders still fully dressed, the candle on the shelf. . . ." Meanwhile an imperial messenger in a parable tries to get a message out of a palace, but "how vainly does he wear out his strength . . . and once more stairs and courts; and once more another palace; and so on for thousands of years. . . ." And then there is the world-famous hunger artist, whose handlers neglect to continue the tally of days written on the front of the cage. No matter how long he starves, no time will appear to have passed in the world.

This is not the time of most novels. But neither is it, as some have claimed, a dream-time, a nightmare-time, although it is true that in dreams, when we are deprived of our timepieces and our calendars, we are closer to understanding it. Kafka's time is bureaucratic—or, rather, bureaucracies reveal to Kafka something of the impossibility of time and living in it. I discovered this temporality for myself with a marvelous concreteness when I went recently to the American Embassy in London to obtain a visa. I had been given an appointment for 8:15 a.m. There were four hundred people in a line outside the building: they also had an appointment for 8:15. Many years appeared to pass; at last we were allowed inside to be given a slip with a number on it. Mine was 169. But the numbers on the screen came up at random—502, 164, 80, 670, 378—and with no discernible connection to the number of people in the room. "Would it be all right if I popped out?" I asked the guard. "Oh,

yes," said the guard, cheerily. "You can always go out. You're free to go out. But then of course you'll miss your number." I sat down again. In the hall there were two celebrities, a pop singer and an actor. Both considered themselves to be special cases before the law. I watched them plead their special case, and I watched the men at the desk allowing these two to waste their own time, out of a kind of pity, if only to keep them from thinking that they had neglected to try everything.

This is the time of bureaucracy—time with no end, no demarcations, and no benign purpose. In the rather comically demarcated number 39b of Kafka's *Reflections on Sin, Suffering, Hope and the True Way*, he explains how bureaucratic time differs from time as we are trained to think of it: "The way is infinitely long, nothing of it can be subtracted, nothing can be added, and yet everyone applies his own childish yardstick to it. 'Certainly, this yard of the way you still have to go, too, and it will be accounted unto you.'" The speaker's voice here expresses time as we understand it, with our childish yardsticks, our clocks, our calendars, attempting to take an accurate measurement of the infinite mystery.

But bureaucratic time—absurd, infinite, and without revealed meaning—is for Kafka the true glimpse of reality. Benjamin called these glimpses of the infinite in Kafka "the rumor of true things . . . a kind of theological whispered intelligence," and it is because it is *emet*, the truth—though it be awful—that Kafka submits to it. This has confused many readers. Since they read Kafka as an indictment of the "Modern" and bureaucracy as the "Kafkaesque nightmare," they are surprised to find Kafka's characters submitting to the bureaucratic with an almost ecstatic swoon, as if submitting to the law was the ultimate fulfillment. To resolve this perplexity, they call Kafka "ironic." This is a mistake. In Kafka's world it is always

better to submit to a terrible truth than to live a comforting lie. For this reason, people in Kafka mean exactly what they say, and no irony is involved. When Josef K. argues that the doorkeeper in the parable has been deceitful by preventing the man from entering, the priest corrects him.

> "You have insufficient respect for the narrative," said the priest. "The narrative contains two important statements from the doorkeeper about admission into the law, one at the beginning and one at the end. The first is that he 'cannot grant him entry now' and the other is 'this entrance was made only for you.' If there was a contradiction between these statements, then you would be right and the doorkeeper would have deceived the man. But there is no contradiction."

We, too, have insufficient respect for Kafka's narrative. His writing attempts to hold within it contradictory ideas, and when we read him we should, like Job, resist the temptation to resolve what is irresolvable. *The impossible journey home is in fact your home. This door is meant only for you: I cannot grant you entry now.* In that *now* Kafka unpacks the human horror of what time really is, how powerless we are before it. He once remarked that "our task is commensurate with our life." When most of us think of time in our lives, we like to imagine it broken into many tasks, plural—children, decades, houses, careers. Novels are made of this stuff. But Kafka rejects these illusory ways of "filling" our time, and he does so with the vehemence of a teenager. Here he is on October 21, 1921, at the age of thirty-eight: "All is imaginary—family, office, friends, the street, all imaginary, far away or close at hand, the woman; the truth that lies closest, however, is only this: that you are beating your head against the wall of a windowless and doorless cell."

For Kafka, the time of our social life is untrue. To this accusa-

tion, the priest in *The Trial* retorts: "One does not have to believe everything is true, one only has to believe that it is necessary." And Josef K. replies: "Depressing thought. It makes the lie fundamental to world order." If the world lies about time, then the novel as a form is an artistic compression of this lie. From its epistolary beginnings (dates carefully written atop each letter), the novel has prided itself on a beginning, a middle, and an end, produced in convincing sequence. Yet Kafka radically doubted the novel's ability to convey our true experience of time, of how time actually feels.

The following is from the long short story "Description of a Struggle," a title as pertinent to Kafka's troubles with the form of the novel as to any tensions among the two curious characters:

> I could go home alone and no one could stop me. Then, secretly, I could watch my acquaintance pass the entrance to my street. Goodbye, dear acquaintance! On reaching my room I'll feel warm, I'll light the lamp in its iron stand on my table, and when I've done that I'll lie back in my armchair which stands on the torn Oriental carpet. Pleasant prospects! Why not? But then? No then.

Something has gone wrong in this imagined, sequential narrative—a failure of faith, maybe, or an inability to lie when necessary. The novel asks, hopefully, and always with one eye on a happy ending: But then? And Kafka answers: No then.

Kafka found "Description of a Struggle" so difficult to write that when he finished it he told Brod the only thing that he liked about it was getting rid of it. *Amerika* was similarly a battle of "and then . . . and then." There is surely something of Christianity's messianic enthusiasm for the future in this "and then . . . and then," which characterizes the novel's narrative method. But is it possible to identify in Kafka's "But then? No then" something distinctly Jewish? It

is certainly a narrative attitude that turns away from soon-to-come happy endings and finality and admits instead an incomprehensible, infinite "now" that we—with our limited human consciousness— cannot comprehend. Is this Jewish time?

In certain Hasidic parables time is not a benign force marching toward our redemption, but an abject tautology that resolves itself only in God's mind. In these tales men fool themselves when they attempt to manipulate what God has revealed only in partial form. Here is one of Kafka's favorite Hasidic parables:

> A group of Jews sit together in an inn on the Sabbath, all local people except one stranger, a beggar. They make wishes around the table, imagining what they would be if they had their time again. One wishes for money, the other for a new carpenter's bench, another for a pleasant son-in-law to replace the one he has. When it comes to the beggar he says, "I wish I were a great king living in a magnificent castle. But one day the castle is attacked by rebels and I am forced from my bed with only a nightshirt on, leaving all of my possessions. I dash over hill and dale on foot, and run for days until I reach the inn I am sitting in now." "What the hell's the point of that?" asks one of men. "I'd have a shirt," says the beggar.

So much and no more is the beggar's (and our own) ability to manipulate the time of life. In parables of this kind, Kafka found a model, a compressed space to suit his aphoristic intensity. And it was when he was brief, as in the story "The Judgment," that he professed himself most satisfied. He wrote that remarkable story in a single physically demanding nocturnal burst, and compared it to an ejaculation. "Only in *this* way," he said, "can writing be done."

Kafka had come to believe that only brief work quickly done came close to the truth of organic artistic creation. These short

pieces are his greatest work, some of them only a few lines long, and in themselves pure parables of time and its deadly operations. In "The Next Village," time is so foreshortened that the narrator cannot see how the whole of a human life is long enough to ride to the next village. In "The Hunter Gracchus," a man's death ship loses its way; now he cannot die, and yet he is not alive. "I am here," he says, "more than that I do not know, further than that I cannot go. My ship has no rudder. . . ." This is what time *feels* like. Life is like *this*. We are imperial messengers, too, and will find out that just because we have a message and plenty of time does not mean that we will ever succeed in delivering it. As Nabokov coolly tells us in the first line of his own time-defying autobiography, our existence is but a brief crack of light between two eternities of darkness.

So who are we to speak of time? "Nobody could fight his way through here even with a message from a dead man," Kafka writes in the final lines of the "Imperial Message" parable. "But you sit at your window when evening falls and dream it to yourself." That is us, at the window, dreaming, reading a novel. In novels there is time to live. Novels are our necessary lies, our journeys that lead somewhere.

III.

In my dictionary, "Kafkaesque" is defined as a "vision of man's isolated existence in a dehumanized world," as if Kafka feared the rise of the typewriter or an epidemic of those threshing machines that he came across in his insurance work, the ones that so regularly removed human digits. But no. Not dehumanized; human, rather, all too human. It was people in their insatiable fullness, not in their mechanized emptiness, that Kafka feared. If he was a prophet of the coming danger, it was by predicting not the rise of the machines but the rise of a people whose sense of their own human potentiality was dangerously overflowing. He was proved correct. The Nazis

did not go about their business like machines or automatons; they went about it with a lust and a passion.

Life, when it considers itself triumphant, is itself a kind of tyranny. It is triumphant life that replaces the poor hunger artist once the public has tired of him:

> Into the cage they put a young panther. Even the most insensitive felt it refreshing to see this wild creature leaping around the cage that had so long been left dreary. The panther was all right . . . he seemed not to even miss his freedom; his noble body, furnished almost to the bursting point with all that it needed, seemed to carry freedom around with it too; somewhere in his jaws it seemed to lurk; the joy of life streamed with such ardent passion from his throat that for the onlookers it was not easy to stand the shock of it.

The very fullness and variety of life that novels admire—especially contemporary novels—is obscene in Kafka. One person's expansiveness will only result in another person's confinement.

Kafka had personal experience of this, living cheek by jowl with his own oppressively lively father, whom he describes in his magnificent "Letter to His Father" as possessing "the enigmatic quality that all tyrants have, whose rights are based on their person and not on reason." What would Kafka make of present-day England, where pure personality itself—otherwise known as "celebrity"—is the only defense plea that anybody need make? Those chilling final lines of *The Metamorphosis*, in which Gregor's sister takes on an "increasing vitality," finally becoming herself—springing to her feet in the train carriage, stretching her young body to her parents' appreciation—these are ominous

portents of a world of unreason, where just to be full of your own life is enough.

The novel has, historically, been in love with this vibrant individual; but Kafka dreads her. All forms of individuation are to him an echo of the original division: in his blue octavo notebook he claimed to understand the fall of Adam and Eve better than any man on earth. It is separation from the eternal oneness that hurt Kafka. Even mountains and objects and skies can wound this hypersensitive sensibility, just by asserting their own separate thingness. Here he addresses the landscape: "But it is not only the mountain that is so vain, so obtrusive and vindictive—everything else is too. So I must go on repeating with wide-open eyes—oh, how they hurt!"

Yet Kafka would not be so compelling a writer if he were not himself compelled by what he most feared. As Klaus Wagenbach reminds us in his penetrating biography, Kafka was deeply affected by Kierkegaard's definition of dread: "Though dread is afraid, yet it maintains a sly intercourse with its object, cannot look away from it." Dread is a masochistic pleasure in Kafka; the circus audience dreads the life of the panther, but still "they braced themselves, crowded around the cage, and did not want to ever move away." Kafka is both disgusted and fascinated by other people's confident assertion of their own existence. His characters are frequently watching other people, not, as in a novel, in the hope of forming a meaningful relation with them, but as if by observing them one might discover how indeed it is possible to live. "And I hope to learn from you how things really are," says the supplicant in "Description of a Struggle," "why it is that around me things sink away like fallen snow, whereas for other people even a little liqueur glass stands on the table steady as a statue."

Why is life, for some people, a simple fact, obvious as a statue, while for others it remains an impossible feat? Kafka, as well as being the

poet of shame, was the poet of awe. That people managed to locate and to identify themselves was amazing to him. "It is as if," comments Benjamin, "he had spent his entire life wondering what he looked like, without ever discovering that there are such things as mirrors." Here is Kafka in a letter to Brod, expressing this wonder:

> I opened my eyes after a short afternoon sleep, still not quite certain I was alive, and I heard my mother calling down from the balcony in a natural tone: "What are you up to?" A woman answered from the garden, "I'm having my tea-time in the garden." I was amazed at the stalwart technique for living some people have.

Kafka had no such talent for living. The question "What are you up to?" could induce paralysis. Next door the woman answers it as if it were the simplest question in the world, which in a way it is, except that Kafka has no access to simple things. The everyday ability to self-fictionalize, to make of oneself a narrative, to say, "I am here, doing this," was miraculous and strange to him. He could allow himself to enjoy those self-creations only when they were deliberate and not simultaneously a self-deception. This is surely why he so enjoyed the Yiddish theater and grew fascinated with its actors, actors being the one group of people whose vulgar self-making is never disguised. It is the same fondness that Hamlet has for those traveling players. One welcomes the stage players—who are honest about their artificiality—when one lives in a world where artificiality wears the garments of the truth.

Like no other writer, Kafka is debilitated by the idea that when people say, "I am in the garden," they seem able to place their whole being into that "I." Actors, by contrast, only play with "I," it is a provisional "I"—an "I" that is never required to make a real choice and therefore, in an Aristotelian formulation, never truly reveals

character. Character itself is finitude in Kafka; to say "I" is not to be, but to *not be*.

This dread of individuating one's existence—of saying *I am here, doing this, this is my home, my lover*—strikes the English ear as similar to Philip Larkin's dread of "Places, Loved Ones." For Larkin, choosing a place and a person would be to close down one's infinite choice; paralysis is preferable. And for Kafka, as for Larkin, it is women in particular who shut down possibility. "Women are traps," Kafka is reported to have said, "traps which lie in wait for men everywhere, in order to drag them down into the Finite." Larkin's deeply sarcastic poem "To My Wife" catches some of this bleak madness. Kafka did not wish to—as Larkin puts it—"shut up that peacock-fan the future," but rather to hold on to the "unlimited / Only so long as I elected nothing." Likewise Kafka's nasty little parable "Rejection," in which two young people spot each other in the street, imagine choosing each other, imagine the entire relationship, imagine the pain that would result, and decide not to bother—and all this in a handful of sentences—is strongly Larkinesque. At its most comic this attitude can be reduced to: *Why bother? We're all going to die anyway.* ("Give it up! Give it up!" yells Kafka's policeman to the man who asks for directions.)

This was pretty much Larkin's attitude. He, too, couldn't see the point of individuation, seeing as how we are all hurtling toward the unindividuated abyss. He also thought his capacity for getting depressed about all this was far greater than Kafka's. In the poem "The Literary World," he responds to a diary entry in which Kafka complained he hadn't written anything for five months:

> *My dear Kafka,*
> *When you've had five years of it,*

not five months,
Five years of an irresistible force
meeting an
Immoveable object right in your belly,
Then you'll know about depression.

Working out who was the more miserable between these two is rather a mug's game. But Kafka's ethical prose was certainly a more substantial thing than Larkin's exquisite English pessimism. For Kafka, the rejection of individuation has a serious worldly consequence. It unbalances ethics as a set of ideas situated in the world. The individual in Kafka can no longer look to a social universal for its ethical ideas, because there is no social universal and there is no convincing individual.

This is where his split from the novel truly occurs. A consummate novelist, such as Austen, tests her individuals against situations and other people in the world, locating her ethics always within the social. The philosopher Gilbert Ryle compared Austen's procedure to that of a vintner or wine taster. She studies ethical qualities in individuals not by developing the quality in a single character but rather by "matching it against the same quality in different degrees, against simulations of that quality, against deficiencies of it," in other people and in varied social situations. We get to know Elizabeth Bennet and she gets to know herself by way of a series of comparative refinements. She is tested against the world in many different ways, and as an ethical individual and therefore a social one; her moral performance is judged within the totality of a social life.

Simply put, there is nothing that is good for Elizabeth Bennet that is simultaneously bad for the world and the people she lives in and among. This is Hegel's "ethical universal." But Kafka's characters have no such relationship with the world. His refinements are

sketched in absurdist circles that direct themselves inward. There is no attempt at shared meaning. "Is that what you mean?" asks a character. "That or something else" is the reply. And here is another perfect Kafka sentence: "Two possibilities: making oneself infinitely small or being so. The second is perfection, that is to say, inactivity, the first is beginning, that is to say, action."

Where the good is located in this sentence it is impossible to say—in being small, in being inactive, in action, in beginning? Its punctuation frustrates us at every turn, and the things that are compared are not of a likeness; with respect to ethics, they are apples and oranges. This reminds one of Gertrude Stein at her most extreme—forcing one to think alternately, to think in unlikely, nonsensical ways, as if just doing this was an ethical ideal in itself.

The ethical individual in Kafka cannot rely on the world for his morality. Here Kierkegaard was essential to Kafka. Kafka recognized that both personally and philosophically, as he put it, "his case is very similar to mine, despite essential differences." Both Kierkegaard and Kafka left women for books, and both became fixated on the story of Abraham, who in his willingness to sacrifice Isaac introduces a concept that the Hegelian universe does not contain: faith. "The state," argued Hegel, "is in and by itself the ethical whole." The state has faith in itself—and the novel thinks of itself this way also, as a place with an internal ethical structure. The novel judges its individuals in the context of the novel's social world. But Abraham brought Isaac to the altar with no hope of recourse to the social. He could not kill Isaac because it was good for him as an individual, good for Isaac, good for the world, or even good for God. He could kill him because he had suspended the very idea of the ethical and placed his faith in something that he could neither express nor properly conceive.

This Kierkegaardian interpretation of Abraham has been called the beginning of existential thought, but Kafka is not really an exis-

tentialist novelist and his characters are not quite successful existentialists. It is true that his characters dismantle any hope of locating the ethical in the social—not without turning into a bug of a man. But after this (and here is the "essential difference" of which he spoke) they do not ascend to the kind of "self-defining freedom" that Kierkegaard recommends. Instead they struggle terribly, like Kafka did himself. They are unable to create their own ethical sphere or to create themselves, in the absence of other people and of God. It is not easy being one's own judge and jury. As Emerson warned, "If any one imagines that this law is lax, let him keep its commandment one day."

Divorcing oneself from the shared human world is a torturous process. From the very beginning Kafka wanted a prose as torturous as the process that it attempted to describe. As a twenty-year-old, he writes that "I think we ought to read only the kind of books that wound and stab us. If the book we're reading doesn't wake us up with a blow on the head, what are we reading it for? So that it will make us happy? Good Lord, we would be happy precisely if we had no books . . . we need the books that affect us like a disaster." So, no, Kafka does not make us happy like your average best-seller, but he did not make himself happy, just as Kierkegaard did not make himself happy. Judging yourself—being the whole courtroom in your own person—is no easier than being put on trial by your society or by your God. It incurs terrible wounds.

Yet still we do it, we still request judgment unprompted by higher powers: this is the great Kafka joke, the great Kafka terror, the great Kafka mystery. The king's messengers keep on delivering after all the kings are dead. Prometheus hangs against the rock so long that both he and his judges forget what he is doing there. And the officer in the penal colony will put his own body into that ter-

rible machine long after the public has lost interest in such brutal punishments. In the absence of God or moral certainty, how we call down judgment upon ourselves is simultaneously the most horrific and the most beautiful thing about us.

Everybody is in need of judgment in Kafka, especially Kafka himself. This need in Kafka was more than a ploy or a style, it was a condition of the man. In that sense his work is indeed about psychology—but the psychology of only one man. It was the literature of one man's consciousness; the aggadah and the halakhah of Mr. Franz Kafka. Nobody else was ever remotely involved. His concretization of metaphor is symptomatic of this. He does not show you how much a man hates his work by describing his job and his colleagues, but by making these feelings concrete, material. I felt abject as a bug today. I ate shit at work. I was sick as a dog. I am insignificant as a mouse. Kafka makes the word flesh.

This is not to everybody's taste, and there is an obvious harsh judgment of Kafka that he graciously lends to one of his female characters: "You don't impress me at all. Everything you say is boring and incomprehensible, but that alone doesn't make it true. What I really think, sir, is that you can't be bothered with the truth because it's too tiring." We may accuse Kafka of this, and he will be delighted. "God, how good that makes me feel!" says the "I" character in response. "To find oneself so well understood!"

Kafka knew that life is not like that. It is not impossible to live. We do live, obviously. Here we all are. But he was in the business of postulating the opposite truth, a divine negative of the truth, which he expresses in his most difficult parable:

> "It cannot be said that we are lacking in faith. Even the simple fact of our life is of a faith-value that can never be exhausted."
>
> "You suggest there is some faith-value in this? One cannot not-live, after all."

"It is precisely in this 'Cannot, after all' that the mad strength
of faith lies; it is in this negation that it takes on form."

When we are "before Kafka," we sit waiting before an entrance
that the novel will never enter—certainly not without losing its
very shape—and yet must continue to strive to enter, even if it is
only to wait insistently, passing the time by describing the face of
the guard, or making a note of the flies on his collar. I mean that
the novelist does well to keep Kafka's absolute contradictory truth
somewhere in mind, because we will tell fewer lies that way. And
yet "telling the truth like Kafka" also means forgetting many other
significant parts of our life and our work. The ideas with which
Kafka engaged—infinity, absolute paradox, inexpressibility, utter
abjection in the very face of existence—are so awesome that they
can sometimes hide from us Kafka's limits and failures.

Nothing can make of Kafka a bad writer, but there were things
that lay outside his ken. The communal, the shared, the necessary
social lie. And, most significantly, other people. That Kafka fully
comprehended this lack in himself, that he measured the shape and
depth of his own wound—this is finally what made him a genius.

A Fighting Faith

Peter Beinart

December 13, 2004

For many years, the magazine had loosely aligned itself with neoconservatives, publishing the likes of Charles Krauthammer and Irving Kristol. But despite sharing their hawkish affinities, the magazine never moved into that camp. Under Peter Beinart's editorship, the magazine came awfully close, though. In the run up to the Iraq War, the magazine berated its ideological adversaries in a little feature called "Idiocy Watch." It endorsed Joseph Lieberman's presidential bid in 2004 and spoiled for a Democratic Party civil war.

There was, however, a crucial point of departure from the neoconservatives: as Iraq turned increasingly hellish, The New Republic *began questioning the war and itself. Two years into the war, one cover asked, "Were we wrong?" Two years after that, the magazine definitively answered that question, with an editorial apologizing for supporting the war in the first place.*

On January 4, 1947, 130 men and women met at Washington's Willard Hotel to save American liberalism. A few months earlier, in articles in *The New Republic* and elsewhere, the columnists Joseph and Stewart Alsop had warned that "the liberal movement is now engaged in sowing the seeds of its own destruction." Liberals, they

argued, "consistently avoided the great political reality of the present: the Soviet challenge to the West." Unless that changed, "In the spasm of terror which will seize this country . . . it is the right—the very extreme right—which is most likely to gain victory."

During World War II, only one major liberal organization, the Union for Democratic Action (UDA), had banned communists from its ranks. At the Willard, members of the UDA met to expand and rename their organization. The attendees, who included Reinhold Niebuhr, Arthur Schlesinger Jr., John Kenneth Galbraith, Walter Reuther, and Eleanor Roosevelt, issued a press release that enumerated the new organization's principles. Announcing the formation of Americans for Democratic Action (ADA), the statement declared, "[B]ecause the interests of the United States are the interests of free men everywhere," America should support "democratic and freedom-loving peoples the world over." That meant unceasing opposition to communism, an ideology "hostile to the principles of freedom and democracy on which the Republic has grown great."

At the time, the ADA's was still a minority view among American liberals. Two of the most influential journals of liberal opinion, *The New Republic* and *The Nation*, both rejected militant anti-communism. Former Vice President Henry Wallace, a hero to many liberals, saw communists as allies in the fight for domestic and international progress. As Steven M. Gillon notes in *Politics and Vision*, his excellent history of the ADA, it was virtually the only liberal organization to back President Harry S Truman's March 1947 decision to aid Greece and Turkey in their battle against Soviet subversion.

But, over the next two years, in bitter political combat across the institutions of American liberalism, anti-communism gained strength. With the ADA's help, Truman crushed Wallace's third-party challenge en route to reelection. The formerly leftist Congress of Industrial Organizations (CIO) expelled its communist affiliates

and *The New Republic* broke with Wallace, its former editor. The American Civil Liberties Union (ACLU) denounced communism, as did the NAACP. By 1949, three years after Winston Churchill warned that an "iron curtain" had descended across Europe, Schlesinger could write in *The Vital Center*: "Mid-twentieth century liberalism, I believe, has thus been fundamentally reshaped . . . by the exposure of the Soviet Union, and by the deepening of our knowledge of man. The consequence of this historical re-education has been an unconditional rejection of totalitarianism."

Today, three years after September 11 brought the United States face-to-face with a new totalitarian threat, liberalism has still not "been fundamentally reshaped" by the experience. On the right, a "historical re-education" has indeed occurred—replacing the isolationism of the Gingrich Congress with George W. Bush and Dick Cheney's near-theological faith in the transformative capacity of U.S. military might. But American liberalism, as defined by its activist organizations, remains largely what it was in the 1990s—a collection of domestic interests and concerns. On health care, gay rights, and the environment, there is a positive vision, articulated with passion. But there is little liberal passion to win the struggle against Al Qaeda—even though totalitarian Islam has killed thousands of Americans and aims to kill millions; and even though, if it gained power, its efforts to force every aspect of life into conformity with a barbaric interpretation of Islam would reign terror upon women, religious minorities, and anyone in the Muslim world with a thirst for modernity or freedom.

When liberals talk about America's new era, the discussion is largely negative—against the Iraq war, against restrictions on civil liberties, against America's worsening reputation in the world. In sharp contrast to the first years of the cold war, post-September 11 liberalism has produced leaders and institutions—most notably Michael Moore and MoveOn—that do not put the struggle

against America's new totalitarian foe at the center of their hopes for a better world. As a result, the Democratic Party boasts a fairly hawkish foreign policy establishment and a cadre of politicians and strategists eager to look tough. But, below this small elite sits a Wallacite grassroots that views America's new struggle as a distraction, if not a mirage. Two elections, and two defeats, into the September 11 era, American liberalism still has not had its meeting at the Willard Hotel. And the hour is getting late.

The Kerry Compromise

The press loves a surprise. And so, in the days immediately after November 2, journalists trumpeted the revelation that "moral values" had cost John Kerry the election. Upon deeper investigation, however, the reasons for Kerry's loss don't look that surprising at all. In fact, they are largely the same reasons congressional Democrats lost in 2002.

Pundits have seized on exit polls showing that the electorate's single greatest concern was moral values, cited by 22 percent of voters. But, as my colleague Andrew Sullivan has pointed out, a similar share of the electorate cited moral values in the '90s. The real change this year was on foreign policy. In 2000, only 12 percent of voters cited "world affairs" as their paramount issue; this year, 34 percent mentioned either Iraq or terrorism. (Combined, the two foreign policy categories dwarf moral values.) Voters who cited terrorism backed Bush even more strongly than those who cited moral values. And it was largely this new cohort—the same one that handed the GOP its Senate majority in 2002—that accounts for Bush's improvement over 2000. As Paul Freedman recently calculated in *Slate*, if you control for Bush's share of the vote four years ago, "a 10-point increase in the percentage of voters [in a given state] citing terrorism as the most important problem translates into a 3-point Bush gain. A 10-point increase in morality voters, on the other hand, has no effect."

On national security, Kerry's nomination was a compromise between a party elite desperate to neutralize the terrorism issue and a liberal base unwilling to redefine itself for the post-September 11 world. In the early days of his candidacy, Kerry seemed destined to run as a hawk. In June 2002, he attacked Bush from the right for not committing American ground troops in the mountains of Tora Bora. Like the other leading candidates in the race, he voted to authorize the use of force in Iraq. This not only pleased Kerry's consultants, who hoped to inoculate him against charges that he was soft on terrorism, but it satisfied his foreign policy advisers as well.

The Democratic foreign policy establishment that counseled the leading presidential candidates during the primaries—and coalesced behind Kerry after he won the nomination—was the product of a decade-long evolution. Bill Clinton had come into office with little passion for foreign policy, except as it affected the U.S. economy. But, over time, his administration grew more concerned with international affairs and more hawkish. In August 1995, Clinton finally sent NATO warplanes into action in Bosnia. And, four years later, the United States, again working through NATO, launched a humanitarian war in Kosovo, preventing another ethnic cleansing and setting the stage for a democratic revolution in Belgrade. It was an air war, to be sure, and it put few American lives at risk. But it was a war nonetheless, initiated without U.N. backing by a Democratic president in response to internal events in a sovereign country.

For top Kerry foreign policy advisers, such as Richard Holbrooke and Joseph Biden, Bosnia and Kosovo seemed like models for a new post-Vietnam liberalism that embraced U.S. power. And September 11 validated the transformation. Democratic foreign policy wonks not only supported the war in Afghanistan, they generally felt it didn't go far enough—urging a larger NATO force capable of securing the entire country. And, while disturbed by the Bush ad-

ministration's handling of Iraq, they agreed that Saddam Hussein was a threat and, more generally, supported aggressive efforts to democratize the Muslim world. As *National Journal*'s Paul Starobin noted in a September 2004 profile, "Kerry and his foreign-policy advisers are not doves. They are liberal war hawks who would be unafraid to use American power to promote their values." At the Democratic convention, Biden said that the "overwhelming obligation of the next president is clear"—to exercise "the full measure of our power" to defeat Islamist totalitarianism.

Had history taken a different course, this new brand of liberalism might have expanded beyond a narrow foreign policy elite. The war in Afghanistan, while unlike Kosovo a war of self-defense, once again brought the Western democracies together against a deeply illiberal foe. Had that war, rather than the war in Iraq, become the defining event of the post-September 11 era, the "re-education" about U.S. power, and about the new totalitarian threat from the Muslim world that had transformed Kerry's advisers, might have trickled down to the party's liberal base, transforming it as well.

Instead, Bush's war on terrorism became a partisan affair—defined in the liberal mind not by images of American soldiers walking Afghan girls to school, but by John Ashcroft's mass detentions and Cheney's false claims about Iraqi WMD. The left's post-September 11 enthusiasm for an aggressive campaign against Al Qaeda—epitomized by students at liberal campuses signing up for jobs with the CIA—was overwhelmed by horror at the bungled Iraq war. So, when the Democratic presidential candidates began courting their party's activists in Iowa and New Hampshire in 2003, they found a liberal grassroots that viewed the war on terrorism in negative terms and judged the candidates less on their enthusiasm for defeating Al Qaeda than on their enthusiasm for defeating Bush. The three candidates who made winning the war on terrorism the centerpiece of their campaigns—Joseph Lieber-

man, Bob Graham, and Wesley Clark—each failed to capture the imagination of liberal activists eager for a positive agenda only in the domestic sphere. Three of the early front-runners—Kerry, John Edwards, and Dick Gephardt—each sank as Howard Dean pilloried them for supporting Ashcroft's Patriot Act and the Iraq war.

Three months before the Iowa caucuses, facing mass liberal defections to Dean, Kerry voted against Bush's $87 billion supplemental request for Iraq. With that vote, the Kerry compromise was born. To Kerry's foreign policy advisers, some of whom supported the supplemental funding, he remained a vehicle for an aggressive war on terrorism. And that may well have been Kerry's own intention. But, to the liberal voters who would choose the party's nominee, he became a more electable Dean. Kerry's opposition to the $87 billion didn't only change his image on the war in Iraq; it changed his image on the war on terrorism itself. His justification for opposing the $87 billion was essentially isolationist: "We shouldn't be opening firehouses in Baghdad and closing them down in our own communities." And, by exploiting public antipathy toward foreign aid and nation-building, the natural building blocks of any liberal antitotalitarian effort in the Muslim world, Kerry signaled that liberalism's moral energies should be unleashed primarily at home.

Kerry's vote against the $87 billion helped him lure back the liberal activists he needed to win Iowa, and Iowa catapulted him toward the nomination. But the vote came back to haunt him in two ways. Most obviously, it helped the Bush campaign paint him as unprincipled. But, more subtly, it made it harder for Kerry to ask Americans to sacrifice in a global campaign for freedom. Biden could suggest "a new program of national service" and other measures to "spread the cost and hardship of the war on terror beyond our soldiers and their families." But, whenever Kerry flirted with asking Americans to do more to meet America's new threat, he found himself limited by his prior emphasis on doing less. At

times, he said his primary focus in Iraq would be bringing American troops home. He called for expanding the military but pledged that none of the new troops would go to Iraq, the new center of the terror war, where he had said American forces were undermanned. Kerry's criticisms of Bush's Iraq policy were trenchant, but the only alternative principle he clearly articulated was multilateralism, which often sounded like a veiled way of asking Americans to do less. And, because he never urged a national mobilization for safety and freedom, his discussion of terrorism lacked Bush's grandeur. That wasn't an accident. Had Kerry aggressively championed a national mobilization to win the war on terrorism, he wouldn't have been the Democratic nominee.

The Softs

Kerry was a flawed candidate, but he was not the fundamental problem. The fundamental problem was the party's liberal base, which would have refused to nominate anyone who proposed redefining the Democratic Party in the way the ADA did in 1947. The challenge for Democrats today is not to find a different kind of presidential candidate. It is to transform the party at its grassroots so that a different kind of presidential candidate can emerge. That means abandoning the unity-at-all-costs ethos that governed American liberalism in 2004. And it requires a sustained battle to wrest the Democratic Party from the heirs of Henry Wallace. In the party today, two such heirs loom largest: Michael Moore and MoveOn.

In 1950, the journal *The New Leader* divided American liberals into "hards" and "softs." The hards, epitomized by the ADA, believed anti-communism was the fundamental litmus test for a decent left. Non-communism was not enough; opposition to the totalitarian threat was the prerequisite for membership in American liberalism because communism was the defining moral challenge of the age.

The softs, by contrast, were not necessarily communists themselves. But they refused to make anti-communism their guiding principle. For them, the threat to liberal values came entirely from the right—from militarists, from red-baiters, and from the forces of economic reaction. To attack the communists, reliable allies in the fight for civil rights and economic justice, was a distraction from the struggle for progress.

Moore is the most prominent soft in the United States today. Most Democrats agree with him about the Iraq war, about Ashcroft, and about Bush. What they do not recognize, or do not acknowledge, is that Moore does not oppose Bush's policies because he thinks they fail to effectively address the terrorist threat; he does not believe there is a terrorist threat. For Moore, terrorism is an opiate whipped up by corporate bosses. In *Dude, Where's My Country?*, he says it plainly: "There is no terrorist threat." And he wonders, "Why has our government gone to such absurd lengths to convince us our lives are in danger?"

Moore views totalitarian Islam the way Wallace viewed communism: As a phantom, a ruse employed by the only enemies that matter, those on the right. Saudi extremists may have brought down the Twin Towers, but the real menace is the Carlyle Group. Today, most liberals naively consider Moore a useful ally, a bomb-thrower against a right-wing that deserves to be torched. What they do not understand is that his real casualties are on the decent left. When Moore opposes the war against the Taliban, he casts doubt upon the sincerity of liberals who say they opposed the Iraq war because they wanted to win in Afghanistan first. When Moore says terrorism should be no greater a national concern than car accidents or pneumonia, he makes it harder for liberals to claim that their belief in civil liberties does not imply a diminished vigilance against Al Qaeda.

Moore is a non-totalitarian, but, like Wallace, he is not an anti-totalitarian. And, when Democratic National Committee Chair-

man Terry McAuliffe and Tom Daschle flocked to the Washington premiere of *Fahrenheit 9/11*, and when Moore sat in Jimmy Carter's box at the Democratic convention, many Americans wondered whether the Democratic Party was anti-totalitarian either.

If Moore is America's leading individual soft, liberalism's premier soft organization is MoveOn. MoveOn was formed to oppose Clinton's impeachment, but, after September 11, it turned to opposing the war in Afghanistan. A MoveOn-sponsored petition warned, "If we retaliate by bombing Kabul and kill people oppressed by the Taliban, we become like the terrorists we oppose."

By January 2002, MoveOn was collaborating with 9-11peace .org, a website founded by Eli Pariser, who would later become MoveOn's most visible spokesman. One early 9-11peace.org bulletin urged supporters to "[c]all world leaders and ask them to call off the bombing," and to "[f]ly the UN Flag as a symbol of global unity and support for international law." Others questioned the wisdom of increased funding for the CIA and the deployment of American troops to assist in anti-terrorist efforts in the Philippines. In October 2002, after 9-11peace.org was incorporated into MoveOn, an organization bulletin suggested that the United States should have "utilize[d] international law and judicial procedures, including due process" against bin Laden and that "it's possible that a tribunal could even have garnered cooperation from the Taliban."

In the past several years, MoveOn has emerged, in the words of *Salon*'s Michelle Goldberg, as "the most important political advocacy group in Democratic circles." It boasts more than 1.5 million members and raised a remarkable $40 million for the 2004 election. Many MoveOn supporters probably disagree with the organization's opposition to the Afghan war, if they are even aware of it, and simply see the group as an effective means to combat Bush.

But one of the lessons of the early cold war is scrupulousness about whom liberals let speak in their name. And, while MoveOn's frequent bulletins are far more thoughtful than Moore's rants, they convey the same basic hostility to U.S. power.

In the early days after September 11, MoveOn suggested that foreign aid might prove a better way to defeat terrorism than military action. But, in recent years, it seems to have largely lost interest in any agenda for fighting terrorism at all. Instead, MoveOn's discussion of the subject seems dominated by two, entirely negative, ideas. First, the war on terrorism crushes civil liberties. On July 18, 2002, in a bulletin titled "Can Democracy Survive an Endless 'War'?," MoveOn charged that the Patriot Act had "nullified large portions of the Bill of Rights." Having grossly inflated the Act's effect, the bulletin then contrasted it with the—implicitly far smaller—danger from Al Qaeda, asking: "Is the threat to the United States' existence great enough to justify the evisceration of our most treasured principles?"

Secondly, the war on terrorism diverts attention from liberalism's positive agenda, which is overwhelmingly domestic. The MoveOn bulletin consists largely of links to articles in other publications, and, while the organization says it "does not necessarily endorse the views espoused on the pages that we link to," the articles generally fit the party line. On October 2, 2002, MoveOn linked to what it called an "excellent article," whose author complained that "it seems all anyone in Washington can think or talk about is terrorism, rebuilding Afghanistan and un-building Iraq." Another article in the same bulletin notes that "a large proportion of [federal] money is earmarked for security concerns related to the 'war on terrorism,' leaving less money available for basic public services."

Like the softs of the early cold war, MoveOn sees threats to liberalism only on the right. And thus, it makes common cause with the most deeply illiberal elements on the international left. In its

campaign against the Iraq war, MoveOn urged its supporters to participate in protests co-sponsored by International ANSWER, a front for the World Workers Party, which has defended Saddam, Slobodan Milosevic, and Kim Jong Il. When George Packer, in *The New York Times Magazine*, asked Pariser about sharing the stage with apologists for dictators, he replied, "I'm personally against defending Slobodan Milosevic and calling North Korea a socialist heaven, but it's just not relevant right now."

Pariser's words could serve as the slogan for today's softs, who do not see the fight against dictatorship and jihad as relevant to their brand of liberalism. When *The New York Times* asked delegates to this summer's Democratic and Republican conventions which issues were most important, only 2 percent of Democrats mentioned terrorism, compared with 15 percent of Republicans. One percent of Democrats mentioned defense, compared with 15 percent of Republicans. And 1 percent of Democrats mentioned homeland security, compared with 8 percent of Republicans. The irony is that Kerry—influenced by his relatively hawkish advisers—actually supported boosting homeland security funding and increasing the size of the military. But he got little public credit for those proposals, perhaps because most Americans still see the GOP as the party more concerned with security, at home and abroad. And, judging from the delegates at the two conventions, that perception is exactly right.

The Vital Center

Arthur Schlesinger Jr. would not have shared MoveOn's fear of an "endless war" on terrorism. In *The Vital Center*, he wrote, "Free society and totalitarianism today struggle for the minds and hearts of men. . . . If we believe in free society hard enough to keep on fighting for it, we are pledged to a permanent crisis which will test the moral, political and very possibly the military strength of each side.

A 'permanent' crisis? Well, a generation or two anyway, permanent in one's own lifetime."

Schlesinger, in other words, saw the struggle against the totalitarianism of his time not as a distraction from liberalism's real concerns, or as alien to liberalism's core values, but as the arena in which those values found their deepest expression. That meant several things. First, if liberalism was to credibly oppose totalitarianism, it could not be reflexively hostile to military force. Schlesinger denounced what he called "doughfaces," liberals with "a weakness for impotence . . . a fear, that is, of making concrete decisions and being held to account for concrete consequences." Nothing better captures Moore, who denounced the Taliban for its hideous violations of human rights but opposed military action against it—preferring pie-in-the-sky suggestions about nonviolent regime change.

For Schlesinger (who, ironically, has moved toward a softer liberalism later in life), in fact, it was conservatives, with their obsessive hostility to higher taxes, who could not be trusted to fund America's cold war struggle. "An important segment of business opinion," he wrote, "still hesitates to undertake a foreign policy of the magnitude necessary to prop up a free world against totalitarianism lest it add a few dollars to the tax rate." After Dwight Eisenhower became president, the ADA took up this line, arguing in October 1953 that the "overriding issue before the American people today is whether the national defense is to be determined by the demands of the world situation or sacrificed to the worship of tax reductions and a balanced budget." Such critiques laid the groundwork for John F. Kennedy's 1960 campaign—a campaign, as Richard Walton notes in *Cold War and Counterrevolution*, "dominated by a hard-line, get-tough attack on communism." Once in office, Kennedy dramatically increased military spending.

Such a critique might seem unavailable to liberals today, given that Bush, having abandoned the Republican Party's traditional

concern with balanced budgets, seems content to cut taxes and strengthen the U.S. military at the same time. But subtly, the Republican Party's dual imperatives have already begun to collide—with a stronger defense consistently losing out. Bush has not increased the size of the U.S. military since September 11—despite repeated calls from hawks in his own party—in part because, given his massive tax cuts, he simply cannot afford to. An anti-totalitarian liberalism would attack those tax cuts not merely as unfair and fiscally reckless, but, above all, as long-term threats to America's ability to wage war against fanatical Islam. Today, however, there is no liberal constituency for such an argument in a Democratic Party in which only 2 percent of delegates called "terrorism" their paramount issue and another 1 percent mentioned "defense."

But Schlesinger and the ADA didn't only attack the right as weak on national defense; they charged that conservatives were not committed to defeating communism in the battle for hearts and minds. It was the ADA's ally, Truman, who had developed the Marshall Plan to safeguard European democracies through massive U.S. foreign aid. And, when Truman proposed extending the principle to the Third World, calling in his 1949 inaugural address for "a bold new program for making the benefits of our scientific advances and industrial progress available for the improvement and growth of underdeveloped areas," it was congressional Republicans who resisted the effort.

Support for a U.S.-led campaign to defeat Third World communism through economic development and social justice remained central to anti-totalitarian liberalism throughout the 1950s. Addressing an ADA meeting in 1952, Democratic Senator Brien McMahon of Connecticut called for an "army" of young Americans to travel to the Third World as "missionaries of democracy." In

1955, the ADA called for doubling U.S. aid to the Third World, to blunt "the main thrust of communist expansion" and to "help those countries provide the reality of freedom and make an actual start toward economic betterment." When Kennedy took office, he proposed the Alliance for Progress, a $20 billion Marshall Plan for Latin America. And, answering McMahon's call, he launched the Peace Corps, an opportunity for young Americans to participate "in the great common task of bringing to man that decent way of life which is the foundation of freedom and a condition of peace."

The critique the ADA leveled in the '50s could be leveled by liberals again today. For all the Bush administration's talk about promoting freedom in the Muslim world, its efforts have been crippled by the Republican Party's deep-seated opposition to foreign aid and nation-building, illustrated most disastrously in Iraq. The resources that the United States has committed to democratization and development in the Middle East are trivial, prompting Naiem Sherbiny of Egypt's reformist Ibn Khaldun Center to tell *The Washington Post* late last year that the Bush administration was "pussyfooting at the margin with small stuff."

Many Democratic foreign policy thinkers favor a far more ambitious U.S. effort. Biden, for instance, has called for the United States to "dramatically expand our investment in global education." But, while an updated Marshall Plan and an expanded Peace Corps for the Muslim world are more naturally liberal than conservative ideas, they have not resonated among post-September 11 liberal activists. A new Peace Corps requires faith in America's ability to improve the world, something that Moore—who has said the United States "is known for bringing sadness and misery to places around the globe"—clearly lacks. And a new Marshall Plan clearly contradicts the zero-sum view of foreign aid that undergirded Kerry's vote against the $87 billion. In their alienation over Iraq, many liberal activists seem to see

the very idea of democracy-promotion as alien. When the *Times* asked Democratic delegates whether the "United States should try to change a dictatorship to a democracy where it can, or should the United States stay out of other countries' affairs," more than three times as many Democrats answered "stay out," even though the question said nothing about military force.

What the ADA understood, and today's softs do not, is that, while in a narrow sense the struggle against totalitarianism may divert resources from domestic causes, it also provides a powerful rationale for a more just society at home. During the early cold war, liberals repeatedly argued that the denial of African American civil rights undermined America's anti-communist efforts in the Third World. This linkage between freedom at home and freedom abroad was particularly important in the debate over civil liberties. One of the hallmarks of ADA liberals was their refusal to imply—as groups like MoveOn sometimes do today—that civil liberties violations represent a greater threat to liberal values than America's totalitarian foes. And, whenever possible, they argued that violations of individual freedom were wrong, at least in part, because they hindered the anti-communist effort. Sadly, few liberal indictments of, for instance, the Ashcroft detentions are couched in similar terms today.

Toward an Anti-Totalitarian Liberalism

For liberals to make such arguments effectively, they must first take back their movement from the softs. We will know such an effort has begun when dissension breaks out within America's key liberal institutions. In the late '40s, the conflict played out in Minnesota's left-leaning Democratic Farmer-Labor Party, which Hubert Humphrey and Eugene McCarthy wrested away from Wallace supporters. It created friction within the NAACP. And it divided the ACLU, which split apart in 1951, with anti-communists controlling

the organization and non-communists leaving to form the Emergency Civil Liberties Committee.

But, most important, the conflict played out in the labor movement. In 1946, the CIO, which had long included communist-dominated affiliates, began to move against them. Over fierce communist opposition, the CIO endorsed the Marshall Plan, Truman's reelection bid, and the formation of NATO. And, in 1949, the Organization's executive board expelled eleven unions. As Mary Sperling McAuliffe notes in her book *Crisis on the Left: Cold War Politics and American Liberals, 1947–1954*, while some of the expelled affiliates were openly communist, others were expelled merely for refusing to declare themselves anti-communist, a sharp contrast from the Popular Front mentality that governed MoveOn's opposition to the Iraq war.

Softs attacked the CIO's action as McCarthyite, but it eliminated any doubt about the American labor movement's commitment to the anti-communist cause. And that commitment became a key part of cold war foreign policy. Already in 1944, the CIO's more conservative rival, the American Federation of Labor (AFL) had created the Free Trade Union Committee (FTUC), which worked to build an anti-totalitarian labor movement around the world. Between 1947 and 1948, the FTUC helped create an alternative to the communist-dominated General Confederation of Labor in France. It helped socialist trade unionists distribute anti-communist literature in Germany's Soviet-controlled zone. And it helped anti-communists take control of the Confederation of Labor in Greece. By the early '60s, the newly merged AFL-CIO was assisting anti-communists in the Third World as well, with the American Institute for Free Labor Development training 30,000 Latin American trade unionists in courses "with a particular emphasis on the theme of democracy versus totalitarianism." And the AFL-CIO was spending a remarkable 20 percent of its budget on for-

eign programs. In 1969, Ronald Radosh could remark in his book, *American Labor and United States Foreign Policy*, on the "total absorption of American labor leaders in the ideology of Cold War liberalism."

That absorption mattered. It created a constituency, deep in the grassroots of the Democratic Party, for the marriage between social justice at home and aggressive anti-communism abroad. Today, however, the U.S. labor movement is largely disconnected from the war against totalitarian Islam, even though independent, liberal-minded unions are an important part of the battle against dictatorship and fanaticism in the Muslim world.

The fight against the Soviet Union was an easier fit, of course, since the unions had seen communism up close. And today's AFL-CIO is not about to purge member unions that ignore national security. But, if elements within American labor threw themselves into the movement for reform in the Muslim world, they would create a base of support for Democrats who put winning the war on terrorism at the center of their campaigns. The same is true for feminist groups, for whom the rights of Muslim women are a natural concern. If these organizations judged candidates on their commitment to promoting liberalism in the Muslim world, and not merely on their commitment to international family planning, they too would subtly shift the Democratic Party's national security image. Challenging the "doughface" feminists who opposed the Afghan war and those labor unionists with a knee-jerk suspicion of U.S. power might produce bitter internal conflict. And doing so is harder today because liberals don't have a sympathetic White House to enact liberal anti-totalitarianism policies. But, unless liberals stop glossing over fundamental differences in the name of unity, they never will.

Obviously, Al Qaeda and the Soviet Union are not the same. The USSR was a totalitarian superpower; Al Qaeda merely espouses a

totalitarian ideology, which has had mercifully little access to the instruments of state power. Communism was more culturally familiar, which provided greater opportunities for domestic subversion but also meant that the United States could more easily mount an ideological response. The peoples of the contemporary Muslim world are far more cynical than the peoples of cold war Eastern Europe about U.S. intentions, though they still yearn for the freedoms the United States embodies.

But, despite these differences, Islamist totalitarianism—like Soviet totalitarianism before it—threatens the United States and the aspirations of millions across the world. And, as long as that threat remains, defeating it must be liberalism's north star. Methods for defeating totalitarian Islam are a legitimate topic of internal liberal debate. But the centrality of the effort is not. The recognition that liberals face an external enemy more grave, and more illiberal, than George W. Bush should be the litmus test of a decent left.

Today, the war on terrorism is partially obscured by the war in Iraq, which has made liberals cynical about the purposes of U.S. power. But, even if Iraq is Vietnam, it no more obviates the war on terrorism than Vietnam obviated the battle against communism. Global jihad will be with us long after American troops stop dying in Falluja and Mosul. And thus, liberalism will rise or fall on whether it can become, again, what Schlesinger called "a fighting faith."

Of all the things contemporary liberals can learn from their forbearers half a century ago, perhaps the most important is that national security can be a calling. If the struggles for gay marriage and universal health care lay rightful claim to liberal idealism, so does the struggle to protect the United States by spreading freedom in the Muslim world. It, too, can provide the moral purpose for which a new generation of liberals yearn. As it did for the men and women who convened at the Willard Hotel.

American Adam

JOHN B. JUDIS

March 12, 2008

For the past twenty years, John B. Judis has served as The New Republic's *in-house grump. As a veteran of the Berkeley left, he sees the world differently than the rest of us. With his training in Marxist dialectics—the substance of which he abandoned a long time ago—he thinks about capitalized History and can pick out the trends within it. He's also immune to some of the faddish thinking that occasionally inflicts the rest of us. During the 2008 presidential primaries, he and Leon Wieseltier were the only members of the staff who resisted the euphoria surrounding Barack Obama's candidacy. This essay was Judis's attempt to understand everyone else's enthusiasm.*

When Barack Obama announced a year ago that he was running for president, I scoffed. How could a black man whose middle name is Hussein and who looks like he is 25 years old win the White House? To be sure, he was a U.S. senator, but he had been elected largely on a fluke when his toughest Democratic and Republican opponents were felled by scandals. "He'll fade by December," I assured anyone who would listen.

One year later, Obama is the front-runner for the Democratic

nomination, having built a formidable coalition of whites and blacks, Democrats and independents, and even a few stray Republicans. As the only major candidate to oppose the Iraq war before it started, he appeals to the large number of Democrats who want the United States to withdraw. African Americans threw him their support after he demonstrated in Iowa that he could attract white votes. And college-educated whites have flocked to him en masse.

But Obama has done more than cobble together a political coalition. He has made himself into a political phenomenon, the likes of which the country has not seen since Ronald Reagan. He fills stadiums. His rallies—where he asks the crowd to "stand up for change" and it responds by shouting, "Yes we can!"—are like revival meetings. He has inspired thousands of volunteers and dramatically boosted turnout rates, particularly among young voters. Al Gore and John Kerry, the last two Democratic nominees, certainly never attracted this kind of following.

While I worry about Obama's inexperience, I haven't been immune to his charms. When I have gone to see him speak or watched him on television, he has invariably given more or less the same speech about "fundamental change" and "choos[ing] the future over the past." Yet, each time, I find myself listening raptly, even after the sixth or seventh reiteration of the same slogans and catchwords. It is partly his voice and his cadences, but there has to be more to it than that. And there is.

Obama is the candidate of the new—a "new generation," a "new leadership," a "new kind of politics," to borrow phrases he has used. But, in emphasizing newness, Obama is actually voicing a very old theme. When he speaks of change, hope, and choosing the future over the past, when he pledges to end racial divisions or attacks special interests, Obama is striking chords that resonate deeply in the American psyche. He is making a promise to voters that is as old as the country itself: to wipe clean the slate of history and begin again from scratch.

Looming over all of American history—but particularly the country's formative years—is the Biblical figure of Adam, the only person, according to the West's major religions, to have lived unburdened by what came before him. As literary critic R. W. B. Lewis wrote in 1955, in his wonderful book *The American Adam*, early generations of Americans became captivated by the idea that they could create a future without reference to the past. The revolutionaries who fought for America's independence saw themselves as breaking not only with the Old World but with history itself. "The case and circumstances of America present themselves as in the beginning of a world," Thomas Paine wrote in 1792. Thomas Jefferson believed the new nation should regularly renew itself, arguing that, if necessary, "[t]he tree of liberty must be refreshed . . . with the blood of patriots and tyrants." But, as Lewis explains, it was after the War of 1812—after the United States had finally cut loose from Great Britain and other foreign entanglements—that the notion of a country unbound from the constraints of history really began to take root. *Democratic Review*—the magazine of a nineteenth-century progressive movement known as Young America—captured this sentiment in 1839, when it editorialized, "[O]ur national birth was the beginning of a new history . . . which separates us from the past and connects us with the future only."

According to this line of thought, each generation of Americans could always start over and transform their country. In a lecture in Boston in 1841, Ralph Waldo Emerson described politics as a clash between "the party of Conservatism and that of Innovation" or between "a Conservative and a Radical." "It is the opposition of Past and Future, of Memory and Hope, of the Understanding and the Reason," Emerson explained. "Conservatism stands on man's confessed limitations; reform on his indisputable infinitude." At the time Emerson was giving his lecture, it was the Democratic Party that claimed the mantle of innovation and reform. The heirs of

Andrew Jackson believed that, in expanding American democracy over the continent, they were creating a new world that would eventually eclipse the old. "The expansive future is our arena," wrote *Democratic Review*. "We are entering on its untrodden space . . . with a clear conscience unsullied by the past."

In his *Studies in Classic American Literature*, which appeared in 1923, D. H. Lawrence identified the celebration of the new and the rejection of the old as "the true myth of America." According to this myth, Lawrence wrote, America "starts old, old, wrinkled and writhing in an old skin. And there is a gradual sloughing of the old skin, towards a new youth." The myth of America as Adam runs through our country's literature—from Walt Whitman's self-description as a "chanter of Adamic songs / Through the new garden the West," to Mark Twain's Huckleberry Finn to F. Scott Fitzgerald's Jay Gatsby to Ralph Ellison's invisible man. And it reemerges periodically in American politics—usually during times of upheaval or discontent.

In the early 1960s, after three recessions in a decade and the apparent loss of America's lead in space, President John F. Kennedy sounded the tocsin of change: "Change is the law of life," he said. "And those who look only to the past or present are certain to miss the future." Later, amid the growing unrest created by the Vietnam war, an Adamic culture took root among the revolutionaries of the New Left, who imagined revolution to be imminent. "The foundation of civilization is growing here," declared a spokesman for the Diggers, a San Francisco communal organization, adding, "Hope is . . . the foundation of it."

Today, the conditions seem propitious for another Adamic moment: six years of fruitless war, the looming prospect of another recession, a political system paralyzed by partisanship. Enter Barack Obama, the latest representative of Emerson's party of innovation, radical reform, and hope. He has appropriated these older themes and translated them into the political rhetoric of the early twenty-

first century: "Hope and change have been the causes of my life." "Hope is the bedrock of this nation: the belief that our destiny will not be written for us, but by us; by all those men and women who are not content to settle for the world as it is, who have the courage to remake the world as it should be." "There is a moment in the life of every generation, if it is to make its mark on history, when its spirit has to come through, when it must choose the future over the past." "People want to turn the page. They want to write a new chapter in American history." And so on.

Obama's youthful unlined face, his exotic name, and his unusual upbringing in Hawaii and Indonesia by a white mother and grand-parents, black father, and Indonesian stepfather contribute to the sense that he can give the United States a fresh start. He is like Herman Melville's Adamic hero, Billy Budd, a foundling who was "happily endowed with the gayety of high health, youth and a free heart" and "looked even younger than he really was."

Of course, as *New York Times* columnist Gail Collins has re-marked, some voters are repelled by a promise of fundamental change. "Women—especially older women—are often politically risk-averse," she writes. But many voters, particularly among the young, have been enthralled by Obama's message. They flock to rallies festooned with banners trumpeting CHANGE WE CAN BE-LIEVE IN. In an article in the Suffolk University student newspaper, Andrew Favreau compared Obama's campaign to "the movement that my parents lived through back in the 60s, and that I had wished I had the opportunity to experience. . . . What I'm interested in is that millions of people believe again. They believe in America, and they believe in one another, but more importantly they are filling themselves with hope."

Journalists and politicians appear drawn to the same qualities. Responding to the charge that Obama lacks experience, *The New Yorker*'s Hendrik Hertzberg wrote that "experience is a problematic

argument, especially when voters are hungry for a new beginning." Former Connecticut Senate candidate Ned Lamont said of Obama, "I've fallen for him. I like the fact that he brings a fresh perspective to Washington. I love the idea that he gives us a fresh start around the world." New beginning, fresh perspective, fresh start: These are sentiments that Americans of the post-1812 generation would have recognized as their own.

As it turned out, the idealism of the early nineteenth century would ultimately be thwarted by an issue that has bedeviled every generation of Americans before and since: race. Today, nearly two centuries later, there is probably no other topic on which Americans' need for a clean break with the past is so acute—no issue on which we crave an Adam figure quite so much. And many Americans believe they have found that figure in Obama.

While some white voters have rejected Obama because he is black, plenty of others have been more inclined to vote for him for the same reason. These are whites who grew up in the shadow of the '60s civil rights movement and who came to venerate Martin Luther King, observing his birthday as a national holiday. They yearn for racial reconciliation, and they see voting for Obama as a means to achieve that.

There are no polls to measure this sentiment, but it pops up repeatedly in interviews. One Obama supporter told *The Washington Post* at a campaign event in Tampa, Florida, that he hoped "someday we'll erase all this nonsense about race." His support for Obama, he said, was "reverse prejudice. It's just about time that someone of color got some credibility in a race like this for president." Joe Lance, an independent, wrote on a Tennessee website that he was backing Obama "because he transcends the old divides between black and white Americans. . . . It is thrill-

ing to imagine that in electing this person to the highest office, we could see centuries' worth of animosity and despair start to melt."

Such ideas underlie enthusiastic newspaper endorsements of Obama. *The Dallas Morning News* wrote, "[I]t is undeniable that America has failed to heal its racial wounds, including here in Dallas. We need a motivated leader capable of confronting the problem, and no candidate is better equipped than Mr. Obama. His message isn't about anger and retribution. It's about moving forward." In its endorsement, the *Los Angeles Times* noted that "[a]n Obama presidency would present, as a distinctly American face, a man of African descent, born in the nation's youngest state, with a childhood spent partly in Asia, among Muslims."

Not any African American could have created such high hopes for racial reconciliation, but Obama's background has made him especially well-suited to capitalize on these sentiments. He is at once part of black America and also removed from it and from its political history—an Adam figure with respect to the country's oldest and most painful conflict.

Although born to a Kenyan father and white mother, Obama is a black American and a black American politician. In the United States, blackness has always been a social rather than an ethnic category, so that, if someone looks black and has some African blood, he is black, even if one of his parents was white. "If I'm outside your building trying to catch a cab," Obama told interviewer Charlie Rose, "they're not saying, 'Oh, there's a mixed race guy.'"

At the same time, Obama was brought up by white relatives, lived in Hawaii, and attended elite schools. His divergence from previous black politicians like Jesse Jackson and Al Sharpton comes out most clearly in his unwillingness to embrace race-specific remedies or any program that smacks of reparations. "An emphasis on universal, as opposed to race-specific, programs isn't just good

policy; it's also good politics," Obama writes in *The Audacity of Hope*, which he published on the eve of the campaign. Obama also has little of the typical black politician's underlying outlook. Many black politicians descend from slaves brought from West Africa. That is part of their frame of reference when speaking about the United States. Jackson, for instance, reminded Michael Dukakis, his rival for the Democratic nomination in 1988, that his ancestors had come over on "slave ships" while Dukakis's had arrived on "immigrant ships." Just before the Democratic convention that year, miffed that Dukakis had passed him over for the vice presidency, Jackson claimed that the Massachusetts governor wanted to use him as a "vote picker" to bring his followers to the "big house." Obama, by contrast, is the son of an East African whose ancestors were not shipped to the New World as slaves. He wouldn't simply shun these kind of metaphors; they probably wouldn't occur to him because they aren't part of his political heritage. To put it in Adamic terms, he is outside of America's racial history and conveys little resentment over his own racial past.

As he tells it, Obama's message is very much that of the successful immigrant who has miraculously transcended the racial divide. Speaking in the town in Kansas in which his maternal grandfather grew up, Obama said:

> Our family's story is one that spans miles and generations, races and realities. It's the story of farmers and soldiers, city workers and single moms. It takes place in small towns and good schools, in Kansas and Kenya, on the shores of Hawaii and the streets of Chicago. It's a varied and unlikely journey, but one that's held together by the same simple dream. And that is why it's American. That's why I can stand here and talk about how this country is more than a collection of red states and blue states—because my story could only happen in the United States.

When white Americans hear these words, they don't feel guilt about past injustices, but rather hope for racial reconciliation.

Interestingly, should he make it to the general election, Obama will face someone who once had an analogous appeal to voters on a different issue. In the 2000 Republican primary, John McCain held out the prospect of ending the three-decade schism in American politics over the Vietnam war. As a former prisoner of war who also led the effort to restore diplomatic relations with Vietnam, McCain was an Adam figure in his own right—someone who could have, in theory, wiped the slate clean on a question that had haunted American politics for a generation. His fervent embrace of the Iraq war probably vitiates that appeal in 2008, but much of the enthusiasm Baby Boomers felt for McCain in 2000 stemmed from the promise of reconciliation over Vietnam that his campaign implicitly held out. This year, Obama's campaign offers a similar promise—but on a far more profound conflict that spans generations.

There is one last way in which Obama appeals to the American craving for an Adam figure: He has campaigned not just against the current occupant of the White House, but against Washington itself. Obama denounces the "dead zone that politics has become, in which narrow interests vie for advantage and ideological minorities seek to impose their own versions of absolute truth." He promises to "overcome the power of lobbyists and special interests." He criticizes Republicans *and* Democrats for excessive partisanship and vows to end the divide in Washington by bringing "Democrats, Republicans, and independents together." In short, he sets forth a vision of Washington shorn of special interests in which politicians pursue a nonpartisan agenda that reflects the public will.

These sentiments—a general distrust of government and a specific hostility to political parties—go back to America's founding.

Paine wrote that government, "even in its best state, is but a necessary evil." Jefferson wrote of political parties, "If I could not go to heaven but with a party, I would not go there at all." The Jacksonians invented and celebrated the modern party system, but they shared Paine's disdain for government itself. During the years that followed, Americans' wariness toward both government and political parties would endure. And, as Alexis de Tocqueville pointed out in *Democracy in America*, this suspicion of lasting institutions is closely linked to Americans' dismissal of the past.

Obama is hardly the first politician in recent memory to place himself within this tradition. Jimmy Carter in 1976 (who promised a "government as good as its people"), John Anderson in 1980, Gary Hart in 1984, Jerry Brown in 1980 and 1992, Ross Perot in 1992 and 1996, and Bill Bradley in 2000 each attempted to highlight their opposition to government as usual, and sometimes to political parties as well. In the mid-'80s, the late political consultant Alan Baron and CNN analyst William Schneider characterized this single-minded focus on cleaning up government as "radical centrism" (a phrase that has since become a cliché) since many of its practitioners, epitomized by Anderson, were quite moderate in the substantive policies they proposed but radical in their general attitude toward government.

Radical centrism has now developed its own constituency within the electorate. Independents currently make up about one-third of all voters. Fifty years ago, they tended primarily to be younger voters who hadn't yet decided which party to support. That's still the case for some—but, for many independents, the label has become a political statement in its own right, on par with calling oneself a Democrat or a Republican.

In 1992, some of these voters flocked to Ross Perot. In 2000, a plurality of them supported George W. Bush, with his promise to be a "uniter, not a divider," over the Washington-tainted Al Gore.

But, in 2006, angered by Republican scandals, they came roaring back to the Democrats, whom they supported in congressional races by 57 to 39 percent. Obama is a perfect fit for these voters. Independents are well represented at Obama's rallies, and, in the primaries and caucuses where they have been allowed to vote, they have overwhelmingly supported him. He lost California, but carried independents by 58 to 34 percent. In states he has won, the margins were even larger—64 to 33 percent in Wisconsin and 67 to 30 percent in Missouri. One independent, writing on a Minnesota website, summed up Obama's Adamic appeal this way: "Obama is a true leader not spoiled by years in the beltway."

Like that last great Adamic Democrat, John F. Kennedy, Obama is running on the cusp of a new political movement. His campaign is very much a descendant of Howard Dean's primary effort in 2004 and of the political movement that preceded and grew up around it—including MoveOn.org, Dean for America (now Democracy for America), and the networks of bloggers that promote and raise money for Democratic campaigns. This movement has expanded during the last three years, but, if Obama were to win the nomination, it could burst forth in the way that the New Left of the '60s grew after Kennedy and in the way that a new conservatism spread after Ronald Reagan was elected in 1980. Call it progressive or liberal—whatever it is, this movement could provide a countervailing force to the Republican alliance of social conservatives and business that dominated Congress from 1994 to 2006. That is the underlying promise of Obama's campaign.

But not all candidates who promise a break with the past succeed. For every John F. Kennedy, there is a Jerry Brown or Ross Perot. Obama could still fail to win the nomination, or, if he wins the nomination, he could lose in the general election. He has yet to

weather the kind of attacks on his character and associations that will come from Republicans. And the ranks of those who resist a call to "fundamental change" could certainly swell during a general election that would pit the party of youth against the party of experience—and a young black man with a Muslim-sounding middle name against an aged and revered war hero who has been in the Senate since 1986.

Even if Obama manages to win, he could very well fail as president. Just as the hopes of Jacksonian Democrats were shattered by the irrepressible conflict over slavery, Obama's dreams—and his movement—could founder in Iraq and the Middle East. Obama himself seems to be of two minds on Iraq. In *The Audacity of Hope*, he declares that America's "strategic goals" should be "achieving some semblance of stability in Iraq, ensuring that those in power in Iraq are not hostile to the United States, and preventing Iraq from becoming a base for terrorist activities." That would suggest a very cautious strategy for withdrawal. But, in his presidential campaign, he has wooed antiwar Democrats with a promise to start withdrawing from Iraq immediately. Once in office, he would have to weigh his strategic goals against his promise to withdraw—while very likely facing a military, with which he has had little experience, determined to continue the fight until it is won.

Obama's commitment to radical centrism could also be severely tested. Franklin Roosevelt and Ronald Reagan, who enjoyed the support of popular movements, gave priority to getting their substantive legislative agendas adopted; and they succeeded by uniting their supporters and dividing their opponents. If they had focused first on uniting Democrats and Republicans behind common objectives, they probably would not have gotten their way. And, if they had initially turned their attention, as Obama has proposed, to "the most sweeping ethics reform in history," it is unlikely they would have passed public works spending (Roosevelt) or tax cuts (Reagan).

Jimmy Carter, too, provides a cautionary tale: The last Democrat to take office on a radical centrist agenda, Carter failed to tame Congress or K Street and was defeated for reelection. He had campaigned for the presidency on the presumption that reformers could overturn the status quo in Washington. In the end, he turned out to be wrong.

The American instinct to continuously remake ourselves in the image of Adam—to achieve a decisive and final break with history—has periodically proven seductive to voters. And, sometimes, this instinct can produce important, transformative results. Yet the past—in the form of race or war or deeply held partisan animosities—has a way of lingering around. At the very least, it rarely recedes without a bitter fight. None of which is to say that Barack Obama will fail. He has already defied the expectations of wizened political journalists like me who believed he had no chance to win the nomination. If he becomes president, he will have a chance to prove me wrong again: to show that the party of youth and hope and change can govern effectively. No one will be more delighted than I will if he succeeds.

The Idea of Ideas

LEON WIESELTIER

May 13, 2010

Michael Kinsley stole the idea of The New Republic's *back page, "The Diarist," from the London* Spectator. *Each week, the staff took turns writing short first-person essays that seemingly caromed from subject to subject, except that they were far more coherent than they appeared. It was a chance to flash a little bit of personality and to write on topics that would have never otherwise found their way into the magazine. In 2006, Leon Wieseltier became the magazine's full-time diarist. It was a perfect form for him—allowing him to be at once casual and metaphysical, both funny and aggressive.*

What is an idea? Any notion in a person's mind, obviously: an image, a concept, a memory, a desire—"whatever it is which the mind can be employed about in thinking," as Locke said. But this level of generality, however necessary it was for the rise of epistemology, is hardly the end of it. All people think, but all people are not thinkers. Since the dawn of thought about thinking, ideas have been classified and ranked according to various kinds, not least with the aim of ascertaining which among them can be raised above the swim of subjectivity and secured by the more obligating author-

ity of reason. Some philosophers went so far in their ambition for ideas that they divinized some of them, imagining that they exist, as gorgeous unchanging forms, in an empyrean of their own. Leave aside the mysticism: the insistence upon establishing a hierarchy of mental representations is right. There are higher and lower, bigger and smaller, more significant and less significant, more rigorous and less rigorous ideas. An individual may be known by his idea of ideas, and a culture, too. "IDEAS WERE, ARE, AND always will be the next big thing," Richard Stengel wrote pantingly in his editor's letter in *Time*'s "third annual 10 Ideas issue," published last month. (What a damning admission, to announce an annual special ideas issue.) His assumption that the next big thing is what we most desperately need to know is itself an idea to which some analytical pressure must be applied, but it nicely captures the spirit of the love of ideas in contemporary America. "Conceptual scoops," Stengel calls the ideas in his issue. Most of them are just pop futurology, fantasies about this and that generated by bits of data about this and that: "TV will save the world," or "The twilight of the elites," or "The future of work looks a lot like unemployment." Bracing stuff. The latter scoop was articulated in one of the most imbecilic articles I have ever read: "Rather than warehouse their children in factory schools invented to instill obedience in the future mill workers of America, bourgeois rebels will educate their kids in virtual schools tailored to different learning styles." That is not an idea, it is an invitation to child protective services. Also, "The cultural battle lines of our time, with red America pitted against blue, will be scrambled as Buddhist vegan militia members and evangelical anarchist squatters trade tips on how to build self-sufficient vertical farms from scrap-heap materials." This "idea," the bastard child of Philip K. Dick and Mark Penn, is not only obscure, it is also a fine illustration of the way in which ideas these days are frequently little more than a pundit's hot mix of slogans and stereotypes. In this

circus of ideas, as in every circus, what counts most is novelty. In our fresh thinking, the fresh is more important than the thinking.

The New York Times Magazine also has an "annual year in ideas" issue, which appeared last winter. Some of its ideas were just news of the weird, such as "music for monkeys" or "cows with names make more milk"; but most of them were cute little inventions or discoveries—ethical robots ("Imagine robots that obey injunctions like Immanuel Kant's categorical imperative"), and bicycle highways, and lithium in the water supply, and the kitchen sink that puts out fires. Whatever all this is, it is not the life of the mind. Or more precisely, it is the life of the mind conceived pragmatically. These are indeed the archetypal ideas for a society in which the most important question to be asked about a proposition is not whether it is true or false, or good or bad, or right or wrong, but whether it will work—a society in which a checklist can be mistaken for a manifesto. Pragmatism is also an idea, of course: the big idea of small ideas, of ideas as directions and instructions, like the arrowed drawings in Ikea boxes.

This impoverishment of our idea of ideas—our satisfaction with what Owen Barfield witheringly described as "dashboard knowledge"—may be attributed to the new prestige, even the new tyranny, of the social sciences. You may have noticed that the digital age is the golden age of data; and intellectuals everywhere seem to have fallen under the spell of e-positivism. In American journalism, the most comic representative of the cult of "new research" and "recent studies" is David Brooks and his tiny empirical sentences. My recent favorite was his freakonomical discussion of Sandra Bullock's predicament, in which he comfortably noted that "research by Donald A. Redelmeier and Sheldon M. Singh has found that, on average, Oscar winners live nearly four years longer than nominees that don't win." The Redelmeier-Singh hypothesis! This "science" is related to the rise of behavioral economics, which looks to me

like an unfortunate expansion of utilitarianism. Bentham was at least dead to questions of sensibility; but the behavioral economists are confident that they can quantify those questions, and thereby disguise an old and narrow interest in the outcomes of decisions by consumers and investors with a new and broad interest in the mysteries of the human psyche. But you do not honor those mysteries with econometric expressions. Here, from a recent paper in the catch-fire field of "happiness studies," is an example:

$$\text{Happiness}_{it}^{*} = x_{it}\beta_t + \sqrt{x_{it}\gamma_t}\varepsilon_{it},$$

I do not pretend to be able to read such notation. I confess to a certain philistinism about all this. But my conscience is less troubled when I consider the philistinism of the equation-makers in their treatment of realms of human experience in which their methods have no place, their contempt for the deep and hard-won distinction between explanation and understanding in the analysis of human affairs. I find their regressions regressive. They owe their ascendancy to the reduced intellectual aspirations of their society. I do not mean to say that the only ideas are philosophical ones; but I half-mean to say so. I miss the days when our public disputations were torn between Marx and Burke; when people believed *in* as much as they believed *that*; when we had battles of ideas and not festivals of ideas. And I worry that it is only the liberals who have moved into the natty minimalist and instrumentalist universe. The Tea Party is thinking big.

Afterword
Mind Without Silos

The Next Hundred Years

CHRIS HUGHES

Strong institutions adapt to their times. In 1787, the framers of the United States Constitution laid the groundwork for twenty-seven amendments to be added over the following two hundred years. The Harvard University of 1636 could not have imagined the one hundred thousand students in India the university now welcomes today. Generations of military generals could have never expected women would serve on the front lines of combat in the American army as they will for the first time this year. All of these institutions are a step closer to fulfilling their ideals by reinterpreting their missions for the modern age.

The art of adaptation is in knowing where to give and where to hold firm, what to protect at all cost and what to turn over to the historians.

In a way, adaptation is the liberal creed—the idea that institutions of law, government, and society are organisms that must evolve. It is not that liberalism denies the existence of transcendent values. But it believes that human beings and their institutions can

always improve, can continue to strive for excellence and mold themselves to new circumstances. That idea has animated this institution, and it is a principle that has been reflected in its ever-shifting shape, which for one hundred years has remained in a state of flux, experimentation, and ferment.

My journey to *The New Republic* was not a particularly romantic one. I discovered it in my early twenties in a moment of obsession with the journals, reviews, and magazines that made up the world of American letters. I found myself drawn to the magazine's fiery arguments, refined feature writing, and earnest criticism. But more than anything, my passion for *The New Republic* stemmed from a belief that no discussion of politics, policy, or society makes sense without a consideration of what makes life worth living. This has been integral to the identity of the institution from its start.

In the days before the digital revolution, the "front of the book" was charged with analysis and debate about politics and policy, animating our search for a better nation. Discussion of the arts and culture flourished in the "back of the book." Newcomers to the magazine often wondered why reviews of theater and an occasional piece of fiction would be paired with political commentary from a sitting secretary of state.

To my mind putting politics, culture, and ideas side by side and on an equal plane improves the consideration of each topic in its own right. When we obsess over politics alone, it becomes a sport, a shortsighted obsession with who's up and who's down and what the next election might hold. And when we allow ourselves to drift too far into the world of aesthetics, we can easily forget the deep and abiding injustices that exist in our world. *The New Republic* committed itself from its beginning to asking the political mind to linger in the world of the arts, and for artists and intellectuals to wrestle with the hard questions of how to organize ourselves. Many other

institutions have covered the range of topics; few have put them on such equal footing.

We now live in an era of extreme disambiguation thanks to the digital revolution. As the printed book, newspapers, and print magazines gradually fade, the fear that quality journalism would not survive has not proven true, although we are still in the earliest of days. But the often overlooked and alarming change in this digital migration has been the disappearance of the physical binding of the print magazine for digital readers and its effect on the ideas digital readers encounter. Of the many bombs the advent of the Internet set off, the scattering of topics into "silos" and "verticals" has been perhaps the most destructive.

In a networked digital world, we tend to surround ourselves with content on topics that we like from perspectives similar to our own. When we rely on our friends to filter our news, it's no surprise that a romantic breakup or a vacation to Aruba wins out over the latest news from the Middle East. Not only do we find ourselves listening almost exclusively to others who share our ideology and worldview; we also start to think that other perspectives don't exist or have fallen out of favor. Our ability to insulate ourselves from the challenging or unpleasant is addictive and corrosive not only to our minds but also to our polity.

Recent history shows that ideologies across the board are hardening and cooperation and compromise are becoming more difficult. Similarly, with the explosion of information and data about all topics, it's rare that we feel the need to venture far afield to unknown topics or subjects. The practice of stumbling upon a new idea, an experience, a different opinion is becoming increasingly difficult and rare. A reader a century ago suffered from much less access to important information, but would have been exposed to more diverse and potentially unfriendly ideas than today.

Ironically, the more information we have and the more we

listen to those we agree with, the more cynical it seems we become. Americans in 2014 have lost faith in virtually all institutions—government, multinational companies, even the military. Polls show that we seem to feel a deeper sense of alienation and resignation than ever before and worry that our children will not be able to find the same—let alone greater—success than we have.

It is in the midst of this generalized cynicism that the project of *The New Republic* for the next century comes into focus. Even in the most difficult moments of the past hundred years, it's hard to find much cynicism in the voices of *New Republic* writers. There has been plenty of skepticism and wit, but little resignation that what will be, will be. Few other institutions can push influential thinkers and writers to invent and elucidate what our government and society must do in order to ensure the dream of American democracy and opportunity reaches all of us. A stratified, unjust, and uncultivated public is in none of our interests, and *The New Republic* must offer insights and create debates that reignite a collective desire to build a stronger country and world.

In our view, the best way to do this is to offer deep, thought-provoking analysis that encourages critical dialogue between influential people in our country and world. We aim to strengthen an institution where new ideas are meant to provoke and surprise. Our role and responsibility in the next century is to support and expand the kind of journalism and criticism that wrestles with the personalities, policies, and cultural and social issues of the day with an eye toward making a more just world in which the opportunity to live well and flourish abounds. This kind of informed and often contentious dialogue builds knowledge and lays the groundwork for progress.

In an era where the owner of a smartphone can watch in real time events and conversations on the other side of the world, our collective need is not for more data. The data explosion is well

underway and will almost certainly continue. Even if the economic logic of an enterprise like ours may drift toward timely news and entertaining content, our expertise and passion lie elsewhere with depth, analysis, and context.

Our work in the coming century is animated by a social mission to produce great journalism and criticism that helps readers understand their worlds and shape society. This requires engaging with the unfamiliar just as often as what we already know and thinking about politics, culture, and ideas as intimately related. Great writing, alongside new storytelling techniques, fosters these unexpected encounters and incites the "little insurrections" of the mind that our founding editor Herbert Croly called our mission in the magazine's earliest of days.

Fortunately for the institution, we celebrate our one-hundred-year anniversary at a stronger point than we have been in a long time. It's hard to imagine that any of the founding writers or editors of the magazine could have hoped to reach an audience as large as ours today. Several million people read *The New Republic* each month on phones, computers, tablets, and in print. They may not study a full issue of the magazine as closely as the original three thousand subscribers of 1914, but the reach of the institution has never been as wide or as meaningful.

My generation has grown up with the technology that makes this scale possible, but all of us, regardless of age, wrestle with the new challenges it has introduced: it is harder to concentrate for long periods of time; our tech tools close us off from contrasting opinions; new storytelling forms don't always allow for nuance or depth. All of these are legitimate and real problems. Yet none of the advancements of the early twenty-first century seem to have dampened enthusiasm for and interest in quality writing and influential journalism. The explosion of "content" has led many to believe we have a century of superficiality and inconsequence ahead of us.

But everything we have seen here at *The New Republic* suggests that the craving for ideas-driven journalism will not abate despite these challenges. Perhaps the market will not make institutions like ours enormous profit-making businesses, but there is more to the mission than the balance sheet.

Walter Lippmann, a founding editor of *The New Republic*, wrote in 1921 in *Public Opinion*, "The hypothesis, which seems to me the most fertile, is that news and truth are not the same thing, and must be clearly distinguished. The function of the news is to signalize an event, the function of truth is to bring to light the hidden facts, to set them in relation with each other, and make a picture of reality on which men can act." This institution will continue in pursuit of the truth in its study of politics, culture, ideas, and the arts. Just as idealism was its hallmark in the past century, so too will it be in the century ahead.

Acknowledgments

I owe a special debt to Jake DeBacher, who helped me cull the archives—and did many of the less-than-glamorous tasks that guided this book to fruition. He enthusiastically embraced the assignment, treating the months he spent with the bound volumes as if it were a semester of graduate school. Nora Caplan-Bricker, Hilary Kelly, Alice Robb, and Chloe Schama also helped launch this book. Christopher Benfey, Casey Blake, Jonathan Chait, David Greenberg, Michael Kazin, Michael Kinsley, and Sean Wilentz nominated pieces for inclusion. Thanks to Greg Veis, Rachel Morris, Michael Schaffer, James Burnett, and Leon Wieseltier for covering during the hours I spent away from the magazine. Tim Duggan and Emily Cunningham did an expert job editing this volume—and Elyse Cheney was its energetic agent. *The New Republic* would not exist today—at least not in its present form—were it not for several recent saviors, especially Bill Ackman, Michael Alter, John Driscoll, and, above all, Larry Grafstein. They helped guide the magazine to the Chris Hughes era, where we can (for once) sleep soundly about the future of this enterprise we love.